Masterclass in Photography

Masterclass in Photography

MICHAEL & JULIEN BUSSELLE

PAVILION

Contents

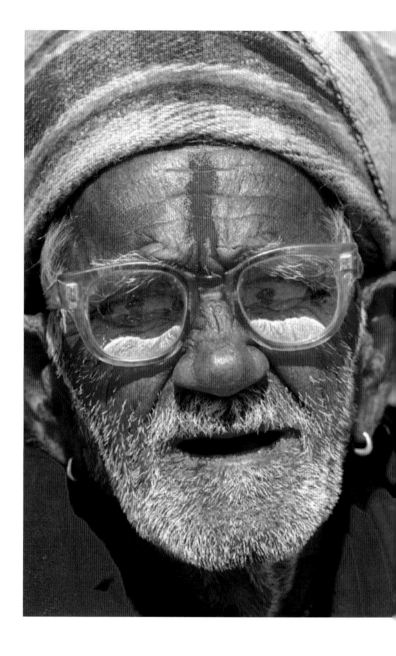

Introduction 6

The Visual Skills 8
Identifying the Elements 10
Discovering Shape 14
Harnessing Pattern 22
Seeing Lines 26
Identifying Form 32
Using Texture 40
Colour Awareness 46
Seeing in Black and White 56

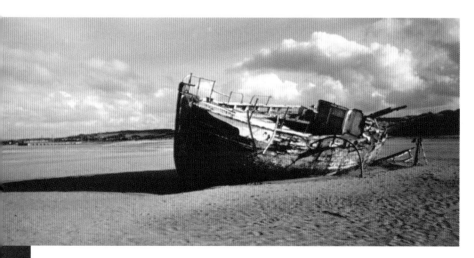

The Art of Composition 64
The Process of Selection 66
The Importance of Viewpoint 76
The Focus of Interest 84
Placing the Frame 90
Choice of Format 96
Choosing the Moment 100
Exploiting Perspective 104
Colour and Design 110
Style and Approach 116

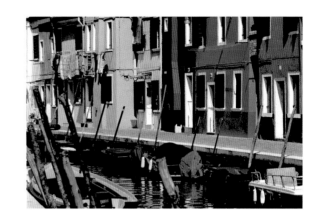

The Magic of Light 124
The Nature of Daylight 126
Shooting in Sunlight 132
The Time of Day 138
Light and the Sky 148
Artificial Light 160
Studio Lighting 162

The Specialized Subject 170
Portrait Photography 172
The Nude 176
Still Life and Close Up 180
Wildlife 186
Plants and Gardens 192
Architectural Photography 196
Landscape Photography 202
Documentary and Travel Photography 210

Recording the Image 216
Camera Types 218
Camera Formats 224
Using Lenses Creatively 228
Using Filters 234
Camera Accessories 238
Apertures and Depth of Field 242
Shutter Speeds and Movement 246

Controlling Exposure 250
Film and the Image 254

The Monochrome Darkroom 258
Choosing Film 260
Choosing Developer 262
Achieving Negative Quality 264
Exposure Test Strip 266
Exposure Selection 268
Selecting Contrast 270
Selective Exposure Control 274
Selective Contrast Control 278
Toning 280
Lith Printing 288
Finishing and Presentation 294

Digital Imaging 296
Controlling Density and Contrast 298
Controlling Colour Values 304
Converting to Monochrome 308
Adding Colour to Monochrome 310
Enhancing the Image 312
Creating Effects 316
Combining Images 322

Further Information and Index 330

The invention of photography more than a 150 years ago has had a huge impact on our lives. Nowadays, it is difficult to imagine what it would be like without photographic images to inform and entertain us.

In the early days the process of recording an image was both difficult and laborious. Today it is so simple that a child can make a sharp, colour-accurate record of a scene on their first attempt and see the results straight away. But this simple pressing of a button is not enough to produce photographs that will attract attention. The elemental characteristic that makes the difference has not changed over the decades – the awareness and approach of the person using the camera.

We believe that the beginning of the 21st century has seen the most exciting developments in photography during its history, not just in terms of new technology but in the changing attitudes of those who use it as a means of creative expression. In the past there was a tendency for the various genres of photography to be viewed and treated as separate disciplines but now there is a growing fusion and freedom in the way photographers make their images, with cutting-edge digital techniques now sitting comfortably alongside older, more traditional ones, rather than replacing them. We both feel it is important to make the point that no matter which medium you choose to work with, or whatever type of subject you favour, in the end it's all about the same thing – a visually stimulating and satisfying end result.

The purpose of *Masterclass in Photography* is to show how the basic visual and technical skills can be applied to all subjects

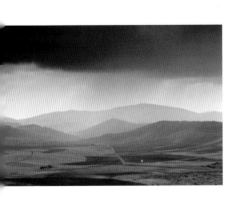

and situations to create compelling images. We believe that no matter where your main interests lie – wildlife or portrait photography, still life or landscape, monochrome or colour, silver halide or digital, there will be something on each page that can help you to understand how to make the most of every opportunity and how to produce your very best work.

Raising the level of your photographic ability to one where others will take notice of your images and admire them requires only awareness, understanding and application. The images in this book with the explanations of why and how they were taken, together with the comments about them, are designed to encourage you to analyse and judge them in ways that can be applied to the subjects *you* photograph. Understanding exactly why you do or don't like an image, or why you are pleased or disappointed with a particular result, is one of the most important ways of developing your abilities.

Above all, *Masterclass in Photography* aims to help you develop a "photographer's eye" so that you can see more clearly what constructs a striking image and consequently apply this awareness to a wide range of subjects and situations. When you have good visual skills and a basic understanding of equipment and techniques you will be able to produce memorable, telling images of whatever you choose and in any way you wish.

Michael and Julien Busselle

The Visual Skills

One of the main things that distinguishes a photographer from a person who simply takes photographs is that a photographer has (or develops) the ability to look beyond the actual subject and to see visual qualities that will produce a striking image. It is the photographer's ability to recognize the existence, or lack, of certain vital ingredients that makes the difference between a snapshot and a good photograph.

The qualities that make a good photograph are shape, form, texture, pattern, perspective and colour. They can exist in a scene or a subject that is, in itself, uninteresting and even unimportant, but the presence of just one of these elements is often enough to create a striking image. Conversely, an interesting, or even beautiful, scene or subject can be so lacking in these qualities that a photograph of it will not be aesthetically pleasing or satisfying.

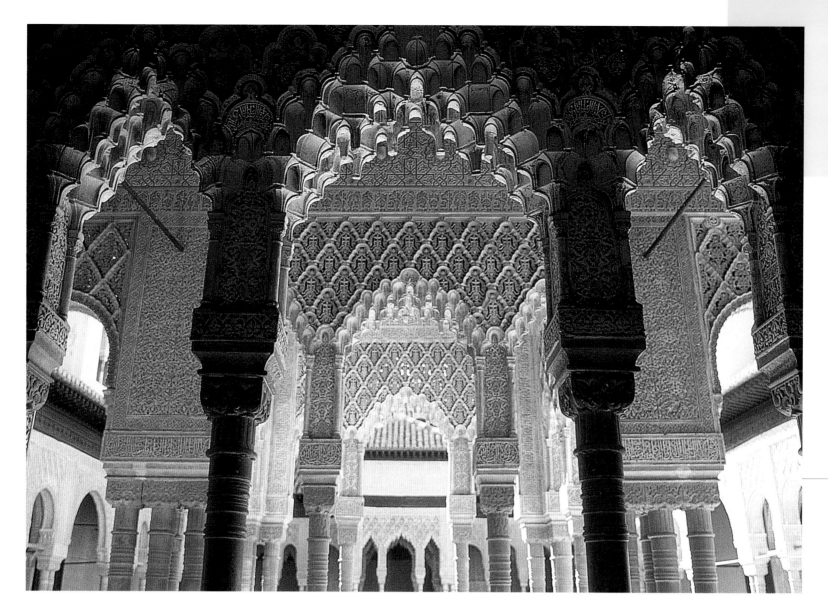

Identifying the Elements

When you're looking at a potential subject for a photograph, you need to be much more objective and analytical than you do when you're simply admiring something that is visually appealing. The most important step in acquiring a photographer's eye is to look beyond the subject itself and to identify the essential visual qualities that the camera likes so much. Some of these can be inherent in the scene, such as colour, texture and shape; others can be revealed or enhanced by lighting. Recognizing these key qualities is an essential step towards making decisions about how to compose the image, such as your choice of viewpoint and framing.

Situation and Approach

The Lion's Court in the Alhambra Palace in Granada is probably one of the most photographed subjects anywhere in the world and I claim no prize for having spotted its photographic potential. I managed to be almost first in the queue when the gates opened and headed straight for this spot, which gave me about ten minutes before anyone else arrived. The early-morning light had created a rich texture and colour in the stonework, and I decided to make this the main feature of the image. The lighting presented a few problems with contrast and shadows and I tried a number of angles to overcome this. This image, with the camera tilted to emphasize the shapes of the arches and a viewpoint that retained the symmetry of the architecture, is the one I liked best. (MB)

Jules' Comment

Shooting from the inside out has worked well, as the light reflected back onto the interior details has enhanced the texture and intricacy of the carved stone.

Technical Notes

35mm SLR, 20mm lens, Fuji Velvia.

Situation and Approach

I took this shot of a sticker on the door of a derelict garage at the end of a fruitless day spent looking for colourful landscapes. It was the vivid colours that appealed to me – partly because I still had the colourful landscape in my mind. I had to position the sticker near the top of the frame in order to exclude unwanted detail above it – an unusual approach, but one that also gave the image a graphic quality, like that of a cigarette or cereal packet. (JB)

Useful Advice

Inexperienced photographers often take their photographs from the place where they first saw the subject. While this may, on occasions, be the best viewpoint, try to get into the habit of looking for alternatives to see if your subject can be made to appear more striking, or more interesting, when shot from a different angle.

Mike's Comment

Although Jules had no option but to place the lettering so close to the top of the frame, it works because the red logo attracts the eye so powerfully that it needs a large area of blue below it to create a satisfying balance. The bold framing has also become an eye-catching element of the composition in its own right.

Technical Notes

Medium-format SLR, 120mm macro lens, Fuji Velvia.

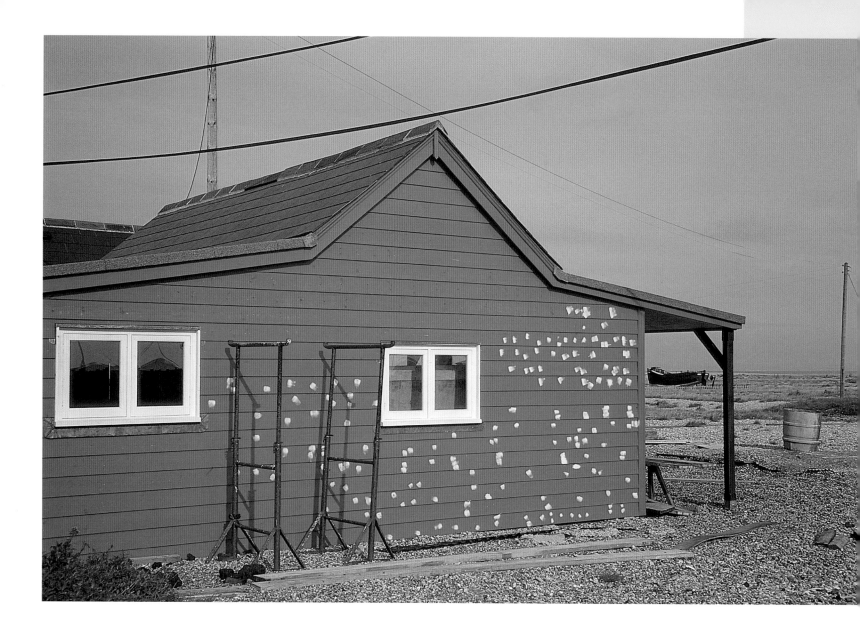

To a casual observer, the images in this book may seem to be characterized largely by their subject matter. To the eye of a perceptive photographer, on the other hand, other less obvious qualities are more significant. A beautiful subject by no means guarantees a great photograph. No matter how stunning a view may be, it will not produce a striking photograph if it does not possess certain visual elements – and for the image to have maximum impact, you must clearly identify and exploit those elements to the full. If they are present and successfully revealed in an uninteresting subject or a scene that is super-ficially unattractive, the outcome will be a better and more striking photograph than a record of a beautiful view in which these elements do not exist, or are not clearly identified.

Situation and Approach

I took this photograph at Dungeness, a rather bleak spot on the south coast of England. I was attracted by both the colour and the shape of the building and by the seemingly incongruous white patches with which it is decorated. I chose a viewpoint that presented the hut's shape in the most appealing way and included the distant boat, as well as enough of the criss-crossing cables to contribute to the composition. (MB)

Jules' Comment

This shot is not only about the striking colour of the building, but also about conveying the setting in a very direct, uncontrived way. Although the telegraph wires are a little distracting, the image itself has the charm of some of the American urban and architectural art photographs of the 1970s.

Situation and Approach

The light on this particular day was unsettled and finding a subject to take advantage of the stormy sky was difficult. Rather than drive on and risk losing the light I stopped at a breaker's yard, which I thought might give some interesting pictures. The white car on its side gave a slightly strange composition. I framed it so as to include the other wrecks in the background and make the most of the threatening sky. I had to place the car almost centrally in the frame to include all the elements and exclude unwanted detail. Although the composition is far from ideal, I think the combination of subject matter and light still gives a pleasing image. (JB)

Useful Advice

One way of learning how to identify the key visual elements, and to understand how effective they can be in creating strong images, is to look for potential photographs in locations that are not conventionally attractive or photogenic. Places such as rubbish tips and builders' yards can prove quite fruitful. This will help you to see the subject simply as a vehicle for the visual qualities it possesses – shape, form, texture, perspective and colour.

GREEN HUT, DUNGENESS

VERTICAL CAR WRECK

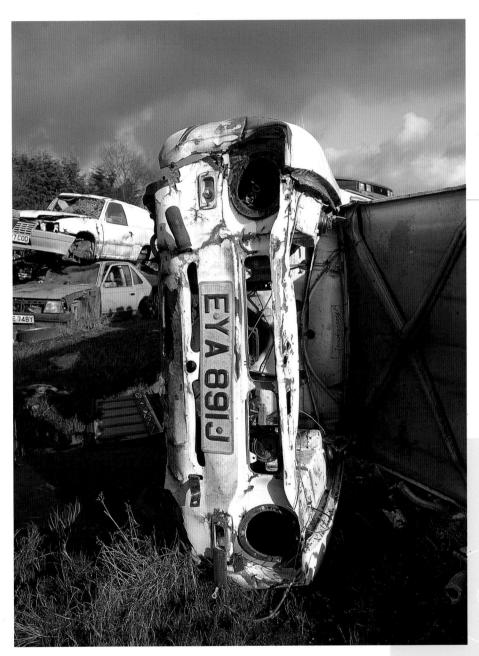

Technical Notes

Medium-format SLR, 55–110mm zoom lens with polarizing and 81A warm-up filters, Fuji Velvia.

Mike's Comment

In an ideal world I would have liked to see a little more to the left of the main subject and a little less of the shadowed car bonnet on the right. But I suspect that Jules framed it this way because of a distracting element further to the left; to have framed it more tightly would have meant cutting out the nice cloud.

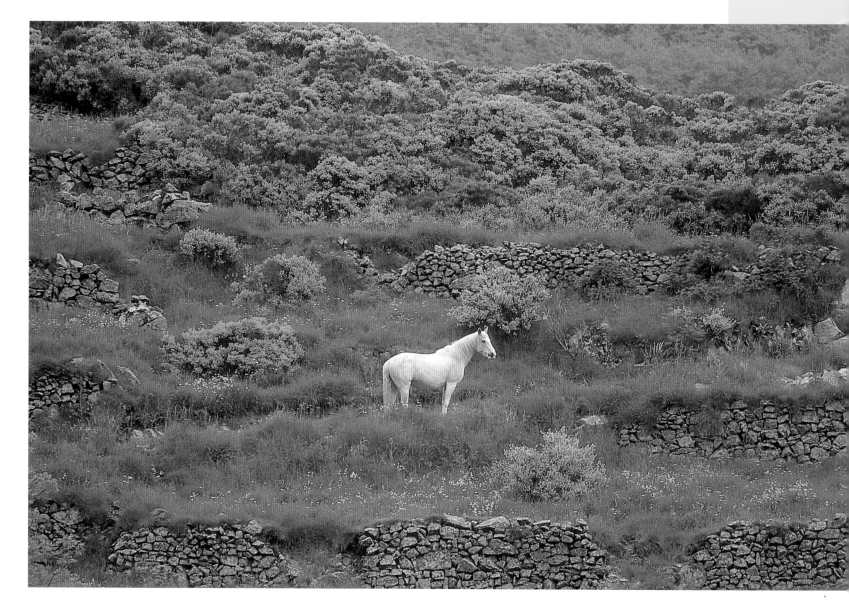

Discovering Shape

We usually identify objects through their shape and our ability to do this is so potent that it can be surprising how little we need to see of many things before we are able to recognize them: even a tiny, distant figure silhouetted on the horizon can be instantly identified as a human being. We can consciously exploit this fact when composing photographs.

An image with an interesting and boldly defined shape invariably has impact, even when there are few other visual elements present. When shape is combined with other qualities, such as a striking colour or a pronounced texture, the result can be a truly arresting image.

Situation and Approach

I was travelling through the mountains in the Ardèche region of France on an overcast day in spring, when the slopes were covered with bright yellow gorse bloom, but I had not seen the possibility of a picture until I spotted this distant, solitary horse. Although it is small in the frame, its bold shape and the strong contrast that it makes with its surroundings have helped to produce an eye-catching composition. (MB)

Jules' Comment

This shot would work well even without the horse: it has a pleasing, subtle light and lovely rich greens and yellows, while the stone wall provides texture and helps to give a pattern to the image. The horse does make the image stronger – but by keeping it small in the frame and positioning it just off centre, Mike has retained the subtlety of the landscape.

Situation and Approach

Although the texture and colour of the feathers were very pleasing individually, I felt that their shapes could be built into a satisfying arrangement. The lighting was both simple and soft, so that the emphasis was on the colour and patterns of the feathers. They were arranged on a piece of slate, which provided good separation and was also in keeping with the overall colour scheme. The shape of the main feather was the most important feature and I placed it diagonally across an upright frame to give it dominance. One feather on its own was not enough, so I used two small blue feathers to fill the frame, inverting the top one to give a playing-card effect. (JB)

Mike's Comment

The choice of background was very good in this shot: it creates a strong enough contrast to emphasize the feather's shape, while its natural colour and texture are completely appropriate to the subject.

WHITE HORSE, ARDÈCHE

FEATHERS

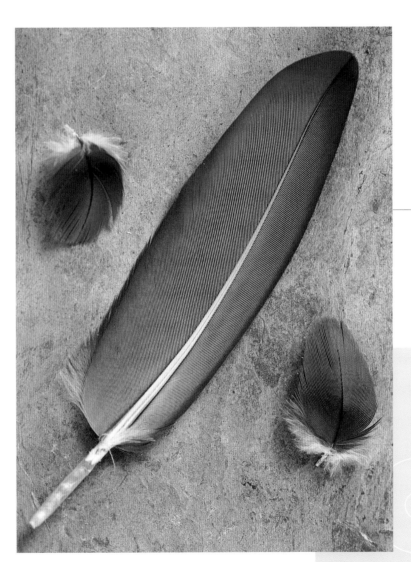

Useful Advice

The element of shape is most readily enhanced in an image when an object is separated clearly from its surroundings – by a tonal or colour contrast, differential focusing or back lighting, for example. Even small shapes within a larger scene can pull the eye very strongly when they are defined in this way and when they are especially interesting or unexpected, such as a lone human figure in an otherwise deserted scene.

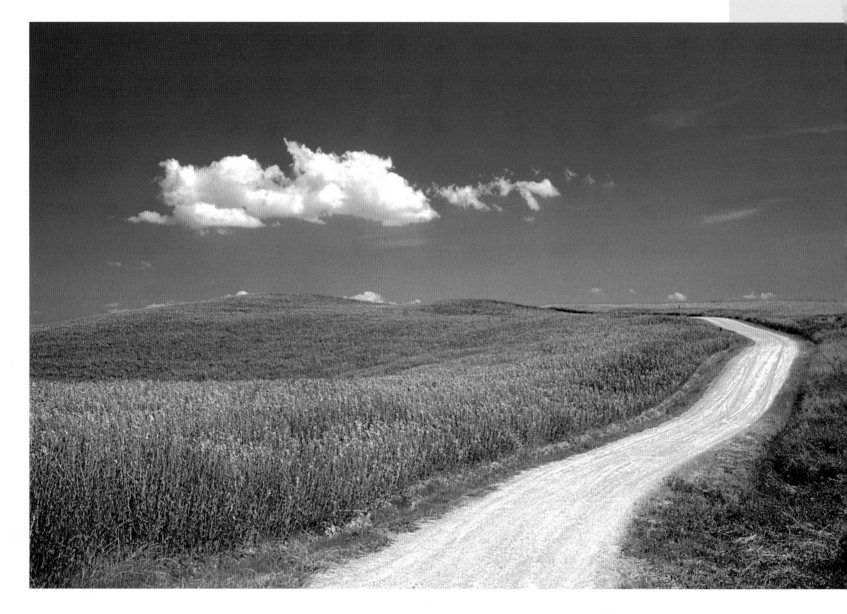

Intangible, Transitory Shapes

It is not only the fixed shapes of objects that can be harnessed to create interesting images – the random, transitory shapes created by light and shadow can be just as effective in a composition and even more fascinating to observe. The shapes of clouds, for instance, can be a powerful element in landscape photographs, as can the shapes produced by reflections in water and the shadows cast by sunlight.

Using such transitory, fleeting shapes in an image makes timing a vital consideration, and very often there is a single optimum moment at which to make the exposure. You need to react swiftly to such opportunities as they present themselves: things change so quickly that a few seconds can make all the difference.

Situation and Approach

I spotted this farm track while driving through Tuscany in the early summer. It was its winding shape that caught my attention and it was not until I had begun to look for a viewpoint that I noticed how the shape of the single cloud above could be used as a counterpoint. I had to work quite quickly, as even a slight change in the position of the cloud changed the balance of the image. I used a polarizing filter to darken the sky and make the cloud stand out more clearly. (MB)

Jules' Comment

I admit to having a track fetish, so a shot like this is always likely to please me. A great sky and vibrant colours add to the effect. I might have tried moving a little to the right to have the track entering the frame from the bottom left-hand corner and to see if I could squeeze in a little more as it vanishes over the horizon.

Technical Notes

35mm SLR, 28–70mm zoom lens with 81B warm-up and polarizing filter, Fuji Velvia.

Situation and Approach

I loved the richness of these moss-covered roots, but I initially dismissed the idea of taking a picture because of the shadows. After a while, however, I began to realize that the shadows actually make the picture more interesting, with horizontal shadows on the vertical roots creating an unusual pattern. I framed the shot tightly to limit any distractions, as there were a lot of unsightly twigs on the ground. I didn't use a filter as the light was particularly pleasing in its warmth and I didn't want to interfere with the colours that I saw. (JB)

Mike's Comment

The entwined shapes of the tree roots alone would have made an interesting image, but the superimposed shapes of the shadows have given it an almost mysterious quality. Although it works well in colour, I would have been interested to see it as a black-and-white photograph, because the lack of colour would have removed the image even further from "real life" and added to the element of mystery. The black-and-white process would also have emphasized the tonal quality of the image.

TUSCAN TRACK

Technical Notes

Medium-format SLR, 55–110mm zoom lens, Fuji Velvia.

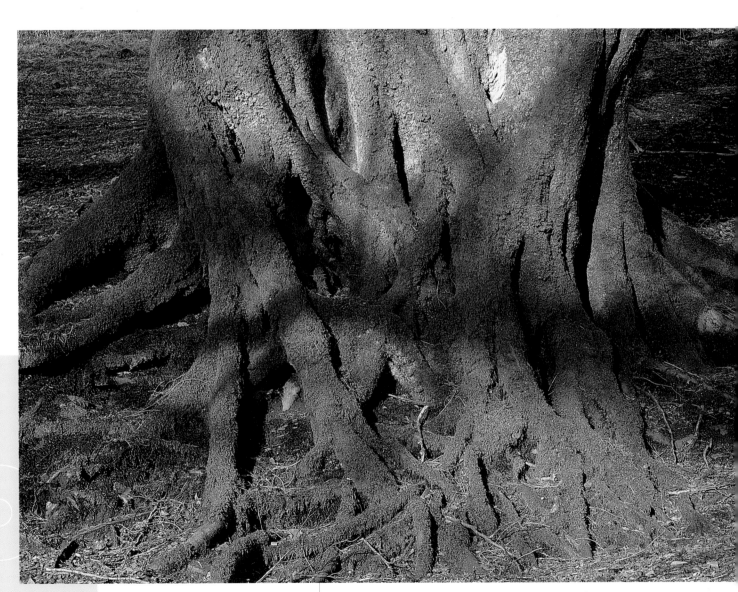

SHADOWY TREE ROOTS

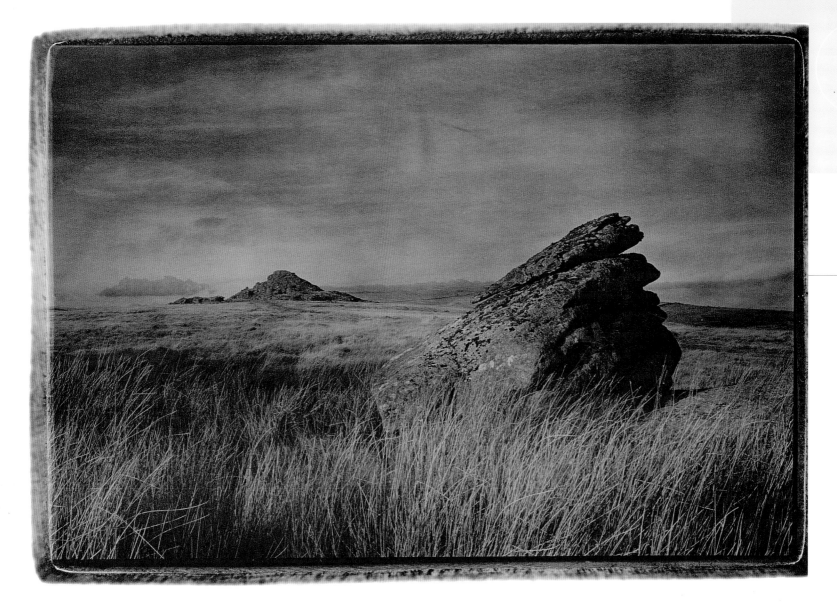

Juxtaposing Shapes

Setting one shape against another can be a very effective way of producing an eye-catching composition, especially when there is a pronounced difference in shape, such as a round object in a rectangular box. The effect can be further enhanced when the shapes are different in colour or tone or are used to create a sense of depth. Shapes that echo each other produce a calmer feel, a feeling of continuity.

You need to develop a feeling for the balance of an image and to judge the weight of one shape against another depending on its size and position in the frame. The colour of opposing shapes also affects the balance of the image. An effective device is to frame one shape with another, perhaps framing a building with an archway or overhanging branches.

Situation and Approach

This shot was taken on Dartmoor, in the south-west of England, and was composed to maximize the perspective and add drama. Oddly enough, the impact of the shot was lessened by applying the usual rule of thirds (see page 90), so I placed the horizon in the middle of the picture. Although the opposing boulders fall in separate halves of the image, their difference in scale and shape has prevented the composition from becoming too symmetrical and static. They also effectively divide the picture into quarters, which helps to offset the "half and half" feeling produced by the central line of the horizon. The print was made using the lith process to create the atmosphere I wanted – a touch dreamlike, part of a distant memory. (JB)

Mike's Comment

I find this image very atmospheric and the lith colouration has enhanced this. The sky works well because it has interesting tones: the light areas near the horizon have made the rock shapes more prominent.

Situation and Approach

It was the brightly coloured walls and the rectangular shapes of the windows that initially caught my eye and my first shots were taken from a closer viewpoint using just these elements. It was not until I began to explore the possibilities that I recognized the potential of the silhouetted shape of the tree and I moved back to a much more distant viewpoint in order to include it. The final choice of camera position was critical, because I wanted the shutters to remain a strong element of the composition. I used a telephoto lens to allow me to crop out the sky above the building and to exclude all but the most interestingly shaped part of the tree. I wanted both the tree and the more distant wall to be sharp and so I used a small aperture to create enough depth of field. (MB)

TORR ROCKS, DARTMOOR

ROUSSILLON TREE

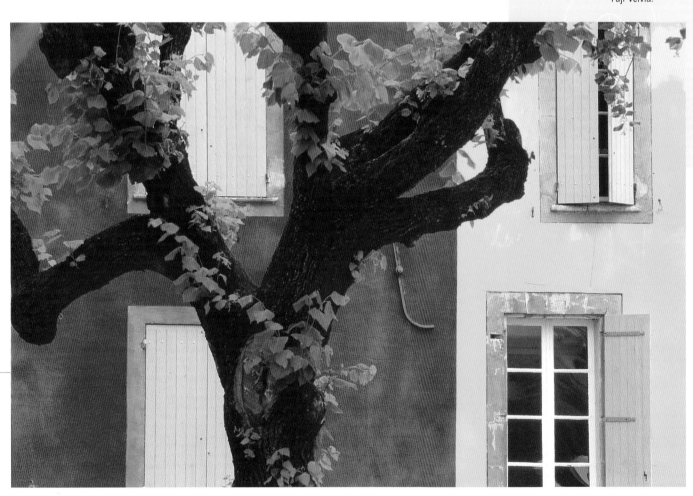

Jules' Comment

Definitely one of Mike's less subtle shots – in-your-face colour and composition. I like it – but without the interesting play between the regular shapes of the shutters and the stark silhouette of the tree, the vivid colour of the building might well have been too much.

Henri Cartier-Bresson

was born in 1908 in Chanteloup-en-Brie, France, not far from the banks of the Marne, where this photograph was taken. He was educated in Paris at the Lycée Condorcet, and initially his creativity was channelled into painting, a medium to which he has returned in later life. He did not take up photography until 1930, travelling widely at this time, to countries such as Spain, Italy, India, Mexico, America and Africa. He spent nearly three years in a German prison camp during the Second World War but escaped after three attempts and joined the Resistance as a photographer. He directed a film, *Le Retour*, for the USA Office of War Information in 1945. In 1947 he held a one-man exhibition at the Museum of Modern Art in New York and, together with Robert Capa, founded the Magnum Photographic Agency, a cooperative which to this day distributes the work of its members throughout the world.

Cartier-Bresson was the first photographer to exhibit work at the Louvre Museum in Paris in 1955. Of his numerous acclaimed books perhaps the most significant was *The Decisive Moment*, published in 1952, as it has also defined an entire genre of photography. He lives in Paris close to the Tuileries gardens.

Mike's Comment

One thing which distinguishes all of Henri Cartier-Bresson's photographs is an unfailing recognition of the moment when all the elements of the image combine to produce the most striking effect. In this image he has made his exposure at the moment he moved into the position where all the differing shapes of people and boat are distributed in a way that creates a sense of movement, together with perfect balance and harmony.

BANKS OF THE RIVER MARNE

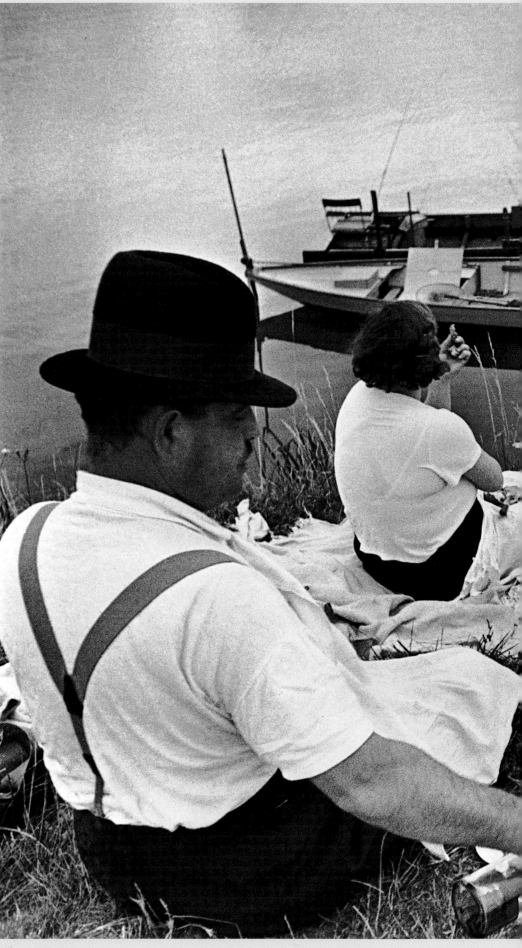

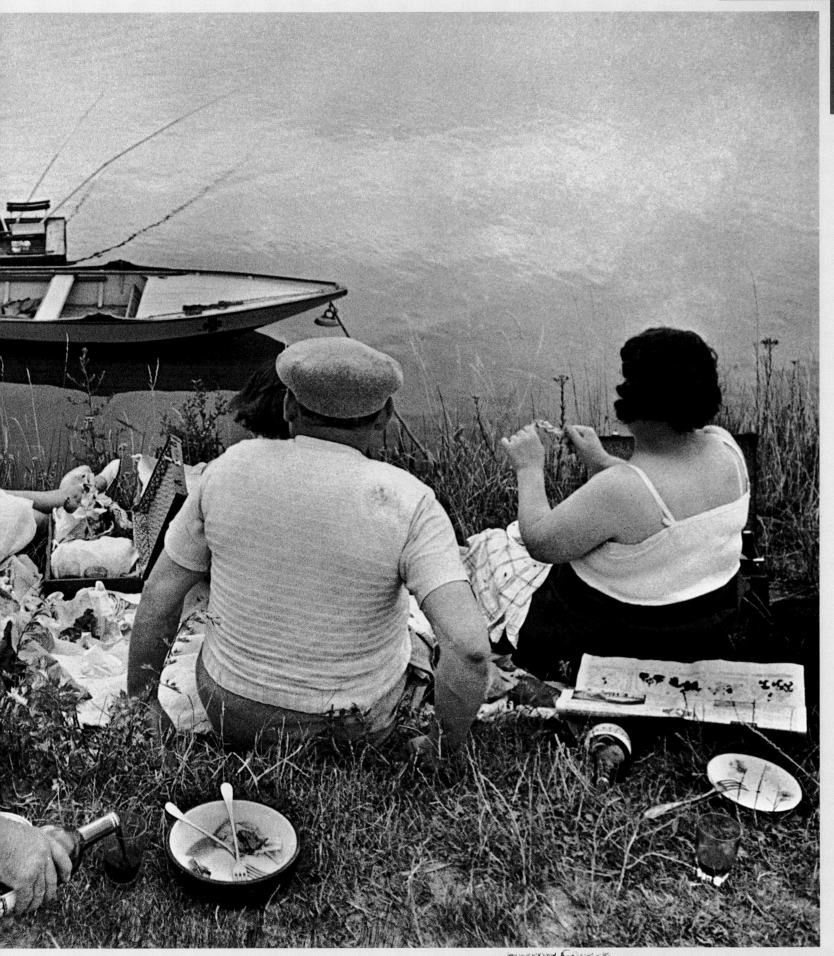

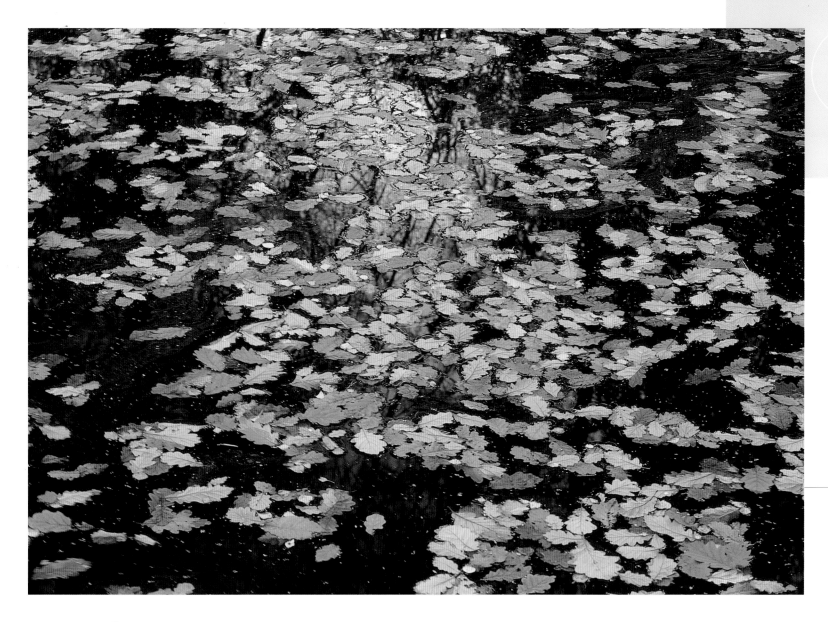

Harnessing Pattern

In photographic terms, a pattern is created when a distinctive shape is repeated within the image several or many times. The shape does not have to be exactly the same, provided an element of continuity is created.

Pattern can have a very powerful impact on a photograph, even when the subject itself is not particularly interesting: just as a repeated motif in a piece of popular music gives the listener a comforting feeling of familiarity, so too does a repeated visual motif. But, like the latter, its attraction can wane quite quickly if there is little else in the image to hold the viewer's attention. Perhaps the most effective way of making an image like this more compelling is when there is a break in the pattern, such as a single red apple in a box of green ones.

Situation and Approach

This pond is in a wood near my home and is surrounded by beech trees. I shot this at the beginning of November, when fallen leaves had almost completely covered the surface of the water, creating a very satifying pattern. It was an overcast day and the light was quite soft, but this has helped to record the leaves with a rich colour. A patch of sky visible through a gap in the trees has created a bright reflection on the surface of the water, which I used as a focus of attention. I used a polarizing filter to control the brightness of the reflection and increase the colour saturation of the leaves. (MB)

Jules' Comment

The colours are wonderful, but I really would have liked to have seen this shot taken from a closer viewpoint. The image would also have been stronger had there been a more positive focus of interest, such as a tin can floating among the leaves to break the pattern.

Technical Notes

Medium-format SLR, 55–110mm zoom lens with 81A warm-up and polarizing filters, Fuji Velvia.

Situation and Approach

This shot of licence plates displayed in a tourist shop in the United States was so obviously set up that I was reluctant to take it at first, but I soon realized that I'd be very lucky to come across something like this again. With so many licence plates I was unsure which ones to pick out; and every time I attempted to frame a section, the impact was lost. I framed the image to include as many plates as possible and let the colours and letters become a medley around the predominance of reds and yellows; this has helped to prevent the image from becoming too repetitive. The Coke bottle sign was placed centrally on the wall so my framing kept this, as it added a "hidden" focal point. (JB)

Mike's Comment

While this is a pattern with little real focus of interest, the subject is so striking and interesting that the initial impact of the image is sustained.

LICENCE PLATES

Technical Notes

Medium-format SLR, 55–110mm zoom lens, Fuji Velvia.

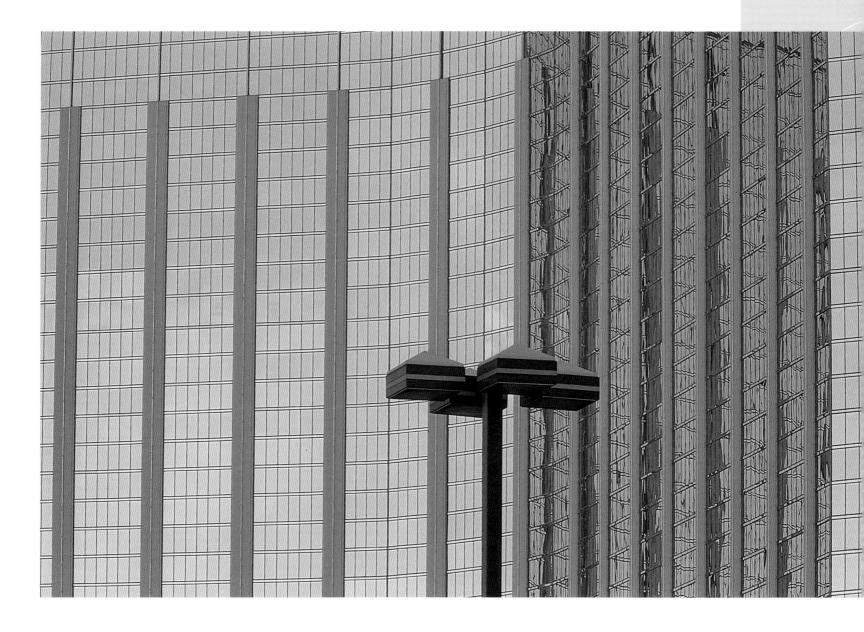

A large number of subjects have inherent patterns, and many of those that offer rich potential to the observant photographer can be found in natural forms such as flowers, trees and geological features. But the same potential also exists within many man-made objects and structures, and the urban environment can be especially fruitful.

Situation and Approach

After a long period of shooting mainly rural landscapes, a recent visit to Las Vegas provided something of a visual shock to my system. In this scene, photographed an hour or so before sunset, I was attracted by the quality of the lighting. Highly reflective objects like this glass-fronted hotel building are often best photographed in indirect light; in this case, light was reflected from the sky, which had taken on the warmer tone of evening, creating a slightly golden hue that contrasts effectively with the blue structure.

I used a long lens to enable me to isolate the most interesting area of the building from a distant viewpoint. This has also helped to reduce the effect of perspective and to avoid obviously converging verticals. My choice of viewpoint was also determined by the fact that I wanted to include the lamp standard as a focus of interest. I used a tripod together with mirror lock to eliminate the possibility of camera shake and vibration. (MB)

Technical Notes

35mm SLR, 70–200mm zoom lens with x 1.4 converter, Fuji Velvia.

Situation and Approach

Near my home is a storm beach that faces the Atlantic; a small section of it is broken by interesting rock shapes with the most amazing patterns. An overcast day at low tide is the best time to photograph them: in bright conditions the contrast is too strong for the patterns to break through the shadows. Overcast days also prevent the rock from drying out quickly, and the wetness gives a nice, subtle shine. This particular section of rock has an almost living, animal-skin feel to it. I chose to come in close, but not so tight as to make the image completely abstract. It still takes a while to work out what it is, though! (JB)

Mike's Comment

Although this composition works well, I would like to have seen it as an upright image, as I find I want to see more of the pattern beyond the top of the frame.

LAS VEGAS HOTEL

Jules' Comment

I have to disagree with Mike here, because I find that the lamp distracts from the pattern of the building behind. I think the colours are perfect, however, and I do like the shot – it's just that I'd like to see a version without the lamp. Maybe Photoshop could work here.

BARRICANE ROCK PATTERN

Technical Notes

Medium-format SLR, 80mm lens, Ilford XP2 processed in standard C41 (colour negative) chemicals.

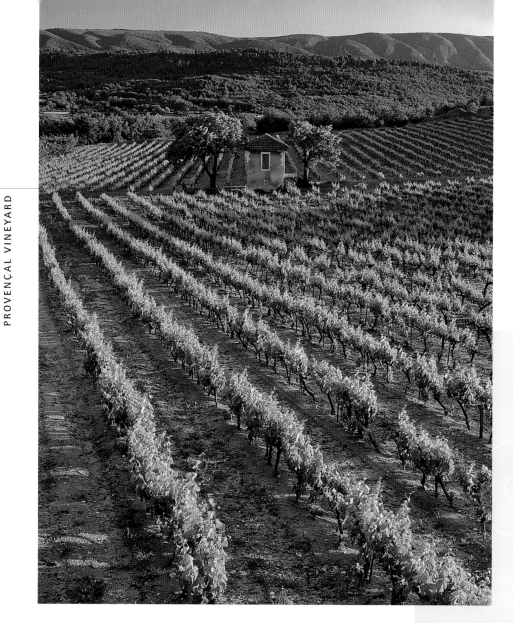

Technical Notes

Medium-format SLR, 55–110mm zoom lens with 81A warm-up and polarizing filters, Fuji Velvia.

Seeing Lines

Lines can be created within an image in a variety of ways, one of the most fundamental of which is when the lines form the main feature of a scene or subject. These lines are sometimes actual lines, sometimes merely implied. It can be both interesting and revealing to look at the bare bones of a photograph, as this can show the composition of an image in a very clear way. One way of doing this is to place a sheet of tracing paper over an image and trace the main outlines. This can show you how effective a bold shape is, for instance, and help you to become aware of the perspective within the image. Any picture treated in this way that does not result in an interesting drawing is likely to be lacking in interest as a photograph, too.

Situation and Approach

I spotted this scene as I drove through the vineyards near the village of Roussillon in Provence. I'd passed this way previously and had been attracted by the small stone hut flanked by the two trees, but the picture had simply not seemed to work before. On this occasion, the very low evening sunlight picked out the orderly rows of vines in strong relief and created bold lines that drew the eye towards the stone hut and the distant mountains.

My viewpoint was high above the vineyard and this has helped to make the lines more prominent and increase the impression of depth and perspective in the picture. The vines beyond the stone hut had been planted at a different angle and created a zig-zag effect, which has added interest and balance to the image. (MB)

Jules' Comment

A classic "Mike" shot. All the elements are there – light, pattern and the focal point of the hut flanked by the two trees.

Situation and Approach

I was familiarizing myself with a new panoramic-format camera in my home when the early-morning light came in through the blinds and created this arrangement of lines of highlights and shadows. I recognized the potential, but did not realize how effective the image could be until I made the print. It would probably have worked well in colour, but the black-and-white process has emphasized the image's tonal quality and, in doing so, has made the effect of the lines more striking. (JB)

Mike's Comment

A wonderfully minimalist photograph that works so well as a panoramic shape. A squarer format would have lessened the sense of movement that this picture has created.

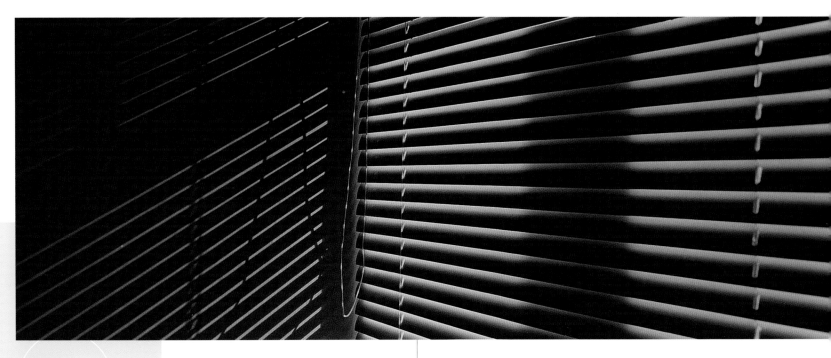

MORNING LIGHT THROUGH BLINDS

Technical Notes

35mm panoramic camera, 45mm lens, Kodak Tri-X developed in Kodak HC110.

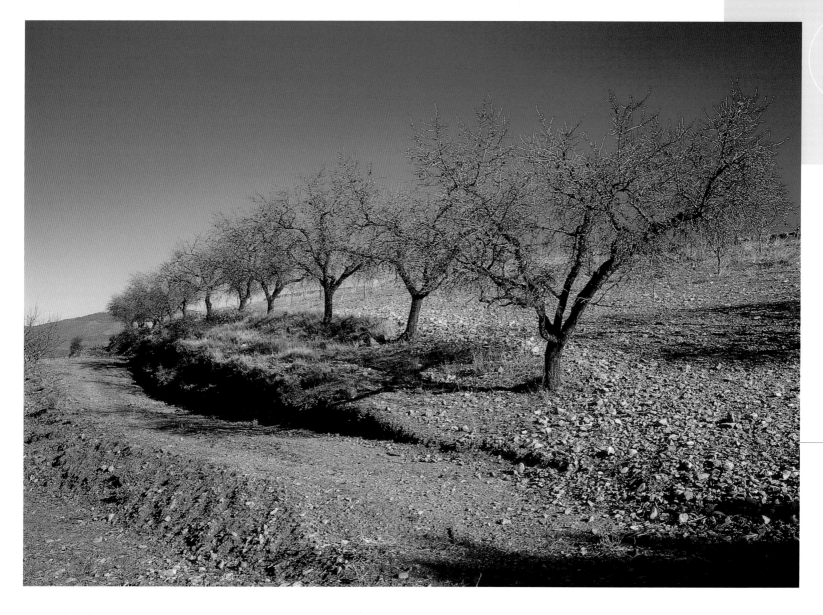

Implied Lines

Lines can be implied in an image by the outline of a dominant shape or by the effect of perspective. Although they are perhaps less immediately obvious than the examples on the previous pages, lines created in this way can still have a powerful effect on the composition of a photograph and help to create a strong visual impact. When an image contains objects close to the camera, they appear much larger than similar objects far away. This creates the effect of perspective – but it can also suggest the presence of lines. The direction of these lines has a significant influence on the composition of an image. A picture that contains predominantly horizontal lines, such as a landscape, tends to have a restful and reassuring quality, whereas diagonal lines can impart a sense of movement and create a more dynamic effect.

Situation and Approach

I was travelling through a very rural part of Aragon in Spain during the winter when I came across this row of trees planted alongside a farm track. The effect would probably not have been so striking in the spring or summer, when the branches would have been covered by foliage. The scene appealed to me because of the curving line created by both the trees and the track and the way it seemed to almost sweep away into the distance.

I used a wide-angle lens and shot from a viewpoint close to the nearest tree, which has caused it to appear a little distorted and accentuated the impression that it is leaning to one side. For me, this produced a sense of movement in what is, in reality, a very static scene.

I used a small aperture to create enough depth of field to ensure that both the nearest and furthest details were in sharp focus. I also used a polarizing filter – not only for the usual reason of making the sky a richer blue, but also to make the trees stand out in greater relief. This has helped to strengthen the effect of the curving line. Although the winter sunlight had quite a warm quality, the addition of a polarizing filter tends to make a scene look a little blue – so I also used a warm-up filter to balance this. (MB)

Situation and Approach

I drive past this location frequently but had never seen a potential picture there; on this particular day, however, it stood out because of the lighting conditions. Although the light was soft, it created strong highlights on the wet ruts and puddles, emphasizing the effect of lines that lead away into the distance. This impression is quite strong, even though the viewpoint and lens have not produced an especially marked impression of perspective. Although I initially made this as a straight black-and-white print, I prefer the sepia-toned version shown below. Normally I dislike sepia toning, but somehow it works with this image – especially the gold highlights in the puddles. (JB)

Mike's Comment

I have to confess that this is one of my favourite shots of Jules' as it is the view I see just before I arrive at his home and, for me, it captures the feeling of reaching the sea at last after a long journey. This is emphasized by the feeling of lines leading into the distance, which the highlights have created. I have this as a straight black-and-white print, but much prefer the toned version reproduced here.

Useful Advice

When using a wide-angle lens with objects that are quite close to the camera, even a slight change in viewpoint can have a very significant effect on both the perspective and the composition of an image. It is well worth exploring different viewpoints before taking a shot.

Jules' Comment

The perspective in this shot is what makes it for me. I'm not wild about the colours, however, and wonder whether it might have been more effective in black and white. I would have liked to see if the shot could have been improved by tilting the camera up slightly to give more sky and lose the shadow in the bottom right corner.

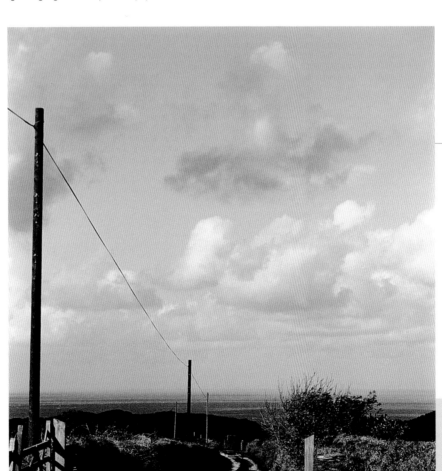

Technical Notes

Medium-format SLR, 55–110mm zoom lens, Fuji Velvia.

Situation and Approach

It would have been difficult to miss this subject as the bubblegum-pink of the door virtually leapt out at me as I walked by. This alone would not have tempted me to take the shot: it was the interplay between the vertical lines of the corrugations and the bold X-shape of the metal struts that attracted me. I framed the shot so that the right-hand legs of the crossed lines stopped short of disappearing into the corners of the frame and, at the same time, made the X-shape fill roughly two-thirds of the image. This has produced a slightly off-balance effect, which I feel underlines the unconventional nature of the subject. (JB)

Mike's Comment

I find there is something almost mesmerizing about this image: the conflicting lines have a similar quality to those optical-illusion drawings, where you have to look several times at something before you understand it. I have to say that I have reservations about the colour. I don't suppose Jules will let me, but I'd like to see if it could be changed in Photoshop to something more to my taste.

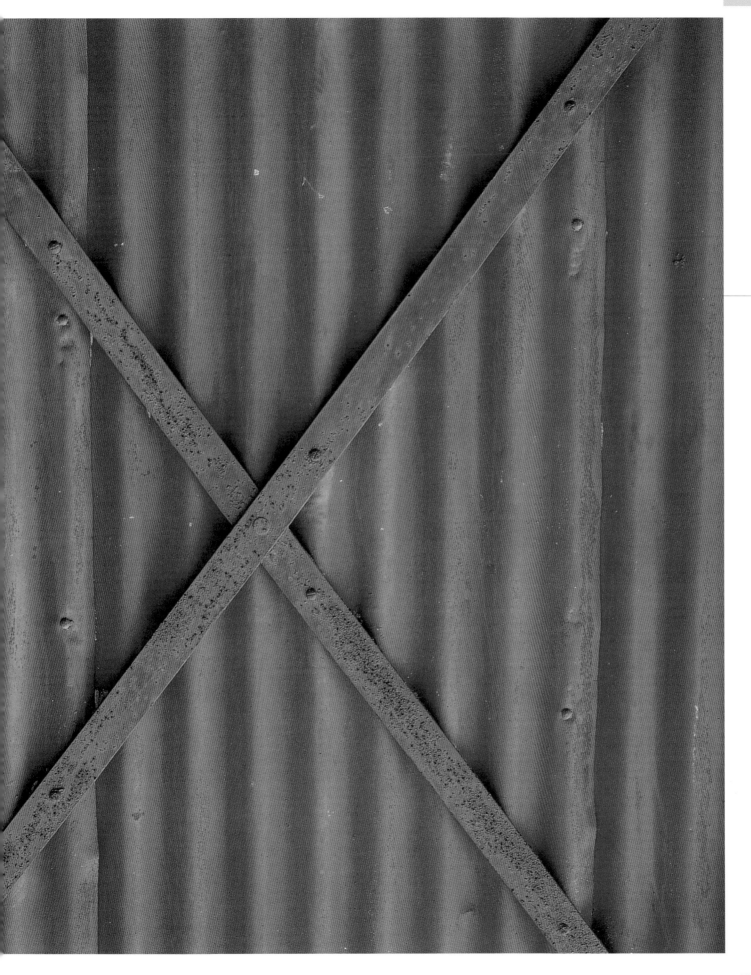

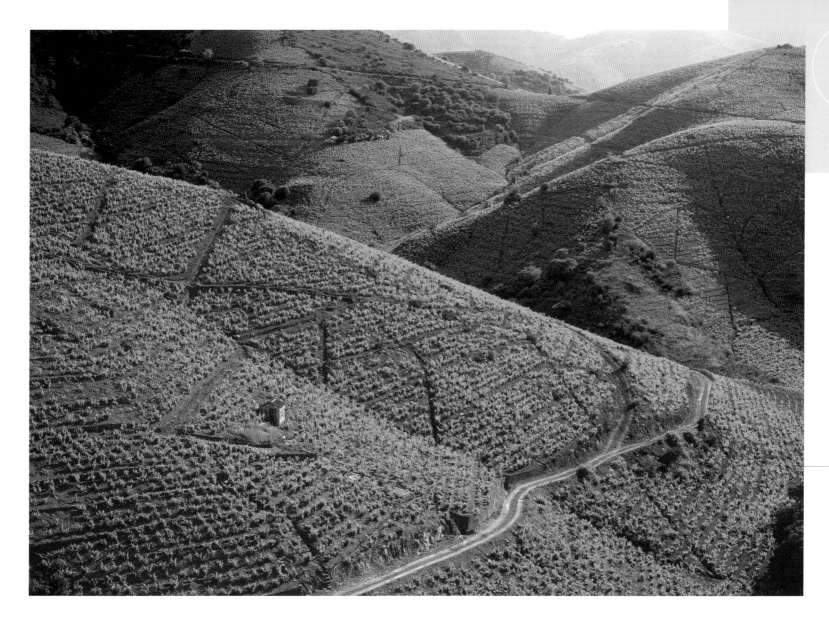

Identifying Form

Even though a photograph is nothing more than an image on a flat piece of paper or film, it can still create an astonishing impression of three dimensions. This is because when light falls on a subject, areas of light and shade are created: a single-colour object, such as an orange, looks as if it contains a range of different tones, and this tonal gradation is what makes the object look solid and three-dimensional. This is known as *form*.

The direction from which the light comes is critical in establishing a sense of form. Imagine a white sphere lit from directly in front, so that no shadow is created: it looks like a flat disc. But if that same sphere is lit from one side in a way that creates a range of tones from white to black, it looks three-dimensional.

Situation and Approach

The foothills of the Pyrenees around the French–Spanish border, just inland from the Mediterranean, consist of steep rounded hills that are covered either with fragrant maquis or with vines. This shot was taken on a day when there was enough haze to soften the evening light a little. A harsher light would not have created such a gentle transition of tone and the shadows would have been much more dense, which would have detracted from the solid, three-dimensional quality of the image.

I chose a viewpoint that allowed me to include the track and small stone hut. I framed the image so that these elements appeared towards the bottom left corner and to exclude the white sky visible above the far distant hill. (MB)

Jules' Comment

Superb lighting conditions have really made this shot by bringing out the rich greens and texture. The track helps to lead the eye into the image and, along with the hut, provides a sense of scale.

Situation and Approach

I shot this on a walk along a scenic section of river on a day when I had struggled for pictures, despite the scenery: as it was summer, everything was green. Then I came across this group of fungi. The light was heavily diffused by the surrounding vegetation and this helped to give the pleasing gradation of tone and prevent dark shadows that would have ruined the photograph. As the shot was taken close in and under diffused light, I did not use any colour-balancing filters; this has helped to retain the wonderful, natural hues. (JB)

Mike's Comment

While the colour quality of this picture is appealing, it is the beautiful, glowing gradation of tone that really makes it work and conveys the feeling of the fungi's soft, round forms.

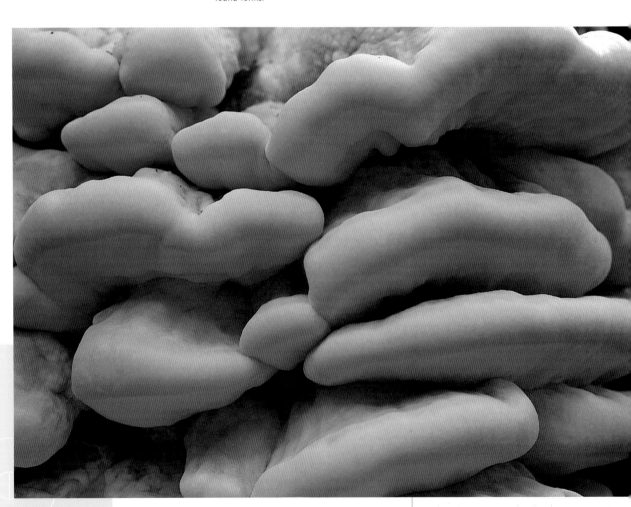

Technical Notes

Medium-format SLR, 120mm macro lens, Fuji Velvia.

FUNGI

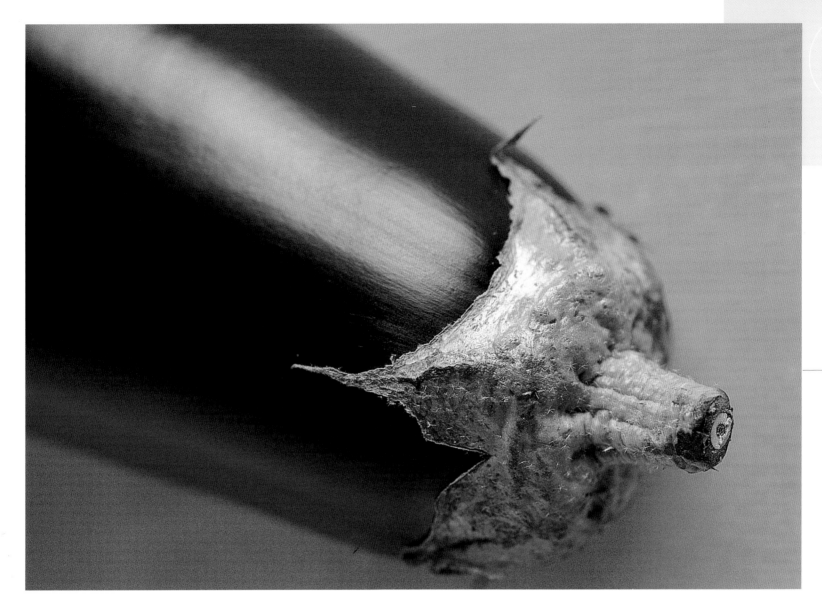

Limited Colour and Detail

Because form is created by tone and not by colour, black-and-white images and colour photographs that have a limited colour range often depend on form for much of their impact. Conversely, the impression of form is frequently lessened when the subject is very colourful.

Unlike texture, form does not depend on an image containing clearly defined details; in fact, lack of detail can often enhance the impression of form and solidity because attention is focused more on the tonal gradation of the image. Some of the soft-focus portraits and nudes of the Victorian era are good examples of this.

Situation and Approach

The background here was painted especially to complement the rich aubergine colours, so this shot isn't entirely my own work. I chose to limit the depth of field by selecting a relatively wide aperture. The lighting used was studio flash, but I fitted a large soft box to give a very even and soft light. (JB)

Mike's Comment

The shallow depth of field has allowed the sharply defined stem of the aubergine to enhance the softness and roundness of the main body of the vegetable.

Technical Notes

Medium-format SLR, 120mm macro lens, Fuji Astia. Studio flash.

Jules' Comment

A superb shot. I'm jealous – I never seem to be able to get shots like this. It has a great composition and "feel" to it. The gentle light helps to capture the detail in the hands and balls.

Situation and Approach

A game of pétanque was taking place in the shade of the plane trees as I passed through a small French village and I stopped to ask if I might take some photographs of the game and the players. I concentrated first on the wider scene, the action of the game and individual players, but then I became fascinated by one man who had the habit of holding his boules behind his back.

I liked the muted colour quality and the way in which the soft, shaded light defined the shape and form of the man's hands, the folds of his clothes and the round, shiny metal boules. Using a medium-range zoom lens I moved as close as possible, as I did not want him to become aware of being photographed. I framed the shot as tightly as I could to focus attention on the main elements of the image. (MB)

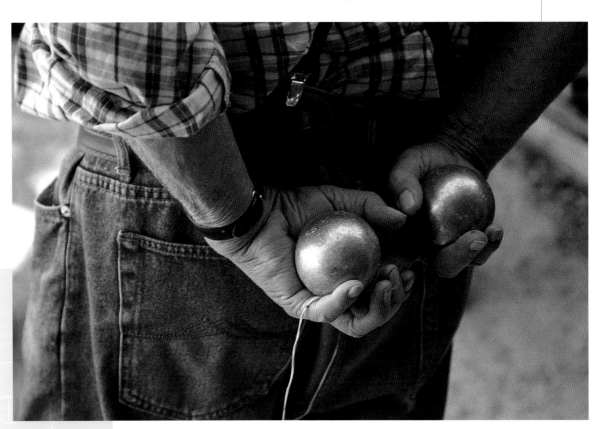

Technical Notes

35mm SLR, 24–85mm zoom lens, Fuji Provia 400F.

Useful Advice

The contrast of a subject (the difference in brightness between the lightest and the darkest tones) tends to look significantly greater when recorded on film than it does to the human eye, and this can make the tonal gradation less subtle than you anticipate. When shooting subjects such as portraits, where you have some control over the situation, it can help to use a reflector to reduce the density of the shadows. With close-up pictures, fill-in flash produces the same effect.

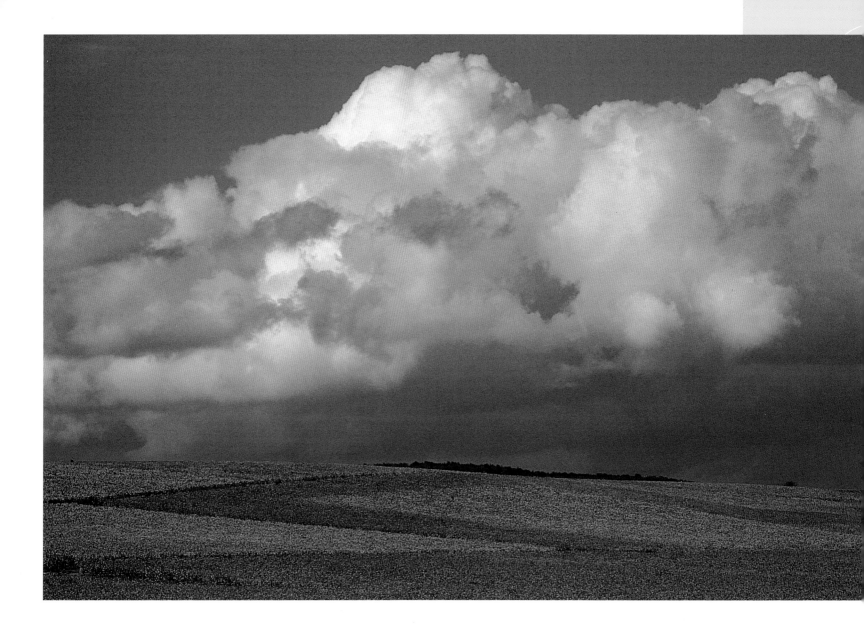

Situation and Approach

The sky is frequently an important element of landscape photographs and the presence of clouds can add considerably to a picture's impact. But in this shot, photographed in the French Champagne region, the cloud has become the main feature of the image.

I was attracted first by the impressive bulk and tonal range of the cloud, which has given it a strong three-dimensional quality, and also by the colour of the land below, a vineyard in which the autumn foliage had taken on an attractive golden colour. The contrast in colour between the two areas appealed to me, as did the fact that, here, the land seemed flat and two-dimensional while the sky above had all the interest of shape and form – a reversal of the usual situation.

I used a telephoto lens to frame the most interesting part of both sky and land tightly and a polarizing filter to deepen the colour of the sky and give the cloud stronger relief. I also used a warm-up filter to enhance the colour of the vines and a neutral graduated filter to darken the sky, enabling an exposure that records good tone and detail in both areas. (MB)

Jules' Comment

A great landscape that proves you don't need glowing evening light and an obvious dominant feature to succeed. The simplicity and pleasing light of the picture really helps the overall feel and the clouds add an element of drama.

Technical Notes

35mm SLR, 70–200mm zoom lens with 81A warm-up, polarizing and neutral graduated filters, Fuji Velvia.

Situation and Approach

I came across this waterfall just as the light faded, but still thought that the scene had potential. I tried a variety of viewpoints before settling on the one shown here. I had already set quite a slow shutter speed because of the lighting conditions and was reluctant to use a polarizing filter as it would make it slower still. But it really did improve the colour of the scene, which I emphasized by using a warm-up filter, and the long exposure has resulted in the very "smoky" quality of the water. Perhaps almost too much, in fact – but the colours were improved enough to make this trade-off acceptable to me. (JB)

Mike's Comment

The soft lighting and limited colour range of this picture have contributed very much to its effect, because the subdued colour has emphasized the image's tonal range and, consequently, the impression of form.

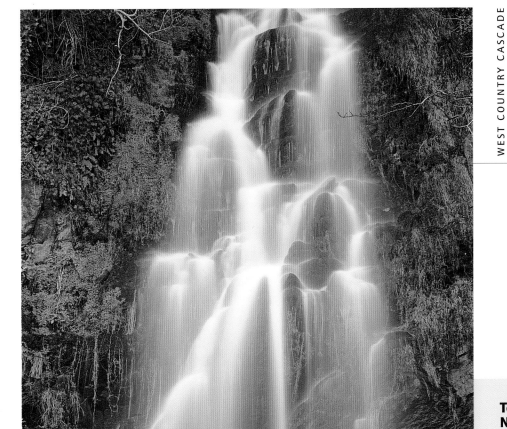

Useful Advice

Exposure is critical when photographing a subject in which form is a dominant feature, as it is responsible for ensuring that a full range of tones is recorded. A small degree of underexposure can sometimes help, but overexposure tends to limit the range of tones and detract from the effect.

Technical Notes

Medium-format SLR, 55–110mm zoom lens with polarizing and 81A warm-up filters, Fuji Velvia.

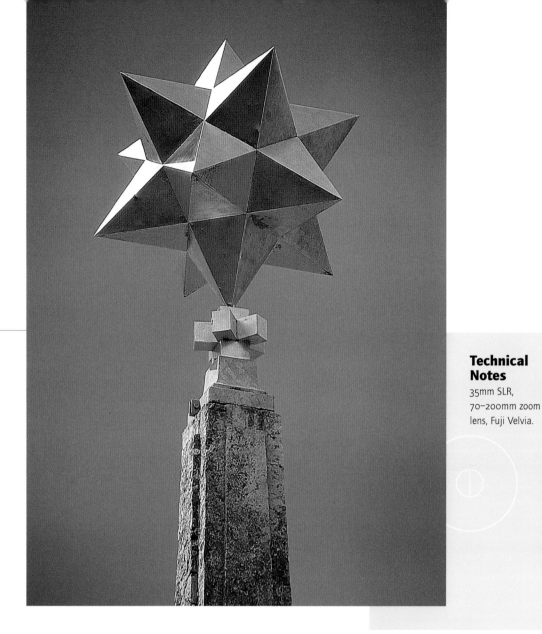

MOUTON ROTHSCHILD OBELISK

Technical Notes

35mm SLR,
70–200mm zoom
lens, Fuji Velvia.

Lighting for Form

Because the impression of form and solidity is so dependent on the tonal range of an image, the quality and direction of the light is a vital factor. For some subjects such as still lifes and nudes, for example, a soft light is often most effective as it produces a gentle transition of tone from highlights through mid-tones and into shadow. But ultimately it is the nature of the subject that determines the most appropriate lighting – and in some instances, a more abrupt change of tone is desirable in order to create the most telling effect. An angular subject such as a building, for example, might look more solid if the different planes have a more abrupt transition of tone as a result of hard, acutely angled lighting.

Situation and Approach

This curious structure can be seen on the roadside in front of the home of one of France's great red wines, Château Mouton Rothschild. The metallic sculpture on top is very reflective, making it quite difficult to photograph. I'd tried during the day, both in sunlight and when it was overcast, but could not obtain the effect I wanted. On this occasion I saw it at dusk, when the sky was beginning to get quite dark. However, there was enough daylight left to illuminate the differently angled facets of the geometric shape and it did so in a way that revealed a wide variation of tone. This has given the sculpture a strikingly three-dimensional quality and created a bold contrast against the dark blue of the sky. (MB)

Jules' Comment

A very striking shot, helped not only by its graphic nature but also by the angle of the camera. Having to shoot upwards like this often produces a dynamic image. The lighting conditions and colours are wonderful, too.

Situation and Approach

This boat would have been hard to miss – fantastic colours against a lovely blue sky. Although the bright sunlight created hard-edged shadows, the gently curving contour of the boat's hull has revealed a full range of tones. I opted for a straightforward composition, although I could have produced a more striking image by using a wider-angled lens and coming in closer and lower. I chose the filters carefully to keep the simple nature of the scene. I used a polarizing filter to help bring out the colours, but didn't polarize it fully as I didn't want the sky to end up a deep blue. I also used an 81A warm-up filter to ensure the scene wasn't "cooled down" too much by the midday light. (JB)

Mike's Comment

I would have been tempted to see how this picture looked from a slightly lower viewpoint, as I would have liked a little more separation between the horizon and the top of the boat's hull.

Technical Notes

Medium-format SLR, 55–110mm zoom lens with polarizing and 81A warm-up filters, Fuji Velvia.

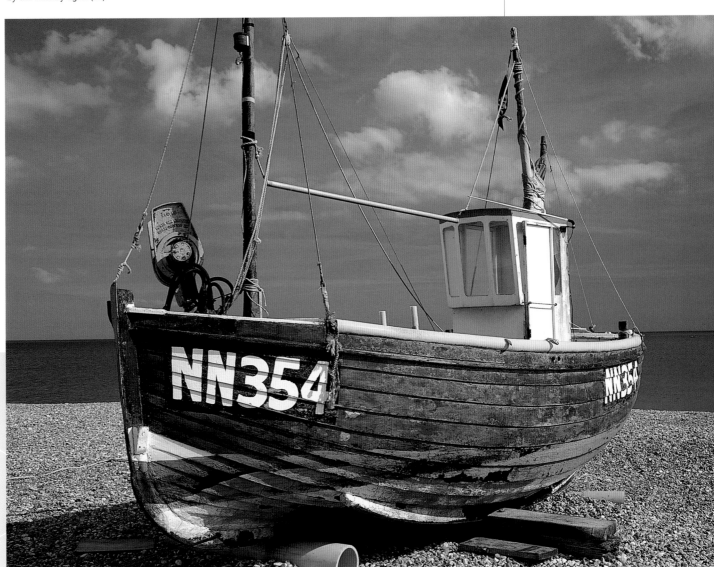

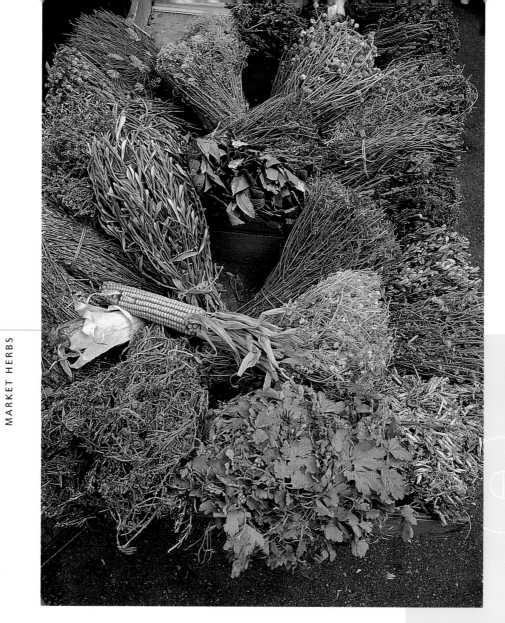

Technical Notes

Medium-format SLR, 55–110mm zoom lens, Fuji Velvia.

Using Texture

The presence of a bold, well-defined texture in a subject can give an image considerable impact. Like form, texture is largely a function of the tonal range of an image, in that it depends on the quality and direction of the light to reveal it fully; for this reason it can be a particularly valuable element in black-and-white photography. To show the subtle texture of a fabric like hessian, for example, the light would need to be angled acutely and be, at most, only slightly diffused; conversely, the fine detail of something with a pronounced texture, such as a gnarled tree trunk, would be largely obscured if it was lit in a similar way.

Situation and Approach

I spotted this display in a French market and was struck by the wonderful textures of the herbs. They were also nicely arranged and I liked the muted colour quality. The light was from an overcast sky and was very soft, but the subject had an excellent tonal range, with both clean highlights and dense shadows, and needed only a straightforward exposure to record it effectively. I set my camera on a tripod and placed it almost directly above the arrangement, framing the image tightly to exclude unwanted details at the top and sides. I used a small aperture to ensure there was enough depth of field to render the image sharp from front to back. As the light level was quite low, I needed an exposure of about one second. (MB)

Jules' Comment

You can almost smell the scene! A market shot like this one is sometimes difficult to find nowadays. The soft light helps to retain those gentle colours.

Situation and Approach

This shot was taken during an evening photography session at a local beach. The light was low and warm, casting long shadows, and lacked the clarity I generally prefer. But as I looked around, literally beneath my feet, I spotted this "found" still life. The closeness of the subject ensured that the image had the clarity I wanted. The fine detail, lit so obliquely, heightened the textural quality of the image. I framed the shot to give the impression of space and emptiness that the scene evoked. (JB)

Mike's Comment

Jules tells me he's gone off this picture a bit but I do like it, as it satisfies my fondness for very simple images. I also like the rather bleak atmosphere and the feeling of space.

Useful Advice

If the impact of a textured subject is to be fully exploited, the image needs to be bitingly sharp. For this reason it is best to use a slow, fine-grain film and to use a tripod, both to eliminate the possibility of camera shake and to allow the use of small apertures to obtain good depth of field.

Technical Notes

Medium-format SLR, 45mm lens, Ilford XPZ developed in C41 chemicals. Lith Print.

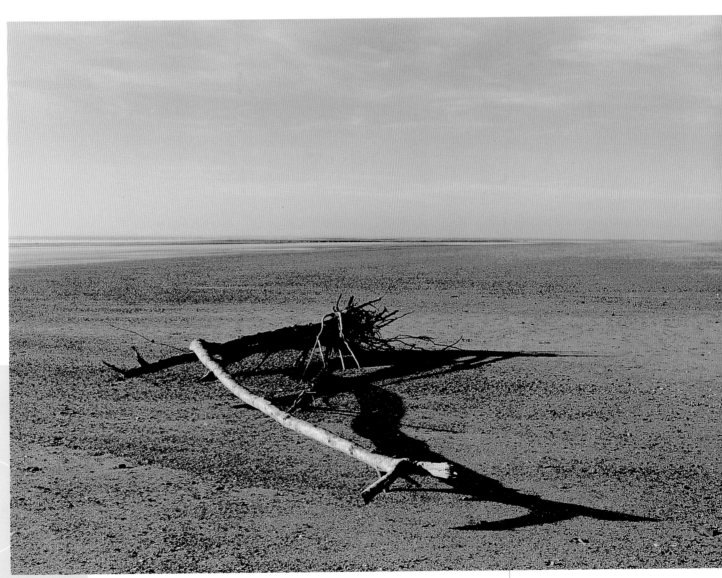

SAND AND TWIG

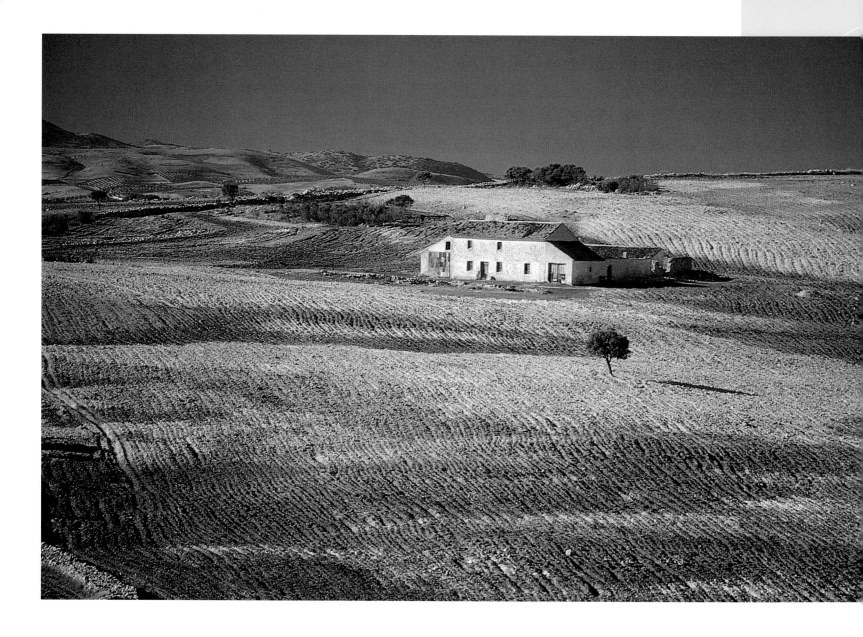

Texture is, in effect, the form of a surface and is governed partly by scale. Seen in extreme close-up, the textured surface of, say, the bark of a tree can become an object with an identifiable form and bulk. Conversely, seen from a greater distance, almost anything can become simply a textured surface, as observatory photographs of the moon can confirm. But in all cases, it is the quality and direction of the light that determine how texture will be revealed in the image.

Situation and Approach

I photographed this landscape in Andalucía at the end of the summer, after the crops had been harvested and the land ploughed. It was quite late in the day with the sun low in the sky and this has created an acutely angled, slanting light that skims across the surface of the furrows, revealing a rich texture. This was what initially caught my attention, along with the curious shading of colour on the soil.

I chose a viewpoint that enabled me to place the small tree just below the building and slightly to the right, effectively making the two details a single focus of attention. I framed the shot so that they were placed close to the intersection of thirds (see page 90) and to exclude unwanted details at the edges of the frame. The sky was a clear blue without clouds; my first thought was to frame the image to include only a small strip of sky and more foreground than in the version shown here, but this seemed to make the image too bottom heavy.

I used a polarizing filter to make the sky a deeper blue and a warm-up filter to enhance the rich colour of the soil. (MB)

Technical Notes

35mm SLR,
70–200mm zoom
lens with 81A
warm-up and
polarizing filters,
Fuji Velvia.

Situation and Approach

I have a fondness for detail shots and sometimes search out subjects like these because the lighting conditions may not suit a wider vista or because the landscape itself is so appealing that I feel the need to explore it in more detail. I like the colours and the textures in this shot. Although the light was quite soft and not very acutely angled, when combined with the close viewpoint it has effectively emphasized the inherent textural quality of the subject. (JB)

Mike's Comment

The ambiguity of this picture appeals to me: it could be almost anything, even a painting. The colours work well and complement the rich texture of the lichen.

SPANISH FARMHOUSE, ANDALUCÍA

LICHEN

Jules' Comment

I really like the way that this image has used the light to best effect, creating rich colours and a pleasing warmth. The low light has also helped bring out the rich textures. It is quite a simple shot but with one very nice touch – the lone tree and its long shadow.

Technical Notes

Medium-format
SLR, 120mm macro
lens, Fuji Velvia.

This man was the guardian of a temple in Jaipur, India, and was sitting in the sun. It was the effect of the strong overhead sunlight that compelled me to take this shot. In normal circumstances I would have asked him to move into the shade: the lighting was deeply unattractive, with dense shadows obscuring details of his face, and the strong sunlight made him squint badly which, in a conventional portrait, would be unacceptable. But I was interested mainly in the variety of rich textures that the light revealed. Even so, I doubt that I would have shot this picture had he not been wearing glasses: the overhead lighting had created deep black shadows in his eye sockets, but the glasses have lessened this effect and have added a further element of texture. (MB)

GUARDIAN OF THE TEMPLE

Technical Notes

35mm SLR, 70–200mm zoom lens, Fuji Provia.

The ability of a photographic image to convey a realistic impression of a surface texture is so impressive that it is frequently used in manufacturing processes for synthetic materials, such as melamine, to make them look like wood or fabric. It can be so effective that it's sometimes necessary to touch a surface to see whether it's real or not.

Many subjects have a pronounced texture that can be photographed effectively with a soft, diffused light. Subjects with a more subtle texture need a harder light that is directed at a glancing angle across their surface.

Jules' Comment

This is a good example of how the subject matter has become incidental to the striking visual qualities of the image – qualities that have resulted from what would normally be considered difficult lighting conditions.

Useful Advice

When shooting portraits in strong, undiffused light, like direct sunlight, ask your subject to move if the lighting is not to your liking: even a slight change in position can have a significant impact on the way he or she is lit. With a static subject, such as a building, try changing your camera position.

Situation and Approach

Mike and I had been driving all morning along a very quiet stretch of road, both looking for a landscape shot. As the car approached a bend, up came this perfect example of Americana. We both set upon this poor mailbox as if it was a celebrity in a compromising position. The lighting conditions, which had so far failed to reveal photogenic qualities in the landscape, suddenly did so in this otherwise insignificant roadside detail, with the angle of the sunlight revealing the texture of the mailbox in a striking way. Had we passed by an hour earlier or later, we might well not have seen any potential for a picture. (JB)

Mike's Comment

Jules and I saw this picture at the same time and both shot it. My version is not as successful because I used 35mm and it has more depth of field. The very out-of-focus background in Jules' shot has accentuated the texture of the peeling paint.

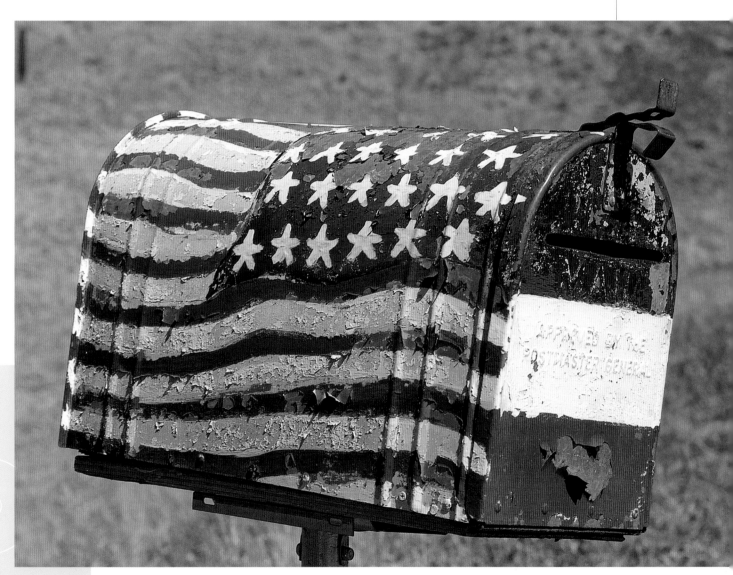

Technical Notes

Medium-format SLR, 105–210mm zoom lens, Fuji Velvia.

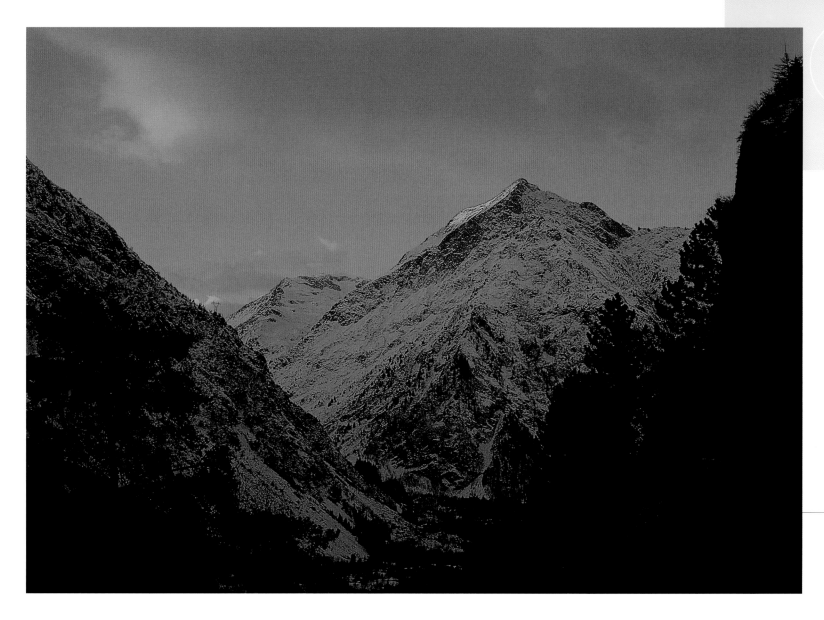

Colour Awareness

The way we perceive colour is a very individual thing: a combination of colours that is attractive to one person may seem quite the opposite to another. But the way in which colours are combined in a photograph can have a profound effect on the mood.

Colour Contrast

The visible spectrum is, for convenience, usually shown divided into bands that begin with the shortest wavelength of light (red) and progress through green, blue and indigo to violet – the colours that we see in a rainbow. If you imagine this formed into a circle, with green and violet next to each other, the greatest degree of contrast will be created between the hues that oppose each other diametrically.

Situation and Approach
I had entered a deep valley in the French Alps; the sunlight had not been visible for quite some time and it seemed as though dusk was falling. On turning a corner, I was confronted with this scene in which the light from the sun, which was almost on the point of going below the horizon, had literally painted the very tip of the mountain peak and the cloud above it a pleasing pink. At the same time the shaded valley sides had taken on a deep blue tint and created a striking, but quite subtle, contrast. I used a long lens to frame the cloud and peak tightly in a way that emphasized the V-shape of the valley. (MB)

Jules' Comment
A dramatic shot with fantastic light. I like everything about this image – especially the illuminated cloud and silhouetted trees.

Technical Notes

Medium-format SLR, 105–210mm zoom lens, Fuji Velvia.

Situation and Approach

This bizarre image came about as a result of a truly unproductive still-life session. I'm not entirely sure whether I actually like it or not, but it is at least a change from the normal. I had been photographing flowers and vegetables but had failed to come up with a really striking shot. In order to keep things in position I used a few pins here and there. When I dismantled the normal still life I had shot, I noticed the pins and liked the combination of metal, colour and texture. I then got carried away and kept adding pins until I achieved something that I thought was interesting – not at all pleasant, but interesting. (JB)

Mike's Comment

This is so contrived that I wasn't sure if I liked it at first, but it's grown on me. Although it suggests that a little psycho-analysis might not go amiss, there is such an interesting contrast of textures, shapes and colour that I find it encourages me to keep revisiting it.

Useful Advice

A subject that is dominated by two colours that create a bold contrast will invariably produce a photograph with a high degree of visual impact. However, the effect will be lessened if the image includes colours from other areas of the spectrum.

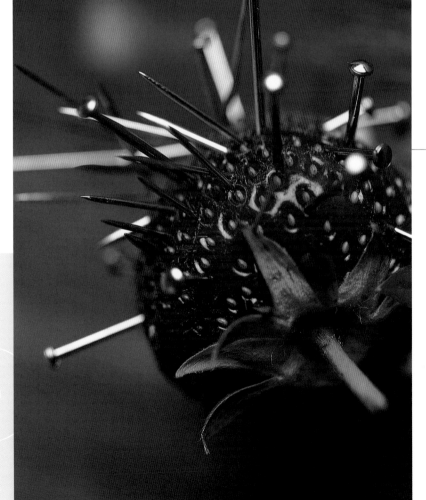

Technical Notes

Medium-format SLR, 120mm macro lens, Fuji Astia. Studio flash.

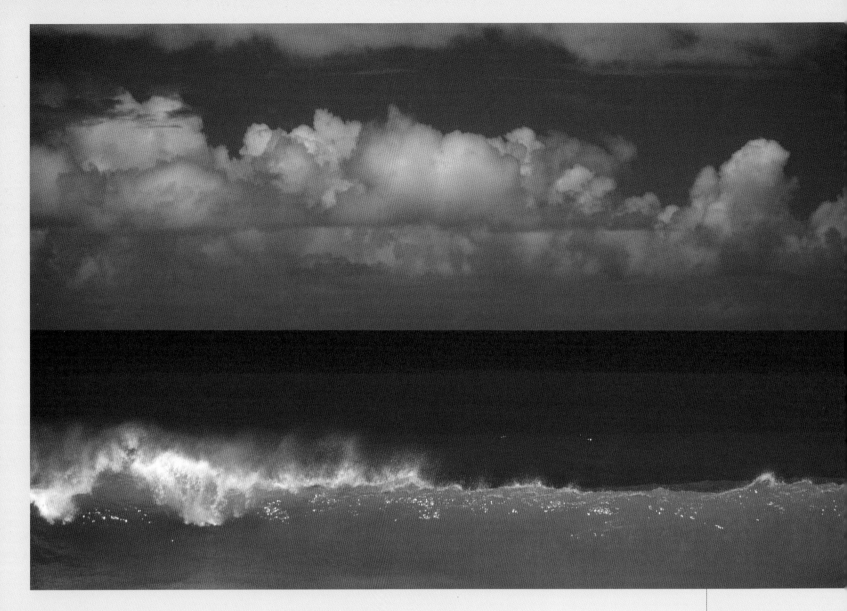

Ernst Haas

initially studied medicine but an inherently creative personality led him to take up photography. He was born in Vienna, Austria, in 1921, and without any formal training, he attracted attention at the age of 26 with an essay on the homecoming prisoners of war photographed in his native city. Such was its impact that he was invited by Robert Capa to become a member of Magnum and also to join the staff of *Life* magazine. He began to work in the USA and although his early work was in black and white he developed a great love of colour, which became a life-long obsession.

Haas's first major publication was a huge 24-page essay on New York, his adopted home city, in *Life*. His fascination with colour photography caused him to turn his attention away from reportage to exploring the possibilities of the natural world. He often used devices such as blur and double exposure to create images with an abstract quality, of which many fine examples are included in his book *The Creation*, 13 years in the making and published in 1971. It became the bestselling book of colour photographs ever with over 350,000 copies sold. He was included among the world's ten greatest photographers in 1958, chosen by an international panel of over 200 leading critics, photographers and art directors. He died of a stroke at the age of 65.

Mike's Comment

An acute awareness of the subtle nuances of natural colour is at the heart of Ernst Haas's work and this image is a fine example. In terms of composition it could hardly be simpler while ignoring the rule of not allowing the horizon to divide the image equally. It is the subtle interplay between the hues of sky and sea that make the image work so well, with the breaking surf and cloud bank creating both balance and tension.

Martin Parr's

early interest in photography was fostered by his grandfather, George Parr, who was an enthusiastic amateur photographer. He was born in 1952 in Epsom, Surrey, England, and studied photography at Manchester Polytechnic between 1970 and 1973. He was a teacher from 1975 until the early 1990s while fostering his career as a freelance photographer. Although his early work was devoted mainly to the black-and-white medium, he became more widely known because of his innovative colour work that was characterized by the use of bold saturated colours and fill-in flash. This style of imagery, combined with his eye for humorous juxtaposition and social comment, gives his work an instantly identifiable quality. He has also photographed film and TV documentaries.

Mike's Comment

The use of highly saturated colour heightens the rather tacky seaside atmosphere of this shot, and the moment is well observed and captured with precise timing. This is an example of subject matter being chosen for, and very effectively coupled with, a specific photographic technique, something that has helped to give Martin Parr's images a very distinctive look.

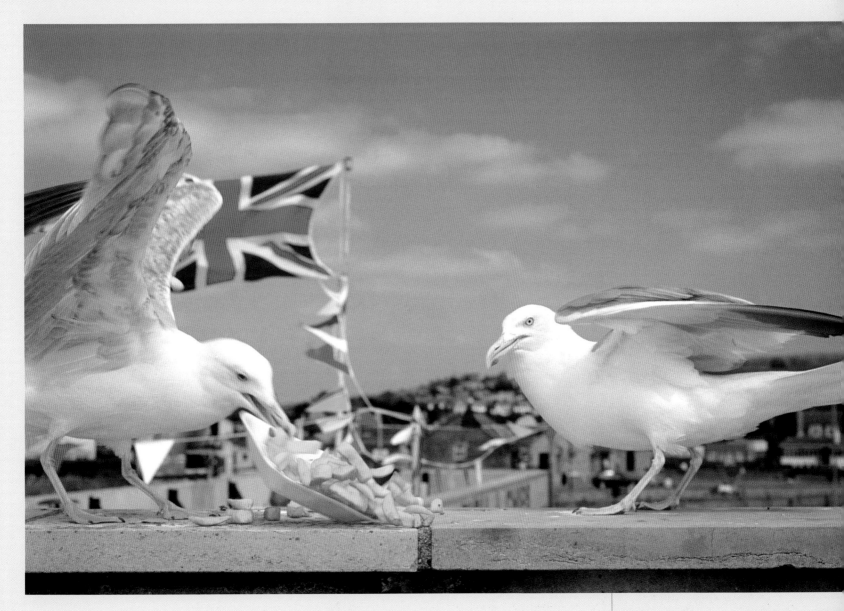

WESTBAY 1996

Colour Harmony

While a photograph containing contrasting, saturated colours creates a strong initial impact, equally satisfying photographs can be taken where the dominant colours are from a similar area of the spectrum. The ability of the colours in an image to harmonize with each other also depends on the degree of saturation: colours from a wider area of the spectrum can blend together happily if they are quite soft and subtle. In this way, yellow and blue can create a harmonious quality, especially if they are not fully saturated hues. (Colour saturation is a term that refers to the purity of a colour; when a hue contains some black or white, it becomes less saturated and not as bright.)

Situation and Approach

I came across this tranquil scene while driving along the valley of the River Yonne in northern Burgundy. The sky was a little hazy, the sunlight was quite soft and the harmonious colours created a very pleasing, restful quality. Without the darker tone of the tree in the foreground, however, the scene would have lacked tonal as well as colour contrast, and it was for this reason, as well as to mask the pale sky, that I included it. The tree has also broken up the large area of grass and helped to create a feeling of depth and distance in the image. I used a wide-angle lens and set a small aperture to ensure that both the nearest and furthest details were sharp. (MB)

Jules' Comment

Thanks largely to the harmonious quality of the soft green grass and the pale blue sky, this photograph has captured a peaceful, rural mood. The foreground tree has added an essential element of tonal contrast.

Technical Notes

Medium-format SLR, 50mm lens with 81A warm-up and polarizing filters, Fuji Velvia.

Situation and Approach

I took this shot at the Royal Observatory in Jaipur, India – a place where large stone structures have been built to study the constellations. It is a curious place and the very large, oddly shaped edifices offer numerous possibilities for photographers. I was attracted purely by the colour of this wall and flight of stairs. It was a bright, sunny day with a blue sky, but this area was completely shaded from the direct sunlight that was being reflected back and forth between the surfaces. This has made the already unified colours appear to blend even more effectively. (MB)

Technical Notes

35mm SLR, 28–70mm zoom lens, Fuji Velvia.

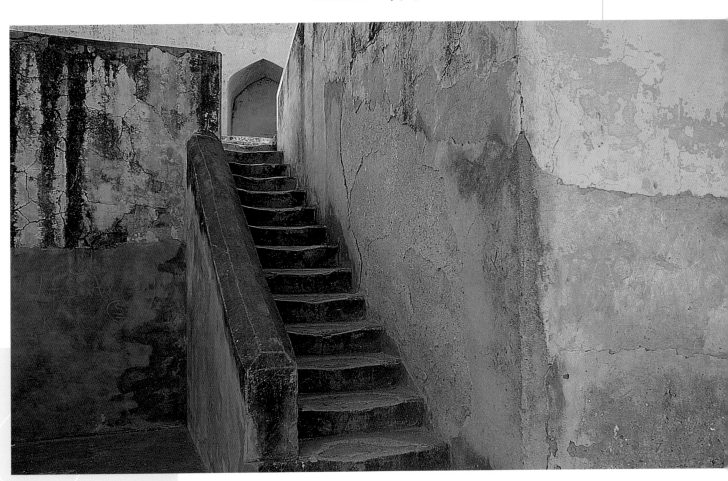

Jules' Comment

This shot really appeals to me – great texture has been enhanced by the limited colour range. I would have been keen to try variations on this, as I can imagine the combinations of subtle hues, interesting shapes and textures that might be achieved by changes in viewpoint and composition.

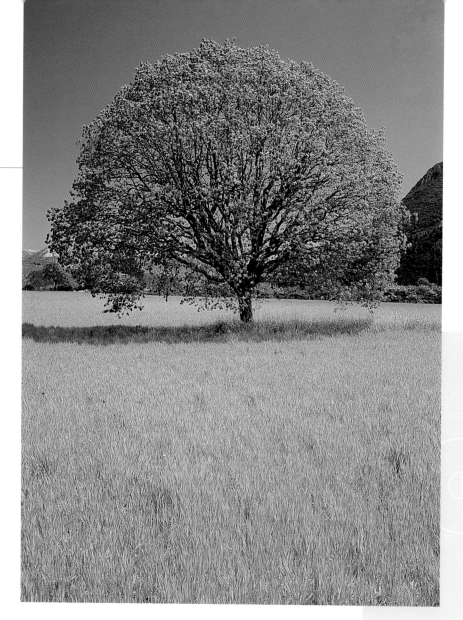

Restricted Colour

Although it is often bright, very colourful scenes that initially appeal to photographers, subjects with a very limited range of colours can, paradoxically, produce the most interesting and atmospheric images. Bold, saturated colours can easily overwhelm other visual elements within the image, such as shape, pattern and texture, while a photograph with a restricted palette usually emphasizes them. Colour photographs that are almost monochromatic, such as those taken at dusk or dawn, or a subject where one colour dominates, like a green forest scene in springtime, can have an especially interesting quality and mood.

Situation and Approach

The colour of foliage in the early spring is, I think, one of the most beautiful in nature's palette. Later in the year, at the height of summer, it becomes a dense and leaden hue. I took this photograph in May in the Drôme region of France. Apart from the glorious, fresh colour of the leaves, which is enhanced by the fact that the soft blue of the sky is virtually the only other hue in the image, a number of things attracted me to the scene: the almost perfectly symmetrical roundness of the tree, the texture created by the overhead sunlight, and the fact that the skeleton of the tree was still visible through the newly formed leaves. I chose a viewpoint that showed the symmetry of the tree to its best advantage and also separated it as much as possible from the hills behind it. (MB)

Jules' Comment

It's surprising that such a soft colour can have such a strong impact. I think this is due largely to the limited colour range of the image: if more strongly contrasting colours had been included, the green of the tree might simply have looked a bit dull.

Situation and Approach

From my car I initially noticed only the saturated sky and beautifully lit tree. First I considered taking the shot in black and white, but then I decided that the subtle colour would give the image an extra dimension. When I walked through the brush to get to the tree, I saw the rock structure as well and was able to include it in the shot. The use of both near and far objects and the altered sense of scale help to make the image even more dramatic.

I used a wide-angle lens, because I had a limited space to work with, and this has enhanced the perspective. Although at first I wanted to include all of the tree I wasn't able to, as I couldn't move back any further. Now I'm pleased that I couldn't, as I quite like the crop of the tree. (JB)

Mike's Comment

As Jules is an almost fanatical devotee of black and white, I'm surprised that he opted to shoot this in colour. But I'm glad he did, as I find the colour of the sky, albeit muted, so interesting and appealing. It also sits well with the colour of the tree, while still creating a strong enough contrast to accentuate its shape.

Technical Notes

Medium-format SLR, 50mm lens with 81A warm-up and polarizing filters, Fuji Velvia.

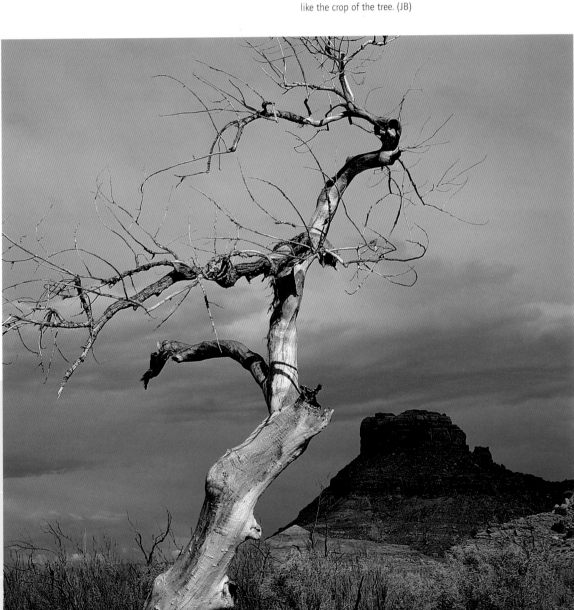

SKELETAL TREE

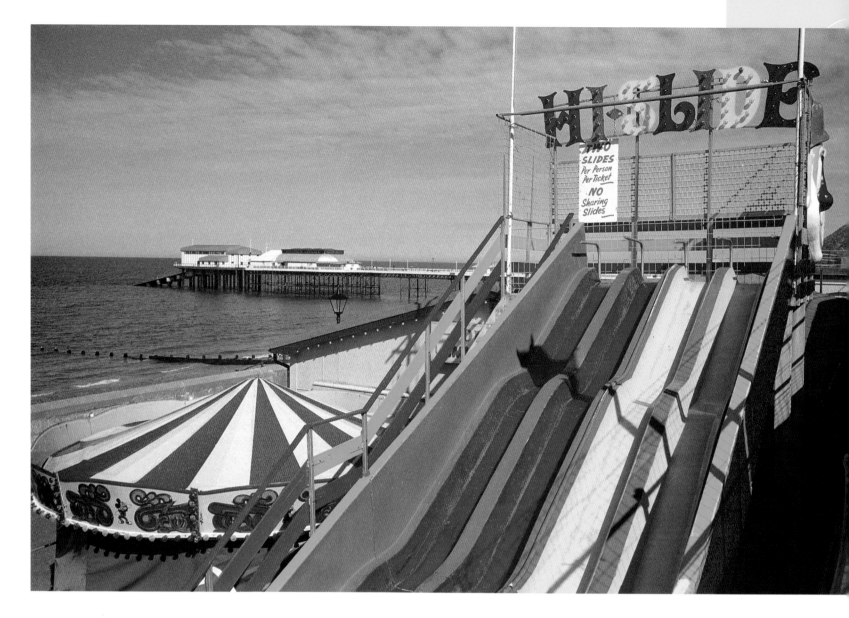

Colour and Mood

The effect of colour on our mood has long been exploited by designers and marketing managers. It may seem simplistic to say that a particular colour universally evokes a particular response (red for danger, for example), but there is an element of truth in this. You have only to compare the peaceful mood of a summer landscape, when green and blue predominate, with the garish, saturated hues of a fairground, where red, orange and yellow are widely used.

One difficulty in photography is that the colour content of a subject is not always appropriate to the mood you want to convey. The impact of an image of war or famine, for instance, would be greatly lessened if the scene included bright, lively colours. This is one reason why some photographers prefer to shoot their more expressive images in black and white.

Situation and Approach

I think there is something rather special about the English seaside – not just the wild and beautiful coastline, but also the traditional resorts, which I am particularly drawn to out of holiday season. This picture was taken in the East Anglian town of Cromer in the early spring, when there were very few tourists around and the funfair was closed. This view of the pier, framed by the garishly coloured slide and carousel, seemed to encapsulate the mood of the place. The slope leading down to the promenade provided a good choice of viewpoints and enabled me to place the distant pier in exactly the position I wanted. I used a wide-angle lens to exaggerate the effect of perspective and a polarizing filter to maximize the colour saturation. (MB)

Jules' Comment

I remember taking a picture of this slide in black and white. If I had seen this opportunity I would have grabbed it, as the composition of bold colours against a slightly muted background has created a lively mood, even though the scene is completely deserted.

Technical Notes

35mm SLR, 24–85mm zoom lens with 81A warm-up and polarizing filters, Fuji Velvia.

Situation and Approach

This was taken on a garden visit. It was actually a small section of a short walk and would have been easy to miss as the waterfall itself was small. Luckily it was a quiet and still day and the sound of the water made it hard to miss. When I set up the shot I chose to include the surrounding foliage on the left-hand side only as it helped to balance the image. I used a polarizing filter to help lift the greens and allow me to use a slow enough shutter speed for that misty quality of the water. (JB)

Mike's Comment

This shot evokes a sense of coolness, freshness and tranquillity. Had it been possible, a slightly faster shutter speed might have retained a little more detail in the lower section of the water without losing the misty quality.

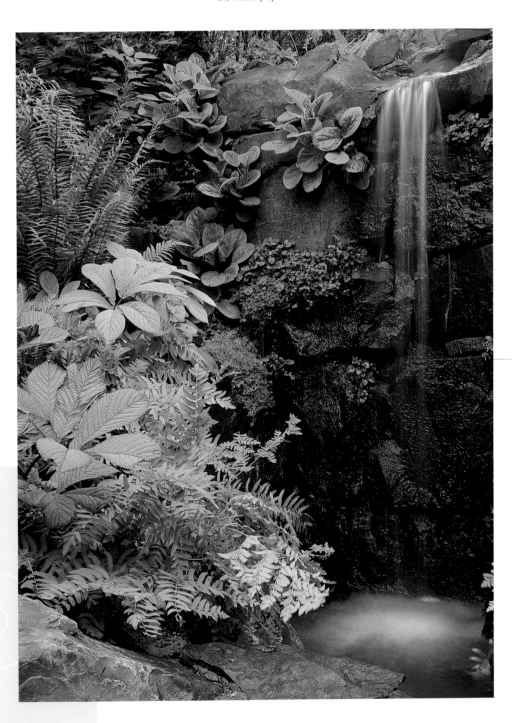

Technical Notes

Medium-format SLR, 55–110mm zoom lens with polarizing filter, Fuji Velvia.

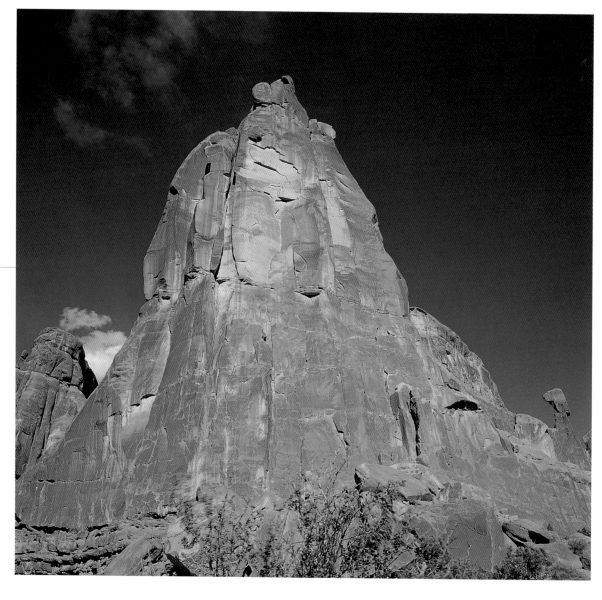

ROCK FORM IN COLOUR

Seeing in Black and White

For many people, black and white is the one area of photography than can lay claim to being called "art". Somehow, draining the scene of its colour allows you to concentrate on the very essence of the picture.

It takes experience to assess whether something is a suitable subject for a black-and-white photograph, as you need to train yourself to see colours in tones of black and grey. As a starting point, half closing your eyes can help to subdue some of the colour. Manually stopping the lens down in the same way as you would to assess depth of field is another option. You can also buy a monochrome viewing filter. However, the best, and most productive, method is practice.

Light

There is one element that you need to consider above all others when working in black and white, and that is light, as light affects the tonal range and overall contrast of your subject. Importantly, you can increase or decrease the contrast of the original scene in the darkroom and this gives you more control than you have with colour.

With black-and-white photography, poor light no longer means failure in the same way that it does when shooting in colour. Both cloudy and sunny conditions can give ideal opportunities for monochrome photography and your task is to match subject and light in the most effective way.

Situation and Approach

This was taken on a recent trip to the United States; nearly every day was consistently sunny and relatively free of cloud. In photographic terms, however, such conditions give less opportunity for variety.

The light here is one that a lot of colour landscape photographers might pass by. The colour image (left) shows the light conditions at the time – a quite harsh, contrasty light that produces few shadows coming from in front of the subject. The sky here is heavily polarized, giving a more intense feel to the image. For this to work as a colour image, a softer and warmer evening light without full polarization would be a better approach.

The black-and-white version (right), shot some five minutes later, has taken elements that were not desirable in the colour version and enhanced them to give a more dramatic image. By increasing the contrast and density I have added shadows and richness where there was little; allowing the sky to go black has intensified the rock form. These elements were present in the colour image, but only in black and white have they been fully exploited. (JB)

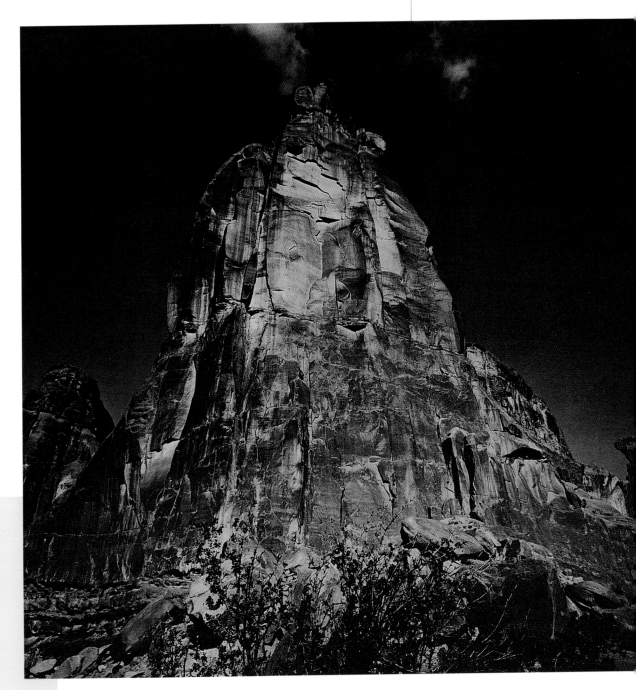

ROCK FORM IN BLACK AND WHITE

Technical Notes

Both images: Medium-format SLR, 50mm lens. Colour image: polarizing filter, Fuji Velvia. Monochrome image: orange filter, Ilford Delta 100, developed in Agfa Rodinal. Lith print on Ilford Multigrade FB warm paper.

This picture was lit by a single, diffused
flash. Although the lighting was reasonably
soft, I positioned it close enough to the lily
to produce a full range of tones, but the
inherent contrast of the subject was high
enough for me to ensure that the lighting
did not increase it significantly. I used a
black background to make the subject
stand out boldly and placed it well behind
to prevent any light from being reflected
from it. (JB)

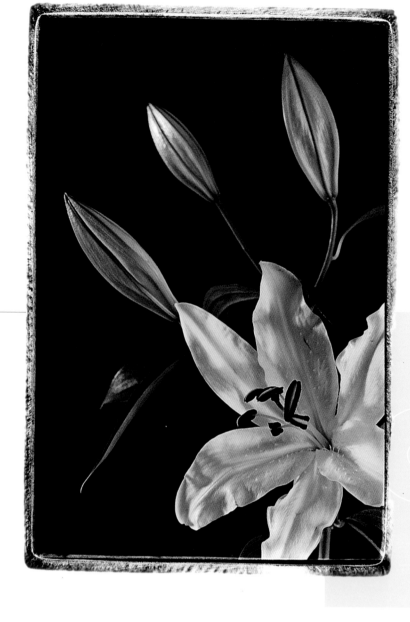

LILY

**Technical
Notes**

35mm SLR,
70–200mm zoom
lens, Kodak T400CN
(a C41 film).

Contrast

Once you understand what quality of light to look for with
black and white, you then need to understand how this affects
the final contrast of the image. The contrast of a subject is
determined by the difference in brightness between the
lightest and the darkest tones. The contrast can be inherent in
the subject: a black cat sitting in front of a white wall would
create high contrast, for instance. It can also be created by the
way the subject is lit: an all-white subject, such as a white vase
on a white background, could produce both very bright high-
lights and dense black shadows if it was lit strongly from an
acute angle. But in black-and-white photography, contrast can
be controlled to some degree in the processing and printing
of a negative.

Although you can change the lighting in a studio, you still
need to pay attention to the inherent contrast within the
subject. On location, you have to wait for the right light or
look for subjects that will work with the prevailing lighting
conditions – for example, by shooting a subject that has high
inherent contrast on a day with soft shadowless light.
Matching subject to light, and vice versa, is the key to
successful monochrome photography.

If you're new to monochrome, C41 (colour negative)
compatible black-and-white film, which can be processed at
any high-street processing store, is a good starting point.
Although the prints are on colour paper, the negatives can also
be printed using conventional black-and-white materials.

Situation and Approach

This image was shot during the same session as the lily picture opposite, but with slightly altered lighting and a different film. The model was placed against a white background and a diffused light source was moved further away to create a more gradual range of tones. With lower contrast, the skin tones become smooth and gentle, blemishes are lessened and the image appears simple and natural. In both pictures the level of contrast was controlled at the printing stage. The nature of the subject determined what level of contrast was appropriate. (JB)

Technical Notes

35mm SLR, 28–70mm zoom lens, Konica VX 400 (a C41 film).

NUDE

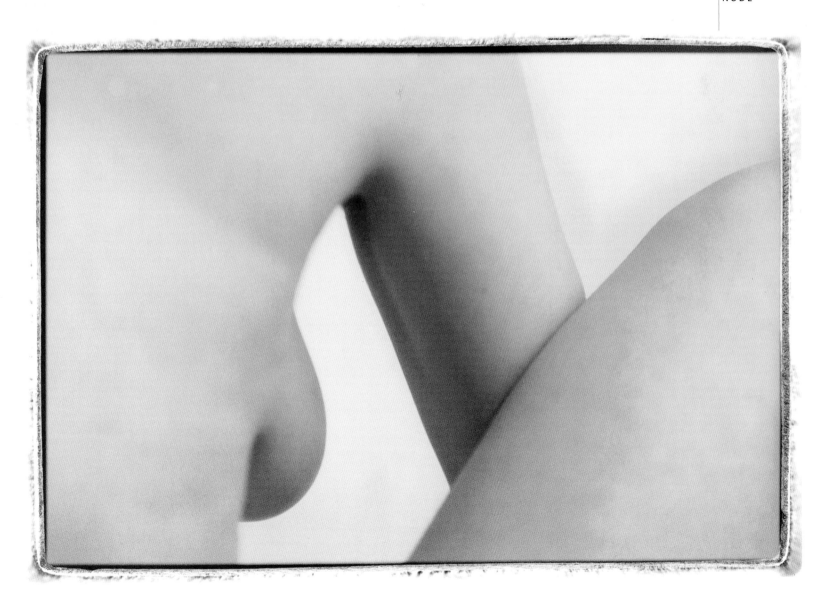

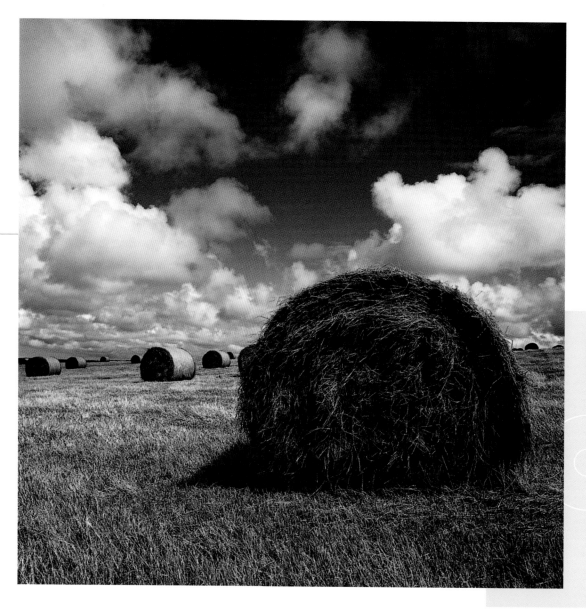

Technical Notes

Medium-format SLR, 50mm lens with orange filter to darken the sky, Ilford Delta 100 developed in Agfa Rodinal.

Texture

Texture is an essential element of monochrome work and brings together the previous elements of light and contrast. An increase in contrast often (but not invariably) enhances the textural quality of a subject. Every subject has its own inherent texture; your task is to recognize this and use the techniques described in chapter six, The Monochrome Darkroom, to reveal that texture in the most effective way.

Different textures need different qualities of light and contrast to enhance them. A subject with a pronounced texture, such as the bark of a tree, is likely to need a softer, more diffused light than a surface with a subtle texture, such as a fabric. Texture can create a very rich and tactile quality in black-and-white photography and is something that can be further enhanced in the printing process.

Situation and Approach

Harsh midday light is rarely a good time to take pictures, but it is not always a lost cause. This particular image works because of the lighting conditions rather than in spite of them.

Had this been a colour image it would have been rejected. In monochrome, however, the hard light has emphasized the subtle texture of the hay. The heavy shadow on the front of the bale works because of the loose, highlighted straws sticking out; had the light been softer, the effect would not have been so striking. Although initially the light appeared to be unsympathetic, I felt there was potential; it took a little work to find a bale with the right contrast to bring out those textures. (JB)

Situation and Approach

This photograph was taken in the afternoon, when the lighting conditions were ideal. The right subject matter, on the other hand, was harder to find. A group of eucalyptus trees seemed perfect, but the low-angled light meant that most of the trunks were lit more directly than I would have liked. I eventually found a trunk with nice markings that was shielded from direct light, and this enabled me to capture the subtle texture of the leaves and trunks that would otherwise have been lost. I framed my chosen trunk between two others and selected an aperture that threw these out of focus in order to give a slight element of abstraction and mystery. (JB)

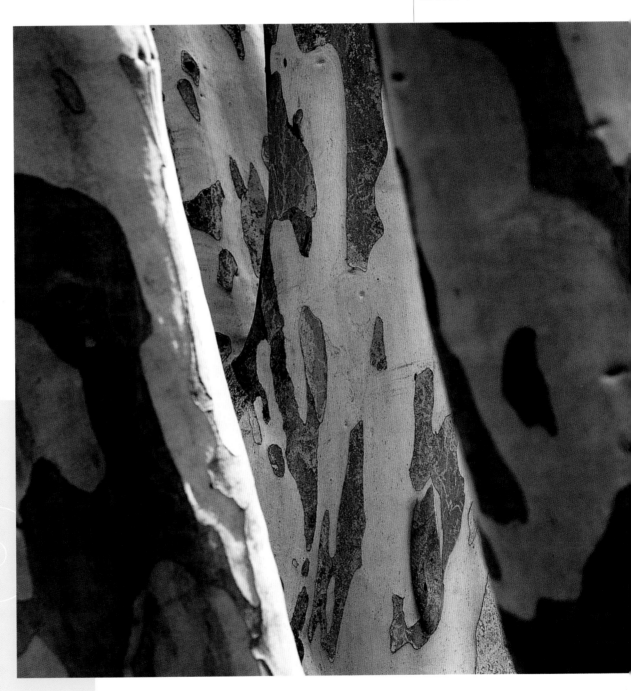

Technical Notes

Medium-format SLR, 100mm lens, Ilford Delta 100 developed in Agfa Rodinal.

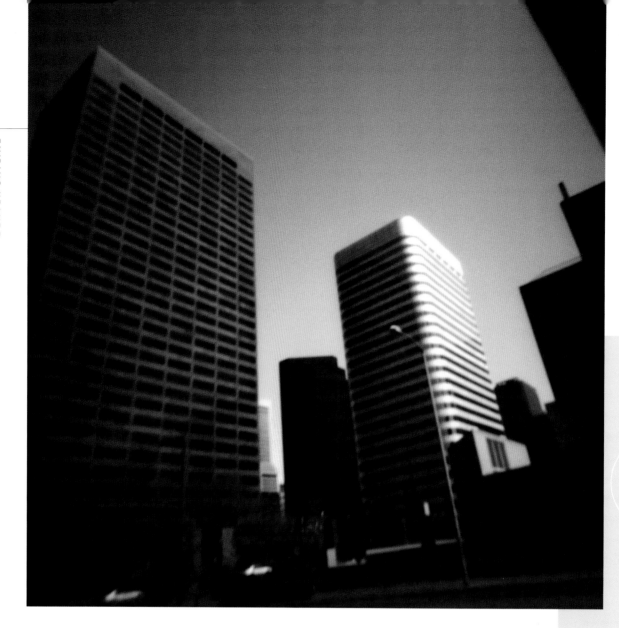

Technical Notes

Pinhole camera, Ilford Delta 100 developed in Agfa Rodinal for 8½.

Using the Medium

So far we have only touched on the "ideals" that help make a good black-and-white picture, but sometimes the ideal conditions are simply not there and it is not possible or desirable to wait for better lighting or search for an alternative subject. Under poor lighting conditions, which are low in contrast and definition, it often helps to look at bold subjects with patterns, texture or colours that supply their own contrast. Shooting close-ups on these days is frequently more productive than the general vista.

The biggest overall favour you can do yourself, however, is to process and print your own work – this gives you total control over the process and can produce a superior result. This aspect of the black-and-white medium is dealt with fully in chapter six.

Situation and Approach

This picture was taken with a pinhole camera, which has no lens and no method of viewing the image before you take it. As a result, the final image is unsharp, low in contrast and vague in definition – a photographer's nightmare.

To get around the problems I used the bold, dark parts of the buildings against a much lighter section of sky for a little contrast. The windows in the buildings towards the centre of the picture and on the left add interest and detail. Pattern works in a similar way to texture. (JB)

Situation and Approach

I really liked this image when I saw it and it seemed to suit the panoramic format. Unfortunately the lighting did not enhance the texture as much as I would have liked. I decided to shoot it anyway and to see if I could bring out its potential in the darkroom at the printing stage.

The method that I thought would be most effective was the lith printing process, which boosts contrast and adds a pleasing colour to the image. The process not only achieved this but also added an interesting texture of its own.

Being able to use the development and printing stage of monochrome work in this way enables you to add a further dimension to the picture-taking process. It is important to learn to see a subject in terms of what darkroom techniques can do to enhance its potential as well as recognizing its inherent visual qualities. (JB)

LITH PALM TREES

Technical Notes

35mm Panoramic camera, 45mm lens, Ilford FP4 developed in Ilfosol.

The Art of Composition

One of the most effective ways to approach the composition of your photographs is to think of the viewfinder as the equivalent of a painter's blank canvas. This may seem to be a rather pretentious proposal but, just like a painter, your success as a photographer depends on you deciding what to include in your photographs, what to leave out, and how to arrange the elements of your shot within the frame. In other words, you need to make a conscious choice about what to put on your canvas. This chapter looks at all the individual elements that you need to consider.

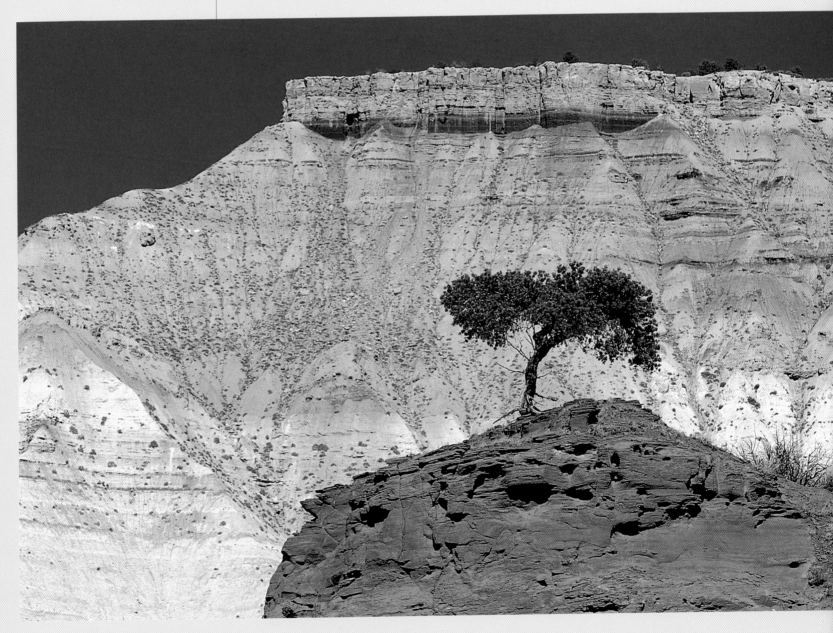

UTAH ROCK TREE

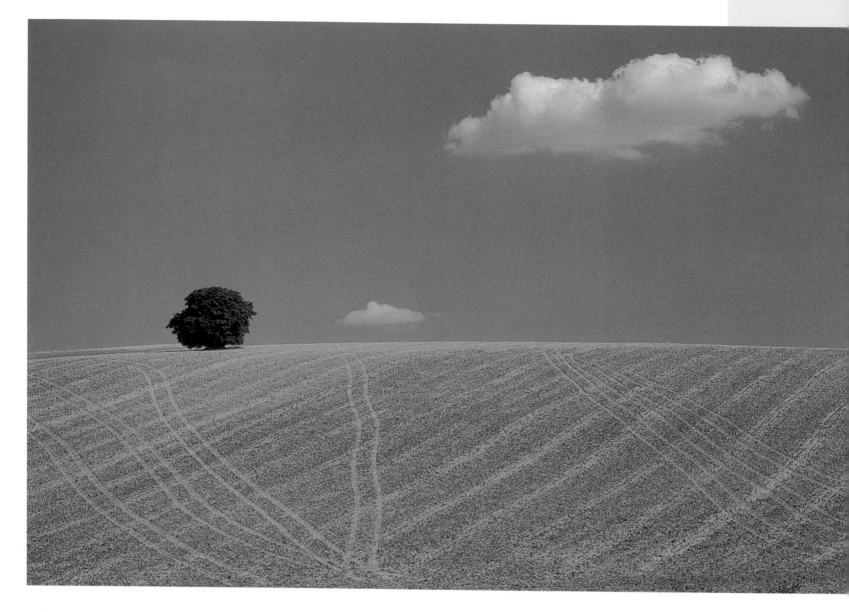

The Process **of Selection**

When you are confronted with a scene or subject that you want to photograph, it can be tempting to try to cram in as much as possible and shoot it in its entirety, without giving enough consideration to the process of selection. A very large proportion of unsuccessful photographs are the result of including too much information and detail in the image and simply not being selective enough.

Although getting close to your subject and framing it tightly generally produces images that have strong visual impact, there are many occasions where an equally, or more, striking photograph can be created by including a greater area of a scene. Consequently, deciding exactly what to include is a vital first stage in making a photograph.

Situation and Approach

I found this summer landscape while driving through Burgundy when most of the crops had been harvested. I was initially attracted by the curious, almost spherical tree that was growing on the brow of the hill and the pattern created by track marks in the stubble. Having found the viewpoint that I felt showed these two elements most effectively, I used a long lens to isolate them.

As I worked, a small cloud appeared close to the horizon and near enough to the tree for me to use it as a balancing element in the composition. It was only then that I began to take note of the wider area of sky and hillside. By using a wide-angle lens I was able to include the nicely shaped cloud formation and also to show the pleasing curve of the horizon. (MB)

Technical Notes

35mm SLR, 200mm lens with 81C warm-up and polarizing filters, Fuji Velvia.

Jules' Comment

The photograph on the left has a great combination of blue sky, two simple clouds and the texture and patterns within the soil itself. The tree adds interest, but is positioned in such a way that it does not dominate. The quality of light plays a large part, too, as it gives texture to the soil and a pleasing blue to the sky.

The photograph below takes the same elements as the first but has more drama because of the wider angle and the expanse of sky. There is less detail in the soil, but the tree seems to me to have more importance than it did in the first shot, even though it is smaller in the frame. I prefer the second shot simply because I like the effect of wide-angle lenses. Most important of all is the fact that two successful shots have been created from one scene, stressing the need to carry at least two different focal-length lenses and to experiment with composition.

LONE TREE, BURGUNDY

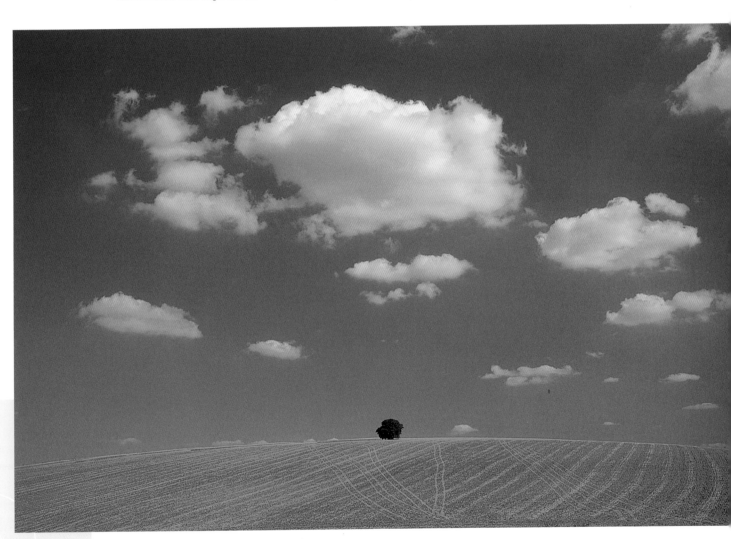

Technical Notes

35 mm SLR, 24mm lens with 81C warm-up and polarizing filters, Fuji Velvia.

Useful Advice

Don't just accept the first approach you make to shooting a scene. If you get into the habit of always exploring alternative ways of framing and angling the camera, not only will you produce more striking images but you will also develop your visual skills and personal style.

The reason we need to select is quite simple. Our eyes scan continuously and a composite image of everything that we see is formulated from this by our brain. In doing so, less interesting details can become subdued as the mind focuses on the key elements. The image that a camera records, on the other hand, gives equal weight and importance to all the details. This can often lead to the most striking features of a subject being diluted by those of lesser importance.

In many cases, you may well be able to produce two or more strong images from a single scene. The first step in considering which elements of a scene to select is to make sure that you have identified all of them, and then, mentally, to place them in order of importance.

Situation and Approach

These two photographs are of one of the most photogenic and best known locations for landscape photography – Bryce Canyon in Utah, USA. I'd gone to one of the well-mapped viewpoints to be in time for the sunrise and, blessed with sharp, clear sunlight and a good sky, had shot some wide views with which I was quite pleased.

When I studied the scene more carefully, I became aware of the astonishing variety of shapes and colours within the rock formations. There were two particularly interesting areas some distance apart – but even when I framed the image to include nothing else, their impact was greatly diminished.

Another problem was that the scene contained both very dense shadows and bright highlights that were beyond the range that the film would be able to record. Although a very wide-angle view made these areas small enough to become relatively unimportant, framing the shot just a little more tightly resulted in a loss of detail and colour in both the lightest and the darkest areas.

By using a very long lens I was able to frame the two most interesting areas of the scene in a way that fully exploited the shapes and colours of the rock formations, as well as keeping the brightness range well within the tolerance of the film. (MB)

Technical Notes

35mm SLR, 70–200mm zoom lens with x 1.4 converter, Fuji Velvia.

Jules' Comment

The use of a long lens has made all the difference here: this is one of those situations where is it impossible to move in closer unless you learn how to fly! Both images are successful because Mike has isolated and emphasized very striking elements of the scene. I have a preference for the warmer image on the left – not just because of the colour, but also because I feel that including the trees has added a sense of scale.

Useful Advice

Using a long lens to scan a scene section by section can be a very instructive way of discovering which elements within it are of the greatest interest and whether there is the potential for more than one picture.

Technical Notes

35mm SLR, 70–200mm zoom lens with x 1.4 converter, Fuji Velvia.

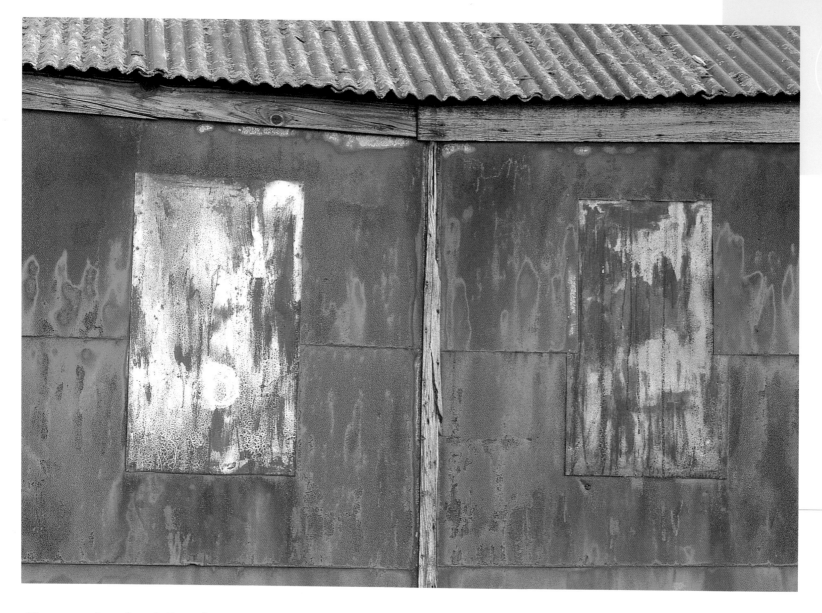

Beauty in the Mundane

One of the most powerful qualities of photography is its ability to present only the aspects of a scene or subject that the photographer wishes to be seen. This can be done to deceive: there are many occasions when photographers are asked by clients to produce an image that will misrepresent something, such as photographing an attractive hotel but omitting to show the industrial site next door. Of course, part of a professional photographer's skill is being able to make a silk purse out of a sow's ear. But it can also be done to make beautiful images from mundane or unattractive subjects — provided those subjects are sufficiently rich in the key visual qualities discussed in chapter one.

Situation and Approach

The subject of these two photographs was a battered fisherman's hut on a lonely beach – a distinctly unlovely structure in a setting that could most kindly be described as bleak. But I was attracted by the gorgeously rich colour of the rusting panels and their neat, geometric shapes.

My first shot was taken with the intention of allowing the subject to be recognized. Because of this, I included a section of the corrugated roof, which I thought also added an element of interest and contrast to the composition.

When I studied the subject more carefully, I realized that the left-hand panel possessed some especially interesting markings which, to my mind, had something of the quality of an abstract painting. I decided to frame the image more tightly by moving a little closer and using a longer setting on my zoom lens. This has resulted in a picture that is almost purely abstract, in which it's difficult to identify the subject. (MB)

Technical Notes

Medium-format SLR, 105–210mm zoom lens, Fuji Velvia.

Useful Advice

A good general rule of thumb is to remember that, in photographic terms, less is often more; in other words, an image is more likely to fail because it contains too much information and detail than because it shows too little.

Jules' Comment

These two pictures illustrate that one of the best ways of getting more and better pictures is to thoroughly explore what's in front of you. Despite the obvious similarities, each one gives a different interpretation of the subject. I love the colours and the contrast between the two shutters on the wider-angled version, and prefer this shot to the tighter, more abstract composition below.

Technical Notes

Medium-format SLR, 105–210mm zoom lens, Fuji Velvia.

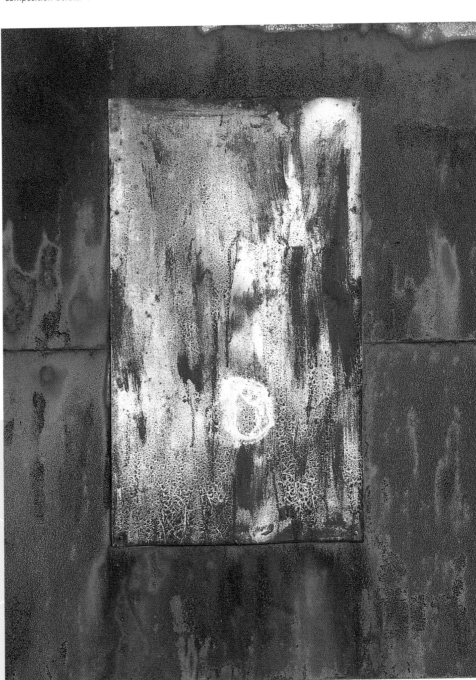

The Abstract Approach

The vast majority of photographs are taken with the aim of producing a record of a particular subject in a way that makes it readily recognizable. When images are produced with a more creative or expressive intent, however, they need to have a quality that sets them apart from the more functional type of image. This can be done in a variety of ways, such as with lighting and choice of viewpoint, and one of the most effective methods is through the process of selection. There is a natural inclination to include all of a subject in the frame, but this is not always the best way to maximize the impact of an image. It is good to get into the habit of seeing whether leaving out certain details produces a better effect.

Situation and Approach

I stayed in a country hotel recently where there was a resident population of hungry ducks that were fed on the breakfast leftovers and gathered on the lawn at the same time every morning. I wanted to photograph them but did not want just an ordinary picture of a duck.

In the end, my approach was partially decided by my subjects: as soon as I got close enough to fill the frame, they began to waddle away. This drew my attention to the pictorial potential of their rear quarters and I discovered that by excluding their heads the shape of their body and colour and texture of the plumage took on a very interesting quality. I took a number of shots, using a long lens to frame the image tightly, and this one was the most successful. (MB)

Jules' Comment

I like this mainly because of the rich colour of the grass behind the duck and the patterns and textures of the feathers. However, I would have preferred a tighter crop to make the image even more abstract in feel.

Technical Notes

35mm SLR,
70–200mm zoom
lens, Kodak
Ektachrome
100SW.

Mike's Comment

I find this combination of colour and texture very satisfying and the shot has a nicely balanced composition. Using a shallow depth of field has helped to make the rusting hulk stand out in strong relief from the background.

DUCK'S BOTTOM

Technical Notes

Medium-format
SLR, 120mm macro
lens, Fuji Velvia.

Situation and Approach

Junk is a favourite subject of mine as it allows me to be quite abstract in my photography and daring in composition. The photograph below was taken in a breaker's yard and is, in fact, the front end of an old Morris car. The colours and the pleasing light made me feel there must be a picture there. The most photogenic section was around the front headlight, where the colours were most prominent. I came in close to eliminate unwanted detail. Depth of field was a major consideration: I needed to keep the car in focus, but throw the background out. To do this, I used the depth-of-field preview button on my camera. I also chose to include the headlight, liking the way it suggested the empty eye socket of a skull. (JB)

ABSTRACT JUNK

Application and Purpose

The purpose of a photograph, or the way in which it is to be presented, is an important factor in deciding how you should go about shooting it. For a passport photograph, for instance, where identification is the main purpose, it would be both pointless and counter-productive to include any more of a person than their face. But for a picture taken for, say, a model's index card, it would be important to shoot them full length. In the same vein, an image for an illustration in a travel brochure might well need to be framed in a different way to illustrate an article on the environment. It is important to have a clear understanding of your motives for taking a photograph before you begin the process of selection and composition.

Situation and Approach

I spotted this delightfully seedy and obviously derelict shop while exploring an English seaside resort out of season. It appealed to me primarily because of its drab and dated colour scheme, although I also liked the texture of the peeling paint and the broken effect of the lettering.

I chose a viewpoint that showed all of the door and the side window, which has helped to create a three-dimensional quality. I framed the shot to include some of the green pipe as well as the blue lettering at the top of the frame, as I felt it was the combination of these colours that gave the image its "charm". This framing has also placed the white panel with its red lettering at the strongest point in the composition, more or less at the intersection of the thirds – see page 90. (MB)

Jules' Comment

I missed this shot altogether as I was looking for a black-and-white image: the colour aspect didn't even register. In many ways, the colour shot actually increases the feeling of decay: although the colours are bold, their condition emphasizes the gloom of the scene.

Technical Notes

35mm SLR, 24–85mm zoom lens, Fuji Reala ISO 100 (colour negative) film.

Situation and Approach

Working in black and white often means that you have to simplify an image to make it work. Here, the most striking result was achieved by simply isolating the sign; in fact, it is little more than a straight copy. Concentrating on the condition of the sign and its lettering makes a better and more simplistic statement than the wider view which, in monochrome, seemed too cluttered to deliver its message.

Mike's colour picture, however, tells the same story in a different way. This provides an interesting comparison between the way black-and-white and colour photographers work to achieve the same end result. The whole picture is one of dereliction which, unusually, the monochrome image seems to romanticize slightly. (JB)

SEAFOOD BAR, COLOUR

Technical Notes

35mm SLR, 28–135mm zoom lens, Kodak Tri-X 400 developed in Kodak T-Max developer.

SEAFOOD BAR, BLACK AND WHITE

The Art of Composition **75**

The Importance **of Viewpoint**

It would be hard to overstate the importance of the choice of viewpoint when taking a photograph, because it is one of the most fundamental ways of controlling and selecting the content of an image. It also has a strong influence on other factors, such as perspective and lighting. With subjects such as still lifes and portraits, where the subject can be moved at will and the image's content physically repositioned, it is less critical because, by and large, the key elements of the image can be placed to suit a given viewpoint. With most other subjects, such as landscape, architecture and documentary photography, the choice of viewpoint is crucial not only to the basic composition of the image, but also to the lighting, as the direction of the light in relation to the subject will alter as the viewpoint changes.

Situation and Approach

When I mentioned that I was going to Sydney, a friend recommended an apartment hotel with a good view of the Harbour Bridge and Opera House. You can imagine my delight when, on being shown to my room, I looked out of the window to see this. I was able to take a number of shots at different times of the day with very little effort.

It was pure good luck that I was allocated this room: had my room been on the floor above, the bridge would have obscured much of the Opera House; had I been on the floor below the gap between the base of the bridge and the top of the Opera House would have been too great. Ideally, I would have liked to have been about half way between the two floors – but I'm well past my abseiling days. (MB)

Technical Notes

35mm SLR, 70–200mm zoom lens, Fuji Velvia.

Situation and Approach

I was keen to take other photographs of the Opera House, and the bridge, and spent some time exploring alternative viewpoints. This shot was taken in the early evening after a stormy day, just as the sky was beginning to clear. I'd visited this location on another occasion and felt that the viewpoint produced a rather bland and uninteresting image.

On this occasion, the lighting on the building was quite pleasing, with the warmth of the evening sunlight and the dense cloud above adding a touch of drama. Ultimately, however, my choice of viewpoint was determined by the reflection on the water, which I thought provided an effective foreground. I positioned myself so that it was as strong as possible. (MB)

Jules' Comment

In both these shots, Mike has captured fantastic lighting conditions, but the viewpoints give each picture a very different feel – though as Mike has said, the lighting really dictated the viewpoint.

I really like the drama of the stormy shot on the right, but I prefer the clever composition of the other image. The lighting in this particular shot is stunning: I love the way the bridge and the top of the Opera House are fully illuminated, with the blue-tinted, shadowed foreground emphasizing the rich, warm quality of the sunlight. My only criticism is that the bridge is a little close to the roof of the Opera House.

SYDNEY

Technical Notes

35mm SLR, 24–85mm zoom lens with neutral graduated and 81B warm-up filters, Fuji Velvia.

STORMY OPERA HOUSE

Moving Objects

One effect of a change in viewpoint is that it also changes the way in which objects at different distances from the camera are placed in relation to one another. A small shift can make a significant difference – especially when there are close foreground details. If the camera is moved to the right, close objects appear to move to the left of more distant ones; moving the camera to the left makes the objects appear to move to the right. In the same way, a lower viewpoint makes close objects rise higher in the frame in relation to distant details, while a higher viewpoint has the opposite effect. These changes are more noticeable with a wide-angle lens and when there are objects both close to the camera and far away.

Situation and Approach

I had spent the night in the Bugey region of France, a peaceful unspoilt area between Burgundy and the Alps. On waking, I discovered there was a dense mist. I remembered passing through a plantation of trees the previous evening and it occurred to me that it might look quite atmospheric in these conditions.

The mist was beginning to clear when I found the wood and I needed to find a photogenic section of it quickly. This spot was my best option, as the grass below had no untidy weeds in it and it provided an undistracting foreground. I then needed to find a viewpoint that would create the most pleasing and balanced arrangement of tree trunks. I experimented with moving the camera just a few inches to both the left and the right before deciding on this arrangement. I used a small aperture in order to provide enough depth of field for both the nearest and furthest details to be sharply in focus. (MB)

Jules' Comment

I love the subtlety of this picture: with so much emphasis on saturated colours these days, it is refreshing to see a picture that evokes a feeling of calm rather than hitting you between the eyes like a cannon-ball.

Technical Notes

Medium-format SLR, 55–110mm zoom lens, Fuji Velvia.

Mike's Comment

Bold, saturated colour – this is my kind of shot. However, the colours could have been overwhelming had the choice of viewpoint not separated them well. Including the tall trees has also helped to create a well-balanced composition.

Situation and Approach

This picture was taken as part of a commission for a gardening publication. The viewpoint was determined by finding the most photogenic area and cutting out the undesirable elements. This particular flower-bed was by far the most attractive in the garden, but only a small section of it actually worked as an image. Having decided on the crop I then chose to come in very close and low with a wide-angle lens to cut out an untidy path and include a large section of the attractive blue sky. Thankfully, everything fitted together nicely in the frame and the lighting, although harsh, was ideal for illuminating the flowers. I also used a polarizing filter to increase the colour saturation. (JB)

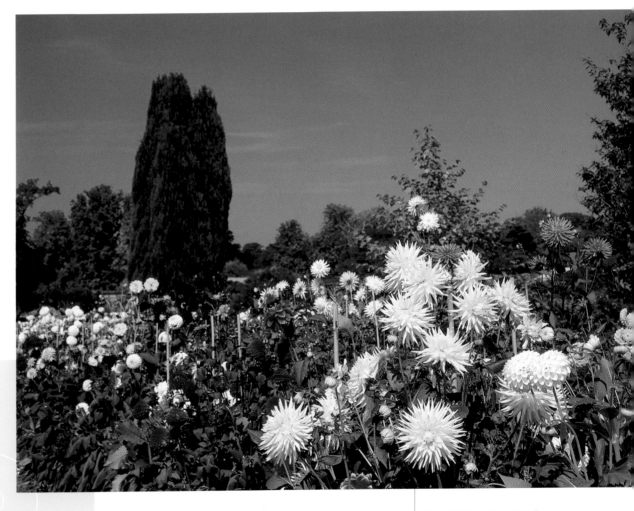

Technical Notes

Medium-format SLR, 55–110mm zoom lens with polarizing filter, Fuji Velvia.

FLOWERS AND TREES

PALM SHADOW

Technical Notes
Medium-format SLR, 55–110mm zoom lens with 81A and polarizing filters, Fuji Velvia.

Including a Foreground

Many photographs contain only relatively distant details and objects and because of this they lack a sense of depth and distance. The inclusion of close foreground details is an effective way of overcoming this, and also adds an element of interest to the composition. When you are choosing a viewpoint it is worth considering whether there is something that can be used in this way – even if it means making a radical change to your initial choice. In many cases something quite insignificant, such as the overhanging branch of a tree in a landscape shot or a foreground of flowers, can be used very effectively. As a general rule, foreground details need to be in sharp focus and clearly defined – otherwise they can easily look as if they've been included by accident and this can become distracting.

Situation and Approach

I took this shot in the middle of the afternoon, on a blazing hot day with a solid blue sky and harsh sunlight. I really liked the shadow of the palm across the lawn and wanted to include it in the picture. The blue sky was essential, as was the colourful border.

I had to move around bit by bit until I could add the pine tree on the horizon, but it gives a nice vertical element to the picture and contrasts especially well with the shadow in the foreground. Oddly enough it is the harsh quality of the light, which would normally be best avoided, that has made this image work; I often feel that you can get a successful picture in any conditions, if you look hard enough. (JB).

Mike's Comment

There is an enigmatic quality to this image that appeals to me and I like the intrusiveness of the shadow, but I think the most telling factor in the composition is that the shadow appears to be moving to the right while the pine tree is leaning to the left. This has created a feeling of tension and movement in the image.

Situation and Approach

This imposing structure is in the Qutab Minar in Delhi, India – a soaring 73-metre (240-foot) tower of victory, built in 1193 after the defeat of Delhi's last Hindu kingdom. I visited it at the end of the day, when the sun was quite low in the sky and had a very mellow, warm quality. I had taken some shots of the tower from quite close to its base, with a wide-angle lens tilted upwards to create a strong perspective effect, but I felt the picture needed something else. After a little searching I found this viewpoint, which allowed me to use another partially ruined building within the temple complex to create an interestingly shaped frame around the tower. (MB)

Technical Notes

35mm SLR, 24–85mm zoom lens, Kodak Ektachrome 100SW.

QUTAB MINAR, DELHI

Situation and Approach

I took this photograph in Marrakesh, Morocco, which is a very busy place indeed. Although there is a wealth of very photogenic subjects here for anyone interested in photographing people, it is by no means always easy to find ways of separating them from their surroundings.

A method I often use in circumstances like this, when suitable subjects are much easier to find than uncluttered backgrounds, is to find the latter first and wait for the former to arrive. In this case, I found this expanse of plain wall at the edge of the souk. It was nicely lit, had a pleasing colour and people passed by on a regular basis. I chose a viewpoint that gave me an uninterrupted view and simply waited for suitable subjects to walk in front of it. Of the several pictures that I shot, I liked this elderly man the best and felt that his djellaba (cloak) went well with the wall. (MB)

Jules' Comment

Without the right character in front of it the background is actually meaningless. The stripe of shadow running down the wall adds a little area of interest and the timing of the picture, just as the man's shadow meets this, was spot on. Mike does seem to have a knack of capturing the ideal subject: on occasions when I have tried this, I seem to end up with people in day-glo track suits and baseball caps. Perhaps I should wait for longer in future.

MOROCCAN MAN

As well as helping to control the foreground, your choice of viewpoint is also a factor in establishing the background. In many instances a fussy or distracting background can be avoided by changing the camera position. When you are shooting in busy places, such as a market or city street, this is very often the only means you have of making your subject stand out clearly.

Technical Notes

35mm SLR, 24–85mm zoom lens, Kodak Ektachrome 100 SW.

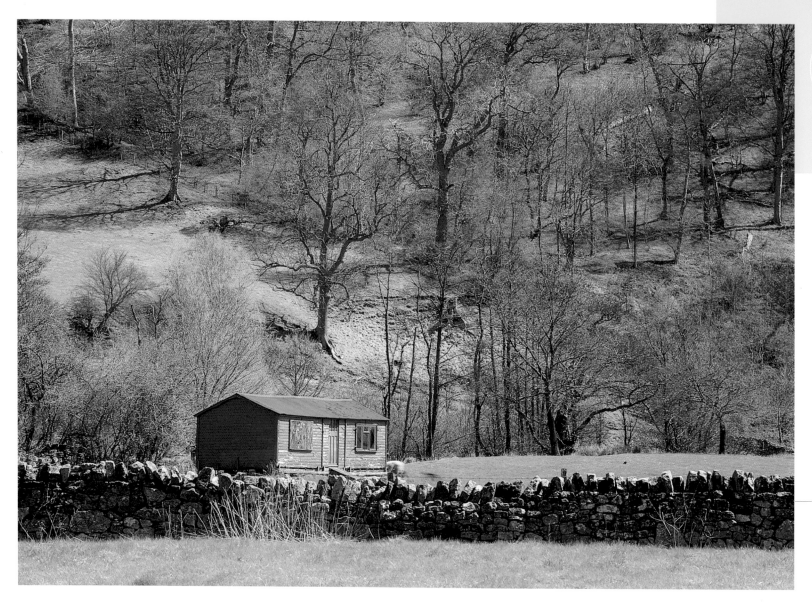

The Focus **of Interest**

Focus of interest is the term used to describe an object or detail that attracts the eye more strongly than anything else in the frame. It is quite possible for a photograph to be successful without a positive focus of interest but, by and large, it is more satisfying to the eye when there is one. The focus of interest can be something very obvious – or something so subtle that it may not seem immediately apparent that the eye is being led towards a particular area of the image. Its position within the frame is a key factor in determining the overall balance of an image. Identifying a potential focus of interest is a vital first step in composition; once you've done this, decisions such as selecting the most telling part of a scene and choosing how to frame it become much easier to make.

Situation and Approach

I shot this picture in the very early spring in the North Yorkshire moors in the north of England, when the grass was a fresh bright green but the trees had little foliage to mask their branches. It was difficult to find a viewpoint that was not too fussy and muddled, but I liked the effect of the bare trees and the bold, saturated colour of the grass and wanted to find a way of creating a sense of order.

This blue hut with its red roof was like a gift from the gods as it pulled the eye towards it, with both its colour and its shape creating a strong contrast with the surroundings. It only remained for me to find a viewpoint that positioned the hut comfortably against the background of the trees. (MB)

Jules' Comment

The hut looks like something you might come across in New England rather than Yorkshire, and this is partly what makes its presence so strong. The red and blue create a bold contrast, which accentuates the other colours in the picture. The stone wall adds the typical Yorkshire feel and I think the tree with gentle yellow foliage behind really adds the finishing touch.

Technical Notes

Medium-format SLR, 105–210mm zoom lens with polarizing and 81A warm-up filters, Fuji Velvia.

Mike's Comment

This is a striking example of how even the most insignificant detail can become a strong focus of interest if it creates a bold enough contrast. In this case, we have the contrast of the circular handle against the parallel lines of the door and the contrast of the strong highlight on its edge against the dark shadow on the right.

Situation and Approach

I was drawn to this door because of its lovely colour and the weathered look of peeling paint. I had actually set the shot up and taken a few frames before I noticed the door handle itself. At this stage the handle was only partially lit. In the image here, the light on the handle is what makes the picture successful, giving both a hint of mystery and a focal point. I simply waited for a few minutes for the sun to move around and illuminate the whole handle for the best effect. Had the light been moving away from the handle, I doubt I would have given the shot a second glance. (JB)

BLUE HUT

Technical Notes

Medium-format SLR, 105–210mm zoom lens, Fuji Velvia.

DOOR HANDLE

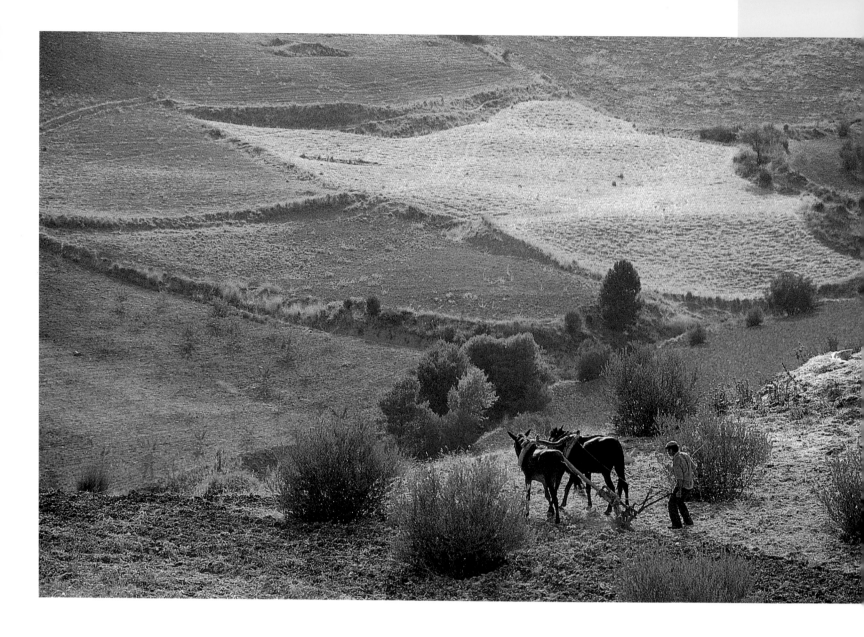

A focus of interest need not necessarily be an object or a person: it can also be created by more transient things, such as light and shadow or a passing cloud. This can be an effective way of producing photographs that have a more spontaneous, unexpected quality.

A focus of interest based on fleeting elements often means that you have to make a rapid appraisal of a situation and set up and shoot quickly. Because it's quite natural to concentrate on the scene itself, it's easy to overlook possibilities like these – but they can make the difference between a pleasing image and a really striking one.

Situation and Approach

In Andalucía, Spain, where this shot was taken, ploughing with horses is still quite a common sight. I saw this trio from a distance. My first thought was to move very close and fill the frame, but the light on the landscape was very pleasing and I liked the pattern created by the diamond-shaped fields. I decided instead to shoot a wider landscape, in which the three figures were the focus of interest, and looked for the viewpoint that would work best. Human beings and animals invariably attract the eye more strongly in an image than inanimate objects, even when they are quite small.

The difficulty was that they were constantly on the move and I had to keep changing my viewpoint. I'd shot a number of pictures before I saw that the man was heading for the corner of the field where I could position him against the background of the green bushes and I quickly changed my viewpoint again so that I would have a clear view when they reached this spot. It was only when I'd processed the photograph that I realized that the highlights on the horses' backs made such a useful contribution to the image. (MB)

Jules' Comment

In addition to capturing the atmosphere of rural Spain, this picture is composed in a understated way: nothing about it is forced, the light and composition are great, and it's a wonderfully natural image.

Technical Notes

35mm SLR,
28–70mm zoom
lens, Fuji Velvia.

Situation and Approach

This lovely shaft of light appeared suddenly and my viewpoint was far from ideal. Many people think of landscape photography as being a bit of a waiting game, but as far as I am concerned most of my pictures end up being a race against time to capture moments like these.

I grabbed my tripod and framed the picture, using the sand as foreground interest. Without this, the foreground would have been too flat and dark. I waited until the waves reached a nice curl and managed to shoot a few frames before the light went. The shaft of light was even more eye-catching because it created a strong diagonal line in an image dominated by horizontals. I did have time to put a graduated filter on to darken the sky, and now I carry a filter holder ready loaded with graduated, warm-up and polarizing filters just for situations like this. It is much easier to get rid of the filters you don't want in a hurry than it is to find and fit the one you need. (JB)

Mike's Comment

This is one of those wonderful landscape images that captures a fleeting moment that one feels will never be that way again. Many landscape images have a static quality, but this one oozes spontaneity and movement.

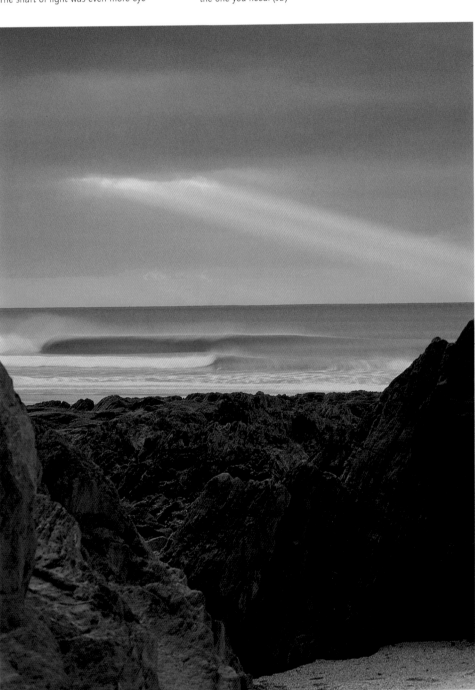

<div style="writing-mode: vertical">LIGHT SHAFT</div>

Technical Notes

Medium-format SLR, 55–110mm zoom lens with neutral graduated filter, Fuji Velvia.

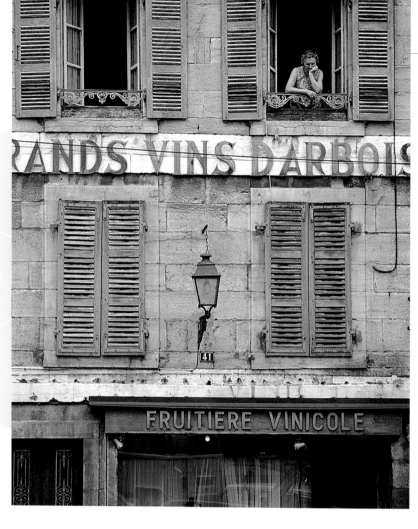

Technical Notes

35mm SLR,
70–150mm zoom
lens, Fuji Velvia.

Placing the Focus on People

Of all the things that can provide a focus of interest in an image, a human figure is one of the most powerful. Even when it is very small within the frame, an isolated figure in, say, a landscape can attract the eye like a magnet attracts a needle. You see many fine landscape images which, with the addition of a human figure, would have changed from a nice photograph into a stunning one. Sadly, when people do appear, they are often inappropriate to the scene: a group of hikers dressed in multi-coloured waterproofs does little to enhance an atmospheric landscape, for example. This is why professional photographers shooting pictures for travel brochures, for instance, usually take models to ensure they can control what they wear and where they are placed.

Situation and Approach

I was shooting photographs in the old Jura town of Arbois for a book on French wines when I spotted this ancient façade with its flaking shutters and bold red lettering. I was in the process of setting up my camera and deciding how best to frame the shot when a woman suddenly appeared at the window. This of course made the decision for me and I worked quickly as I was not sure how long she would remain. I wanted to include all four shutters and part of the shop front, which meant that she was naturally positioned at the intersection of the thirds – see page 90 – and this has helped to make her an even stronger focus of interest. (MB)

Jules' Comment

Mike has a keen eye for this kind of image: years of working as a travel photographer seem to have sharpened his ability to find and capture these moments. The façade itself is a worthy picture but the woman is a perfect touch, right down to the colour and pose. I think the timing here was absolutely spot-on and the composition is ideal, giving a nice blend of architecture and human presence. The French signs accentuate the atmosphere even further.

Mike's Comment
The appeal of this photograph comes
largely from the cool, blue colour of the
image and the contrast of textures between
the spiky tree, the smooth snow and the
soft clouds.

Situation and Approach

I live near Exmoor in England and one
winter's morning a heavy fall of snow sent
me out in search of pictures – always easier
said than done, as many of the roads were
impassable. This shot was taken during the
devastating foot-and-mouth outbreak in
2001, so there was virtually no other traffic.
I was able to stop the car and shoot from
the middle of the road itself, keeping off
the land as advised. The footprints were
made by a farmer and I feel they add to the
image: they suggest a human presence,
which emphasizes the remote and
inhospitable mood, and they lead
effectively to the tree. I like the way the two
trees help to balance each other since
either one on its own would not have
produced such a good composition. I used a
polarizing filter to accentuate the clouds
and to keep everything "cool" looking. (JB)

Technical Notes

Medium-format
SLR, 55–110 zoom
lens with
polarizing filter,
Fuji Velvia.

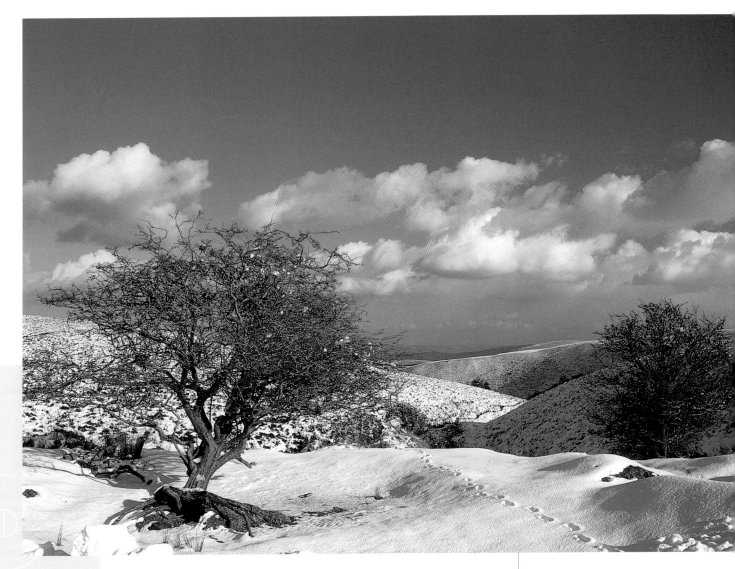

FOOTPRINTS IN SNOW

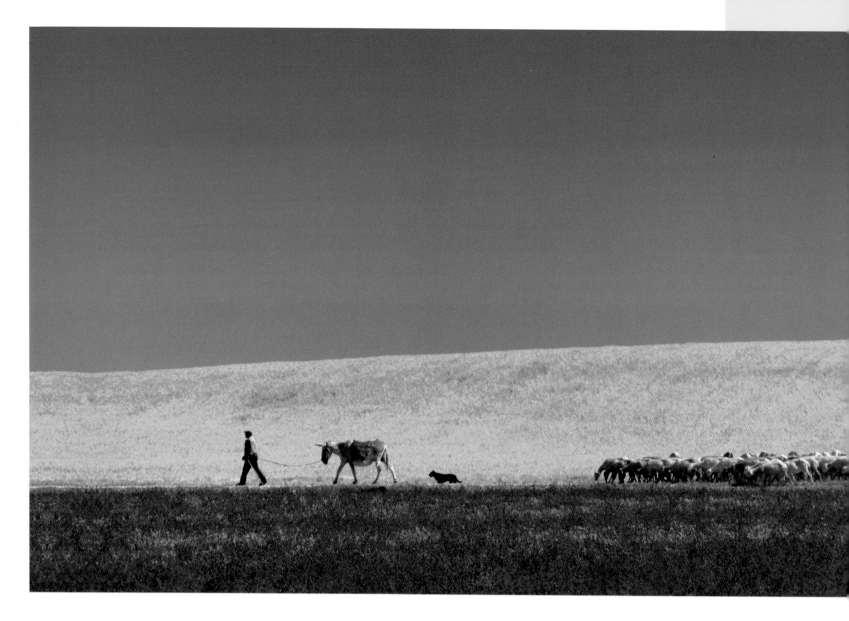

Placing the Frame

Once you have established the image's focus of interest, your next step is to decide how best to place your frame around it. All too often, the viewfinder is used mainly as an aid to aiming the camera and this usually results in the focus of interest being more or less in the centre of the frame. This can sometimes be the best place for it, but it should be the result of a considered decision and not just something you do by default.

The golden rule of composition states that the strongest part of the image is at the intersection of thirds – that is, at one of the points where imaginary lines dividing the frame into thirds both horizontally and vertically meet. This is generally a safe bet and tends to create a well-balanced image most of the time; however, it is not a rule to follow slavishly.

Situation and Approach

The Castilian plain to the west of Madrid was the setting for this shot. Several shepherds from a nearby village were taking their animals to the parched pastures. This group caught my eye, as the man, mule and dog were well separated from the flock and formed a neat line as they passed in front of the low hill. I tracked their progress in my viewfinder from a distant viewpoint until I felt that the various elements had combined to the best effect and then I made my exposure. I framed the shot to include a large area of sky since, for me, it established the feeling of wide-open space. It also balanced the dense green foreground and the semi-silhouetted figures. (MB)

Jules' Comment

It is the very simple bands of colour that make this image work; a more complicated background would have lessened the impact of the figures. I would like to see how it works in a panoramic format, with less sky.

Technical Notes

35mm SLR, 200mm lens with polarizing filter, Fuji Velvia.

Situation and Approach

I had taken a closer picture of this famous lighthouse at Beachy Head, on the south coast of England, from a different viewpoint but I felt I needed some sort of foreground interest – which, on a cliff, is difficult to find. I was unable to get the right angle on the lighthouse without going too close to the edge. This shot was taken from the spot where I felt safest and still had a good view. I liked the light on the cliff and the plant-covered rocks which gave me my foreground interest. The rich blue sea and sky really helped to accentuate the lighthouse. Instead of applying the rule of thirds, I opted to place the lighthouse in the very top corner of the frame to emphasize its loneliness in relation to the massive expanse of cliff. I think this has made the lighthouse an even stronger focus of interest. (JB)

Mike's Comment

Tucking the lighthouse in the very corner of the frame has created a very strong image and added to its importance. I think following the rule of thirds here would have produced a much weaker shot, because it would have lessened the dramatic contrast in size between the two elements.

Technical Notes

Medium-format SLR, 105–210 zoom lens with neutral graduated, 81A warm-up and polarizing filters, Fuji Velvia.

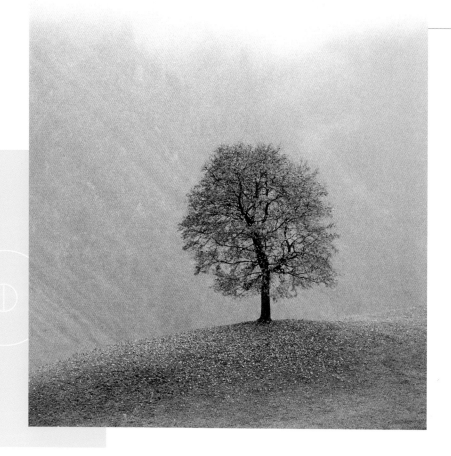

Technical Notes

35mm SLR, 70–150mm zoom lens, Fuji Velvia.

The best way to decide how to place the frame effectively is to study the viewfinder's content while you alter the camera angle and judge for yourself when you feel the balance is right and the focus of interest is in the most telling place. At this stage you may want to alter the field of view, or even the viewpoint, before you arrive at the "ideal" composition, but juggling these variables is a vital part of composing an image and the one big area of control that you have over the end result. The choice is often between the "safe", but relatively static, quality that you can obtain by following the rule of thirds, and the more adventurous, edgy feel that you can achieve by consciously breaking the "rules" in a considered way. The best way of discovering what works is, whenever possible, to try alternative ways of framing the image.

Situation and Approach

The dense fog that I had woken up to had just begun to lift, but I hadn't expected to do any photography for an hour or so until I saw this tree. Its bold colour and the fact that it was relatively close created enough contrast for it to stand out from the mist, even though the light was very soft and almost shadowless.

I felt there were several ways in which I could frame it and spent a while exploring them. My first thought was to frame the image tightly and include only the grey mountain background, but when I widened the view and included a large area of the white fog I felt the effect was stronger. The tree is positioned pretty much on the intersection of thirds; this was not a conscious decision, but it seemed to create the best balance. (MB)

Jules' Comment

A very nicely balanced image with a subtle charm to it. I particularly like the colours and the way the land in the background seems to add a slanting pattern. This picture proves that it is possible to get a successful image even when the sky is a bland white.

Situation and Approach

This wrecked boat is on one of my favourite stretches of coastline. On this particular day I had my panoramic camera with me and the boat and its shadow seemed the ideal subject as together they made a long, thin shape. I framed the shot so that the boat took up half the frame, cutting out distracting elements to the left of the boat but keeping the fluffy white cloud. In addition I decided to keep the bank of stormy looking clouds to the right of the image, because this added intensity. The clear section of sky forms a subtle v-shape in the centre of the image, echoed by the shape of the shadow below. This gives a balanced picture with a more striking appearance than I could have achieved with a more conventional composition. (JB)

Mike's Comment

Although the boat is placed in one half of the frame, there are two things that balance the image: the boat's shadow and the small white cloud near the left-hand edge of the frame.

BOAT WRECK

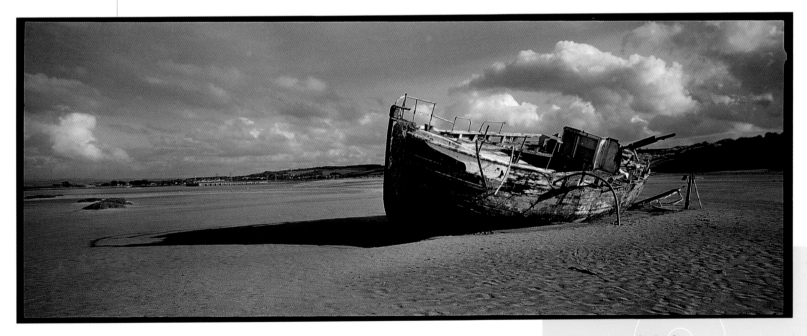

Technical Notes

35mm panoramic camera, 45mm lens with orange filter, Agfa APX 25 developed in Agfa Rodinal.

Sebastião Salgado

was born in Brazil in 1944 and did not begin his photographic career until 1973 after an initial period as an economist. He has dedicated his life and work to recording the harsh conditions under which the majority of the world's population lives. His first collection of images was published in 1986 in a book, *Other Americas*, concerning poverty in South America. Between that date and 1992 he devoted his work to recording the plight of manual labourers throughout the world, culminating in a powerful exhibition and book entitled *Workers*.

Since then he has made the world's displaced people his focus of attention with the acclaimed books *Migrations* and *The Children*, both published in 2000. He works exclusively in black and white using 35mm cameras and his images are notable not only for their dramatic content but also for their striking visual sensitivity and finely crafted photographic quality. In 2001 he was appointed a UNICEF Special Representative. He lives in Paris.

Mike's Comment

This is one of the images from Sebastião Salgado's massive body of work entitled, "Workers". Some of the most compelling of these images were photographed at the Sierra Pelada gold mine in Brazil. While many of them show breathtaking vistas of the steep mountainside massed with swarming workers, this shot creates its atmosphere and drama through tight framing that emphasizes the textural quality of the image and reveals the stress and strain of the miners in a more intimate way.

GOING UP

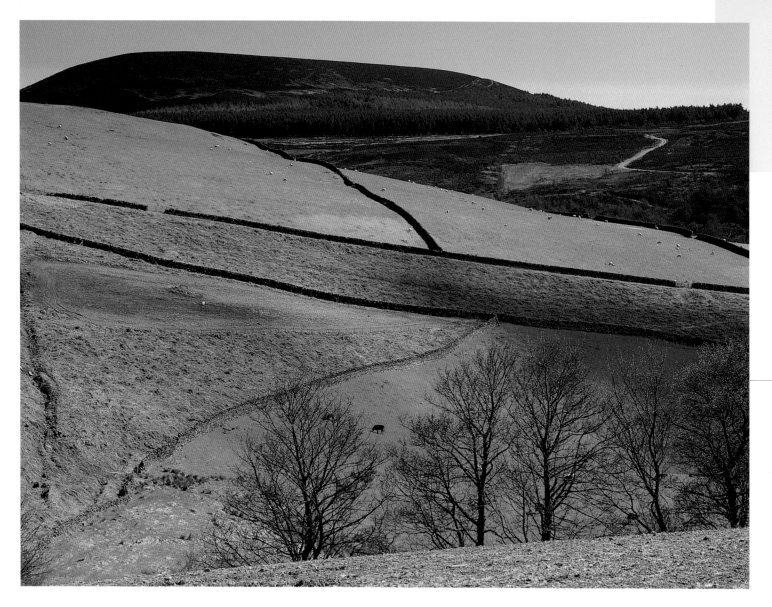

Choice of Format

t is fair to say that one very basic aspect of composition that is often neglected in photography is the choice between an upright and a landscape shape. By far the largest proportion of photographs are taken using the landscape format – simply because a hand-held 35mm camera is much easier to hold in that position. A great many disappointing pictures could have been transformed simply by considering the upright option.

If you have ambitions to see your work published, it is worth remembering that most books and almost all magazines have an upright format and portrait images are often easier to use full page. Landscape-format images are mainly used at half-page size, or smaller, although a very striking photograph might be used over a double-page spread.

Situation and Approach

I photographed this scene in the early spring on England's North Yorkshire moors, when the trees were still bare but the grass had a new, fresh colour. Although the sky was blue and the light clear and sharp, there were some large clouds casting shadows over the land and their changing position made me alter the way I framed the pictures several times.

First I used the landscape format – partly because I wanted to include the highlighted track at the top right-hand corner of the frame and it seemed to be balanced nicely by including the corner of the field in the bottom left corner. However, when the cloud moved and cast a much denser shadow over the background hill, I lost the highlighted track.

Because of this I began to consider an upright shape and found that I liked the banded effect of the foreground, the walled fields, the dark hill and the blue sky. It really seemed to fit nicely and I now prefer this version. (MB)

Technical Notes

Medium-format SLR, 105–210mm zoom lens with 81B warm-up and polarizing filters, Fuji Velvia.

Useful Advice

One way of ensuring that you don't overlook the possibility of using an upright composition is always to frame your pictures this way when you first look through the viewfinder, reverting to the landscape shape only if this doesn't work. But often both formats produce a satisfactory result and shooting both will give you the option of choosing the one you like best in the cold light of day.

Jules' Comment

I much prefer the upright version of this shot. Cropping out the slightly scruffy elements on the right- and left-hand sides seems to have given it a stronger and more dynamic quality than the landscape version.

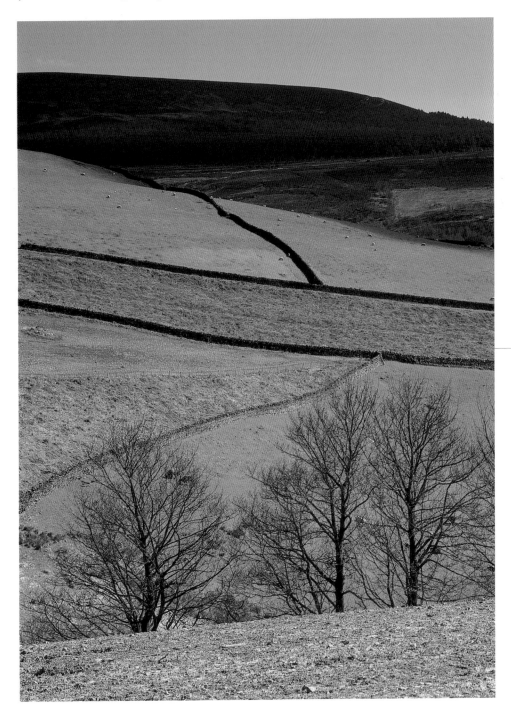

YORKSHIRE MOORS, PORTRAIT

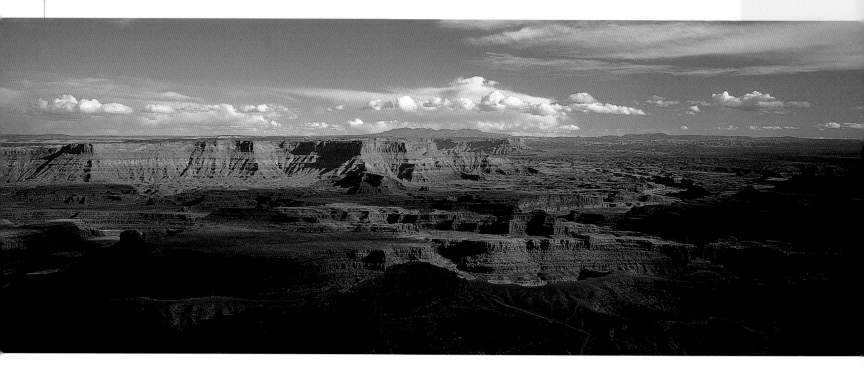

Cropping the Image

The 35mm format possesses the classic 2 x 3 proportions and is, of course, very widely used. But it is by no means the only picture shape available to photographers. The 6 x 6cm format was the industry standard for very many years and a number of notable photographers still use it. Many black-and-white photographers print the film borders of their negatives, partly because it tends to give the image a fine-art look but also because it clearly states that the image is full frame and has not been cropped. This is a very laudable attitude – but if you have a potentially stunning image that does not fit the format you are using, then it makes sense either to switch to another format or to crop it after the image has been recorded.

Situation and Approach

Jules and I timed our visit to Dead Horse Point in Utah's Canyonlands National Park for an hour or so before sunset on a day that had been cloudy but had now largely cleared. When we arrived at our chosen viewpoint, we were dismayed to see that a huge new bank of cloud was looming up from the west and in fact had begun to cast a big shadow over the dramatic landscape below. Even my 6 x 4.5cm format showed an unacceptably large area of deep shadow in the foreground, so with literally only seconds to spare I made a few exposures on my Hasselblad XPan. But without the distant clouds this, too, would have been pointless. (MB)

Jules' Comment

Mike has managed to overcome the heavily shadowed foreground by using the panoramic format. This has not only limited the amount of foreground but also maximized the sky. It would have been difficult to secure a successful picture without this format. I like this shot – much better, in fact, than my own attempt later on.

Mike's Comment

The extra image area that would have been
gained at the sides of this shot by using a
rectangular landscape format would not
have detracted from its impact, but the
square shape has produced a beautifully
balanced composition.

DEAD HORSE POINT, SQUARE

Technical Notes

35mm rangefinder
camera, 90mm
lens with
polarizing and
neutral graduated
filters, Fuji Velvia.

Technical Notes

Medium-format
SLR, 100mm lens
with polarizing
and neutral
graduated filters,
Fuji Velvia.

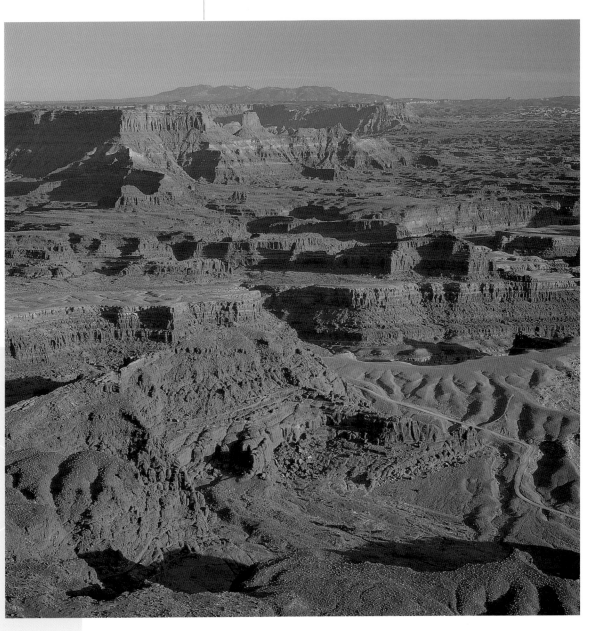

Situation and Approach

I shot this the day after Mike's picture, and
faced the opposite problem: the top half of
the image was actually a little bland, there
was some haze around and the low light
wasn't cutting through it. On the previous
day, like Mike, I had used the panoramic
format but had failed to come up with
anything. The light had been a little too far
gone by the time I took the picture. This
was really my last chance to get a picture
of Dead Horse Point.

The conditions may not have been
ideal but the foreground was very nicely lit,
giving me something to work with. I needed
to include the sky as I felt the image was
too abstract without it, and so I used a
polarizing filter and a neutral graduated
filter to get the most out of it. By using the
square format, I was able to include a large
section of the foreground, placing less
importance on the top of the picture, and
this made the shot. (JB)

Choosing the Moment

One of photography's unique qualities is the ability to isolate and capture a brief and fleeting moment in time. Henri Cartier-Bresson described the recognition of a point at which all of the various elements of an image came together in the most telling way as "The Decisive Moment". It is easy to appreciate this when viewing his work and that of the other great reportage photographers, but perhaps not so obvious in other fields – and yet it is a vital ability in portrait, sports and nature photography, where the passing of a second can be the making or breaking of a shot, and it can also play a crucial role in seemingly static subjects such as the landscape. There are many occasions when a potentially great shot has been missed by seconds and others where one has been captured by sheer good luck.

Situation and Approach

There's a beach in Spain that I visit often, and on summer weekends it is colonized by Spanish families who like to escape from the heat of cities like Malaga and Cordoba for a day or so.

I set out to record one such weekend. This shot was taken very early on Sunday morning, when it was still relatively cool. All manner of folks like to exercise and work out at this time and I spotted this man from some distance as he jogged along the water's edge. I did not immediately see the little dog but when I did it became a must-have shot.

I had plenty of time to choose my viewpoint and provisionally frame the image, needing only to swing the camera up at the last moment, from its discreet hiding place, and shoot. I was shooting in colour but I felt this worked better in black and white, using the the method described on pages 280–287 to obtain a good tonal range. (MB)

Jules' Comment

Although I like this image in black and white, I did prefer the colour version. But whatever the medium, the shot works simply because of the element of humour involved – and that is down to the timing.

Technical Notes

35mm SLR camera 24–85mm zoom lens, Fuji Reala ISO 100 (colour negative film).

Situation and Approach

This was taken on a steep pebble beach. There wasn't much there to use as a focal point so I turned my attention to the sea itself, which was starting to build as a swell moved in. I was using a very slow film so I had to take care to select the right speed: I wanted some degree of movement but also to "freeze" the action and create some slight mistiness in the water. I selected an aperture of f/11, which gave me a reasonable depth of field, and a shutter speed of ⅛₀ second, as I felt this would give me the degree of blur I was looking for. I framed the image to include pebbles in the foreground and the sea as a backdrop and made exposures as each wave receded and mixed with the incoming one. (JB)

Mike's Comment

A combination of a precisely timed exposure and exactly the right shutter speed has resulted in a winning image here. Nice framing, too.

Technical Notes

35mm panoramic camera, 45mm lens, Agfa APX ISO 25 developed in Agfa Rodinal.

BREAKING WAVE

Lighting, too, is something that can require precise timing. On days when there is a clear blue sky or dense even cloud cover, the light on the landscape is pretty constant over a period of an hour or so – but when there are separate, dense clouds with gaps between, the result can sometimes be a bit like those disco lighting effects where a roving spotlight sweeps the dance floor. You need patience and good luck, as well as good timing, to capture that elusive pool of sunlight when it hits the right spot. The key to capturing the decisive moment successfully is being able to anticipate and be ready to shoot at precisely the right time.

Situation and Approach

I found this viewpoint of the Puy de Sancy in the Auvergne region of France as I climbed up the mountain pass from the town of Le Mont d'Or. A cloud had cast a shadow over the whole area: I could see the potential of the scene, but needed to wait for a gap to appear in the cloud. In fact several gaps appeared, each one sweeping a pool of sunlight over the scene before me. One moment the mountain was lit but not the green hillside in the foreground; the next moment the whole scene was evenly lit. If only the foreground was illuminated and the mountain in shadow, I would get a much more dramatic effect. In the end my patience was rewarded. I made several exposures over a period of several seconds, and this one captured the spotlight in just the right place. (MB)

Jules' Comment

The lighting that occurs before, during and after a storm is my favourite as the light is very atmospheric without being obvious, and there is often a clarity that creates good colour saturation. This shot works well because of the light quality and stunning colour, but especially because of the timing.

Technical Notes

35mm SLR, 75–150mm zoom lens with 81C warm-up and neutral graduated filters, Fuji Velvia.

Jules' Comment

This portrait has a very natural feel to it; in addition to the warm colours, Mike has captured the warmth of the person herself. Portraits like these are often hard to achieve because of the person being self-conscious. Timing is the most important factor and taking the picture when the person lets their guard down is never easy, as it may happen for no more than a split second.

Situation and Approach

I saw this woman sitting outside a temple in Jaipur, Rajasthan, and was attracted by her handsome face and the lovely saffron sari she was wearing. On being told that she was happy for me to take photographs I asked her to move into the shade of the temple wall, which created a softer and more pleasing light and also provided an attractive, but unobtrusive, background. There's a risk in doing this that your subject might become self-conscious and freeze, but the woman was very relaxed and smiled easily into the camera. I had a friend with me who stood to one side and chatted with her as I made my exposures. Just for one instant she glanced up at him and showed the whites of her eyes as well as her bright teeth and, for me, this was the best frame. (MB)

Technical Notes

35mm SLR, 70–200mm zoom lens, Kodak Ektachrome 100 SW.

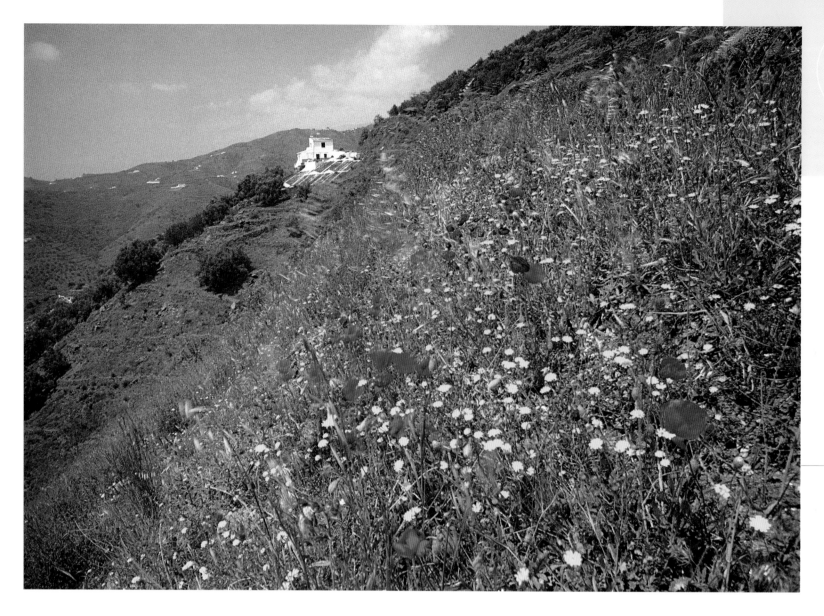

Exploiting Perspective

Perspective is an interesting and very useful element in the depiction of an image in all forms of artwork, because it plays an important role in creating the impression of a third dimension. Perspective is a function of viewpoint: the closer you are to an object, the larger it will appear to be in relation to distant objects. In this way a small plant can appear to be much bigger than a distant tree. The effect also depends on the field of view and the way in which the image is framed. A wide-angle lens enables you to place the camera very close to an object and to include both it and much more distant details in the frame. The result is an exaggeration of perspective and this can be used to create a pronounced sense of depth and distance in an image and also introduce a dramatic quality.

Situation and Approach

One of the best times to visit Andalucía in southern Spain is in the spring, when the hillsides are vivid with the colour of wild flowers. This picture was taken in May near the Moorish village of Frigiliana, after a particularly wet winter. The isolated white farmhouse provided an ideal focus of interest and an effective balance for the mass of foreground colour. I placed my camera quite close to the ground, less than 1 metre (3 feet) away from the nearest blooms, and used a wide-angle lens to give me a field of view that included both a wide expanse of foreground and the distant mountains and sky. I used a small aperture to give sufficient depth of field to keep everything sharp and focused at a point between the two distances. (MB)

Jules' Comment

A very strong image, with the colours and wide-angle lens creating impact. Another thing that increases the strength of the image is the slope of the ground, which has created a diagonal element in the composition.

Technical Notes

35 mm SLR, 20mm lens with polarizing and 81C warm-up filters, Fuji Velvia.

Mike's Comment

This image has an almost surreal quality because of the grossly exaggerated perspective. It is probably no more extreme than the perspective in my picture, but it appears so because of the more obvious distortion of the fish.

Situation and Approach

Lowering oneself down a cliff side on a rope for a spot of light tackle bass fishing seems insane only to those who don't do it – or at least that's what I tell myself. When I caught this fish – the first "keeping size" of the season – I thought I would photograph it as well, though since this was a fishing trip I only had a 35mm camera with a 28–135mm zoom lens with me.

The stunning backdrop of rocks and stormy sea and sky proved perfect, but to get everything in I needed to use an extreme wide-angle setting and come in very close. This exaggerated perspective gave a dramatic look to the picture, and had the added advantage of making the fish look bigger than it actually was. (JB)

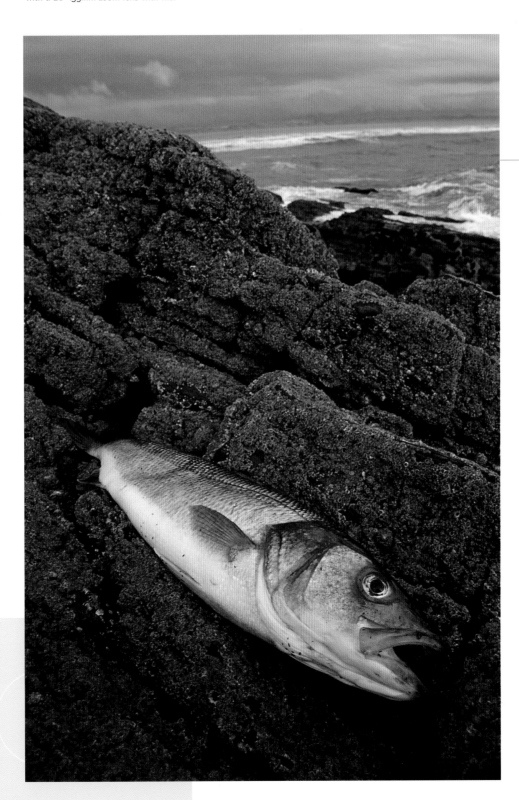

Technical Notes

35 mm SLR, 28–135mm zoom lens, Fuji Velvia.

Technical Notes

35mm SLR,
17–35mm zoom
lens, Fuji Velvia.

Distorted Perspective

Architectural subjects are particularly sensitive to changes in the perspective and it is common practice for photographers who specialize in shooting buildings to use view cameras with rising fronts or shift lenses. By raising the optical axis, these make it possible to include more of the top of a subject without having to tilt the camera upwards, ensuring that vertical lines remain parallel. Even this has its drawbacks, however, because when a large amount of rising front is used from a very close viewpoint the results can look as strange and unnatural as converging verticals. In these cases it is often best to tilt the camera up, using a wide-angle lens from a close viewpoint, and make the exaggerated effect of converging verticals an element of the composition.

Situation and Approach

This is one of the towers of the château of Pichon, Longueville, in the Médoc region of France. It is a very photogenic building with a wide choice of viewpoints and I had already made some pictures showing the full extent of the château in its setting. But on this occasion, I was struck by the potential of the dark, stormy sky and felt there was an opportunity to take a more abstract photograph of the building with a more dramatic quality – a touch of Alfred Hitchcock, I thought.

Using a wide-angle zoom lens, I moved very close to the tower's base to a place where I was able to tilt the camera up and make the vertical lines converge. I made several small adjustments to both the viewpoint and the zoom setting before I made the exposure. (MB)

Jules' Comment

A combination of dramatic light and a very wide-angle lens pointing upwards has made this an interesting image. Although a shift lens is popular for this sort of photography, sometimes using it to correct verticals can leave the image a little clinical. This treatment has produced a rather creepy, cinematic feel.

Situation and Approach

This shot came about as an act of desperation on a day when I hadn't found anything to inspire me. During a walk in the woods I sat down in a clearing to take a drink. As I drained the last of the water from the bottle, my upturned head made me look straight up into the trees. I realized the potential and virtually lay on the ground with the tripod in a very awkward position, in an attempt to frame the shot. I used a very wide-angle lens and aimed straight up, moving the camera around until I got the trees into a nice position in the frame. I also used a polarizing filter to deepen the blue of the sky. (JB)

WINTER SKY

Technical Notes

35mm SLR, 20–35mm wide-angle zoom lens with polarizing filter, Fuji Velvia.

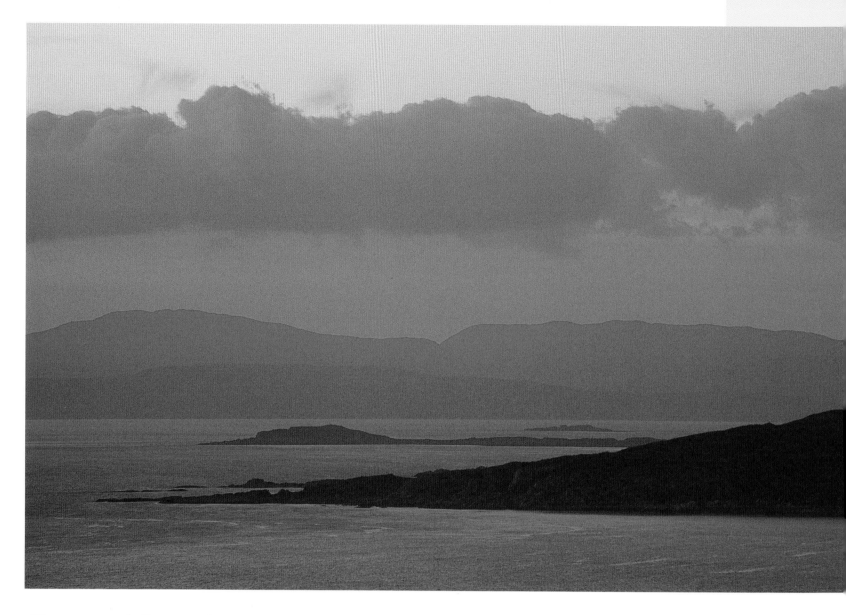

Compressed Perspective

Just as including objects in the close foreground of an image exaggerates the effect of perspective, excluding them lessens it. If all the objects and details in a photograph are at a considerable distance from the camera, they will all appear to be close to their true relative sizes and the image will look flat and two-dimensional. When a long lens is used to isolate a small area of a scene like this, the perspective appears to be distorted to the point where the image can seem compressed. This can be particularly noticeable when a very long lens is used, such as in sports photography where athletes or horses running towards the camera appear to be almost on top of one another. It is a useful and effective way of producing pictures with a more graphic, designerly quality.

Situation and Approach

Travelling along the west coast of Scotland at the end of a cloudy day just after sunset, I watched these lovely colours evolve in the sky and sea. It was almost dark and the only tones were in the sky and its reflection in the water. There was no chance of producing any detail in the immediate foreground: it would simply be silhouetted and there was nothing with an interesting shape that could be used in this way. Because of this I decided to use a long lens to isolate the most interesting areas of the scene, and included only a small portion of a closer, small headland for contrast. (MB)

Jules' Comment

This is quite a serene scene and I like the subtle colours. Overcoming the lack of foreground detail by using a long lens has produced a good image from a difficult situation. But I do find it just a little empty; a more positive focus of interest would have made the image more striking.

Technical Notes

35mm SLR, 70–200mm zoom lens with x1.4 converter, Fuji Velvia.

Situation and Approach.

During a two-day stopover in Bangkok a few years ago, I decided to visit a few of the sights. It was a hazy day with very soft lighting and a white sky, and the potentially stunning buildings lacked the sparkle and impact I'd seen on postcards. I felt my best approach was to concentrate on details, rather than wider scene-setting pictures, as they were rich in colour and were not so reliant on crisp light and a blue sky. My initial intention was make this temple detail the sole content of the picture and to frame it very tightly, but when I included part of the building behind I found that I liked the compressed effect that the juxtaposition created. (MB)

THAI TEMPLE

Technical Notes

35mm SLR, 70–20mm zoom lens with x 1.4 converter, Fuji Velvia.

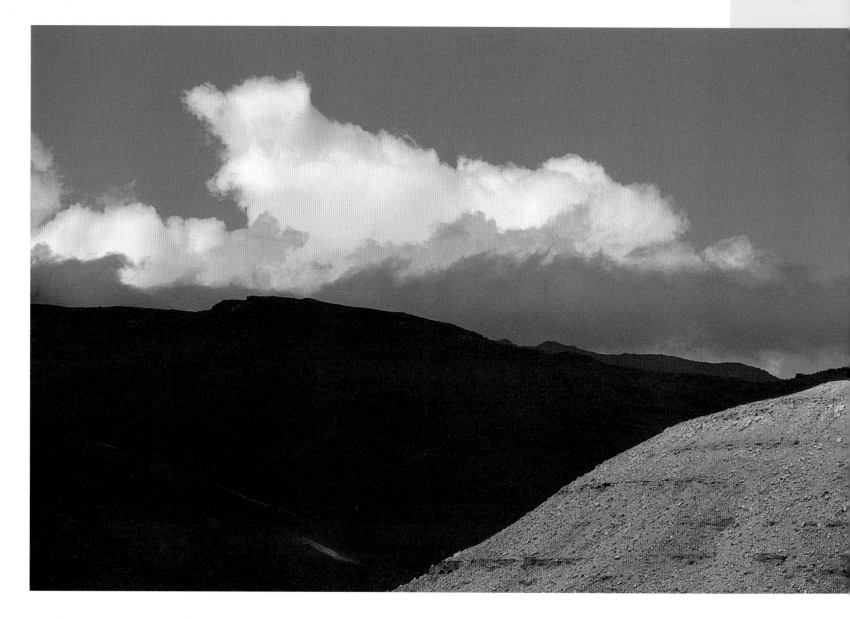

Colour and Design

Colour is a very powerful element in an image and one that can override all others. Consequently, if you are to produce striking colour photographs, you need to give considerable thought to the way you use it. Random distribution of colour in a photograph tends to create images that lack the bold, eye-catching qualities that are necessary to make your pictures stand out from the rest.

As with other visual qualities, such as texture and pattern, it can be more productive to seek out and compose images primarily for their colour content than simply to focus on interesting subjects. There is a significant difference between a photograph of something interesting that happens to have been shot in colour and one that is first and foremost a good colour photograph.

Situation and Approach

I took this photograph in the Atlas mountains in Morocco, a country with an astonishing and dramatic landscape. I'd be the first to admit that it shows nothing of the stunning countryside and could have been taken in a great many places – but that was not my reason for shooting it. Instead, I'd seen the potential for an interesting image in which the colour elements produced an effective design.

I used a long lens to isolate a small area of the scene and chose a viewpoint that placed the three main components of the image in the best juxtaposition. I used a polarizing filter to make the blue sky a richer colour and the cloud stand out in greater relief, with an 81B warm-up filter to enhance the colour of the sunlit mountainside. I would have liked a little more of the red earth in the image, but there were details below and to the right that would have been distracting. (MB)

Jules' Comment

Great timing to get all the elements together. Contrasting the hillside in the shade with the illuminated one is very successful. I particularly like the way this contrast is echoed in the clouds.

Situation and Approach

It was of course the red building that immediately grabbed my attention, but to prevent distortion I would have needed a shift lens, which I didn't have. So I decided to try something different. By moving the composition away from the building I was able to include part of a skyscraper, giving an old and new feel. The image was taking on an abstract quality, but I felt that it needed a bit more colour to add to the impact. I noticed this tree with strong green foliage, which seemed ideal. I had to move around quite a bit to get the tree into position, and to move further away to include it, which meant that both the red building and the skyscraper were less dominant. As a result the image became more abstract – but it improved because of that additional colour. (JB)

ATLAS MOUNTAINS, MOROCCO

RED HOUSE IN DENVER

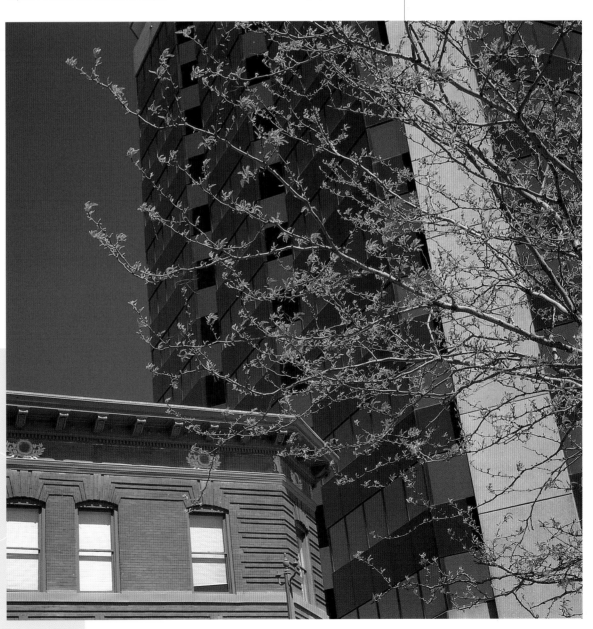

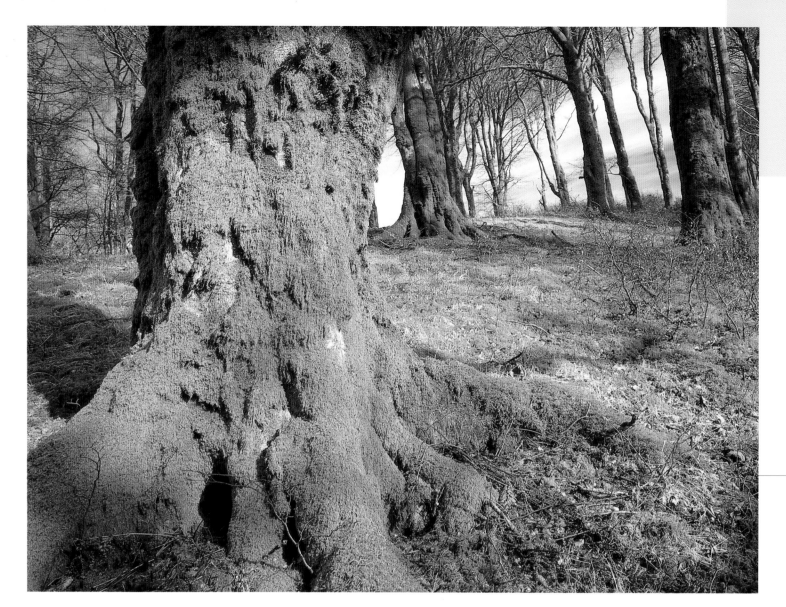

Perhaps the most powerful effect that colour can have is the element of surprise. At a funfair, for example, it would not be at all surprising to see buildings painted red or yellow, but in a normal urban environment they would almost certainly attract attention. The most common colour on our planet is green and one notable landscape photographer is said to work mainly in black and white largely because green is so commonplace and boring. Poppy fields, lavender and sunflowers are all immensely popular with landscape photographers, perhaps because (in terms of their colour, at least) they have an element of the unexpected and create a bold contrast with the more prevalent colours of the countryside.

Situation and Approach

This situation caught my eye because of the strong colour and the way the light was highlighting both the colour and the texture. Originally I came in close, but then I decided to shoot a few frames that included more background. The frames that had a wider view were much more striking, as the pool of light was easier to see and the trees behind helped to give a strong sense of perspective. (JB)

Mike's Comment

I think this would have worked just as well in black and white, maybe better. But it does make a very satisfying colour image because the potential boredom of the dominant green is overcome by the strong shapes and textures of the subject and the way in which the image has been framed.

Technical Notes

Medium-format SLR, 55–110mm zoom lens with polarizing and 81A warm-up filters, Fuji Velvia.

Jules' Comment

Wonderful backlighting has made those trees almost glow and created a really vivid colour. It is the contrast between this and the warmth of the rocks and the blue sky that makes this image so strong. A well-thought-out shot, using everything that the light had to give.

Useful Advice

When you need maximum colour saturation, it's important to avoid overexposure. A small degree of underexposure is often helpful when shooting on colour transparency film.

Situation and Approach

I photographed this scene in the Canyonlands National Park in Utah, USA, when the spring foliage of the cottonwood trees was at its most vivid. But it was the luminous quality created by the back-lighting that made me want to take a shot. I also liked the sense of organization imposed by the separate solid blocks of colour. I needed the sun to be almost directly in front of the camera in order for the branches to be clearly outlined and this dictated my viewpoint. I used a long lens to isolate the essential areas of the scene and a polarizing filter to increase the colour saturation, together with an 81B warm-up filter to accentuate the red. I used a flag-style lens shade to shield the lens from direct sunlight; without it, there would have been pronounced flare. (MB)

Technical Notes

35mm SLR, 70–200mm zoom lens with polarizing and 81B warm-up filters, Fuji Velvia.

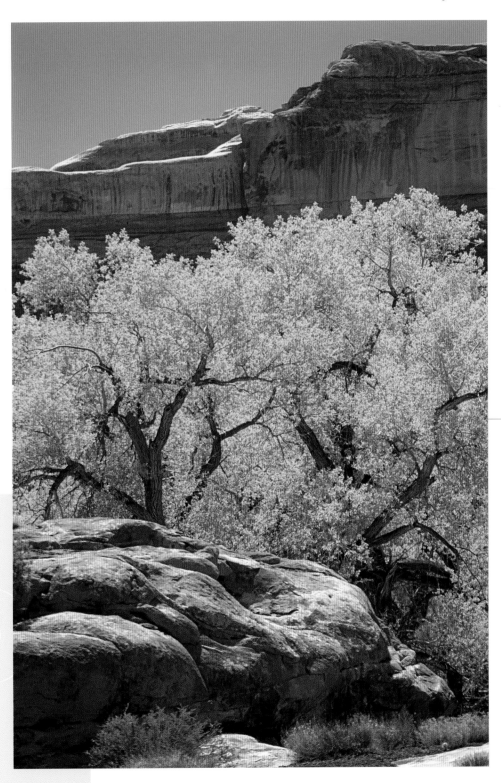

RED, GREEN AND BLUE

Technical Notes
Medium-format SLR, 100mm lens with polarizing and 81A warm-up filters, Fuji Velvia.

The Mark of Man

Colour and design are all around us, both in the natural world and in that created by human enterprise, but they are not always easy to see because of the overwhelming presence of things that are visually unappealing. Some of the most pleasing images come from combining man-made objects with natural ones. In landscape photography, it can be more difficult to make well-designed photographs in wild and untamed places than in areas where the hand of man has left its mark.

Perhaps the most useful thing that man adds to the natural world, from a visual point of view, is organization. Nature can be very untidy and human beings' feeling for design can help to make things easier on the eye. A beautiful garden is a good example of a happy union between man and nature.

Situation and Approach

I found this barn down a country lane near where I live. The colour and texture seemed almost perfect. My main problem was that in order to include most of the front of the barn, I had to include some unwanted detail, which made the picture less striking. By keeping things simple the impact of the colour was much improved so I concentrated on just one side and used those lovely rusty hinges with the yellow as a focal point. I then included the rich, blue sky as it worked so well with the green. The strong shadow separating the two colours also worked well in this composition. (JB)

Mike's Comment

The appeal of this shot for me is based on two things – the combination of the two hues and the effect of the black diagonal line. Had the sky not been such a pure, flat colour, or had the green been a different hue, I don't think it would have worked nearly as well.

Jules' Comment

This is one of my favourite images of Mike's. The picture has an almost monochrome feel to it because of the limited colour palette and this, as well as the incredible colour and dramatic perspective, is what makes the effect of the pattern so striking.

Situation and Approach

I spotted this plantation of poplar trees in northern Spain while driving through the countryside in the early evening. It had been overcast all day, with a flat, featureless white sky, and the light had been too soft for scenic landscape photography. But these autumnal trees had such a strongly saturated colour that the shadowless light became an advantage. My viewpoint was slightly raised on a bank and

I was anxious to retain the image's symmetry and to keep the tree trunks parallel. Because of this I used a shift lens, which allowed me to include a larger area of the leafy foreground without having to tilt the camera down. As a rule I find a white sky to be a disadvantage in colour landscape photography, but in this case the small wedge visible at the top of the frame provided a useful focus of interest. (MB)

POPLAR TREES

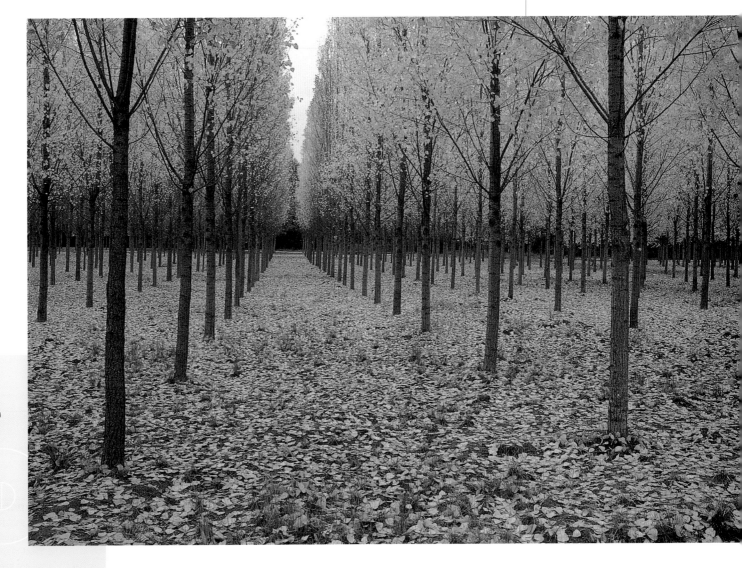

Technical Notes

35mm SLR, 35mm shift lens, Fuji Velvia.

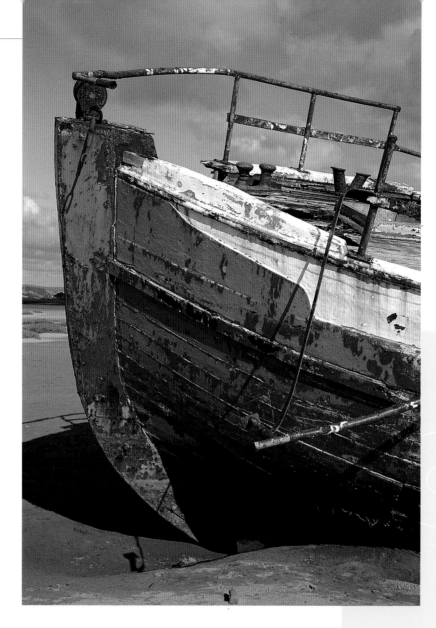

Technical Notes

35mm SLR,
24–85mm zoom
lens, Fuji Velvia.

Style and Approach

Put ten photographers in the same spot at the same time and the odds are that they will produce ten quite different pictures. With the exception of subjects such as still life, fashion and portrait photography, the only real control you have over the way your photographs look is in the choices you make when composing the image. In many ways, it's quite astonishing just how much scope this leaves for your own interpretation. A personal style is something that evolves. It may begin with you following the approach of a photographer you admire but, in time, your personal preferences about subject matter, lighting and composition will dictate the direction you take. But the most important thing is to follow a genuine feeling for the way you do things and not to consciously cultivate a "style" for style's sake.

Situation and Approach

There's a great place near Jules' home called Crow Point where he often takes me when we visit. This old boat has been rotting away out on the estuary for, I guess, many years, but until now I've never ventured over to take a shot. On this particular occasion the light was at an angle that revealed great colour and texture in the hulk and the sky had some interesting clouds. I made several pictures before settling on this as my definitive image and chose a viewpoint that excluded intrusive details in the background as well as including some clouds to break up the blue sky. I framed the image tightly, with the hull taking up the bottom two-thirds of the image and the rusty railing dividing the sky area. (MB)

Jules' Comment

Mike's shot makes good use of the colours and the derelict feel, but the effect is less abstract than my shot of the same subject because of the easily identifiable shape. We both tend to see the same elements within a scene, but Mike tends to give a bold framing with less distortion than me, preferring longer focal lengths to my favourite wide-angle lenses.

Situation and Approach

When I moved around to the side opposite the one on which Mike was concentrating, I found that the sky gave a pleasing background that complemented the side of the boat nicely. I opted for a panoramic camera and used it hand held, and I was able to include a sweeping section of colourful, peeling paint. The picture really did seem to fit the panoramic format and produced a subtly abstract image which, I think, has the edge over the standard 35mm frame. (JB)

CROW POINT BOAT, JULES

Technical Notes

35mm panoramic camera, 45mm lens, Kodak E100 VS.

Mike's Comment

Jules' much closer viewpoint has produced a more confrontational image than mine and I particularly like the way the rusty brown bar has become so dominant. I'm also a bit envious of his two perfect white clouds, which are so nicely placed.

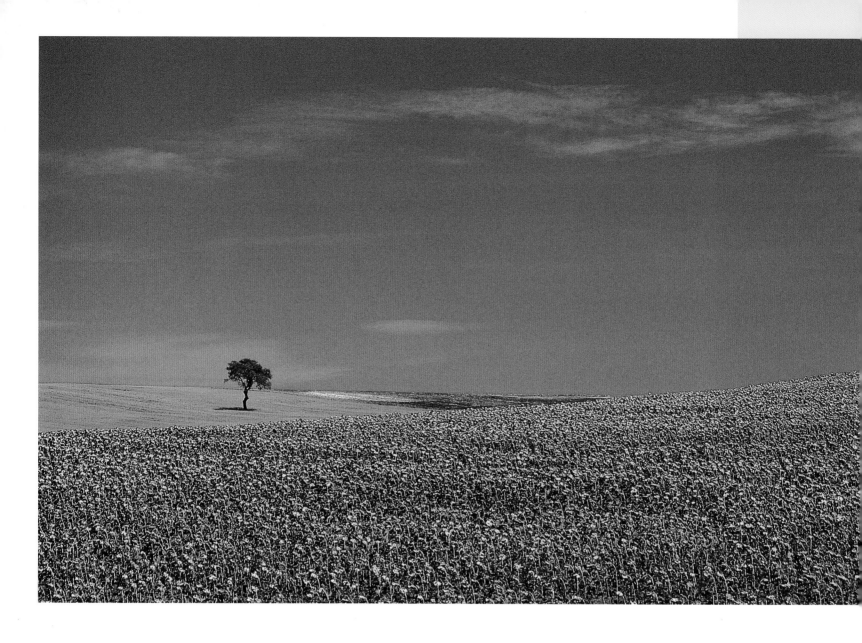

We all have favourite subjects and themes. Similarly, very often we select a subject because it lends itself to a favourite approach and a compositional technique that is tried and tested. This can lead to us taking the same kind of photograph over and over again and is, in essence, what helps to establish a personal style. Be wary, however: to be told that someone recognizes an uncredited picture as being yours should give you pleasure – but it might also be a warning that you have become too formulaic and predictable.

Situation and Approach

I have a serious obsession with trees of all kinds, but the lone tree is one theme to which I return time and time again. I spotted this one while driving through the Périgord region of France. The sunflowers were not yet mature enough to make an interesting photograph close to, but from a distance they had a pleasing texture and colour. But it was the tree that triggered my urge to take a photograph – it looked so small and vulnerable. I found a viewpoint where the tree was set clearly in the small triangle of grain and, first of all, framed the image more tightly. But I decided that the small wisps of cloud were interesting enough to warrant including a much larger area of sky and this enhanced the impression of the tree's isolation. (MB)

Jules' Comment

This shot combines elements that I feel define Mike's style. The lone tree is a real favourite of his and it is often placed in such a way that it is a subtle, but important, feature of the landscape. The other hallmark of Mike's style is his use of a strong blue sky and sweeping colour in the foreground.

Technical Notes

35mm SLR,
24–85mm zoom
lens with
polarizing and 81B
warm-up filters,
Fuji Velvia.

Jules' Comment

This shot is so easily identifiable as one of Mike's. I love his use of the limited colour range. The stunning green of the tree really lifts it out from the darker background. Mike has such a keen eye for these shots that I sometimes wonder if he doesn't drop the odd seed into an ideal spot and go back years later.

Useful Advice

Don't shy away from the urge to pursue your favourite subjects and themes – but try to balance this by sometimes exploring different subjects and ways of shooting them.

Situation and Approach

I shot this picture on a very overcast day in the Auvergne region of France in the early spring. Although the light was very soft, I was in a small valley and, because of this, the tree was quite strongly top lit, which created a reasonable degree of contrast. I framed the shot so that the tree was placed in the lower half of the frame and included a small area of lighter green at the top of the image to create a balance. (MB)

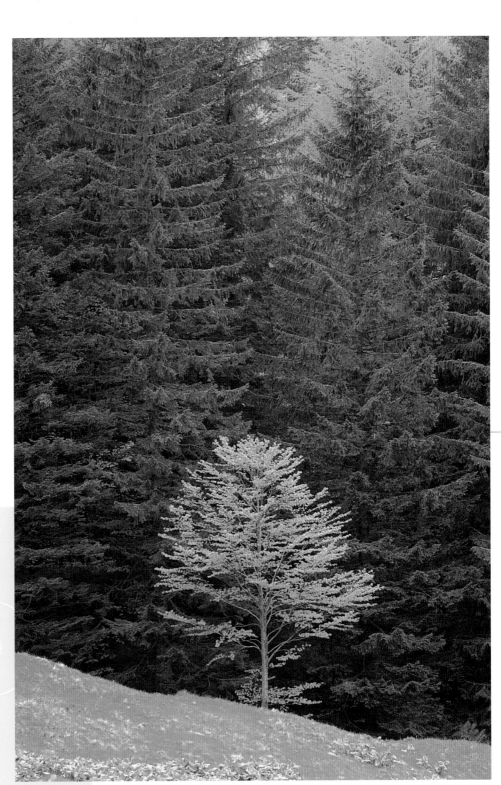

TREE AND SUNFLOWERS

MIKE'S TREE

Technical Notes

35mm SLR,
70–200mm zoom
lens with
polarizing and 81A
warm-up filters,
Fuji Velvia.

Situation and Approach

If I had to pick a favourite way of working, regardless of whether it is in colour or monochrome, it would be seascapes and the use of the panoramic format. Using this format opened new doors for me, because I had to rethink certain elements of composition, which forced me to become more experimental again.

This shot and the beachscape opposite were both taken on my first roll of film using the panoramic format. The first thing that I noticed was that I could make dramatic use of perspective because of the long frame; the other thing was that, because the frame was so narrow, the sky had less influence, unless I chose otherwise.

The wave picture was framed in this way because of the area where the tones were most interesting. This particular wave came rolling in gently and bowed perfectly. A shutter speed of 1/30 second helped to capture this but also allowed some blur, giving the image a sense of movement. (JB)

MOVING WAVE

Technical Notes

35mm panoramic camera, 45mm lens, Fuji Velvia, polarizing filter.

Style is something that develops: initially it is experimental and then it becomes second nature. One of the easiest ways of developing a personal style is to examine pictures that you particularly like, photographic or otherwise. Pick out the elements that you feel work – perhaps the use of a particular focal length, a method of framing, or the subject matter. Build these elements into your own work and eventually a style that is your own will evolve. You will add some elements and take others away, but the end result will be a picture that you feel is successful and reflects your own personal view – which is all style really is. If your images are becoming too predictable, take some chances: new doors will open.

Mike's Comment

Like Jules, I'm very fond of the panoramic format but for much of the work I do it is often not the ideal shape. I find that many panoramic images would work just as well, if not sometimes better, cropped down to a more conventional shape, but with these pictures I feel that every bit of space is working. Jules' passion for seascapes also lends itself so well to this approach.

Situation and Approach

This shot was taken just around the corner from the wave picture opposite and the element that I think works well here is the dramatic perspective. This shot is far more successful than it would have been using a standard format, because the sky was very bland and uninteresting. The panoramic format meant that I could focus attention on the foreground and the perspective, without the sky lessening the impact. The equivalent focal-length lens using 35mm would be about 24mm and the sky would have been too dominant, weakening the drama of the foreground.

Both the pictures here have a favourite element of using panoramic format, which I try to include in a lot of my pictures, regardless of format – namely, that intense feeling of the edges zooming in and pulling you into the centre of the image. Overall, I find this gives a less static feel than the other formats. (JB)

BEACHSCAPE

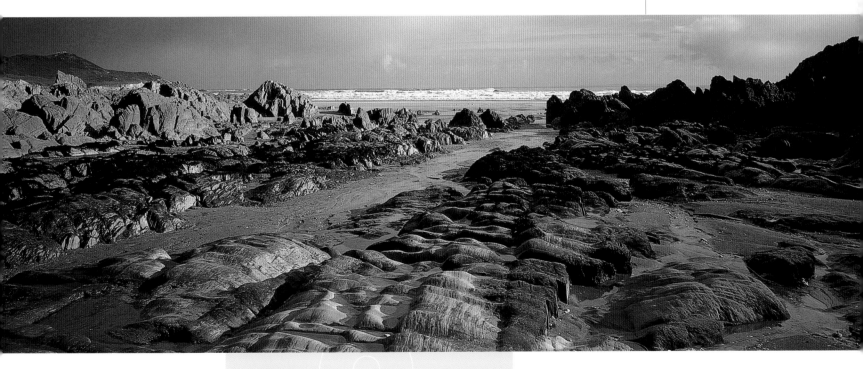

Technical Notes

35mm panoramic camera, 45mm lens with polarizing filter, Fuji Velvia.

Technical Notes

Medium-format SLR, 105–210mm zoom lens with polarizing, neutral graduated and 81A warm-up filters, Fuji Velvia.

The Pragmatic Approach

The way in which the image will be used is also a factor to consider when composing an image. A photograph that is taken solely for the purpose of creative expression gives you the freedom to compose it however you wish. An image that is taken for a particular purpose, however, needs to take that purpose into account. If a picture of a house was commissioned by an estate agent for advertising purposes, it is unlikely that an abstract architectural detail would be very well received. Professional photographers spend a great deal of their time taking commissioned photographs and their approach must be dictated by their clients' needs, and such shots are likely to be very different from the kind of images they would take when shooting for their own pleasure.

Situation and Approach

I was shooting pictures for a guide book in France and the castle of Castelnau near Bretenoux was on my list of subjects. I found several good viewpoints that showed the castle perched up above the surrounding countryside, but this particular one had the advantage of making the most of late afternoon sunlight, which enhanced the colour of the castle walls. I was also able to use the track as a lead-in to the picture, which made me think that it could possibly work as a cover image. This also led me to choose an upright format and I made sure there was a good area of sky above to accommodate a title if necessary. (MB)

Jules' Comment

This is a pleasing image, but perhaps lacks the personal element that I can see in the tree pictures on pages 112–113. I like it, but feel it is a little compromised because of its commercial appeal.

Situation and Approach

In complete contrast to Mike's picture, this was taken because it appealed to me on a purely personal level. It was taken just after a brief downpour which left the pebbles soaked. When the sun came out they began drying very quickly and the effect became even more interesting. I framed the image to include what I felt was the most interesting section and then simply waited for the right combination of wet and dry before making my exposure. (JB)

Mike's Comment

This is one my my favourite images of Jules' since it has a slightly unreal quality, as if it has been painted or hand coloured. The choice of viewpoint and the way the image has been framed make it seem quite abstract and, I think, it's the sort of photograph which would look absolutely right as a big print displayed on a wall.

Technical Notes

Medium-format SLR, 55–110mm zoom with polarizing and 81A warm-up filters, Fuji Velvia.

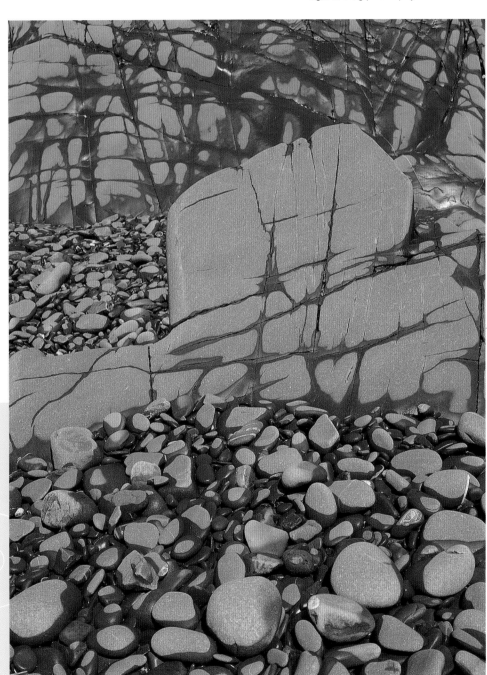

The Magic of Light

Above all, photography is a celebration of light. When the very first photographs were taken, it seemed almost miraculous that light rays could be bent by a lens to form an image and then be accurately recorded. It's no wonder that artists of the time declared, "From today painting is dead," because one of the greatest skills to which painters aspired was the ability to show the effect of light on a subject. And of course even the most skilled of them could give only an impression of the effect of light, while anyone with a camera could do it at will – and in an instant. The observation and appreciation of the nuances of light and its ever-changing effect on the things around us can have an almost sensual quality and, ultimately, it is an awareness of this that defines the truly committed photographer.

The Nature **of Daylight**

We tend not to notice the changes in light that take place during the course of a day unless they are quite sudden and dramatic – when sun emerges from cloud, for example. But light is constantly changing – often very significantly as far as photographic film is concerned. The aspects of light that are most important to photographers are its colour, its direction, the degree to which it is diffused and its intensity or brightness. Light intensity is relevant to exposure, since low light levels need longer exposures and/or faster film. The other aspects have a marked effect on the quality and mood of a picture.

Situation and Approach
I'd planned to arrive at Mono Lake in California an hour and a half or so before sunset to give me plenty of time to look for good viewpoints of the curious tufa rock formations, which have become progressively more exposed as demands are made upon the water supply. I found some good spots almost immediately and the light had taken on the mellow, yellow quality of evening. But I'd miscalculated and I realized the sun would disappear an hour or so before the official time, because of a mountain range to the west. I was able to take a couple of shots that I was quite pleased with before the sun went down, but it was not quite low enough in the sky to produce the rosy-red glow that I'd hoped for. (MB)

Technical Notes

35mm SLR,
24–85mm zoom
lens, Fuji Velvia.

Situation and Approach

This picture was taken only a very short time after the one shown opposite and the difference in both colour quality and mood is quite dramatic. It would, of course, have been a simple matter to use a warm-up filter to correct the predictable blue cast, but I liked the mood that this created, along with the impression of frost that it produced on the white rocks. (MB)

MONO LAKE WITH BLUE CAST

MONO LAKE, CALIFORNIA

Technical Notes

35mm SLR,
24–85mm zoom
lens, Fuji Velvia.

Jules' Comment

It is amazing that these two pictures were taken within a short time of each other; the effect is so different that they appear to have been shot in different seasons. Both create a strong mood and this is important when considering when to pack up and leave. Hanging on after you think you have taken the best shot often brings surprise results. I like the cool feel of the second image and the diffused lighting, but I am drawn more towards the red image because of its stronger textural qualities.

It is not always easy to judge the colour of daylight objectively, because our eyes are so accommodating. When we read a book in the shade of a tree under a blue sky the pages are, in reality, blue, but our ability to adjust is so effective that we are not aware of this. But colour film is very sensitive to even the slightest change in the colour quality of the light that illuminates a subject and, for this reason, we need to be as observant and objective as possible.

This photograph shows one of the nine hundred-plus Jain temples on the summit of Mount Shatrunjaya, which is an important place of pilgrimage in the Indian state of Gujarat. The sun was clear and bright in a cloudless sky and cast dense, hard-edged shadows. The temple that I most wanted to photograph had the overhead sunlight on its façade and, although the effect was very contrasty, some light was being reflected from the surroundings into the shadows. I framed the image to exclude all the non-essential shaded areas, using a wide-angle shift lens to allow me to include less foreground and more of the upper part of the building without having to tilt the camera. People were passing in and out of the doorway at frequent intervals and I waited until this well-dressed woman appeared in my chosen spot before making my exposure. (MB)

JAIN TEMPLE, MOUNT SHATRUNJAYA

Technical Notes

35mm SLR, 24mm shift lens, Fuji Velvia.

Quality

Like any point source of light, the unobscured sun casts a dense, hard-edged shadow. Undiffused sunlight creates high contrast with both dense shadows and bright highlights, and it can easily be beyond the film's capability to record detail in both. It is not always easy to judge when this is occurring, as our eyesight adjusts rapidly to areas of different brightness. Even a small amount of diffusion, such as atmospheric haze or thin cloud, can make a significant difference, softening the edges of the shadows and reducing image contrast. Observing the nature of the shadows is an important step towards an understanding and appreciation of light quality. Noticing how hard or soft the edges are, as well as the size, direction and density of the shadows in a scene, should always be part of your initial assessment of a potential subject.

Jules' Comment

I find this shot very appealing because of the quality of the light illuminating the temple. This light reveals the architectural detailing and, although it is quite hard, there is also a richness there. The limited colour range of the temple also makes the woman stand out very effectively and her position in the frame is very well timed.

Situation and Approach

If any style of picture represents my approach to colour photography, then this is it. Although I like the strong images of rich dusk colours that are so popular now, my preference is for the light that occurs before low-sun or as a result of a storm. Here, low evening light was diffused and made quite subtle by cloud cover. I composed the picture to include a section of rock that led the eye into the picture and also the area of beach where the wave action was most interesting. I waited until the wave was being drawn back to the sea to make my exposure, so that a gentle misty effect was present in the foreground. (JB)

Mike's Comment

The beautiful, gentle quality of this image is due to the fact that the sunlight is diffused. The low sun has created long, large shadows, which would have been much too dense and hard-edged had the sun been completely unobscured.

Technical Notes

Medium-format SLR, 55–110mm zoom lens with neutral graduated and 81A warm-up filters, Fuji Velvia.

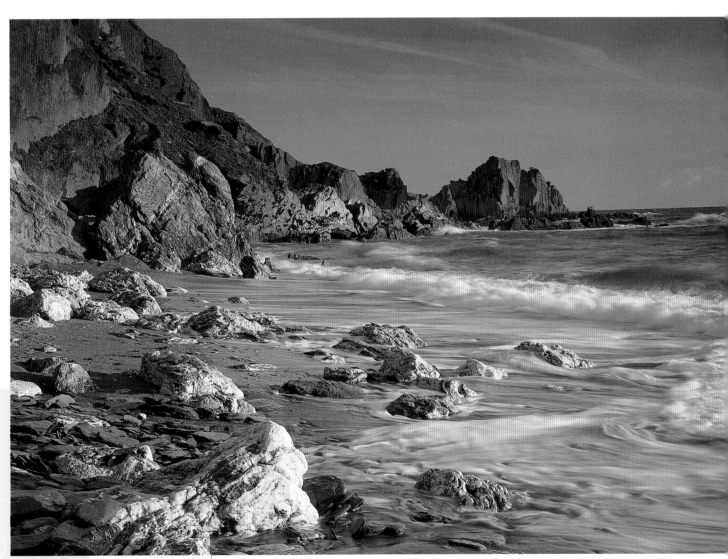

DEVON SEASCAPE

Direction

The angle at which light is directed towards the subject is one of the most important factors in determining the tonal range and contrast of the image, as well as in establishing elements such as shape, form and texture. This is true even when the light is diffused. But when a subject is lit by strong, direct sunlight the relative angles between the sun, the subject and the camera become critical, because they determine the size and direction of the shadows. With subjects such as portraits, you can have some control over this because you can reposition your subject; but when you are working in the landscape or photographing immoveable subjects such as buildings, the direction of the light can only be controlled by your choice of viewpoint and the time of day at which you shoot.

Situation and Approach

I photographed this scene in the countryside near Teruel in the Spanish region of Aragon. It was early summer and, although there were some small clouds, there were large areas of clear blue sky which created quite a harsh light. I spotted this vivid field of poppies from a long way off. It was near midday and the sun was almost directly overhead, so the shadows were quite small and did not raise the image contrast to an unpleasing level. Because of this my choice of viewpoint was not restricted and I opted for this camera angle, which included some of the white foliage and flowers in the foreground as well as the row of distant pine trees. (MB)

Jules' Comment

A fantastic explosion of colour. The rich reds work so well with the blue sky, but because of a subtle diffusion of the light the image is not in any way overpowering.

Useful Advice

Good luck can play an important role in photography and many opportunities created by the perfect alignment of light, camera and subject occur spontaneously. But you can't rely on this. Reconnaissance trips to find good viewpoints and enable you to calculate the best time of day to shoot are an important aspect of making good photographs on a regular basis.

Technical Notes

Medium-format
SLR, 55–110mm
zoom lens with
81A warm-up,
neutral graduated
and polarizing
filters, Fuji Velvia.

Mike's Comment

Often a pattern works best when the light
is quite soft or frontal, because the
presence of strong shadows can become a
distraction. But in this case the hard-edged
shadows created by the strongly directional
sunlight have become an important
element of the image, as well as enhancing
the texture of the shells and the rock face.

Situation and Approach

I loved the shape of this rock and the
limpets added that important element of
texture and interest. The lighting was quite
harsh, but it produced strong shadows that
helped define the image. It was this graphic
quality that made me look at the
background closely. Initially I intended to
use the blue sky, but the colour of the sea
and light on the far rocks provided such an
appealing background that I had to include
them. By keeping this element small,
however, I managed to retain the strong
abstract effect that drew me to the image
in the first place. (JB)

Technical Notes

Medium-format
SLR, 55–110mm
zoom lens with
81A warm-up and
polarizing filters,
Fuji Velvia.

LIMPETS

Situation and Approach

I photographed this scene on a beach just to the south of Sydney in Australia on a day when there was not a single cloud in the sky and the sun was sharp and clear. This image appealed to me because of its stark simplicity and the glorious colours of the sea and sky. I chose a viewpoint that placed the sun almost directly above and behind me, so that the tree was lit quite flatly. The contrast between the silvery wood and the deep blue sky was more than enough, without introducing large areas of shadow. I used a wide-angle lens from quite close by and tilted the camera upwards to distort the perspective. (MB)

Technical Notes

35mm SLR, 24–85mm zoom lens with 81A warm-up and polarizing filters, Fuji Velvia.

Shooting in Sunlight

When shooting in sunlight, you need to be able to judge the effect of direct sunlight in an objective way. Some subjects, such as portraits and busy, colourful market scenes, are best avoided on bright, sunny days because the shadows will be too intrusive and distracting. If such lighting is unavoidable choose a viewpoint and frame the image in a way that minimizes the size of the shadows and controls their distribution within the image. The key is to be aware of the difference in brightness between the darkest and lightest tones. Exposure is critical when contrast is high and it can be a mistake to expose for the mid-tones, as this can result in a lack of detail in both the highlights and shadows. It is better to frame the image so that either the light or the dark tones dominate and to expose accordingly.

Jules' Comment

This is one of those images that makes me wonder what it would have been like in black and white, because of the texture of the trunk. In fact, the whole image is of such a limited colour palette that it has an almost monochrome feel to it. I might have been tempted to exclude the area of foliage, as I find it a little distracting.

Situation and Approach

This was taken on a late sunny afternoon, but after days of rain some humidity had created a certain amount of diffusion that just took the edge off the shadows. I liked the way the light picked out the spikiness of the grass and created rich colour. The sand gives another texture and helps to pull the image together with the blue of the sky. The clouds created occasional areas of shadow and pools of light, so I made my exposure when this seemed to have a pleasing effect on the composition; it did take me quite a few frames to get things right. (JB)

Mike's Comment

The appeal of this image for me is the contrast between the sharp, spiky grass and the smooth, soft sand and it is the mellow quality of the acutely angled sunlight that has created this. The restricted colour palette makes a big contribution to the picture's peaceful mood.

Technical Notes

Medium-format SLR, 55–110mm zoom lens with 81A warm-up, neutral graduated and polarizing filters, Fuji Velvia.

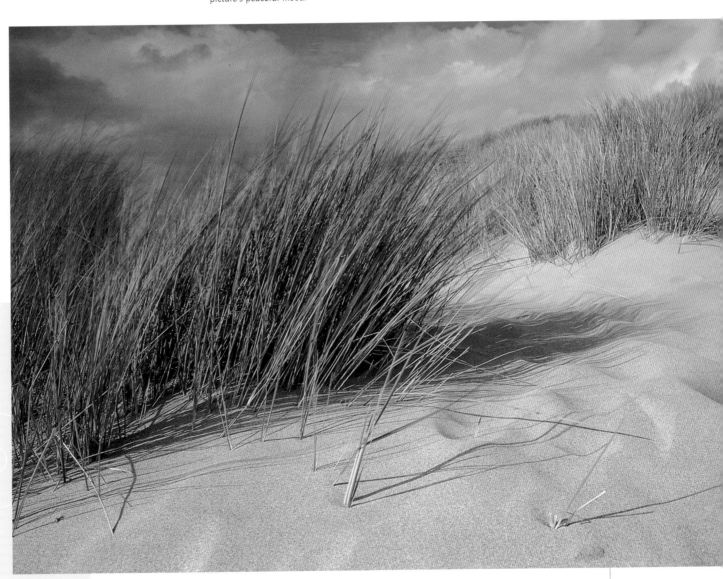

DUNE GRASS

Situation and Approach

The lighting for this picture came about through pure luck. I had my camera set up ready to photograph the Water Palace in Jaipur, India, and was waiting for the sun to go down in order to benefit from the rich, golden quality that I anticipated as it approached the horizon. While I waited, a young man approached me and asked politely if I'd like an elephant in my shot. I declined with thanks. Needless to say, some twenty minutes later he turned up complete with painted elephant. Under normal circumstances I would have probably taken a couple of quick, token shots, paid the required fee and said goodbye, but the lighting was so good that I switched my attention from the Water Palace and began shooting my new subjects seriously. (MB)

PAINTED ELEPHANT

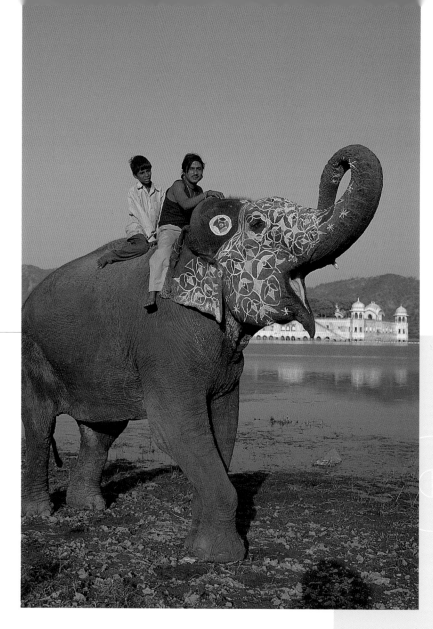

Technical Notes

35mm SLR, 24–85mm zoom lens, Fuji Velvia.

Low-angled Sunlight

Early morning and evening sunlight are highly valued for landscape photography, because of their low angle and mellow quality. This is based on the assumption that landscape subjects are essentially on a horizontal plane and a low-angled light will skate across the surface. But, of course, much depends on the nature of the subject; the most effective light for any given situation is seldom so predictable. When photographing a flat terrain, for instance, low-angled sunlight can emphasize subtle contours and reveal rich texture, but in mountainous or steep-hilled countryside the shadows can become too large and dense, and hide vital details. It's not always possible to judge accurately at what time of day the angle of the light will suit a certain scene or subject and you often need to treat your first attempt simply as a reconnaisance.

Jules' Comment

Now here's something that you don't see every day – not in the West, at least. I like the spontaneous feeling created by the raised trunk, even though the shot was set up. The direct, frontal lighting is ideal as it creates a bold image without large areas of shadow, and the palace in the background gives a real flavour of India.

Mike's Comment

Even without seeing it in shot, you can imagine the sun going down over the sea simply because of the quality of the light and the way it skates across the surface of the sand and stones. It is the contrast between the orange-tinted wooden stakes and the purplish hue of the beach that creates the image's impact.

WOODEN STAKES

Situation and Approach

I took this at one of my favourite locations near my home; although it always produces a shot, this particular afternoon had been unsuccessful as the light just wasn't right. I stuck it out until the rich evening light started to have a dramatic effect on the landscape. My viewpoint and framing were dictated by the fact that all the changes in the light were occurring at ground level; above, the light was still not very inspiring. What I particularly liked here was the warm light picking out the remains of some wooden groynes and the cool blue of the shadows. For this reason I chose to use a polarizing filter to accentuate the colours. Normally I like to add a little warmth when using a polarizing filter, but on this occasion I felt that a warm-up filter would have warmed up those shadows too much and the effect would have been lost. (JB)

Technical Notes

Medium-format SLR, 55–110mm zoom lens with polarizing filter, Fuji Velvia.

Backlighting

Shooting with the sun behind the subject is often an effective way of creating a more pleasing light, as well as of producing a more interesting, and sometimes dramatic, quality. The risk is that backlighting is likely to mislead the exposure meter, as the bright highlights that are created using this technique tend to suggest less exposure than is actually needed. Many cameras are fitted with a "backlight compensation" button, which will automatically give a set amount of additional exposure to compensate for these situations, but this is rather hit or miss. It is better to take a close-up or spot reading from a mid tone within the most important part of the subject. Flare, too, is a potential problem when shooting into the sun, as it can significantly degrade the image: use a lens hood or flag to shield the lens from direct sunlight.

Situation and Approach

I had got up very early one morning to take some pictures on Dartmoor in south-west England, which is a couple of hours' drive from where I live. The sun was beginning to start its climb in the sky as I drove along the road when I noticed this cobweb shining like a diamond from a wheat field. I stopped the car and entered the field, wading through the wet wheat to get close enough. The sun was very low, making it difficult to shade the lens without either causing flare or getting the lens shade in the picture. (JB)

Mike's Comment

This is a very difficult subject to expose for, as the brightness range is at the limit of the film's tolerance, but Jules has retained detail in both extremes and recorded the web with a luminous, silvery quality.

Jules' Comment
Back-lit trees take on a truly beautiful
appearance, but it is difficult to find the
right combination of shape, colour and
luminosity. I think Mike has well and truly
succeeded here.

Situation and Approach

I took this photograph in the early spring in
Cumbria, in the north of England, an hour
or so before sunset. The light almost made
the tree look as if it was on fire. I chose a
viewpoint that placed the sheep just to the
left of the tree, with the steep hillside
behind, and framed the image so that the
tree was more or less in the centre.
Calculating the exposure involved some
guesswork and I bracketed to ensure I had
one that was just right. The best exposure
proved to be about half a stop less than the
meter indicated, but because of the dark
surroundings giving extra exposure was not
necessary. Although I used a lens shade, the
sun was so close to the edge of the frame
that some exposures were spoilt by flare,
but I had a few to choose from. (MB)

BACKLIT TREE, CUMBRIA

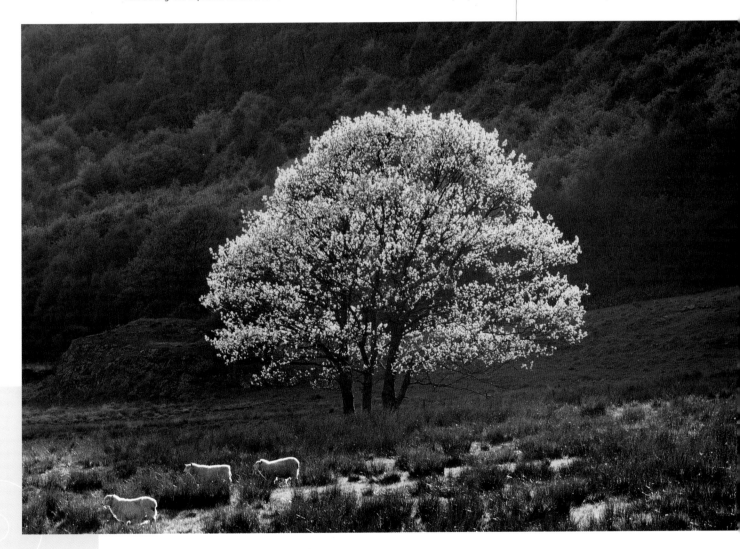

**Technical
Notes**
35mm SLR,
70–200mm zoom
lens with 81A
warm-up filter,
Fuji Velvia.

Useful Advice

Shooting towards the sun presents a real
risk of lens flare and a flat, degraded
image. A conventional lens hood is often of
little help in these circumstances and it is
more effective to shield the lens with your
hand or a piece of black card.

The Time **of Day**

As the sun travels from east to west during the course of a day, the angle at which it illuminates the surface of the Earth changes enormously. The colour quality of the sunlight and seasonal variations add a further element of modification. It is an interesting exercise to spend a whole day, from dawn to dusk, photographing a scene at regular intervals to see just how much the light changes. There will almost certainly be infinitely more variation than you anticipate. Even when the sky appears to be a clear blue, you can find that returning to the same spot at the same time just 24 hours later with, seemingly, the same sky, never produces exactly the same effect. It's one of the things that gives the process of seeing and making photographs such a fascinating and elusive quality.

Situation and Approach

One advantage of shooting well-known tourist spots very early or late in the day is that it's often possible to avoid the crowds. On a visit to Delhi I made the big sacrifice of rising before dawn in order to have the chance to shoot some of the buildings without people and, of course, in the hope that the lighting would be interesting as well. I was delighted to find myself almost alone at this magnificent building and to see that the sky, as sunrise approached, was subtly coloured. I chose a viewpoint that gave me a symmetrical image and used a shift lens to exclude some of the foreground and include the tops of the towers without having to tilt the camera. (MB)

Jules' Comment

The very gentle pastel tones give a warm, calm feeling to the image. Although you see a lot of pictures that are similar to this, they are usually taken at sunset and have strong colours. The tones here are much more harmonious to the building.

Technical Notes

35mm SLR, 28mm shift lens, Fuji Velvia.

Useful Advice

The dramatic colour change of sunlight at first and last light influences the choice of when to shoot more than any other factor in landscape and architectural photography. But subtle changes can also make a big difference to the quality and mood of an image. Judging the effect of such subtle variations comes with experience: the best way to attune your eye to these conditions and the way they are recorded on film is to make a few experimental exposures at times like dusk and dawn. The process is similar to the way your vision improves after being in a darkened room for a while.

Situation and Approach

This is one of my favourite views in France – the river Dordogne from the edge of the cliff upon which the village of Domme is built. For this picture I set my alarm clock very early so that I could be at my chosen viewpoint well before sunrise. It was autumn and the valley contained strands of mist; this intensified the colour in the sky as the sun approached the horizon. (MB)

Jules' Comment

Yet again, beautiful light and colours. Although the sky and fields have a soft quality, the strong green in the foreground has helped to provide depth and balance.

DORDOGNE SUNRISE

Technical Notes

35mm SLR, 20–35mm zoom lens with neutral graduated filter, Fuji Velvia.

The "Golden Hour"

One of the best times of day to shoot pictures with impact is what some photographers describe as the "golden hour" – that period half an hour or so either side of the sun rising or setting. At these times the colour temperature of the light drops to its lowest level and takes on a distinctly red/orange hue, which can create a very pleasing quality with subjects like buildings and panoramic views. Shooting at this time of day can be a very effective way of overcoming the over-familiarity of well-known sights and creating eye-catching pictures. The atmosphere has a big influence on the colour and quality of the light as the sun approaches the horizon, and the final outcome is not always completely predictable. When there is a lack of clarity, the results can often be improved by using a warm-up filter, even at this time of day.

Situation and Approach

The small Normandy town of Honfleur is one of my favourite places and I've shot pictures there many times. I've always fought shy of shooting this view, simply because it is so pretty and can be seen on countless calendars and postcards. On this occasion, my aim was to photograph the wonderful country market that takes place every Saturday morning in the small cobbled square beside the wooden church. Wishing to avoid the crowds I got up early – only to find I'd beaten most of the stall-holders to it and they were still in the process of setting up. As the sun was just coming up, and I had some time to kill, I carried my camera down to the harbour-side where this lovely, golden morning light was striking the façades of the old houses in a very pleasing way. (MB)

Jules' Comment

I often find that the morning light has an extra crispness to it, while evening light tends to be softer. That crispness has worked well with this subject: it seems to have kept the sharpness of the architecture and yet it is wonderfully warm, with the windows that reflect the sun a pure gold. Both the exposure and timing for this shot were spot on.

Technical Notes

Medium-format SLR, 55–110mm zoom lens with 81A warm-up filter, Fuji Velvia.

Situation and Approach

There's a beach on the Costa del Sol in Spain where I spend time whenever I can, mostly doing very little. On days when the sea is very calm, a number of small fishing boats set out at first light from the harbour nearby to trawl for clams close to shore. On this particular day the early-morning sunlight created such a lovely atmospheric quality that I overcame my natural torpor and ventured out with my camera. I found a viewpoint where the low-angled sunlight was reflected from the side of the small boat onto the almost still water, creating interesting reflections. (MB)

Jules' Comment

At the time of writing there is an appaling storm outside, and this kind of image lifts my spirits and reminds me of the tranquillity and colour of summer. The boat is strikingly colourful and works really well against the subtle hues, and the stillness of the sea has created the pleasing reflections.

Technical Notes

35mm SLR, 70–200mm zoom lens, Fuji Velvia.

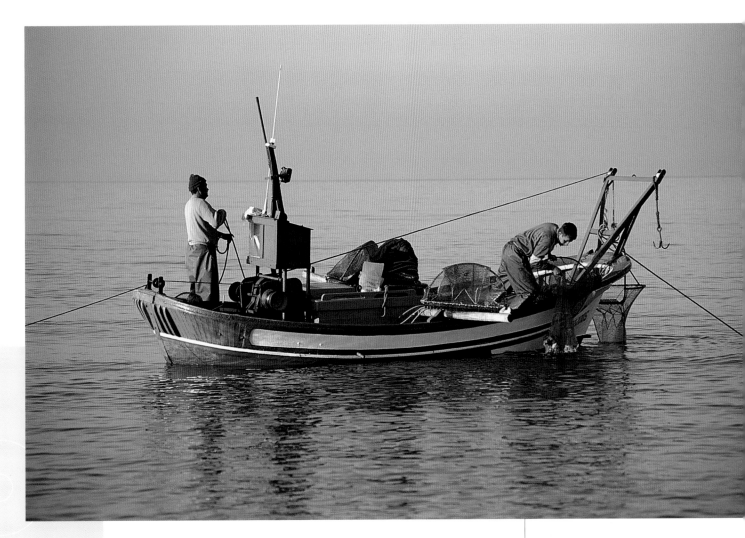

FISHING BOAT

Midday Sunlight

Many photographers consider the middle of the day, when the sun is overhead, to be a dead time and are inclined to pack away their cameras and take a break until later in the afternoon. The reasoning behind this is that at this time shadows are both dense and small and show little texture or form in the contours of the land. But there are many situations when this time of day provides the most effective light: in a steeply contoured landscape, for example, overhead sunlight has the same acutely angled quality that a low sun has in flatter terrain. It can also create very interesting shadows on buildings and vertical objects: with some subjects and scenes, small shadows can be an advantage.

Situation and Approach

Travelling through Morocco it's impossible not to notice the highly decorative doors that adorn every building, from humble sheds and garages to fine houses. I became quite obsessed by them and accumulated a considerable collection of pictures. But it was not so much the door that made me stop to shoot this, but the pattern of shadows, which the overhead sunlight had cast onto to the brightly coloured wall. I chose a viewpoint that placed the door just to the right of the white post and framed the image to include the café sign and part of the window. (MB)

Jules' Comment

I like the strong shadows and the colour in this picture but can't help thinking that the wires on the roof are a bit distracting; I think I would have tried a closer crop.

Situation and Approach

This shot was taken in early afternoon: photographic opportunities seemed limited because the light was harsh and most of the possibilities I'd seen were simply too contrasty. The colours were striking, with the back-lit green and rich blue, but the effect of the light on the trunks is what pulls the image together. Because of the high contrast the trunks have become a near black, emphasizing the twisting shapes – so much so that you can imagine how they look during the winter. I used a polarizing filter and an 81A warm-up filter to enrich the colours and prevent the scene from becoming too cool. (JB)

Mike's Comment

Part of the appeal of this image for me is the fact that the colour is so intense, even though the colour range is limited, and the two hues work so well together. The square shape is perfect for the composition, which makes the pool of blue sky a strong focus of interest.

MOROCCAN CAFÉ

SKY THROUGH GREEN TREES

Technical Notes

35mm rangefinder camera, 45mm lens, Fuji Velvia.

Sunsets

They may be something of a cliché, but it's hard to resist the temptation of a good sunset. The visual appeal of a sunset depends to a great extent on the presence of clouds and the effect is often most striking when the sun is all but obscured. But a clear sky can also mean good opportunities for picture-making, as it becomes possible to use the very last rays of sunlight to illuminate your subject. These occasions do not occur very frequently; often, when all looks promising, a previously unseen bank of cloud on the horizon can rob the scene of those final ruby red rays at the last moment. While any time in the last couple of hours before the sun goes down can produce a very pleasing quality of light, it is quite literally during the last five minutes or so that the colour of the sunlight is at its most dramatic.

Situation and Approach

The extraordinary square of Djemma el Fna is the heart and soul of Marrakech and has recently been dubbed a World Heritage site – not because of its architecture or the snake charmers, story-tellers and acrobats who entertain the crowds during the daylight hours, but because of the activities that take place after the sun has gone down. Dozens and dozens of small stalls are set up and, fuelled by charcoal stoves and gas burners, every conceivable kind of food is prepared and laid out for the customers, who eat sitting on stools and wooden benches around the cooks. As this begins, a haze of smoke clouds the air above the square. It is a remarkable sight and one that can be enjoyed from the terrace of one of the several cafés on the edge of the square. I waited until the sunlight had all but disappeared from the taller buildings but there was still just enough light left in the sky to illuminate the darkening shadows before taking my shot. (MB)

Jules' Comment

This is a great sunset shot with a real human element and incredible colour. I love the blaze of white that lifts the foreground.

SUNSET AT LEE BAY

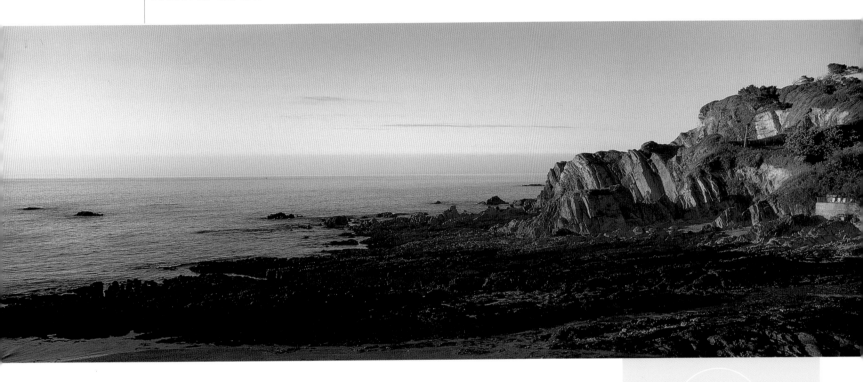

Situation and Approach

I often watch the sun go down from this location; sometimes the cliffs go an incredible vivid red. On this occasion, the effect was more subtle but the warmth from the cliffs is still intense. The element that works best for me is the calmness of the sky: the thin, pink strip of haze on the horizon separates the blues and keeps everything on a more gentle level.
I included the rocks in shadow in the composition because I felt that the shot needed some foreground interest. (JB)

Technical Details

35mm panoramic camera, 45mm lens, Fuji Velvia.

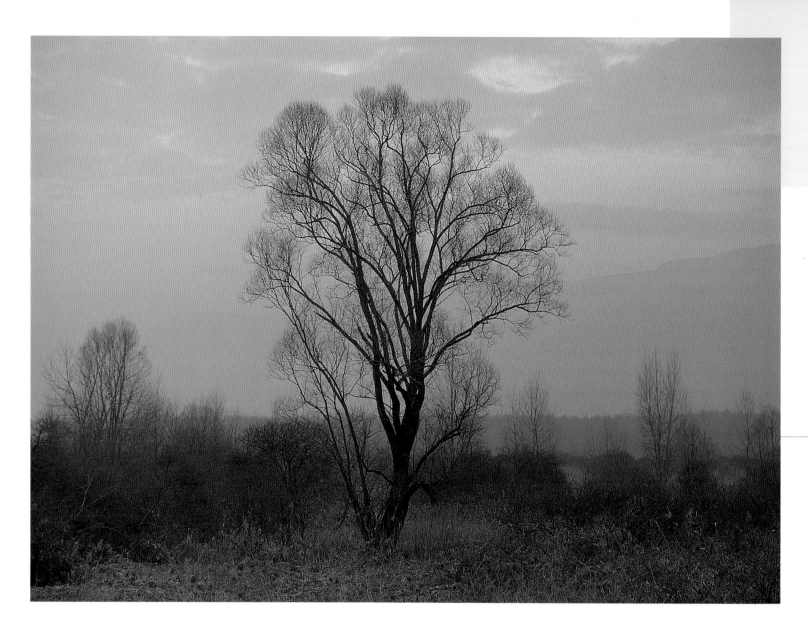

Photographic opportunities do not necessarily end once the sun has gone down and even a sunset can develop further, and sometimes more interestingly, for a period of time after the event. But given the right subject and conditions, the reflected sunlight from the sky at dusk can often create inspiring effects. Mood is one of the qualities that many photographers strive for in their images and it is one that is not always easy to capture. Both the more muted colour quality of the light and the lack of detail in images taken at dusk can create an element of mystery and atmosphere that is difficult to achieve in full daylight. The restrained colour and the way in which detail is suppressed in these conditions tends to simplify the image, allowing the viewer's imagination to play a bigger role in interpreting the photograph.

Situation and Approach

I'd had a frustrating day trying to shoot pictures around Lac du Bourget in the French Alps as it had been solidly overcast with a flat, lifeless light for most of the time. As dusk began to close in, the sky started to clear and I saw some picture possibilities. It was in the depths of winter and the bare branches made attractive, silhouetted shapes against the lighter toned sky, in which there was just a hint of colour. There was still just enough light to reveal some detail in the grassy foreground and the shape of the distant mountain was faintly visible. I chose a viewpoint that separated the big tree from those surrounding it and framed the image to place it in the centre and to include a little of the foreground. (MB)

Jules' Comment

A very wintry shot, in fact I find it quite eerie. The tree has a skeletal appearance and the colour suggests not only coldness but also isolation. Definitely not a pretty image – but an effective one, nonetheless.

Technical Notes

Medium-format SLR, 55–110mm zoom lens, Fuji Velvia.

Situation and Approach

This scene did not appeal to me at all during daylight hours, but it took on an almost surreal look as dusk fell. It was, in fact, getting quite dark when I made my exposures and the reflections of the remains of the sunset in the apartment windows were not nearly as bright to the eye. I used a long lens so that the most striking reflections filled the frame. (MB)

Jules' Comment

This is, to me, a very appealing image. I'm particularly fond of the combination of natural and artificial light in this shot – it's very nicely balanced. The deep blue sky is almost mesmerizing, with the buildings taking on both the coolness of this and the warm gold of the sun.

REFECTION OF SUNSET, SYDNEY

Useful Advice

When photographing illuminated buildings it is important to do so before the sky goes completely dark as, beyond a certain point, the brightness range will become too great and the image will be too contrasty. Also, in most situations, it is best to shoot when the outline of the subject can still be seen against the sky.

Technical Notes

35mm SLR, 70–200mm zoom lens, Fuji Velvia.

Light and the Sky

The sky is the key to light quality: it behaves like a giant combined reflector and diffuser, modifying the effect of the sunlight. Just a few clouds in an otherwise clear sky can make a significant difference to a photograph. Studying clouds and trying to anticipate what might happen to the light as they move around the sky is crucial to an understanding of how light can be made to work to your advantage.

A sky that is covered by a thick, even layer of cloud, with no variation in tone, is most likely to cause difficulty. In effect, the sky becomes the light source and an exposure that reveals good detail in whatever is being illuminated is likely to record the sky as almost pure white. A large area of white sky in an image has the effect of desaturating the colours that are present in the subject, and often reduces the contrast.

Situation and Approach

A solid blanket of cloud had descended, without even a hint of tonal variation; the light was about as soft as it can get and cast virtually no shadows. Shooting conventional landscapes was not really an option – but I felt that, by shooting from a close viewpoint, the combination of the white-painted van and bright red lettering would give the image enough contrast to make it work. I gave one stop more exposure than indicated to allow for the large areas of white in the scene. (MB)

Jules' Comment

I was with Mike when he shot this and didn't find that it had any interest for me. Needless to say, Mike has managed to bring out something that I missed and it is now a compelling and intriguing image.

Technical Notes

35mm SLR, 24–85mm zoom lens, Fuji Provia 400F.

Situation and Approach

A heavy fall of snow in Cumbria in the north of England one winter produced the conditions for this shot. The cloud hung low over the mountains and all but obscured the background details. I found a viewpoint quite close to the trees from where they were placed in a nicely balanced alignment. As with the photograph opposite, exposure is more difficult to assess when there are large areas of white sky. In this case I took a reading from the sky and gave two stops extra exposure to allow the sky and foreground to take on a little tone and colour. Although I knew that the lighting conditions would give a blue colour cast, I didn't use a warm-up filter to compensate as I thought that a cool colour would add to the bleak mood of the image. (MB)

COLORADO GIFT SHOP

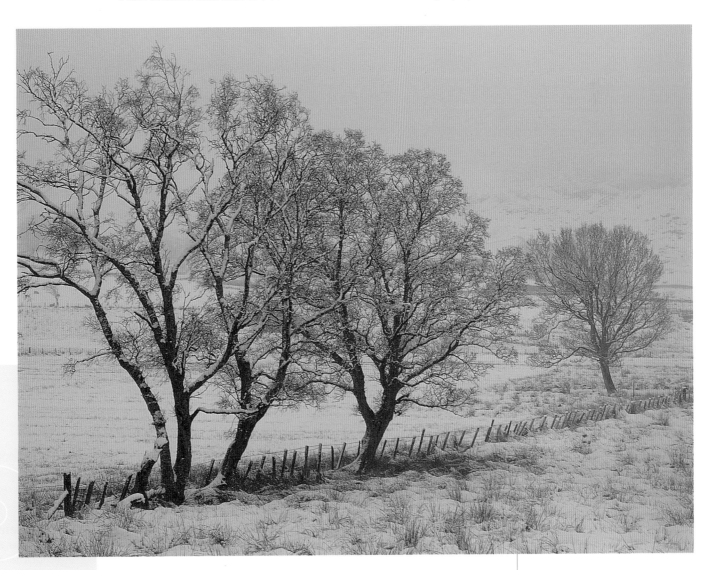

Technical Notes

Medium-format SLR, 55–110mm zoom lens, Fuji Velvia.

BLEAK WINTER SKY

Although the soft, almost shadowless light of an overcast day is far from ideal for subjects such as landscape and architecture, some things (portraits and many close-up subjects, for example) can be photographed more successfully under these conditions than in bright sunshine. This is because the dense, hard-edged shadows and bright highlights that sunlight creates can become too dominant and mask some of the subtle detail, texture and colour upon which subjects like these depend for their impact. For such subjects a more diffused light, with weaker, soft-edged shadows, can create a much more pleasing quality than a bright, sunny day.

Situation and Approach

I found this blaze of heather growing on the sloping side of a cliff. With its two colours and rich green I thought it would make a very pleasing image. I had luck on my side because it was an overcast day and the diffused light allowed me to capture a lot of detail as the shadows were few and deep within the plant. I like the natural, soft quality of the image. The heather was actually growing amongst some very craggy rocks, which I cropped out because they made the image much harder in style. This would have made an effective black-and-white photograph, but showing only the heather gives a more pleasing image in colour. (JB)

Mike's Comment

Apart from the intensity of the colour in this picture, the thing that I find most striking is the way in which the bird's-eye viewpoint has created a sense of movement. The framing has produced a nicely balanced composition.

Situation and Approach

I took this photograph while on a safari in Kenya on a day that was bright but overcast. Harsh African sunlight can make it very difficult to photograph animals, as not only does the high contrast eliminate subtle details, such as the texture of fur, but the bright highlights and deep shadows can make backgrounds very distracting. I used a 600mm lens and got as close as I could to this baboon without scaring him off. (MB)

Jules' Comment

One of my childhood memories is of baboons attempting to dismantle our car and I find them a bit daunting, to say the least. This is a good portrait with a strong shape and good expression, nicely timed – but I still wonder if he's thinking of making off with the hubcaps.

BABOON

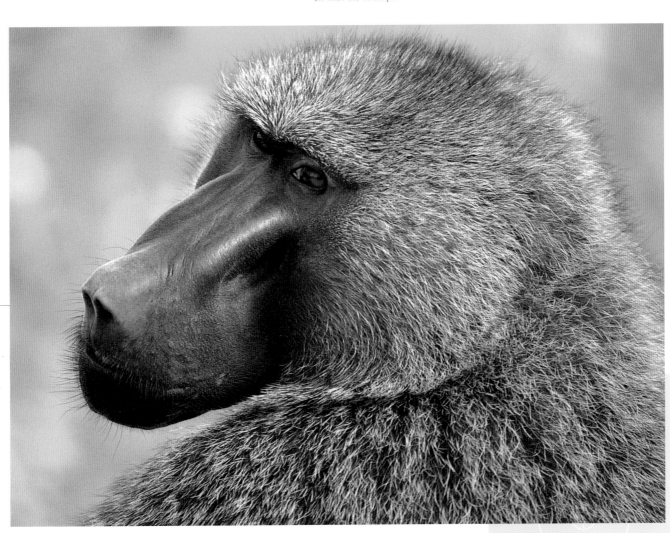

Technical Notes

35mm SLR, 600mm lens, Kodak Ektachrome 100SW.

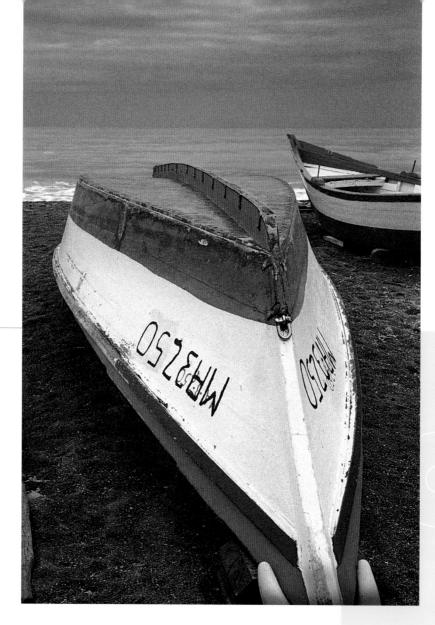

Technical Notes

35mm SLR, 24–85mm zoom lens, Kodak Supra 400 colour negative film.

Dense cloud

When the sky is filled with very dense cloud, it can turn a rich, dark grey and this can produce some very exciting lighting conditions. This also allows the sky to become an effective component of the composition. While a blue sky tends to give an image a rather bland, postcardy quality, a dark grey sky imparts a more dramatic, edgy mood even when it has little or no tonal variation. But, like a white sky, it can result in images with a low brightness range – and this will result in an image on film that has no true blacks and lacks bright highlights.

The most striking effects are created when there are areas of thinner cloud, or gaps where the sunlight can produce a much greater variation in brightness levels within the scene.

Situation and Approach

I photographed these boats pulled up on the beach at Torre del Mar on Spain's Costa del Sol. It was wintertime and there'd been several days of overcast skies which had built steadily until, on this day, it became so dense it seemed like dusk at midday. Because the boats were quite brightly painted, and the sea and sky were so dark, the brightness range was high enough to produce an image with good contrast. I chose a very close viewpoint and used a wide-angle lens to exaggerate the perspective and distort the shape of the foreground boat. (MB)

Jules' Comment

A very intense image. You can feel the dense atmosphere in this picture and the saturation is remarkable. I love the crisp whiteness of the boats and the breaking wave, which contrasts so well with the dark, stormy sky.

Useful Advice

Even when the sky is dark, it is often a good idea to use a neutral graduated filter as it will invariably record lighter on film than it appears to the eye. In these circumstances, it is best to take your exposure reading before you fit the filter, otherwise there is a risk of overexposure.

Situation and Approach

I originally shot this as a rectangular image and I admit that I considered the panoramic version only as an afterthought. Needless to say, when I looked at the transparencies, somehow the panoramic format was much more dramatic. The wider-angled view has included more sky at the sides of the scene and made a feature of the cloud's unusual shape. The quality of light on the rocks is what actually drew me to the shot, so I hadn't initially paid much attention to the sky itself, but I'm so glad that I shot that panoramic version as this is one of my favourite colour shots. (JB)

Mike's Comment

I love the mood of this picture which is due only in part to the swirling cloud. The use of the panoramic format and the way the image has been framed have created an element of tension in the image and, for a static landscape subject, it evokes a strong sense of movement.

CLOUD AND ROCK

Technical Notes

35mm panoramic camera, 45mm lens with polarizing filter, Fuji Velvia.

Technical Notes

35mm SLR, 24–85mm zoom lens with neutral graduated filter, Fuji Velvia.

Situation and Approach

A fishing trip to the far north of Scotland provided this opportunity. The weather here is quite volatile and unpredictable: I had spent the morning happily casting my fly in warm sunshine when suddenly the cloud began to build from the north. I'd passed this deserted croft every day on my way to the river bank and felt that, although it had some potential, it simply did not look interesting enough in the bright sunny weather I'd enjoyed so far. As I hurried to find a viewpoint, the gap through which the sun was shining began to close and the light on the cottage weakened as I watched. I managed only a few exposures before it had gone. (MB)

Jules' Comment

Incredible colour in this photograph, simply stunning. Quite apart from the richness of the image the composition is so pleasing. I like the suggestion of remoteness and storminess but also the fact that the house looks warm and inviting.

SCOTTISH CROFT AGAINST THUNDEROUS SKY

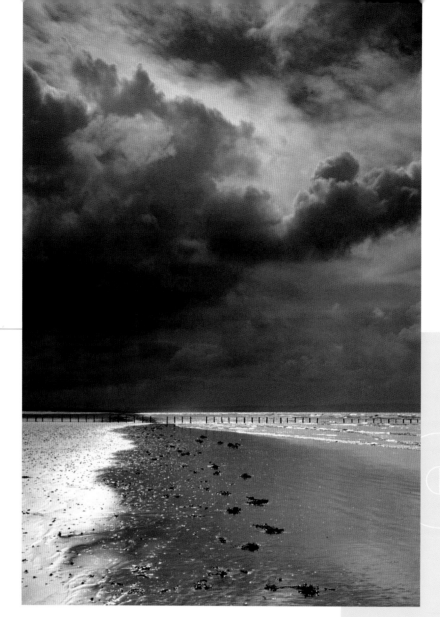

Technical Notes

35mm SLR,
20–35mm zoom
lens, Fuji Velvia.

For landscape photographers in particular, perhaps the most interesting and exciting lighting conditions arise when the sky is filled with large, dark clouds that have the occasional gap between them, allowing pools of sunlight to play on the land and create strong areas of highlight with a corresponding increase in contrast. When this occurs just before or after a storm, you often have the added bonus of the atmosphere being at its clearest: even a small amount of sunlight can behave like a laser beam and illuminate small areas of the land-scape with piercing clarity. The downside is the frustration you feel when that vital pool of light never quite reaches the spot where it's needed. Opportunities like this can at best only be anticipated, never planned, and successful pictures are often the result of good luck and of being able to shoot quickly.

Situation and Approach

I can count myself lucky on several counts for this opportunity on a beach in England's West Country. First, the effect of the sunlight penetrating the swirling cloud has created a beautiful range of shapes and tones. Second, the tide was out, leaving a wide expanse of wet, reflective sand. I was also very lucky that the sunlight was still partly diffused: had it been any stronger, the contrast would have been too great and the subtlety of the tones would have been lost. I used a wide-angle lens and framed the image so that the horizon was placed along the bottom third of the picture. (MB)

Jules' Comment

This is a really dramatic example of the sort of opportunities that exist around the coast. The intense light has produced a very striking image, but the winning elements for me are the area of dark cloud and beautifully illuminated sea.

Situation and Approach

During a visit to eastern Utah, Mike and I were driving into this threatening sky and I had serious concerns about the weather conditions, as it seemed to me that there was a snowstorm on the way. This huge cloud began to loom, looking very dramatic. The problem was that it was changing very quickly and we had to race to get close enough to the mountains to have them as a background. With his telephoto lenses, Mike would have no problem, but I only had a 100mm lens on a 6 x 6cm camera. We stopped the car and I ran into the scene until I was close enough to get the shot. The cloud lost its photogenic quality within a couple of minutes of my exposure. (JB)

Mike's Comment

I was there when Jules shot this and I made some exposures of my own, but this wins easily because he has timed his exposure perfectly. He captured not only a beautiful cloud formation but also the tiny spot of sunlight on the distant snow-capped mountain and the passing shadow on the foreground.

Technical Notes

Medium-format SLR, 100mm lens with neutral graduated and 81B warm-up filters, Fuji Velvia.

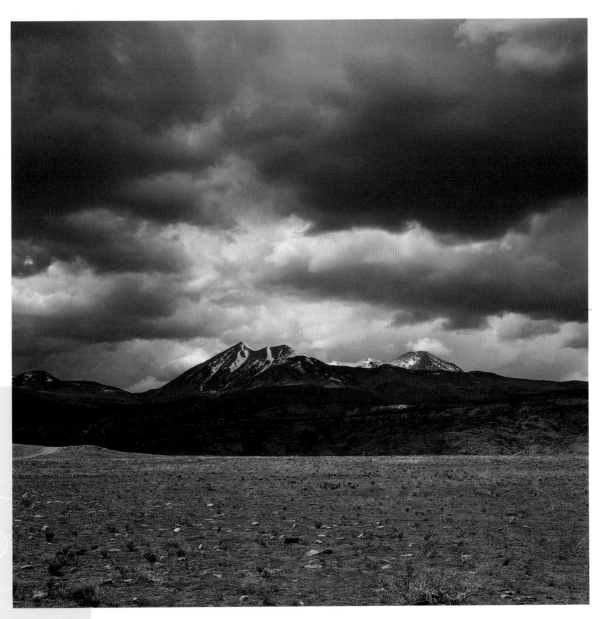

LA SAL MOUNTAINS, UTAH

WOOLACOMBE BEACH

Sunsets

A sunset can provide one of nature's most spectacular displays of light and colour and most photographers are inspired by the promise of a good one. But unless you give some care and thought to how you photograph it, the result on film can be disappointing. The basic problem is that you are, in effect, photographing the light source and any exposure that reveals a good range of tones and colours in the sky will result in most other details in the scene being considerably underexposed.

On top of this, a normal exposure reading will almost certainly result in the sunset itself being underexposed, and so you must ensure that the exposure reading excludes the brightest area of the sky. Take a reading from the section of sky that is either above or to one side of the very lightest tones. In any case, when shooting on transparency film in particular, it is wise to bracket your exposures by at least one stop each side of that indicated by the meter.

Useful Advice

When shooting sunsets, you can overcome the problem of foreground details being underexposed by finding objects with an interesting shape which you can allow to become silhouetted or by finding very light or reflective details. Using a neutral graduated filter will also help to even the balance between the two brightness levels.

Situation and Approach

I could see this magnificent sunset forming as I drove along a busy main road. I knew from past experience that the critical moment would not last long and hoped that I would come across a place to stop before it was all over. I managed to pull in to a car park right alongside the estuary and ran with the camera equipment to a good viewpoint. The colours were intensifying as I began setting up. I had little time to explore composition and went for the most obvious composition first.

I managed to shoot about 12 pictures before the magic had gone. Photography can be very frustrating on occasions, but it only takes an opportunity like this to turn things around. (JB)

Mike's Comment

I find the colour quality of this picture almost unreal, and if I hadn't scanned the image myself I would have suspected that it had benefited from some help in Photoshop. It is the perfect mirror-like reflection, which has inverted the curving shape of the cloud, that makes the composition so striking.

Technical Notes

Medium-format SLR, 55–110mm zoom lens, Fuji Velvia.

WEST OF ENGLAND SUNSET

Artificial Light

When artificial light sources are a feature of a scene, you need to know the colour temperature of the light in order to be able to use filters to prevent a colour cast. When a scene is lit by only one type of light and accurate colour is important, you can use a meter to measure the colour temperature and determine the filtration. Usually, however, you have to make a more subjective judgement, as several types of lighting may be in use, from fluorescent tubes in interiors to tungsten, halogen and sodium lighting in outdoor locations.

In situations such as this, some degree of compromise is inevitable. For most pictorial and creative photography, a pleasing overall colour quality is usually more important than strictly accurate colour.

Situation and Approach

This was shot at a seaside resort that wasn't very photogenic during the day but at night the illuminations were striking. Because there was a huge variation in the colour of the lights, I opted to use daylight film as there could really be no such thing as a correct colour balance. My exposure was based on the reading that came up most frequently and, with the lighting changing every second, an educated guess seemed as good as anything. As it was totally dark, I needed only to consider the exposure for the artificial lights. I framed up on the most interesting section and waited until only a single person was present and when most of the lights flashed on. (JB)

Mike's Comment

Unlike Jules' other picture on this spread where the artificial lights are an element in a scene still partially illuminated by daylight, this image consists solely of artificial light sources and has resulted in a striking effect.

Technical Notes

Medium-format
SLR camera with
105–210mm lens,
Fuji Velvia.

Technical Notes

35mm panoramic
rangefinder
camera, 45mm
lens, Fuji Velvia.

ST IVES AT DUSK

The problem of colour control is most acute with colour transparency film, because it is manufactured to produce accurate colour only when the subject is illuminated by light of a specific temperature. Even a slight deviation will result in a noticeable colour cast. Artificial-light film is balanced for use with special photographic tungsten or halogen lights; if the same film is used under ordinary domestic lighting it will give a different result, unless you use a colour-balancing filter to compensate. When you are making prints from colour negatives or working with digital images, however, it is relatively easy to adjust the colour.

Situation and Approach

This was the most obvious viewpoint from which to photograph the harbour and I had set up in plenty of time to get the evening light. But the colour I'd hoped for never really happened. I spent a good hour or two hoping for a last-minute reprieve, and I think this shot rewarded me. As the light began to fade it took on a bluish hue which might have been too cool and bland had it not been for the artificial lights that began to appear. I timed the exposure so that I achieved a pleasing balance of natural and artificial. I also bracketed fairly widely, as pictures like these are seldom predictable, and it was the shot that was half a stop underexposed that produced the best balance. (JB)

Mike's Comment

This picture works for me because the shot was taken when the ambient light was still bright enough for the artificial lighting not to dominate, resulting in a subtle but atmospheric colour quality.

MIME ARTIST

Technical Notes

35mm SLR, 75–150mm zoom lens, Kodak Ektachrome 64.

Studio Lighting

For many subjects, such as still life and portraiture, studio lighting provides a much more controllable and constant means of lighting than daylight. The majority of photographers working in the studio use lighting that simulates the effect of daylight. Although there have been periods in portrait photography, for example, that favoured a more theatrical style of lighting, the enduring style has used a single source of light, usually diffused to some degree to soften the edges of the shadows. When additional lights are used, it is to make the shadows less dense and reveal more detail in them, to create highlights in specific areas, such as on the subject's hair, or to illuminate the background. However, any additional lights should only supplement the key light and, in most circumstances, should not be too dominant.

Situation and Approach

I used two studio flashes for this portrait of a mime artist. One was placed just to the left of the camera, 12 inches (30 cm) or so above head height, and the other was used to illuminate the background. The subject light was diffused by reflecting it from a white umbrella and I placed a large sheet of white polystyrene, used for insulation, close to the model on the right to bounce some light back into the shadows. I adjusted the background light so that the white paper roll I used was slightly darker than the model's white make-up. (MB)

Jules' Comment

Capturing a subject's character is the challenge laid down to all photographers who aim their cameras at people. Here, I feel the subject's character comes through not so much because of the exaggerated expression but through the hands. Including them in the shot has created a much less static and more meaningful image.

Jules' Comment

The use of simple lighting that is slightly diffused but still gives pleasing shadows and highlights is the key to this picture. Keeping lighting simple but effective is the goal of most studio photographers: complex lighting often results in a loss of impact.

Situation and Approach

I used just one studio flash for this picture, reflecting it from a large sheet of white polystyrene placed quite close to the model and almost at right angles to his right arm. I placed a second reflector close to him on his left, adjusting its position until I felt that the balance between highlight and shadow was right. (MB)

Technical Notes

Medium-format SLR, 150mm lens, Kodak Ektachrome 64.

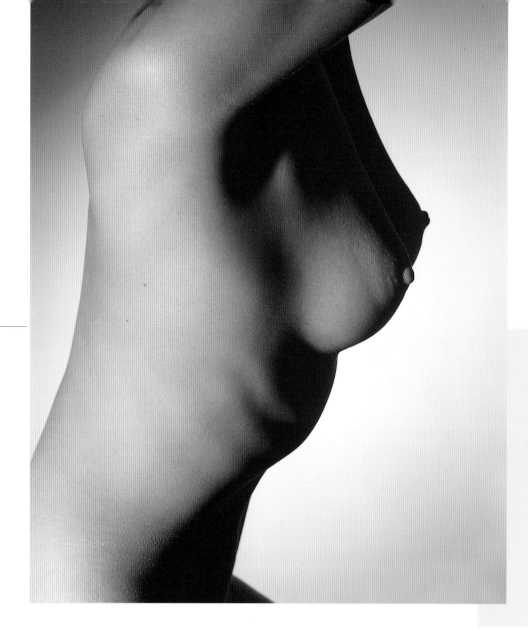

Technical Notes

Medium-format SLR, 150mm lens, Kodak Ektachrome 64.

The first stage in lighting any subject is to consider the position of the key light – the dominant light source that creates the shadows. Study the size, shape, position, hardness and density of the shadows to determine the best position. A small light source, such as a studio flash or tungsten light, produces a well-defined shadow that becomes sharper as the light is moved further from the subject. Conversely, a light source as large or larger than the subject, such as a lamp diffused by a large soft box, produces barely discernible shadows. The shadows produced by a light source also depend on the size of the source in relation to the size of the subject; this in turn depends partly on its distance. The sharp, hard-edged shadow that the sun creates is from a source infinitely larger than our planet – it just happens to be a long way away.

Situation and Approach

I wanted to create a quite contrasty, confrontational lighting for this abstract nude and decided to use a single, undiffused studio flash which I placed at right angles to the model. I adjusted its position until the shadows revealed the shape of the model's breast and ribcage most effectively. I placed a reflector draped with black fabric close to front of the model's body, as I wanted the shadows to remain very dark. I used a second light fitted with a snoot to limit the spread and create a pool of light on the white paper background. (MB)

Jules' Comment

The nude is one subject that a great many photographers have explored, and the human form is as tricky to photograph successfully as any landscape. The hard lighting in this shot accentuates the abstract nature of the picture and, in a way, mimics the lighting that is to be found in many landscape pictures.

Situation and Approach

I used only one light source for this picture – a studio flash in a standard reflector. I aimed it at the white paper background at a point behind the model's abdomen and adjusted the spread of light so that it darkened towards the top of the frame. I asked the model to angle her body so that the light from the background was reflected onto her ribcage and stomach. As I wanted to keep the remainder of her body in silhouette, I placed a large sheet of polystyrene, which I had painted matt black in order to prevent stray light from being reflected from the studio walls, close to her on the right-hand side. I used a low camera angle and framed the image to include only the highlighted area and the curve of her back. (MB)

Technical Notes

Medium-format SLR, 150mm lens, Kodak Ektachrome 64.

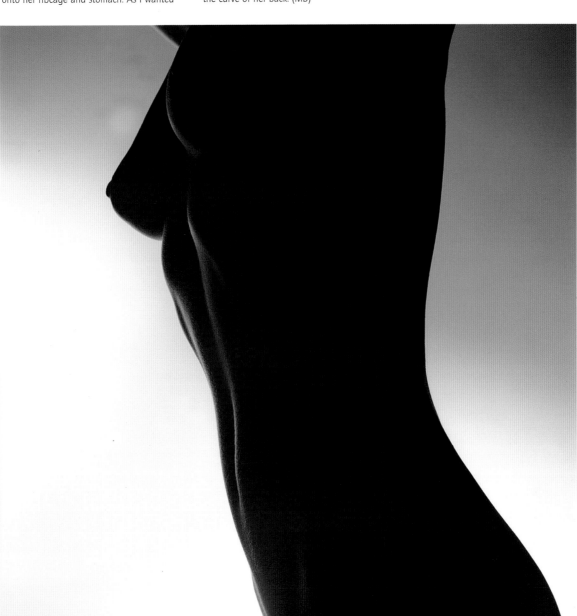

NUDE SILHOUETTE

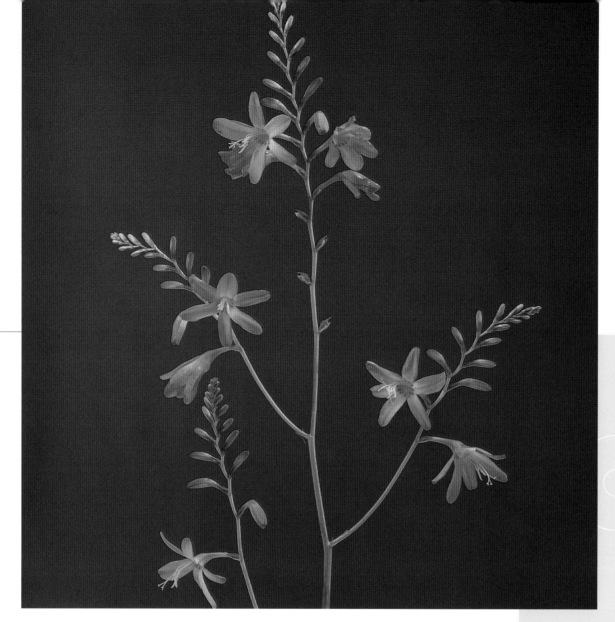

Technical Notes
Medium-format SLR, 100mm lens with extension tube, Fuji Astia.

There are many commercially available reflectors and diffusers, which can be readily attached to most makes of flash and tungsten units. These range from simple reflection or diffusion umbrellas to small soft boxes and the huge window lights commonly used in full-length fashion photography. There are also devices such as honeycombs and snoots, which limit the light beam, and spotlights, which project a tight, controllable beam of light with a very hard-edged shadow. These accessories are used mainly for creating highlights on a specific area of the subject. But it's not difficult to improvise. Sheets of white polystyrene used for insulation make excellent reflectors, a wooden frame covered with a white translucent material such as tracing paper can provide effective diffusion, and a cone of black card is a good substitute for a custom-made snoot.

Situation and Approach

This was lit by a single flash unit with a diffusion box. Although the flower was a fine specimen, the background needed some thought if the image was to work. Initially I chose a black background but this didn't have the impact I'd hoped for. Then rich blue fleece fabric caught my eye; once positioned, it really made the image come to life. The combination of blue, orange and yellow works so well together that it would have been difficult to have made a bad picture from these elements. (JB)

Mike's Comment

This is a good example of how a striking subject needs only simple lighting to make the most of it. Jules has lit this in a way that has emphasized the beautiful shapes and colour of the bloom.

Useful Advice

To judge a subject's brightness range and the contrast of an image, view the set-up through half-closed eyes or use the depth-of-field preview button on an SLR camera with the lens set to a small aperture. The much dimmer image that results makes it harder to see into the shadows and creates an impression that is closer to that which will be recorded on film.

Jules' Comment

I like the way that Mike has used a complementary but contrasting background and the way the simple lighting has emphasized the subject's form and texture.

Situation and Approach

For this picture I used a single studio flash, diffused by a soft box and placed on the left-hand side of the subject, almost at right angles to the set-up. I placed a large white reflector on the opposite side in order to bounce some light back into the shadows, making them less dense and revealing more detail. The background was a sheet of rusted metal found in a scrapyard. (MB)

Technical Notes

35mm SLR, 24–85mm zoom lens, digital capture.

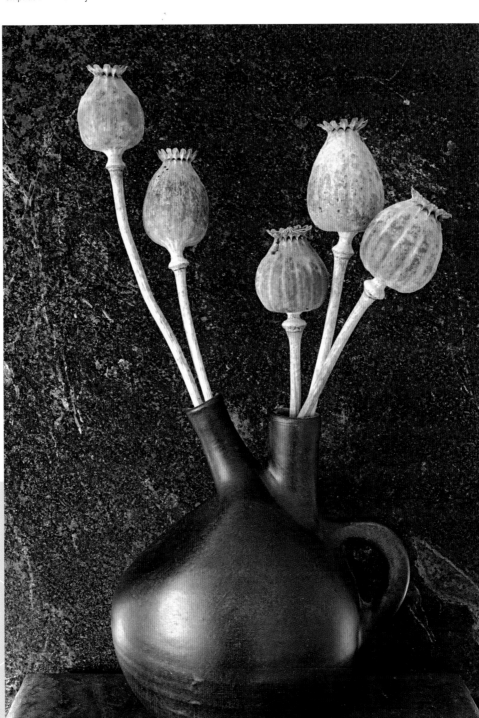

POPPY HEADS AND POT

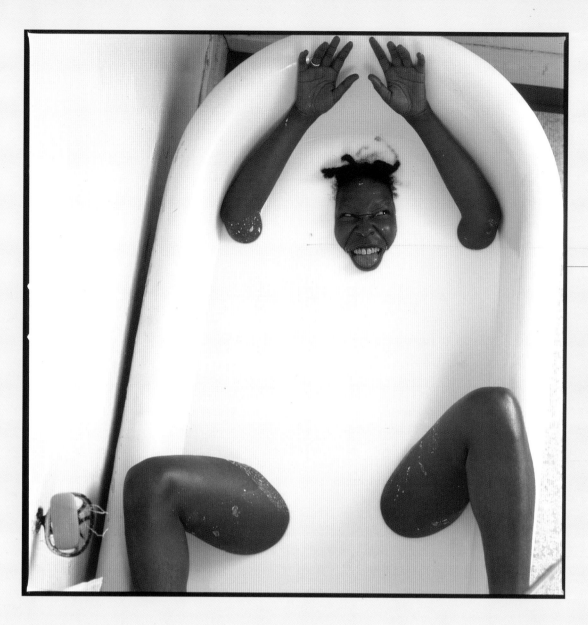

Annie Leibovitz

was born in Westport, Connecticut, in 1949. After receiving a bachelor of fine arts degree she went on to work with photographer Ralph Gibson. In the early 1970s through to the 1980s she was a freelance photographer and the chief photographer for *Rolling Stone* magazine. Starting in 1983 she was a contributing photographer for *Vanity Fair*. The range of work that she produced included musicians, actors, athletes and political figures and she is regarded as one of the outstanding portrait photographers of the modern age. In the early 1990's she founded the Annie Leibovitz Studio in New York. She frequently uses physical action from the whole of the subject's body, giving a fresh and unusual approach to portraiture. Her awards include the American Society of Magazine Photographers' Photographer of the Year in 1984, Innovation in Photography Award in 1987 and the Infinity Award for Applied Photography from the International Center for Photography in 1990.

Jules' Comment

This shot shows the typical Annie Leibovitz style of combining the whole of the subject with body movement and a thoughtful, sometimes humorous, approach. The use of lighting here is very much secondary to the idea and composition of the image, which relies on these elements to reveal the subject's character, rather than focusing on facial features as the Karsh image does.

Yousuf Karsh

was a Canadian citizen but born in Mardin, Armenia, in 1908. His parents left Armenia in 1922 because of Turkish persecution and he was taken to Canada by his uncle, Nakash, who was a photographer. He had planned to take up a career in medicine but abandoned that because of his financial status and, having shown an aptitude for photography, was sent to Boston by his uncle to study under a notable portrait photographer, John H Garo. He opened his own portrait studio in Ottawa in 1932 and began using artificial lighting rather than the daylight used by John H Garo. It was

his portrait of Winston Churchill, taken in 1942 and used as a cover image on *Life* magazine, that brought him international recognition and he embarked on a career that focused on photographing the most powerful and influential figures of the time. This, combined with his distinctively theatrical style of lighting with its rich tones and textures, has resulted in many of his images becoming almost iconic in quality. Among his most famous subjects are President John F Kennedy, Albert Einstein, Pablo Casals and Ernest Hemingway. He died in 2002.

Mike's Comment

This image is almost as much about lighting as it is about the character of the subject. Karsh's use of lighting is designed not only to emphasize facial contours and skin texture but also to produce an image with a full range of tones and a rich photographic quality.

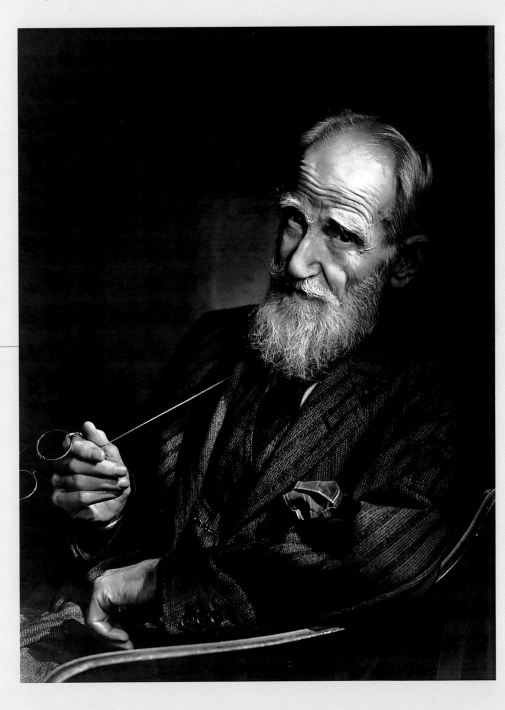

GEORGE BERNARD SHAW

The Specialized Subject

The ability to see and successfully record a striking image is, in principle, something that can be applied to any subject or situation. In practice, most photographers have strengths and weaknesses that result in them being able to produce more telling work with some subjects than with others. Part of this depends on the photographer's interest and enthusiasm for the subject. It's hard to imagine a good landscape photographer, for example, not having a love of the countryside, or a portrait photographer who is not interested in and comfortable with people.

Specialized knowledge can also be an important factor in some areas of photography. A wildlife photographer, for instance, is likely to be more successful if he or she has knowledge of the animals and their habitats. But when creative expression is the driving force it can be a positive advantage not to become too specialized as it keeps your mind and eyes fully open – and if you periodically challenge yourself to shoot less familiar themes, it will encourage you to adopt a more adventurous and innovative approach.

This chapter explores ways in which you can adapt your approach and techniques and apply them to a variety of specialist subjects.

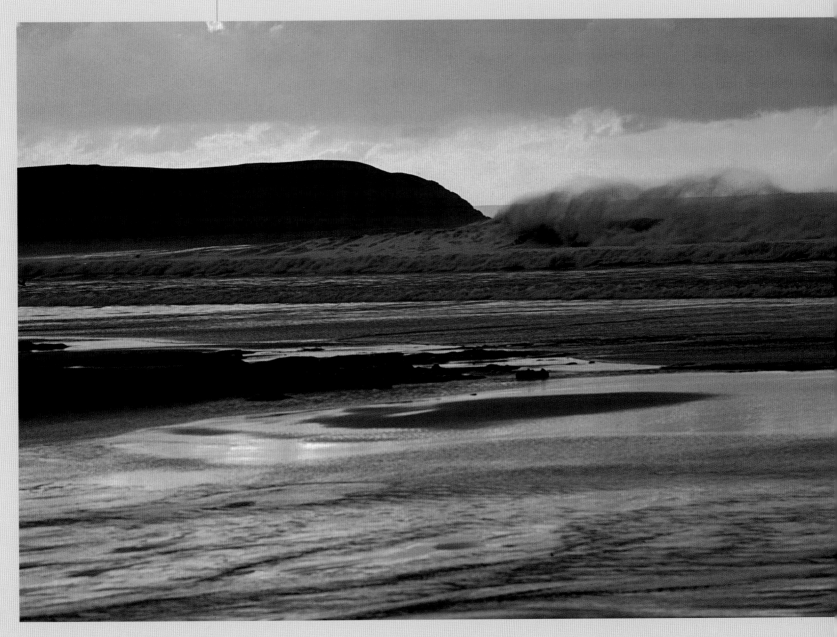

Situation and Approach

This young girl was in a small group of onlookers watching a friend and me take photographs of a building in India. I thought she had a lovely face and was struck by the intensity of her expression. She agreed willingly to let me shoot some pictures and I asked her to sit in a spot where she was shaded from direct sunlight, with an uncluttered area of background behind her. I used a long-focus lens to frame her face tightly in order to place maximum emphasis on her eyes and mouth, and set an aperture that was small enough to ensure both were sharp but wide enough to throw the background details out of focus. In spite of the language barrier, I carried on a flow of enthusiastic chatter while shooting a dozen or so frames. She did smile but I liked this very direct, questioning gaze best. (MB)

Jules' Comment

The most important aspect of this portrait is the girl's relaxed and natural expression, combined with the highlight in her eyes, which are directed straight into the camera.

Technical Notes

35mm SLR, 70–200mm zoom lens, Kodak Ektachrome 100 SW.

Portrait Photography

There are two basic types of portrait photography. In the first, the motivation is solely to create a striking image; in the second, the aim is to produce a photograph that the subject will like. The two are not always compatible. The need to produce a portrait that the subject will find pleasing can be very restricting from a creative point of view and the results can often be bland. But a glance at the work of some of the leading portrait photographers suggests that a good many of their subjects would have been distinctly unhappy with the results.

As a general rule, you need to adopt a different approach for each type of portrait. In both types, however, you need to establish a good relationship with your subject by making him or her feel at ease and confident in your ability. Carrying on a conversation will encourage natural expressions and gestures on the part of your sitter, while good preparation on your part will ensure that no awkward moments disrupt the smooth flow of the session while you struggle with equipment.

It's important to have a clear idea of your objectives before you begin shooting. When you are working in the studio, you should also ensure that you have set up all the necessary backgrounds and that any props you may need are ready to hand. When shooting casual outdoor portraits, it's equally important that you decide where and how to place your subject before you begin and to make basic choices about the viewpoint and the composition. Even for professional models, it can be very unsettling if there is a feeling of uncertainty about your preparation and approach.

Situation and Approach

I photographed my model friend Joanie while on a location shoot and, as she wanted some photographs for her portfolio, my aim was to produce images that would please us both. The sunlight was soft and diffused, but I opted to shoot into the light to ensure that there were minimal shadows on her face. The surroundings were bright enough to reflect some light into her face, but I gave half a stop extra exposure to make sure that the skin tones were pale and to minimize texture. (MB)

Technical Notes

Medium-format SLR camera, 250mm lens, Kodak Ektachrome.

JOANIE MODELLING

Situation and Approach

I met this jovial Frenchman while I was travelling through the vineyards during harvest time. He and two friends were busy picking the grapes from their own small plot of vines, ready to start making their supply of wine for the coming year, and were enjoying a bottle or two of last year's vintage while they worked. He was sitting on the back of the trailer they were using to transport the grapes to their winery. I chose a viewpoint that allowed me to use the plain base of the trailer and one side as a background and framed the image so that his blue overalls were included together with a couple of wine casks in the corner of the frame. I used a wide aperture to throw the background details out of focus. (MB)

Technical Notes

35mm SLR, 35–70mm zoom lens, Fuji Provia 100F.

Backgrounds for Portraits

The background is a crucial aspect of portrait photography. As a general rule, with head-and-shoulder portraits it is better for the background to be relatively plain and unobtrusive and of a tone or colour that contrasts with the subject and allows him or her to stand out clearly. In a studio environment you can use plain or painted paper or fabric backgrounds to achieve this, but for outdoor portraiture you need to choose the area immediately behind your subject with care, especially with full or three-quarter length shots.

Very often the background or setting can become an important element of a portrait, adding interest to the composition and helping to establish the subject's character or occupation. With images of this type, think of the background as the main element of the composition and make the subject the focus of attention within it, either by physically placing him or her in the strongest position or through your choice of viewpoint.

Jules' Comment

One reason this shot works so well is the amount of space that Mike has given his subject. Including some of the setting gives a less intimate feel and the background information, although not obtrusive, has helped to establish the man's character.

Mike's Comment

This is a gloriously muddled image which works well because the subject and background are so compatible with each other. Cropping along the top of the van might have produced a stronger image, but it would have been a shame to have lost the perfectly placed surfboard on top.

Situation and Approach

This portrait was taken at a surfing competition. There was very little room to manoeuvre because vehicles were parked behind and in front. One way around this would have been to come in closer with a longer lens, but I thought that would lessen the impact of the picture and I wanted to include the whole van as well as the surfboard on top. I used a wide-angle lens to achieve this. The result is a scene in which the surfer is the focus of interest, rather than just a portrait. In addition I used a vivid film and emphasized the colour further by using a polarizing filter to intensify the blue sky. (JB)

Technical Notes

Medium-format SLR, 45mm lens with polarizing filter, Fuji Velvia.

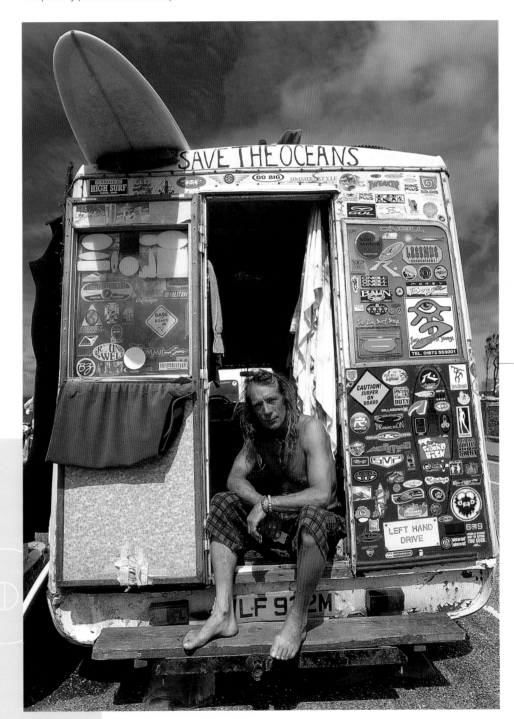

I photographed this model in the studio, using a painted canvas background and a fairly simple lighting arrangement of two undiffused tungsten lights. One light was aimed at the model from just to the right of the camera and the other was aimed from the left to lighten the shadows cast by the the key light that were spilling onto the background. The model's profile pose was intended to mask her identity and also to distance the image from one that was calculatingly sexually provocative. I shot the image on black-and-white film. The colour was created by using the lith printing technique described by Jules on pages 288–289. (MB)

LITH NUDE IN PROFILE

Technical Notes

Medium-format SLR, 105–210mm zoom lens, Ilford XP2.

The Nude

There are distinct similarities between landscape photography and photographs of the human form, not only because they each depend a great deal on contours, form and lighting quality for their visual impact, but also because they have an intrinsic beauty and possess qualities that can evoke a wide range of responses and emotions. But the emotive aspect of nude photography can be a barrier to creating images that will be accepted as purely aesthetic. If you wish to use the naked human body as a vehicle for expressive photography, you need to distance your work clearly from that of the glamour and porn industries. One obvious way to achieve this is by depersonalizing your subject and adopting a more abstract approach. There are various ways of doing this, including the way you pose and light your subject and the way you frame the image. Another method is to avoid the use of natural colour. The nude is an ideal subject for black-and-white imagery and also lends itself well to forms of digital presentation.

Jules' Comment

The use of lith printing in this particular shot has added a warm and slightly mysterious quality, which has helped emphasize the artistic nature of the shot. The pose is a straightforward one, but it places the model's body in a pleasing position without being too contrived. The use of a pale-painted background has also contributed to the mood.

Situation and Approach

This photograph was taken on colour film, against a plain paper background of a similar colour to the model's body. I used a single studio flash, with a large sheet of white polystyrene placed at right angles to the model, on the right of the camera, to reflect the light. I also placed another white reflector close to his right shoulder. In the original photograph I included the model's head, but I felt that cropping more tightly gave the image greater impact and focused attention more on the tones and contours of his body. I used the technique described on pages 302–303 to make the colour a little less natural and to give the image more of the feel of a sepia-toned black-and-white. (JB)

Jules' Comment

The tight framing gives this shot a very intimate feel and, together with the strongly angled lighting, has created an almost abstract quality. The highlights and shadows have defined the body tone and skin texture and the limited colour range has contributed to the mood.

Technical Notes

Medium-format SLR, 150mm lens, Kodak Ektachrome 64.

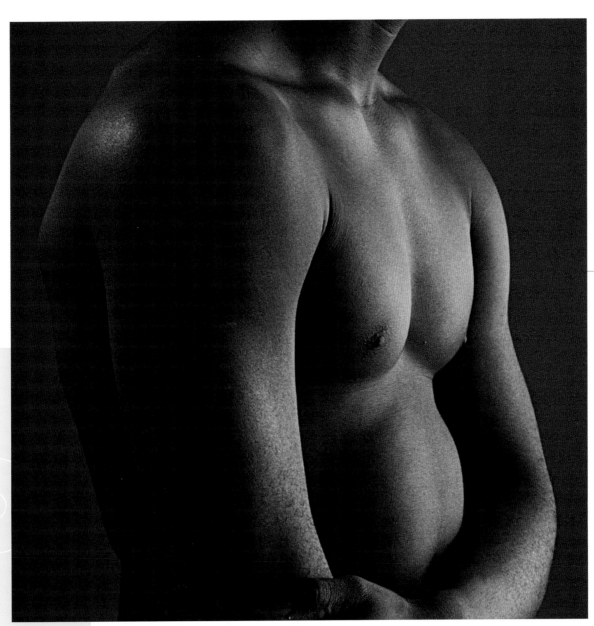

Situation and Approach

I took this photograph on a beach in the
Algarve region of Portugal, at a spot
where there were some very interesting
rock formations. In many ways this is a
landscape image in which the nude
happens to be the focus of attention rather
than the dominant subject. For this reason
I chose my viewpoint primarily with the aim
of creating the most effective lighting on
the rock and I asked my model to position
herself in a way that produced the most
pleasing quality of light on her body.
I framed the image so that the peak of the
rock appeared in the top left corner, as I
felt this balanced the sense of movement
created by the model's outstretched arms.
Although I recorded this on colour film
I was not happy with the colour of the
rocks, so I used a technique similar to the
one described on page 308 to render the
image as black and white and then painted
the colour back into the body using the
History Brush in Adobe Photoshop. (MB)

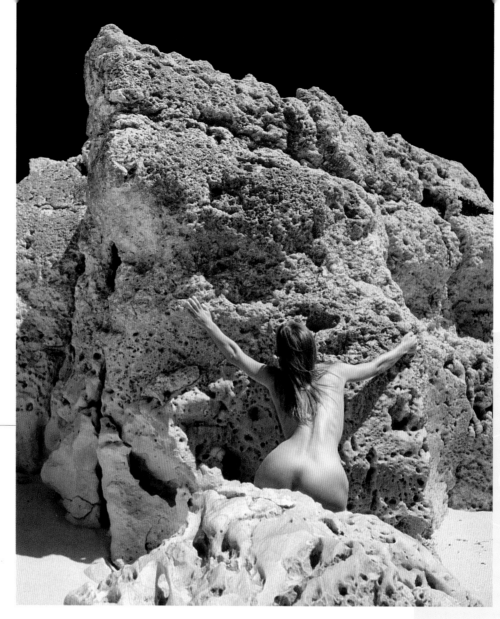

JOANIE'S ROCK

Technical Notes

Medium-format
SLR, 50mm lens,
Kodak Ektachrome
64.

The Nude in the Landscape

While the studio environment offers some very tangible
advantages when photographing the naked human body, not
least those of comfort, privacy and convenience, it can be a
rather sterile atmosphere and one that depends a great deal on
careful planning and the use of backgrounds and props.
Outdoor locations, on the other hand, can allow a more spon-
taneous and natural approach and can be more relaxing for
the model in terms of posing and interaction. But you do
need to have some means of controlling the light: a large
white location umbrella is very useful for creating areas of
shadow, and large white or silvered reflectors are invaluable for
reducing the density of shadows.

Jules' Comment

This is a nicely presented image. The
Photoshop manipulation has worked well,
as it has accentuated the contrasting
textures of rock and skin. The mono-
chromatic rock has a very powerful effect
within the composition: it has great
definition and rich tones, making the nude
stand out boldly while still retaining a
natural feel.

Jules' Comment

This appeals to me because the use of monochrome has made such a feature of the contrasting textures. The black-and-white image has given the grass an intense texture which is balanced by the smooth skin tones of the model. I feel that the use of diffused lighting here was critical in getting the end result, a harder light would not have worked. I would have been tempted to place the body a little higher in the frame and, possibly, at a slightly steeper angle.

Situation and Approach

Setting one texture against another can be an effective way of enhancing the tactile quality of an image. I took this photograph while shooting on location in an English meadow and had been placing my model within a landscape composition in which her figure was a relatively small element. It was a hazy day and the light was very soft, almost shadowless, giving her skin a smooth and quite delicate appearance. It struck me that this made a striking contrast with the quite spiky quality of the grass and I decided to move in much closer and emphasize this aspect of the image. I used a wide-angle lens and chose a viewpoint high above her, which placed her body along a slightly diagonal line. I framed the image to exclude the model's head and to place her body at the bottom of the frame so the main bulk of the grass was above her. The print was made using the Lith process. (MB)

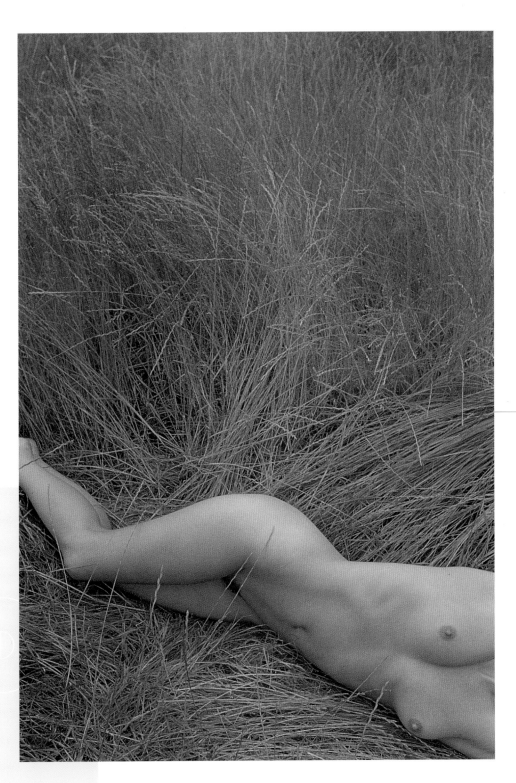

Technical Notes

35mm SLR camera with a 24mm lens and Ilford FP4.

NUDE IN GRASS

Situation and Approach

I'm something of a beachcomber at heart and can't resist picking up things that I find attractive. Sometimes I make them into small, abstract "installations". I did not have a specific idea for this image, but reacted to the shape of part of a shell that I'd painted but then not used for one of my sculptures. I echoed that shape with the two small pieces of driftwood and the white pebble. I set the shot up outdoors and photographed the arrangement from almost directly above. The background was a large mirror reflecting a blue sky. I used another small mirror, placed close to the set-up on the left-hand side, to create some small highlights. (MB)

Technical Notes

35mm SLR, 24–85mm zoom lens with extension ring, Fuji Velvia.

Still Life and Close Up

Still-life subjects offer photographers the opportunity to exercise control over both the content and the composition of their images. It could be considered that there are two distinct types of photographer: those who react spontaneously to transient situations and those who prefer to plan and order their images in a very controlled way. The latter approach requires the ability to visualize and construct a photograph in a way that has more in common with media such as painting and sculpture. Still-life photographic styles vary enormously and range from the commercial needs of product and food photography to abstract and fine-art images. Mostly, however, they begin with an idea.

Jules' Comment

This is an example of really good use of interesting natural forms, with amazing colours. The shapes are nicely balanced and the textures are appealing because of the direct lighting. The use of a mirror underneath has eliminated shadows, and allowing it to reflect the blue sky is a particularly clever touch.

Useful Advice

One way of finding inspiration for pictures of this type is to set yourself a brief to illustrate a book jacket or CD cover, for example. It is also helpful to look at good still-life photography in books and magazines – not to slavishly copy what you see but to help trigger ideas and approaches of your own.

Situation and Approach

This was a spur-of-the-moment shot that came about when I was planning a meal. I was going through the ingredients and noticed that the garlic was a particularly pleasing colour. I sorted through more and put together the best cloves for a shot. I kept the lighting very simple, using a single flash head with a diffusion box. The background was a piece of MDF painted matt black. Rather than try to arrange the cloves into a precisely set arrangement, I simply put them down and then pushed a few pieces further into the frame as I looked through the viewfinder. It's surprisingly difficult to make a shot like this look as if it has not been set up. Keeping things simple helps a great deal and it is important to remember to take a shot before you rearrange things: your first shot is often the one that turns out best. (JB)

GARLIC CLOVES

Technical Notes

Medium-format SLR, 100mm lens with extension ring, Fuji Velvia.

Technical Notes

Medium-format SLR, 100mm lens with extension tube, Fuji Velvia.

Found Still Lifes

Although setting up a still life can be an enjoyable and instructive process, there is also a great deal of potential in seeking found still lifes – things that either just happen to be there or have been arranged by someone else. Places such as markets and fishing ports abound in photogenic objects arranged, either accidentally or consciously, in ways that need only a keen eye and a good choice of viewpoint and framing to produce a striking image. Pictures like this can also be found in nature. As a general rule, you need to be quite selective when composing images like this as the impact of elements such as texture, colour and pattern will be diminished if you include too much in the frame.

Situation and Approach

This was taken in a wood that had one area carpeted with incredible moss. Stunning though it was, my main problem was to find a subject that would work as a focus of interest with the moss as a background. I searched a relatively large area before coming across these ivy leaves. I had set up further away on the first section of moss and had intended to find something to place there, but finding these leaves already lying on moss was almost too good to be true. I retrieved my camera and tripod and shot this quickly, as the light was changing and I didn't want to lose the beautiful soft feel. In retrospect, I feel that a tighter crop would have been an improvement. (JB)

Mike's Comment

This image makes me think of gemstones displayed on a jeweller's baize cloth. The colour and texture of the background provides a subtle but effective contrast with the leaves, which are positioned in such a pleasing way that you think they must have been arranged.

Useful Advice

Pictures of this kind tend either to be taken at a much closer range than usual or to be framed more tightly by using a long-focus lens. In either case, it is advisable to use a tripod whenever possible, since the effects of camera shake will be more pronounced. A tripod will also enable you to use a slower shutter speed and correspondingly smaller aperture in order to obtain greater depth of field, as well as a slow, fine-grained film – the best choice for pictures like these, where fine detail and high image quality are vital.

Situation and Approach

I noticed this small shrine at the side of a street in the Indian city of Jaisalmer and was attracted by what I can only describe as its tasteful garishness and by the obvious time and care that had gone into its construction. I didn't have a tripod with me at the time, but the light was quite bright and I chose a viewpoint that placed all the details I wanted at a similar distance from the camera. This allowed me to use a reasonably wide aperture and a fast shutter speed. I framed the shot so that the small shrine was placed to one side of the image's centre. (MB)

Jules' Comment

This is a complex image, but it works because the choice of viewpoint and the way it has been framed have created a well-balanced composition from a potentially muddled subject.

Technical Notes

35mm SLR,
24–85mm lens,
Kodak Ektachrome
100 SW.

INDIAN SHRINE, JAISALMER

Situation and Approach

I took this photograph while exploring the rock pools on a beach in Scotland. My aim had been to shoot some seascapes, but the sky was featureless and the light very soft, making the wider view of the beach bland and uninspiring. Once I had brought my range of vision down to inches rather than yards, I began to see pictures in almost every nook and cranny. The tide had not long retreated and the wet, glistening surfaces of the rocks, shells and seaweed gave them a bright, sparkling appearance and rich colour. I used a long-focus lens fitted with an extension tube to allow me to shoot this close-up image of seaweed from a comfortable distance and stopped down to the minimum aperture to ensure the image was sharp all over. (MB)

SEAWEED

Technical Notes

35mm SLR, 70–200mm zoom lens with extension tube, Fuji Velvia.

The vast majority of photographs are taken when the subject is 6 feet (2 metres) or more away from the camera. When subjects are approached much more closely than this, a completely new range of possibilities emerges. Close-up photography can be a very inspiring area, because it compels you to look at familiar things in a different way and reveals qualities that are not noticed by the casual observer, giving small objects and details the scale and breadth of a landscape. Perhaps most importantly, though, close-up photography can provide a wealth of image-making possibilities, quite literally on your doorstep. Moving in close also allows you to produce images with an abstract quality, where the identity of the subject is hidden and the viewer is presented with an image that appeals purely on its photographic qualities.

Jules' Comment

A pleasing mix of a nature study and a still life, this image has been thoughtfully composed. It has been framed tightly enough to accentuate the texture of the main subject, but has also included some green seaweed at the base which, together with a red winkle nestled among the fronds, adds an element of contrast.

Situation and Approach

This plant had such an incredible pattern that I couldn't resist photographing it. I found a backlit leaf in which the contrast between the yellow veins and the green was accentuated and there was also a curled new leaf where the fine red outline created a further element of contrast. I framed the image in a way that excluded all but the most important details and angled the camera a little to create a diagonal line. (JB)

Mike's Comment

I have a fondness for images that have a strong, dominant colour, especially when they also have a striking pattern or texture. These elements have been combined to good effect here, emphasizing the flowing lines of the leaf pattern and, along with the control of depth of field, establishing a strong focus of attention.

Useful Advice

When a lens is extended from the film plane by close focusing using extension tubes, bellows attachments or a macro lens, you will need to give additional exposure. Through-the-lens metering systems allow for this, but if you are using a separate exposure meter you will need to increase the exposure by the square of the distance by which the lens has been extended beyond its focal length. For example, when a 100mm lens is extended to 200mm to provide a life-size image it will need four times the exposure (200/100 = 2; 2 x 2 = 4).

Technical Notes

Medium-format SLR, 120mm macro lens, Fuji Velvia.

CANNA LEAVES PATTERN

Wildlife

Understanding your subject is the key to being able to make your own photo opportunities and this is particularly applicable to wildlife photography: knowing how to get close to animals and birds, and the environments and situations in which you're likely to find the best shots, is essential. It's no coincidence that many leading professional wildlife photographers have a background in subjects such as zoology. But shots of domestic and farm animals can be just as eye-catching as images of animals in the wild. Many professionals use game farms and reserves, where their subjects are in semi-confinement and they do not always have to rely on tracking skills.

Situation and Approach

I photographed this subject in the hinterland of an estuary in North Devon and, in many ways, it was a captive subject. The difficulty was that it was not possible to approach the swan's nest very closely – not only because doing so would have disturbed it, but also because there was a wide expanse of water between us.

Even a 600mm long-focus lens did not give a narrow enough field of view for me to be able to frame the picture as tightly as I wanted and I had to use a x 1.4 converter. Because of the converter, I was not able to use the lens at its maximum aperture: I wanted to stop down at least two more stops to ensure good definition. This, combined with the use of a slow film,

meant that I needed a shutter speed of ⅟₆₀ second with a big risk of camera shake. With the camera mounted on a very firm tripod, I used the camera's mirror lock to ensure that there was no vibration. (MB)

Jules' Comment

Unwanted foreground details are often a problem. This shot might have benefited from moving the camera a little to the left to minimize the foreground grass and from framing the image to place the cygnets closer to the centre.

Technical Notes

35mm SLR, 600mm lens with x 1.4 converter, Fuji Velvia.

Jules' Comment

This is the classic koala pose – sitting in the V of a eucalyptus tree and looking deeply relaxed. The tight framing makes the most of the subject matter and, although it looks a little artificial, the fill-in flash has improved the lighting quality.

Useful Advice

Using a very long-focus lens greatly increases the risk of blurred images through camera shake, even when you use a fast shutter speed. Make sure the camera is anchored as firmly as possible: a good, solid tripod is the best option.

Situation and Approach

Koalas are nocturnal animals and very shy, so your chances of seeing one in the wild are slim. I photographed this one at a koala reserve near Adelaide in Australia and was able to get close enough to frame the image quite tightly using a 70–200mm zoom lens. I was also close enough to use fill-in flash to lighten the shadows created by the overhead daylight and to give the image a little sparkle. (MB)

SWAN'S NEST

Technical Notes

35mm SLR, 70–200mm lens, fill-in flash, Fuji Provia 100.

KOALA POSING IN EUCALYPTUS

Situation and Approach

The kudu is a beautifully marked, but very shy, antelope. I had the opportunity to photograph this one near Lake Bogoria in Kenya. We'd managed to get reasonably close, but the light was failing and I needed to use a tripod to ensure a sharp image. Although the animals were not too disturbed by the vehicle's presence, the sight of a person would have spooked them. I got out on their blind side and set up my camera with the vehicle between us, carefully raising the camera over the bonnet to get my shot using a 600mm lens. (MB)

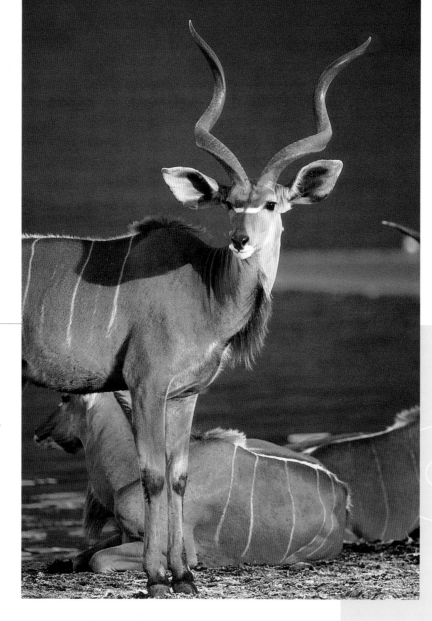

KUDU, LAKE BOGORIA

Technical Notes

35mm SLR, 600mm lens, Fuji Provia 100 pushed one stop in processing.

One of the best opportunities for photographing wildlife at close quarters without too much difficulty is on a safari. In most of the African game parks, many of the animals have become so accustomed to the presence of vehicles that they can often be approached to within just a few metres (yards). Even so, a long-focus lens is vital if you want to take close-up images; a 300mm lens should be considered the minimum requirement. To get the best viewpoint you need to get not only close enough to the subject but also into a position where the background is not fussy or distracting and the lighting creates a pleasing quality.

Useful Advice

When you are shooting from a vehicle, it can be difficult to keep the camera steady and free from vibration, but a bean bag rested on the window frame can provide an effective solution. You can also buy a clamp, complete with a tripod head, which can be fitted to the window frame. However, you do need to make sure that nobody moves in the vehicle when you make the exposure.

Jules' Comment

The shot of the kudu has wonderful lighting, a rich warm glow that seems to accentuate the colours of the animals, underlining the fact that morning and evening light are often the most effective. The lighting has also isolated the kudu from its background, focusing attention on it more strongly.

Situation and Approach

This type of picture is probably among the easiest of all wildlife shots to take. Lions are notoriously languid and dozy after they have fed and you can get quite close without disturbing them. This pride was sleeping in a thicket and we were able to drive our vehicle to within about 6 metres (6.5 yards) of them without any difficulty. The only problem was that they were almost comatose and did not present a very exciting image. We waited for half an hour or so before this animal suddenly raised her head and gave a massive yawn. I'd like to pretend that I was in imminent danger but, after a cursory glance in my direction, she laid down her head and went back to sleep. (MB)

Technical Notes

35mm SLR, 70–200mm zoom lens, Fuji Provia 100 F.

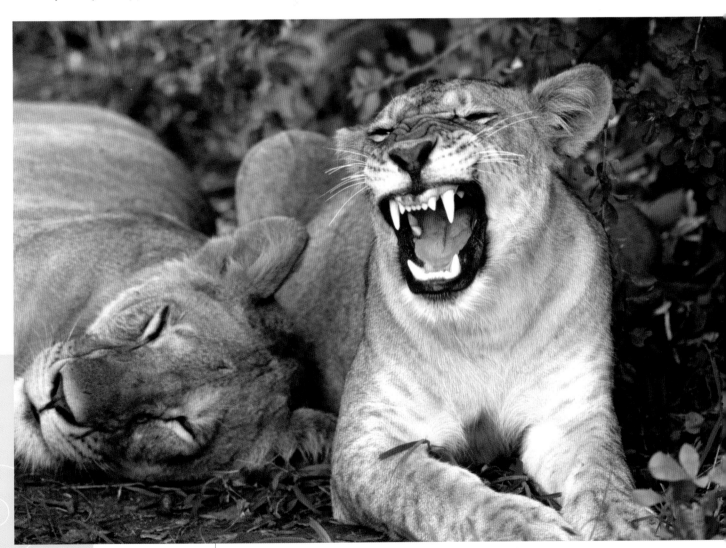

YAWNING LION

Art Wolfe

was born in Seattle, Washington. He graduated from the University of Washington with a bachelor of fine arts degree, minoring in art education. A mere three years after graduation he published his first book, *Indian Baskets of the Northwest Coast*.

Art Wolfe spends around nine months of the year on the road and has photographed every continent, taken an estimated one million images and released over 50 books. His art background and love of nature blend to create his own personal style. Wolfe has received many awards that include an Alfred Eisenstaedt Magazine Photography Award in 2000 and *Photo Media* magazine's Photographer of the Year in 1996. He was also named Outstanding Nature Photographer of the Year by the North American Nature Photography Association in 1998. Without doubt Art Wolfe is one of the most prolific nature photographers but it is his sensitive approach which makes him one of the most successful photographers ever in this difficult field.

Jules' Comment

Quite apart from excellent composition, colour and timing, this shot demonstrates Wolfe's ability to get a first-class image within an environment where the odds are not in his favour. Long waits and dedication pay off. A stunning shot that captures the power and beauty of the bears, it also leaves the viewer with the sense that they were actually there, observing with rapid pulse and silent footsteps.

FIGHTING BROWN BEARS

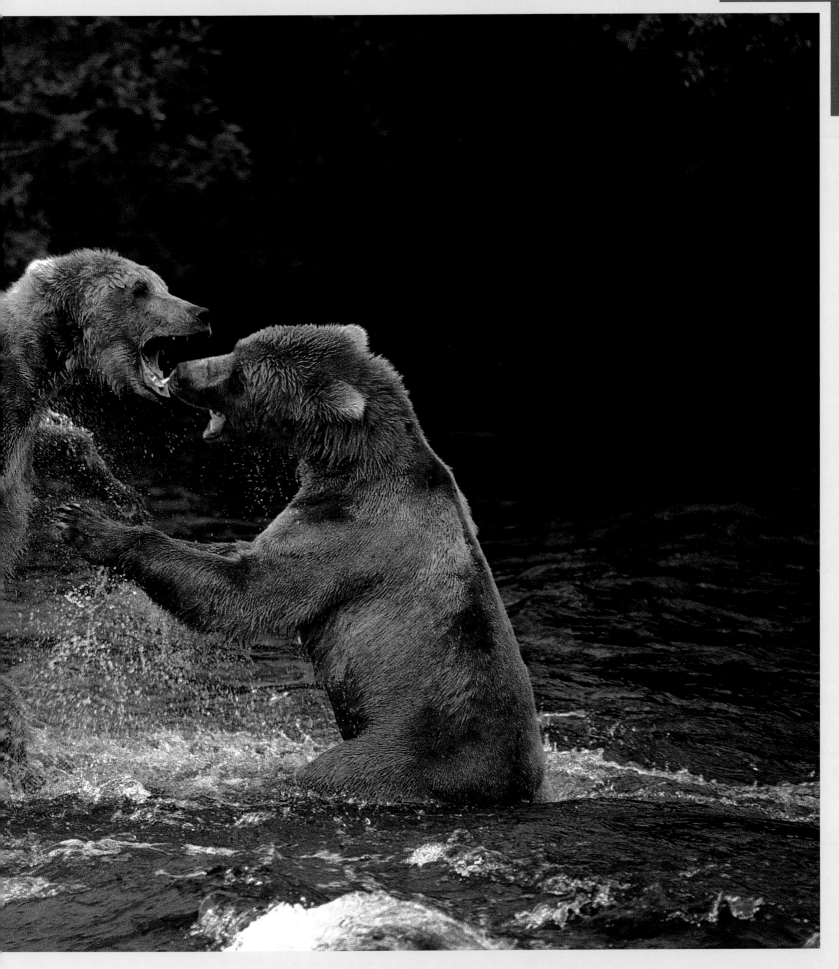

Technical Notes

Medium-format SLR, 50mm lens with polarizing and 81A warm-up filters, Fuji Velvia.

Plants and Gardens

Garden and flower photography has become a quite specialized subject for professional photographers and there is a considerable demand for strong images from photo libraries. But it is also a subject that is readily accessible to all.

In addition to shots of individual plants and blooms, a good garden can provide you with the opportunity for landscape-style images. The added advantage is that a well-designed garden has an inherent sense of order and design, which can help to create a balanced composition.

One of the vital factors in plant photography is to ensure that the plants are in good condition. Shooting early on a summer morning, for example, will avoid wilted blooms and dropping leaves.

Situation and Approach

One of the most productive methods of photographing gardens is to isolate particular features, otherwise the resulting image can easily be overcrowded. This border was so vivid with colour that it was almost painful to look at it. The difficulty was finding a positive focus of interest. I chose a low angle and framed the shot to include the most colourful area of blooms. The blue sky and red tree seemed to make a sympathetic background, but I opened up to an aperture that kept the flowers sharp and threw the background slightly out of focus. This created a focal point and provided an interesting, but not distracting, background to the blooms. (JB)

Mike's Comment

Jules' use of shallow focus has produced an image with an almost abstract, dreamlike quality. The choice of viewpoint has placed the tree in the most effective position against the sharply focused flowers.

Situation and Approach

I came across this delightful English cottage garden while driving through Wiltshire on a perfect summer's day. Unfortunately, the bright sunshine and the deep blue sky created a very harsh and contrasty light, which was not ideal for photographing a scene that contained so many fine details and saturated colours. I explored different viewpoints and found that by shooting into the light the effect was much more pleasing: although the image was still quite contrasty, the amount of deep shadow was limited. Using a polarizing filter helped to subdue some of the brighter highlights on the flowers and foliage and significantly increased the colour saturation. I framed the shot to exclude the sky and to include as much colour as possible in the foreground. (MB)

Jules' Comment

A fine summer's day, a perfect cottage, borders of lavender with roses and hedges combined with the viewpoint, framing and lighting have produced an image that captures the atmosphere of the classic English country garden.

Technical Notes

Medium-format SLR, 55–110mm zoom lens with polarizing filter, Fuji Velvia.

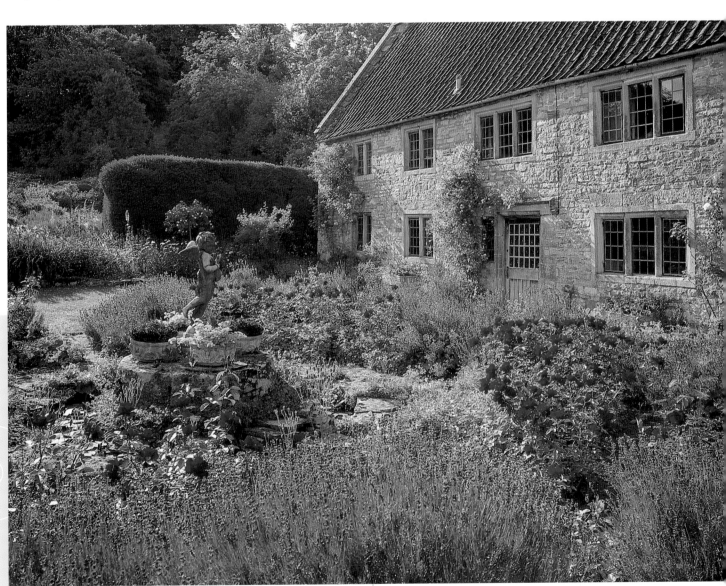

ENGLISH COUNTRY GARDEN

Technical Notes

Medium-format SLR, 120mm macro lens, Fuji Velvia.

Situation and Approach

In this garden, border upon border was filled with colour to the point where it was difficult to find a clear focus of interest. When I came across this stunning red and green leaf nestled amongst some more typical border plants, it seemed the perfect foil. It was difficult to isolate the leaf and still retain the element that made it so striking so it took me a while to find the best viewpoint. I wanted the foreground flowers to partially obscure the leaf and used a wide aperture and very shallow depth of field to achieve this. I framed the image so that the leaf was placed to one side of the picture area, with the out-of-focus red blooms and grass creating a balance. (JB)

Mike's Comment

What makes this picture so striking is the contrast between the red leaf and blooms against the green. This contrast is heightened by the use of a shallow depth of field, which has made the sharply focused red leaf even more dominant.

Jaisalmer, a small, ancient city in the east of the Indian state of Rajasthan, is noted for its exquisitely carved mansions and buildings. Some of the best examples are in a very narrow street that sees the sunlight for only a brief time in the early morning. I had taken a number of close-up details using a long-focus lens, but was anxious to record more of the buildings and their setting. I found a small clearing that allowed me to take up a viewpoint a little to one side of the street, from where the lighting had a lovely glowing quality. Although the viewpoint was very restricted, my 24mm wide-angle shift lens enabled me to include the first two storeys of the nearest building and to see quite a long way down the street. (MB)

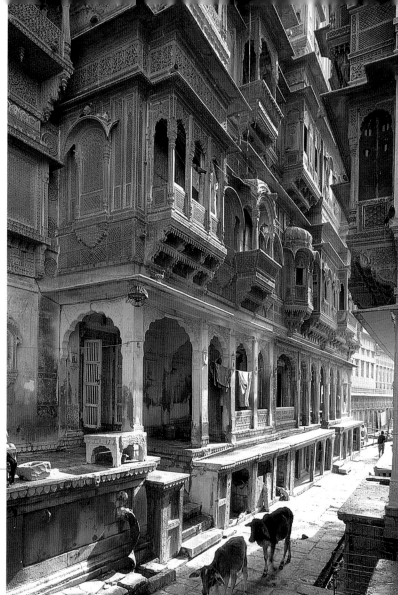

CATTLE IN JAISALMER

Technical Notes

35mm SLR, 24mm shift lens, Fuji Velvia.

Architectural Photography

The choice of viewpoint is crucial for photographs of buildings. It not only determines the perspective of the subject and the aspect of the building that is being presented to the viewer, but also has a big influence on the direction and quality of the light. In urban situations, your choice of viewpoint is often restricted and this can affect both the time at which you record the image and the way in which it can be photographed. When it's important to show the whole structure, or a large part of it, you often need to use a wide-angle lens. Specialist architectural photographers use view cameras or shift lenses to overcome the perspective problems that can be created by a combination of restricted viewpoints and wide-angle lenses. The most common problem is that there is usually more foreground than is needed and not enough space at the top of the frame. Tilting the camera up to overcome this will produce the effect of converging verticals, but the use of a rising front, or shift lens, will achieve the same result without the need to tilt the camera.

Jules' Comment

The atmospheric lighting, together with the wandering cattle, have made this shot less of an architectural study and more of a pictorial essay, which nonetheless captures the intricate decoration and scale of the buildings.

Mike has picked his moment carefully as the lighting seems to be at the optimum angle. I like the use of the reflection, but feel that a bit more of a half-and-half split might have been worth a try as well. The tip is missing from the reflection of the tree, which I find a little distracting; a little more space here would have solved this.

Situation and Approach

There was much less restriction on my choice of viewpoint for this shot of Alnwick Castle in Northumbria, in the north of England, but it was nonetheless critical, as was the time of day at which I photographed it. From this spot, the sunlight illuminated the castle perfectly and I was also able to include the reflections in the foreground. I framed the shot so that the castle itself occupied the top third of the frame. I used a neutral graduated filter to balance the more brightly lit castle with its reflection and an 81B warm-up filter to accentuate the colour of the stone. (MB)

Technical Notes

Medium-format SLR, 55mm lens with neutral graduated and 81B warm-up filters, Fuji Velvia.

REFLECTION OF ALNWICK CASTLE

The Abstract Approach

The angular and geometric nature of buildings makes them an ideal subject for abstract images where the aim is to produce interesting and expressive images as opposed to an identifiable record of a specific structure. Although such images can be made with ancient buildings, modern structures of concrete and glass lend themselves especially well to this approach. Choosing a viewpoint that reveals a particular, and perhaps, unexpected, aspect of a building is the key, together with making full use of the range of lenses. A long-focus lens can isolate a small area of a subject in ways that can create interesting juxtapositions of details, while a wide-angle lens can produce striking perspective effects and add a sense of drama to an image.

Situation and Approach

I took this photograph in Denver, USA, in the early morning when the low-angled sunlight illuminated some buildings but left others in deep shadow. This created some reflections in the office windows, which were accentuated by the fact that the blue sky contrasted boldly with the red brick that features in many of the structures. I used a long-focus lens to isolate the most interesting areas of the scene and found that a slight change in viewpoint and framing presented a quite different image. I also found that by using a polarizing filter I could control the relative brightness of the differently illuminated surfaces. (MB)

Jules' Comment

Reflections can be fascinating and this shot shows how they can be used in a way that creates a strong, but almost abstract, image. Using the forward-facing building to give a sense of perspective and add an element of contrast is effective, giving more dimension to an otherwise flat subject. I like the way the image has been framed to place the brightest reflection well off centre, as it balances the rest of the image.

Technical Notes

35mm SLR,
70–200mm lens
with polarizing
filter, Fuji Velvia.

Useful Advice

Very often, a slight change in viewpoint can
produce a significant difference in the
composition and appearance of an image.
Explore all the possibilities: you will often
be able to find two or more images within
a single subject.

Technical Notes

35mm panoramic
rangefinder
camera, 45mm
lens, Fuji Velvia.

Situation and Approach

It's fairly unusual to use the panoramic
format in the upright orientation, but I felt
it suited this subject very well. The shadows
created by the fire escape were particularly
interesting and I chose a viewpoint that
showed them most clearly. I framed the
shot to include part of the building on the
right, as I also liked the shape that the blue
sky created, and I tilted the camera upwards
to place the two poles towards the bottom
of the frame and include the small pool
of light. The main difficulty was avoiding
flare, as I was shooting almost directly
into the sun; even though the building
obscured it, I needed to shade the lens
with my hand. (JB)

Mike's Comment

This is one occasion when the upright
panoramic format works very well, as it
has isolated the main interest of the
subject and created an ordered arrange-
ment from a potentially confusing tangle
of lines. I also find it interesting that the
shape created by the blue sky has become
a quite dominant element of the
composition of this photograph.

Situation and Approach

This picture is of a detail high up on the wall of the cathedral close in Canterbury, England. I was attracted by the stark, almost theatrical, quality of the statue and the way its bold colour contrasted vividly with the surroundings. In order to minimize the effect of perspective, I used a distant viewpoint in conjunction with a long-focus lens and framed the image to include the two carvings each side of Christ. I used a tripod, as the necessary shutter speed was quite slow, and used both the camera's mirror lock and delayed release to ensure that the image was pin sharp. (MB)

STATUE OF CHRIST, CANTERBURY

Technical Notes

35mm SLR, 70–200mm lens with x 1.4 converter, Fuji Velvia.

Architectural Details

Focusing on individual features and details of a building can produce more interesting and unusual images than the wider view and, as in many other areas of photography, a series of such images will often say more about a building than a straightforward architectural study. The richly carved details on medieval buildings, for instance, can provide a wealth of photographic potential and very often a tightly framed image will reveal striking qualities that would be unnoticed when viewed in the normal context. Subjects like these can often be photographed successfully on days when the lighting is too soft for wider views or when there is a blank sky.

Jules' Comment

Using a distant viewpoint and a long-focus lens has not only helped to fill the frame in a striking way, but has also avoided the perspective distortion that would have been caused by tilting the camera up so steeply. The diffused lighting has made the most of the detail and texture of the statues.

Useful Advice

Even when the light is good enough to hand-hold the camera, it is always best to use a tripod for images like these, as it makes it much easier to frame the image with precision and symmetry – qualities which, if lacking, can detract from the finished photograph.

An intricate subject with wonderful colours and fine detail, which the simple, straightforward approach and soft lighting have recorded well.

Situation and Approach

The Royal Palace in the Indian city of Jaipur is a very impressive building, with numerous options for photography, but the features that most interested me were the magnificent doors. There must be dozens of them and I photographed quite a few of them during my short visit. They are so intricately decorated that a soft and subtle light is needed to reveal their colour and texture. As it was a bright sunny day, I was was only able to photograph those doors that were shaded. This, I think, is my favourite, although it is somewhat the worse for wear. As I had to tilt the camera upwards a little, I used a long-focus lens from a fairly distant viewpoint to minimize the effect of converging verticals. (MB)

Technical Notes

35mm SLR,
70–200mm zoom
lens, Fuji Velvia.

ROYAL PALACE DOOR, JAIPUR

Landscape Photography

A landscape photograph that evokes a mood instantly becomes something much more than simply a record of a nice view. Colour is an important factor in establishing mood and most atmospheric images shot in colour depend to a large extent on their dominant colour quality. This is one reason why the golden-hued sunlight of early morning and late evening is so highly valued. Inappropriate colour, however, can often be a barrier to creating mood, and this is one reason why the black-and-white medium appeals so much to creative photographers. A tranquil lake scene photographed at dusk, for instance, with a bluish cast and a muted colour range, will have a very different mood from the same scene photographed in sunlight, when the colours are brighter and more saturated.

Situation and Approach

It was late afternoon when I caught my first glimpse of Monument Valley, Arizona, and the sun was almost directly ahead. I was attracted by the bold silhouette of the distinctively shaped rocks and the way the road wound towards them. I used a long-focus lens and chose a viewpoint in the middle of the road to recreate the impression I'd had while driving. However, the result was disappointing as the sky was a pale, washed-out blue and the foreground a dull, muddy grey. I scanned the transparency, removed the natural colour, added tone to the sky and then added this golden hue, just as I would have done using a toner on a conventional black-and-white print. (MB)

Jules' Comment

I like the way that the road zig-zags off to the right – a nice element, as it looks as if it should keep going straight between the rock faces. The monochromatic style and golden tone add to the impact. You know a shot works when it is difficult to imagine it any other way.

Technical Notes

35mm SLR, 80–200mm zoom lens with x 1.4 converter, Fuji Velvia.

Technical Notes

Medium-format SLR, 55–110 zoom lens with polarizing filter, Fuji Velvia.

Jules' Comment

The dappled light and vibrant fresh green underline the feeling of spring in this image. Although there isn't a strong focus of interest, the silvery tree trunk draws the eye and the rest of the image is well balanced around it.

Situation and Approach

I found this spot while driving through the mountains of Provence in the early spring. Although the subject matter was unremarkable, I was attracted by the beautiful fresh colours and the dappled sunlight, which seemed to evoke the feeling of springtime very effectively.

I chose a viewpoint that allowed me to see under the main, overhanging tree branch and placed the flowers in the foreground. I framed the shot to exclude the blank sky visible above the branch as well as a more brightly sunlit area immediately to my left. I set a small aperture to ensure that the image was sharp from front to back and used a polarizing filter in order to maximize the colour saturation. (MB)

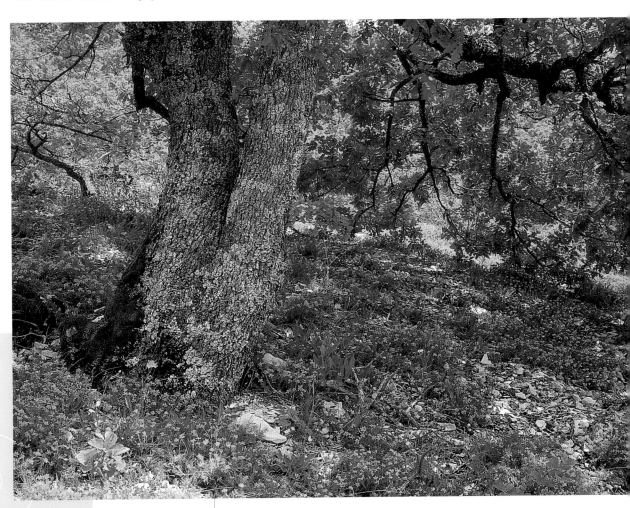

PROVENCE IN SPRING

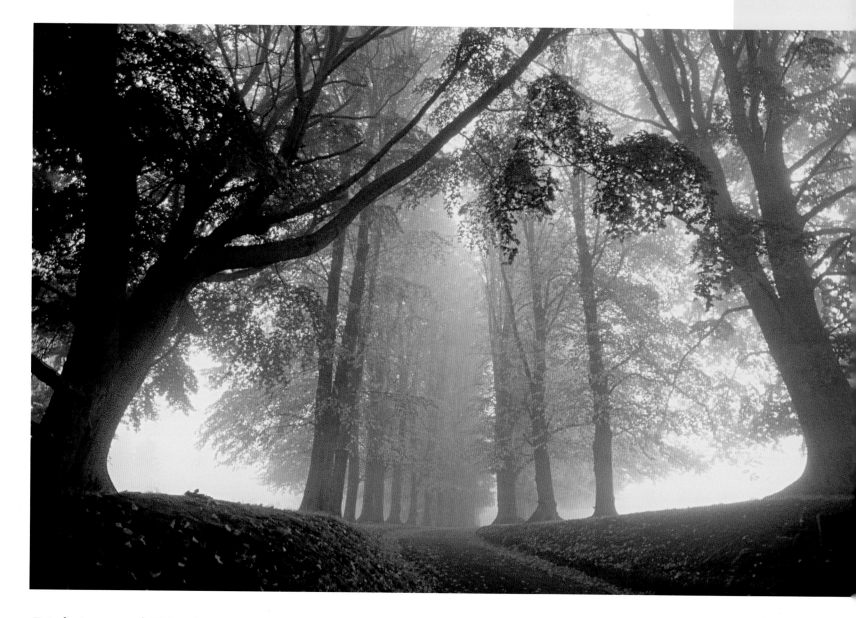

Lighting and Weather

Colour is not the only important factor in creating a sense of mood and atmosphere in an image: the quality of light is also crucial and this, in turn, is influenced by factors such as the sky and the weather. While a bright sunny day with a blue sky and fluffy white clouds might seem like the ideal conditions for landscape photography, in reality truly atmospheric and dramatic pictures are much more likely to be captured on days when you'd think twice about venturing out. The sky is the key to the quality of light in the landscape, as it determines the nature and density of the shadows. Keeping an eye on the weather and the sky can be a very useful way of judging and anticipating the potential of a scene.

Situation and Approach

I took this photograph on a misty morning near my home in Kent, southern England, a good few years ago now and, sadly, the trees were lost in the great storm of 1987. I used a wide-angle lens and tilted the camera steeply upwards to include the overhanging branches of the nearest trees, which were only a few metres away. One reason for doing this was to create impact by distorting the perspective, but it has also enabled me to use the nearest trees and branches as a frame to the image which has, in turn, increased the contrast of a very softly lit scene. (MB)

Useful Advice

Mist and fog often create a larger area of lighter tones than normal, which means that you need to give more exposure than the meter indicates. The best approach is to take a close-up or spot meter reading from a mid tone within the scene.

Jules' Comment

The choice of viewpoint and use of a wide-angle lens have given this image a more dramatic and dynamic quality than I imagine existed in the subject. The composition is perfect, giving a real sense of perspective, and the exposure has captured the misty quality and subtle green of the trees very effectively.

Situation and Approach

The Scottish island of Skye is notorious for its unpredictable and dire weather and my short visit included one day when it seemed like midnight in the middle of the day. This shot was taken at the small port of Elgol, where there were a few fishing boats at work picking up lobster pots and some very satisfying piles of nets – something I find it hard to resist photographing. At this point the sun began to penetrate the cloud a little, which made the dense grey cloud hanging over the mountains seem even more threatening and also created a greater brightness range. I used a wide-angle lens from a close viewpoint to make the most of the fishing nets as a foreground and to enhance the impression of depth and distance. (MB)

Jules' Comment

The wide-angled perspective has underlined the dramatic quality of the lighting and clouds, while the choice of viewpoint has made the most of the saturated colours and produced an image that is both dramatic and serene at the same time.

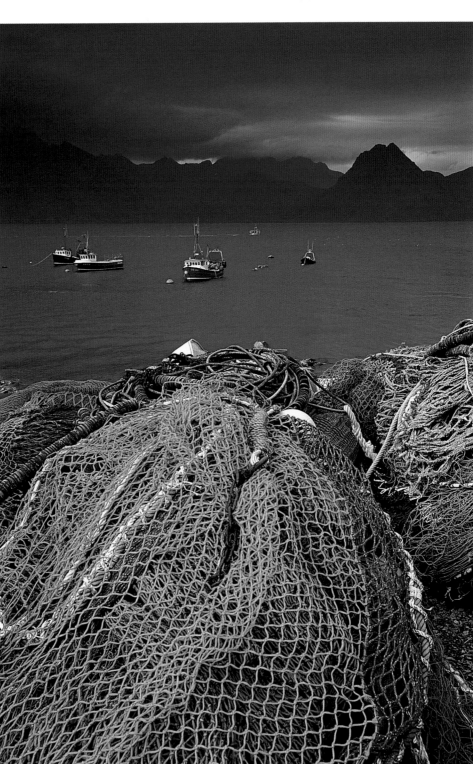

Technical Notes

35mm SLR, 24–35mm zoom lens with neutral graduated filter, Fuji Velvia.

PLASTIC HAY BALES

Technical Notes
Medium-format SLR, 100mm lens with polarizing filter, Fuji Velvia.

The Mark of Man

Many people think of Ansel Adams as being the greatest landscape photographer of all and his style of photography – which could be described as a celebration of wild, unspoiled, natural beauty – finds many adherents (see pages 272–273). As a rule, any sign of man's presence is ruthlessly excluded from this type of image. While such work is very beautiful and inspiring, it does present a rather unrealistic and idealistic impression of the landscape. Beauty, they say, is in the eye of the beholder and there is a valid argument that scenes that might appear unattractive, or even ugly, in conventional terms can still be used to create powerful and evocative photographic images.

Situation and Approach

One of the pitfalls of landscape photography is that you find yourself taking the same kind of picture time after time. Although repeating successful pictures by following the same formula can build up an impressive body of work, it is stimulating to look for a different approach.

This picture came about because I had become frustrated by seeing so many potential images spoiled by black plastic-wrapped hay bales and I decided to look at them in a different way. These bales were stacked against a drystone wall and looked so out of place that it became humorous. I liked the juxtaposition of new and old and the contrasts in shapes and textures. I chose a viewpoint that placed them together in the most telling way and waited for the dramatic bank of cloud to move into position before taking the shot. (JB)

Mike's Comment

This picture pleases me on several levels. First, it makes an interesting image from something that is normally seen as a blot on the landscape. Second, I like the contrast in texture between the shiny plastic, the rough stone wall, the grass and the fluffy white clouds – which seem to echo the shapes of the bales. I also like the four distinct bands of colour.

This appeals to me in the same way as the hay bales. Making a pleasing image from something essentially unsightly is always a challenge and when it works it is rewarding. Here I like the colours and the interaction between the two baskets. I do wonder if a square format would have been more successful in this case, as it would have allowed more of the stand of the first basket to be included.

Situation and Approach

I acknowledge that this picture can only be classified as a landscape in the widest meaning of the term and I'm sure it will not be admired by everyone. I also have only a vague idea of why I felt compelled to photograph it. It was not an impulsive reaction as I'd eyed up this scene on a few occasions before on my regular visits to a beach on Spain's Costa del Sol, but on this occasion the quality of the hazy early morning sunlight tipped the balance as it made the posts stand out boldly from the background. My interest was centred on the juxtaposition of the two rusted posts and the seeming incongruity of the signs within the setting. I chose my viewpoint and framing to create the strongest overall balance. (MB)

Technical Notes

35mm SLR, 24–85mm zoom lens, Fuji Reala colour negative film.

SPANISH BASKETBALL NETS

Situation and Approach

There's a place I visit from time to time in Spain that I can only describe as a waterfall lover's paradise – the Monastery of Piedra, near Nuevelos in the province of Aragon. It is located in a small, deep, wooded valley through which countless waterfalls cascade down through undergrowth and over rocks and cliffs.

I took this photograph in the winter, when there was a good flow of water. It was a sunny day with a deep blue sky and the direct sunlight was quite harsh and contrasty. Most of this area of the valley was in shade and the large expanse of water in the background was illuminated by light reflected from the sky, giving it a bluish tint. I chose a viewpoint that placed the small area of sunlit water in the immediate foreground with a large area of the falls in the background and framed the image to include the leaning tree and the cloud of spray. (MB)

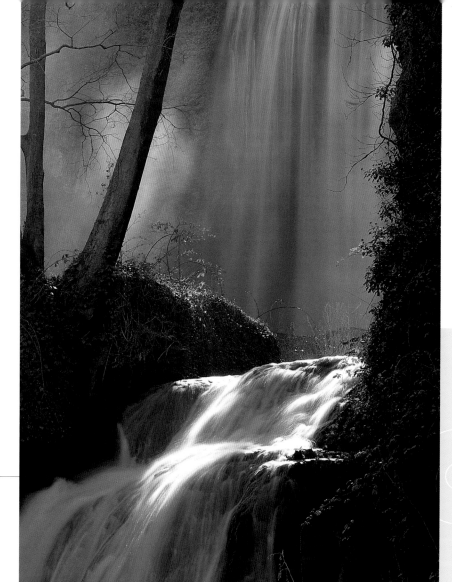

MOVING WATERFALL

Technical Notes

Medium-format SLR, 55–110mm zoom lens, Fuji Velvia.

Natural Elements

Selective areas of the landscape, which create a focus on the natural elements from which it is formed, can also produce telling images. Natural forms such as wood, stone, water, clouds and earth provide such a wealth and variety of shapes, texture, colours and forms that it is often possible to see pictures in the most unexpected places and in locations that would not necessarily be considered photogenic in themselves. In many ways it's a question of focus: landscape photography is often about looking at the distant scene and so it is sometimes possible not to see the trees for the wood. Observing the individual elements that create the landscape in close detail can be both revealing and rewarding.

Jules' Comment

This is an extremely atmospheric shot that owes a lot to the way that Mike has framed it. Using the tree on the left and the foliage on the right has made the scene more intimate. A slow shutter speed has given the classic misty feel and the framing has made the highlight on the water a strong focus of interest.

Situation and Approach

I found this impressive boulder on a beach in Devon, England, near where I live. The evening light was warm and pleasing, but it had yet to reach the really rich and intense stage. My choice of viewpoint was determined by the need to consider the angle of the lighting. From here, the boulder was lit quite evenly but there was enough shadow to provide the feeling of depth and solidity I wanted. In order to make the boulder even more imposing, I chose a wide-angle lens and shot from very close by, from a low angle. I was lucky enough to have a section of blue sky in just the right place to provide a contrasting background and a splash of colour. (JB)

Mike's Comment

Through his choice of viewpoint and sympathetic lighting, Jules has managed to convey a sense of the boulder's massive bulk and solidity.

Technical Notes

Medium-format SLR, 50mm lens with polarizing filter, Fuji Velvia.

GIANT BEACH BOULDER

Documentary and Travel Photography

Photographs that record the way people live their lives tend to be among those that endure the test of time most successfully and, I believe, have a greater lasting value. While iconic landscape images, such as those of Ansel Adams, have become part of photography's heritage, they are in the minority when compared to images that reveal the culture and lifestyle of a society and record historical moments. While artists have recorded world events before and since the invention of photography, I think that the images made by people like Robert Capa, Don McCullin and Tim Page will be those that most people will remember. Imagine how illuminating it would be to have similar images of historic events from many centuries ago.

Situation and Approach

Many years ago, I was commissioned to illustrate a book on Israel. I made my trip in 1968, the year after the Six Day War. There was an incredibly buoyant and optimistic atmosphere in the country and many Israelis had been able to visit the old city of Jerusalem for the first time, as it had been under Jordanian rule before then. My visit coincided with the celebrations for the anniversary of the formation of the state of Israel and a massive parade of military might was the highlight. I was allowed to get very close to the action and, on occasion, in among it.

For this shot, I used a wide-angle lens from as close a viewpoint as possible, as I thought that this would best convey the

sense of energy and movement of the occasion. I used a small aperture to obtain good depth of field, but one that allowed a fast enough shutter speed to freeze the movement. As this was long before autofocus cameras, I pre-focused and framed my shots, waiting until the right moment before making my exposures. (MB)

Jules' Comment

Mike's use of a wide-angle lens from a close viewpoint has enhanced the sense of being part of the march. There is a feeling of movement here that makes the viewer feel almost swept along with it.

Technical Notes

35mm SLR, 20mm wide-angle lens, Kodak Ektachrome 64.

Jules' Comment

This picture pleases on a number of levels, not least that it's an evocative image which has a strong nostalgic quality. Its impact is heightened by a good choice of viewpoint and framing, a nicely balanced composition and sympathetic lighting.

Situation and Approach

I shot this picture more than forty years ago, at a time when the hop fields near my home were harvested by families from the East End of London who would come for several weeks each year to spend their annual holiday in small cabins at the edge of the fields. There was a wonderful sense of community and a very good-natured atmosphere, which made it easy to take quite intimate pictures. For this shot, I chose a viewpoint that placed the two women each side of the "poke" facing me and framed the image so that they were fairly central, with enough of the hop field visible to establish the setting. (MB)

Useful Advice

Few of us have the opportunity, or dedication, to record events of major world importance such as wars and famines, but we can all put our photographic skills to good use to preserve memories of local events and ways of life.

Travel photography requires a similar approach to documentary work. Both depend on being able to capture the essence of a location and convey a sense of being there.

The more sanitized type of travel photography is just as demanding in its own way, as it depends on the photographer being able to produce striking images from subject matter that ranges from wild flowers to food, architecture and landscape.

One of the most desirable qualities in good travel photography is to establish a sense of place. Obviously, a picture of the Eiffel Tower is going to say Paris – but images that have a more subtle and personal slant are more satisfying to take and more interesting to look at. You need to use your powers of observation to identify a location's unique characteristics and to see beyond any preconceptions or clichés.

Situation and Approach

A few years ago I visited the Pushkar Camel Fair in Rajasthan, a combination of pilgrimage, religious devotion, livestock market and fairground. It lasts for about three weeks, during which time the sand dunes surrounding the town of Pushkar become a vast tented village housing the countless people and animals who come, often from great distances, to be there. For three days I did not put my camera down while there was still some light in the sky.

This shot was taken just before sunrise, when people and animals were just beginning to stir. I like it best of all the shots I took of the sand dunes because, for me, it comes closest to the true feeling of the place: the muted colour and haphazard, almost aimless feeling seem to evoke the underlying reflective mood of the event

better than the much more colourful shots I took of people dressed up in their most colourful clothes during the day. I used a long-focus lens to frame the shot in a way that created a reasonably balanced and cohesive image from a very untidy scene. (MB)

Jules' Comment

For me, this image sums up India more than pictures of beautiful architecture and colourful clothes. This image is all about culture and tradition and makes no attempt to glorify or romanticize it.

Mike's Comment

I have a fondness for signs, windows and shop fronts and this picture certainly satisfies on that level, but I also feel that it is unmistakably America – bold, colourful and up-front. The square-on viewpoint and tight framing of the panoramic format maximize the image's impact.

Situation and Approach

This was the perfect subject for a panoramic picture: it fitted the format perfectly. Shooting it wasn't without problems, however, as a car parked in front stuck out like a sore thumb. Luckily the car belonged to the store owner and she was happy to move it.

The day was overcast and the lighting very soft, which had the benefit of reducing the shadow density and allowing me to capture more detail. I would have preferred a blue sky for the background, but the weather seemed unlikely to change in the near future. The viewpoint and framing were, effectively, chosen by the subject itself. This photo works for me largely because of the format and the colourful façade, but it is also a record of a visit which still evokes a sense of being there. (JB)

CONTINENTAL DIVIDE

Situation and Approach

A walk through the bazaar in the old city of Delhi provides a wealth of local colour and interesting subjects, but the crowds and jumble of colourful objects can easily become overwhelming. It is also hard to melt into the background, as all the traders are on the look-out for passing tourists. I was attracted by this man's relaxed demeanour and the way he'd kicked off his shoes for comfort, as well as by the colourful geometric pattern his wares had created. I stood in the spot from which I wanted to shoot, which was only a couple of metres (yards) away from him, and aimed my wide-angle lens at a point to his right. Although I'm sure he suspected that I had him in my sights, he could not resist taking a look at what I appeared to be shooting, and that's when I made my exposure. (MB)

CARPET MAN, DELHI

Technical Notes

35mm SLR, 24–85mm zoom lens, Kodak Ektachrome 100SW.

Working Unobtrusively

Photographing local people is an essential aspect of travel and documentary photography, but it can be rather daunting – particularly in countries that have a different culture. Asking permission first is obviously the ideal approach, but this is not always practicable. In Asian and African countries, a Westerner with a camera will stand out like a sore thumb and even in your own environment you may attract attention. The best approach is simply to take your time: although your presence is initially likely to arouse some curiosity, it will quickly wane. It helps not to look too much like a photographer: don't flaunt your camera ostentatiously, avoid using a smart-looking camera bag and, ideally, keep spare lenses and film in your pockets.

Useful Advice

Using a long-focus lens from a more distant viewpoint might seem like a good way of hiding your intentions, but it is always very obvious precisely where such a lens is aimed. You can, however, convince your intended subject that your interest is directed elsewhere by using a wide-angle lens from a close viewpoint. Take up your chosen viewpoint, look intently at something in the opposite direction and, as soon as your victim loses interest and looks away, aim, frame and shoot.

Jules' Comment

I love the riot of of colour and detail in this shot and feel this could be a picture on its own, but the addition of the man and his expression is what adds the sparkle and a vital focus of attention to the image. I might have been tempted to take a more tightly framed shot as well, to avoid the area of black to the man's left, as I find it a little distracting.

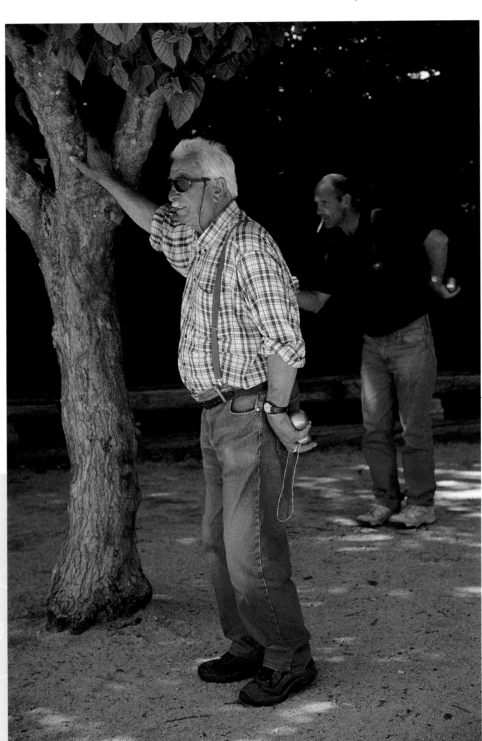

Jules' Comment

The classic French game is captured here in all its relaxed atmosphere, with the dappled light adding a nice touch and the main subject perfectly illuminated in a way that evokes a hot summer's day. The choice of viewpoint has placed the two men in a balanced way.

Situation and Approach

A group of villagers were having a leisurely game of pétanque in the tree-shaded square of a small French village as I drove through. There was a nice quality of light and the scene had a good atmosphere. I walked over and asked if I might shoot some pictures, to which they readily agreed. In fact, I did not begin shooting for a while until they had become totally reimmersed in their game. In the end, I think they forgot I was there and I was able to shoot discreetly, but freely. (MB)

Technical Notes

35mm SLR, 24–85mm zoom lens, Fuji Provia 400F.

PÉTANQUE GAME

Recording the Image

The variety of camera types on the market can be bewildering and their complexity daunting, but in essence a camera is nothing more than a light-tight box with a lens at one end and a place for the film or light sensor at the other. It's worth remembering that many of the greatest photographs have been taken on cameras that were little more than this, and the only really significant way in which they've changed is that they have become easier to use. This chapter provides a brief overview of camera types and formats, so that you can make an informed choice about what's best for you.

One of the keys to success in any kind of craft or creative enterprise is that using the tools should become instinctive. A big step towards this is to choose a camera that you are comfortable using and one that is suited to the kind of work you want to do. The next step is to practise until using the camera and its accessories becomes second nature: if you have to stop and think about the mechanics of taking a shot, the chances are that you will miss some great images. In this section you will find not only an explanation of the basics of camera technique, but also lots of ideas for using those techniques creatively.

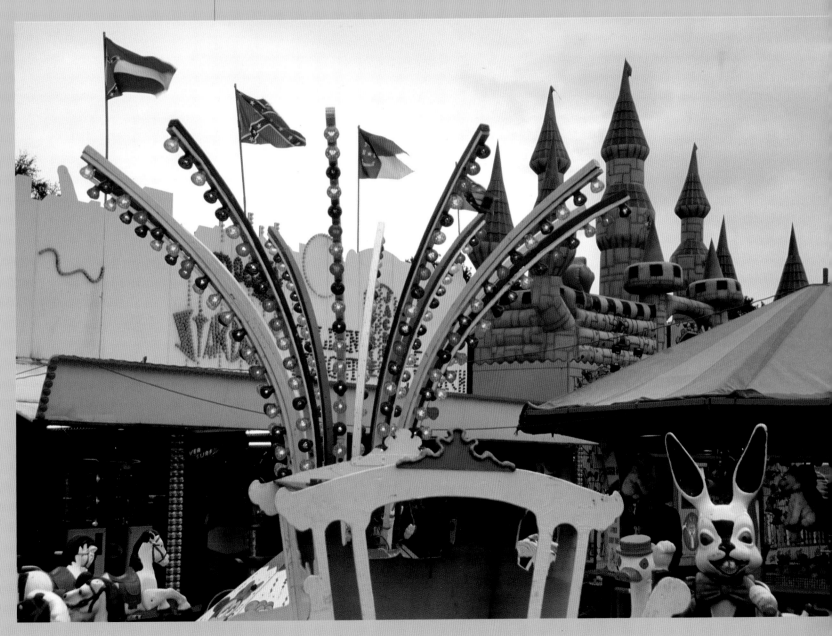

THE PALACE OF SAMODE, RAJASTHAN

Camera Types

There are four basic types of camera and each has its advantages and disadvantages. The main differences between them are the way in which the image is viewed and focused.

The view camera is designed to use large, single sheets of film and offers the ultimate in image quality. One advantage of view cameras is that both the lens and the film plane can be angled and tilted independently of each other, making it possible to have a high degree of control over both depth of field and perspective. The image is viewed by means of a ground glass screen positioned in the film plane, which shows exactly what will be recorded on the film. In order to make the exposure, however, the film replaces the ground glass screen and the image can no longer be viewed. Because of this, view cameras are only really practicable for static subjects such as still lifes, architecture and landscapes.

The viewfinder/rangefinder camera is an advance on this design as far as ease of use is concerned, since it uses a separate optical system to show the field of view and a rangefinder to enable accurate focusing. The image being viewed shows the scene in sharp focus and the lens must be focused by means of a rangefinder, or autofocus. Because of this, you cannot see the effects of focusing and depth of field, or of using filters.

Viewfinder/rangefinder cameras tend to be smaller, lighter and quieter in operation than their SLR equivalents, which makes them a popular choice when some discretion is required – when photographing people in sensitive situations,

**Technical
Notes**

35mm rangefinder
camera, 35mm
lens, Kodak
Ektachrome
100SW.

Situation and Approach

I used a 35mm rangefinder camera to shoot
this image of a market stall in Bangkok.
Its small size and quiet operation make
it less likely to be noticed than a bigger,
noisy SLR. (MB)

for example. For this reason, 35mm viewfinder cameras such as the Leica have been the first choice of photojournalists for many years.

The twin lens reflex is all but extinct, but it does combine separate viewing and exposure and has the advantage that you can see the effects of focusing on a screen. With this type of camera a matched, but separate, lens mounted above the lens that records the image projects an image up on to a ground glass screen for viewing. While this shows the effect of focusing, it cannot show the effects of depth of field, as there is no means of controlling the aperture.

One drawback with cameras that have separate viewing systems, such as twin lens reflex and viewfinder/rangefinder cameras, is that the image that is being recorded is not exactly the same as the one that you see through the viewfinder, because they are from slightly different viewpoints. This causes parallax error. Parallax error is the result of the taking lens being in a slightly different position from the lens that records the image. It's very much like looking at a scene first through one eye and then through the other. This drawback makes these cameras inconvenient for close-up photography and it also means that you cannot see whether the image is in focus before you take the shot or the effect of using any attachments, such as filters.

Situation and Approach

I couldn't get any closer to this reticulated giraffe in Kenya's Samburu game park without running the risk of scaring him away, but I was able to fill the frame using a 400mm lens. I used a 35mm SLR camera, as it is by far the most practical format for use with very long-focus lenses. The size, weight and cost of an equivalent lens for a medium-format camera would be excessive – if, indeed, one was available. (MB)

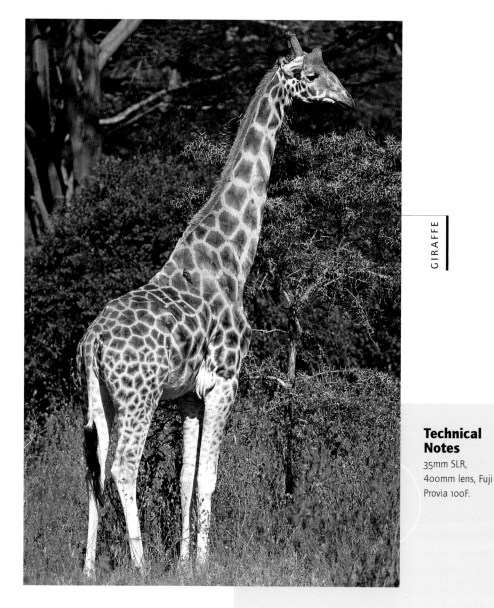

Technical Notes

35mm SLR, 400mm lens, Fuji Provia 100F.

The single lens reflex camera provides the most practical method of viewing and focusing, as the image projected by the lens that makes the exposure is diverted on to the viewing screen by a mirror until the moment the exposure is made, when it flips up momentarily and allows the image to play on the film. You can clearly see the field of view, regardless of what lens is fitted, and the effect of any attachments, such as filters. The SLR system readily allows the inclusion of facilities such as automatic exposure control and autofocusing.

The design of the SLR has made it ideal for the basis of a comprehensive system because the viewing method shows the effects of widely varying focal lengths accurately. The main manufacturers of these cameras offer a vast selection of lenses and accessories, making the camera suitable for almost any application, from macro photography to medical, sport and wildlife.

Because the cameras are relatively small, light and highly manoeuvrable but can be fitted with very long-focus, wide-aperture lenses, the 35mm SLR system has tended to dominate wildlife and sports photography. The top-of-the-range models have very fast motor drives, making it possible to shoot up to ten frames or more per second.

Digital cameras are produced in a variety of types and formats. The main feature, of course, is that they do not use film: the image is captured electronically on a sensor. You can view the recorded image almost immediately after you have made the exposure, but only at the highest level does image quality begin to match that of film at the present time.

Situation and Approach
I used an SLR camera with a macro lens to take this close-up image of two autumnal leaves. It would be very difficult to frame a small subject as accurately as this with a viewfinder/rangefinder camera. (MB)

Technical Notes
35mm SLR, 100mm macro lens, Fuji Velvia.

LEAVES

Michael Fatali

was born in Brooklyn, New York, in 1965. His love of the great outdoors started at the age of six, when his family moved to Southern Arizona, and developed during camping trips with his father. The loss of his mother at the age of 15 moved him to develop his unique relationship with the beauty of nature and he set about rediscovering himself. In 1990 he set off with his wife to the deserts of south-west America with little money, his large plate camera and the desire not only to improve as a photographer but to capture the landscape as he felt it, in harmony. His first gallery was opened in Arizona where international recognition followed.

Fatali and his family now live in Springdale, Utah, where they share their exclusive gallery collection, and teach creativity through the Fatali Schoolhouse of Photography. Famous for his sensitive capturing of light, the crucial element that pervades Fatali's photographs is a sense of connectedness with the natural world and a dedicated and expressive approach.

Jules' Comment

There can be few photographers able to fully capture the grace of the natural world and the unique qualities of light so strikingly, as Fatali. This shot demonstrates both in typical Fatali fashion.

Capturing the subtle qualities with a striking composition creates a photograph that is immediately eye-catching and absorbing. The light has not only enhanced the subject's colour but has also revealed rich textures and subtle tones that have been recorded with optimum quality using a large-format view camera.

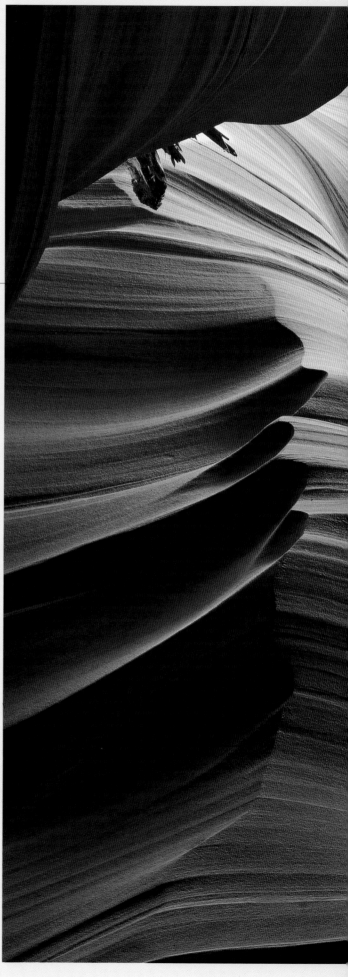

POETRY IN MOTION

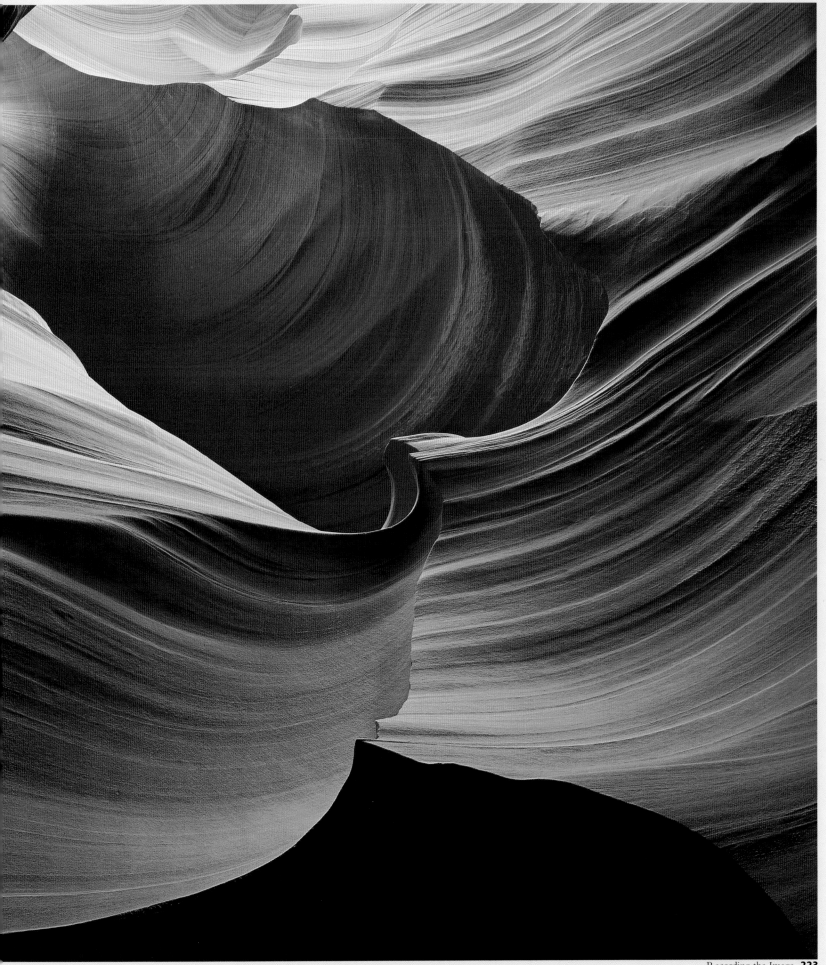

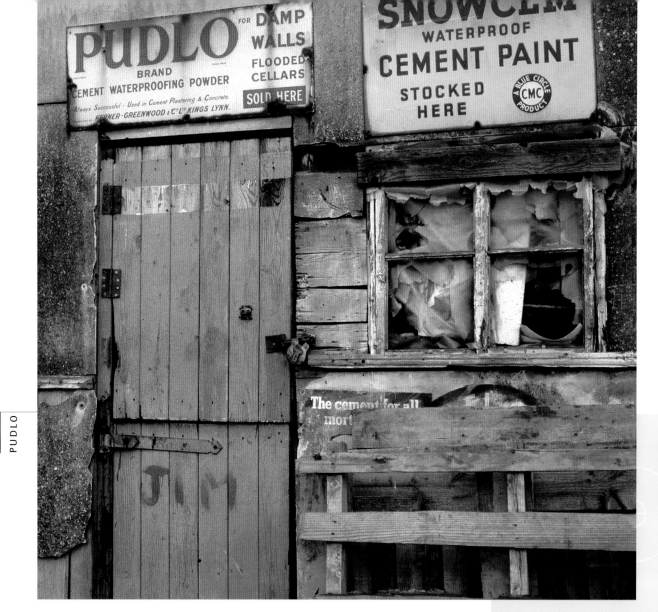

Technical Notes

Medium-format twin lens reflex, Kodak Ektachrome 64.

Camera Formats

The camera format is another important consideration, as it affects the camera's size and weight and the cost of accessories and film. Large-format cameras, which use sheet film varying in size from 5 x 4 to 10 x 8 inches, offer the best image quality for the simple reason that the recorded image does not have to be enlarged as much as it does from medium-format or 35mm cameras. This not only produces better image sharpness but also tends to create smoother and more subtle tonal gradations. But these advantages are not readily noticeable with prints or reproductions of less than about 280 x 216mm (8½ x 11 inches). Cameras that use sheet film are largely restricted to the view camera design, but they can also be fitted with roll-film backs, which allows the use of smaller formats.

Medium-format, or roll-film, cameras range from the extreme panoramic shape of 6 x 17cm to the classically proportioned 6 x 4.5cm format. The 6 x 6cm format has long been used by professional photographers; the square shape allows the image to be cropped to either a landscape or portrait shape after exposure, depending on the needs of a designer or art director.

The 35mm format offers by far the widest choice of camera types and makes and the cameras are much smaller and lighter than medium-format cameras. The relatively small image area also means that lenses can provide very high resolution over an extremely wide range of focal lengths. The choice of film is also much wider for 35mm cameras than the larger formats and, of course, film and processing costs are

Situation and Approach
Shot in a builders' yard using a 6 x 6cm camera, this image (opposite) filled the frame so well that it could not be cropped satisfactorily to a rectangle. This is a potential problem with non-conventional film formats and it can make some images difficult to use in certain circumstances, such as on a page layout, for instance. (MB)

considerably lower. With the increasing popularity of digital imaging, it's also worth remembering that 35mm transparencies and negatives are easier and significantly less expensive to scan than larger formats.

A large negative or transparency does not need to be enlarged as much as a smaller one, making its potential image quality higher, but in practice the quality of 35mm lenses and developments in film technology have narrowed the gap considerably. It is only when very big enlargements are made that the advantage of medium- and large-format images becomes apparent.

The choice of camera type and format can have a significant effect on a photographer's style and approach, and this can be just as important a consideration as image size and quality when deciding what equipment to buy. If you study the work of photographers who use different camera formats, it becomes apparent that those who favour a more studied and controlled approach tend to use medium- or large-format cameras, whereas those who prefer the 35mm format invariably have a looser, more flexible style. There is also a tendency for the much lower cost of shooting on 35mm to encourage a more experimental and adventurous style, while the greater running costs of medium- and large-format cameras prompt photographers to adopt a "safer" approach.

ST MARK'S SQUARE

Technical Notes
35mm panoramic camera, 45mm lens, Fuji Velvia.

Situation and Approach
The panoramic format of 65 x 24mm is more commonly used in the landscape orientation, but a portrait shape suited this image of the tower in St Mark's Square, Venice, perfectly. (MB)

Situation and Approach

I photographed this stand of trees in the Jura region of France in the autumn, using a 6 x 7cm camera. Reproduced at a smaller size, it would be very difficult to distinguish between this and a good quality 35mm transparency; enlarged to fill a double page spread or to the size of an exhibition print, however, the smoother tones and finer detail of the larger image are evident. (MB)

Technical Notes

Medium-format SLR, 105–210mm lens with polarizing and 81B warm-up filters, Fuji Velvia.

Using Lenses Creatively

n the simplest terms, a camera is a means of containing and controlling the image created by a lens, but the lens you choose has a considerable influence on both the quality and the effect of a photograph.

Apart from their optical quality and ability to resolve detail, lenses vary in two ways – their focal length and their maximum aperture. These two factors are related to the area that the lens is designed to cover – the camera format.

A standard lens is designed to produce a field of view of about 45° and this approximates to the diagonal measurement of the image area. Thus, a standard lens is 50mm in length for a 35mm camera, 80mm for a 6 x 6cm camera, and 105mm for a 6 x 7cm camera. Lenses that have a longer focal length than a standard lens have a narrower field of view and produce a

magnified image. To work out the magnification factor, you will need to divide the focal length of the lens by that of a standard lens: a 200mm lens will magnify the image to four times the size of the image created by a 50mm lens and will have an angle of view of 12°.

A wide-angle lens has a shorter focal length than a standard lens. It reduces the size of the image and shows a wider area than a standard lens: a 24mm wide-angle lens on a 35mm camera reduces the image size to slightly less than half that of a 50mm lens and provides an angle of view of 90°

Situation and Approach
This photograph was taken using a 35mm lens on a 6 x 4.5cm camera – a wide-angle lens. Moving further away from the subject was not an option, but the wide field of view and reduction in image size have allowed me to include a large area of this interior in the frame from a restricted viewpoint. (MB)

Lens apertures are indicated by a number that is arrived at by dividing the focal length by the diameter of the aperture. A 50mm f/2 lens would have a maximum aperture of 25mm and a 200mm f/4 lens one of 50mm diameter. Wide-aperture lenses provide a brighter image in SLR viewfinders and allow the use of faster shutter speeds in low light levels.

Many 35mm cameras are now sold with a mid-range zoom, which can vary from 28mm or 35mm focal length to 70mm or 90mm, as an alternative to a fixed focal length standard lens. Wider-range zooms are available, but there is an inevitable trade-off in image quality. For the highest resolution, a good-quality fixed focal length lens is the best option.

ZEBRA

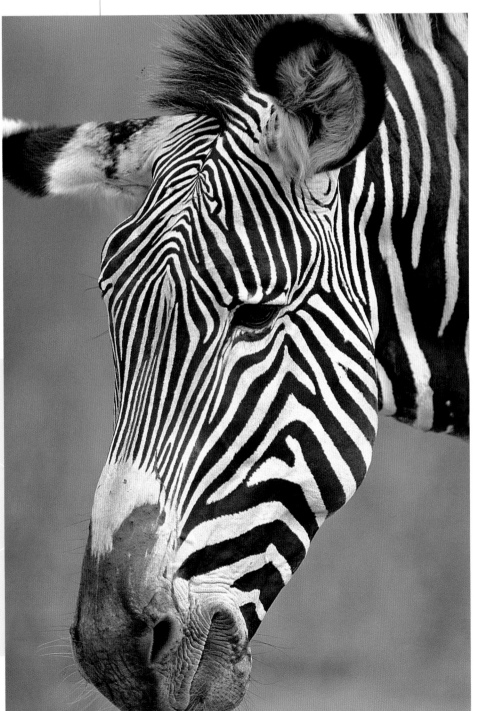

Situation and Approach
I used a 600mm f/4 lens on a 35mm camera to photograph this tightly framed image of a zebra from a distant viewpoint, because moving closer to the animal would have disturbed it. The narrow field of view has made the image 12 times larger than it would have been with a standard lens and the wide aperture has created a very shallow depth of field, making the background details a featureless blur. (MB)

I used a 20mm wide-angle lens on a 35mm camera for this photograph of a railway track in the Colorado Rockies and selected a viewpoint that placed the closest foreground details less than 2 metres (6 feet) from the camera. The lens's wide field of view made it possible to include both this and the distant objects in the frame. I used a small aperture to create enough depth of field to render both near and distant details in sharp focus. (MB)

RAIL CROSSING

Technical Notes

35mm SLR, 20mm wide-angle lens with polarizing and 81B warm-up filters, Fuji Velvia.

The lens that you choose has a marked effect on the perspective of an image. Although perspective is controlled by the photographer's viewpoint, it is the extent of a scene that is included in an image that determines the effect of the perspective. This is because in a two-dimensional image we gain an impression of perspective by comparing the relative sizes of close and distant objects.

A lens that has a narrow field of view and shows only objects that are a long way from the camera minimizes the impression of perspective. A lens with a wide field of view, which includes objects both close to the camera and much further away, emphasizes the effect of perspective and creates an image with a heightened sense of depth and distance.

As far as it's possible to make a comparison, our eyesight provides us with a field of view that is similar to that of a standard camera lens – about 45° – and we are accustomed to viewing things in this way. A significantly wider or narrower angle of view looks unusual and this is something that can be used effectively in a photograph to create impact.

A wider field of view not only allows a much greater area of the scene to be included in the frame, but it can also enable you to include objects that are close to the camera as well as distant ones. This will significantly alter the impression of perspective, as it exaggerates the apparent difference in size between similar objects that are located at different distances from the camera.

A 600mm lens has greatly enlarged this image of a canoeist returning home after a day's fishing in Sri Lanka and in doing so has created an impression of compressed perspective, with the sun appearing unrealistically large in relation to the rest of the scene. (MB)

Technical Notes

35mm SLR,
600mm lens,
Fuji Velvia.

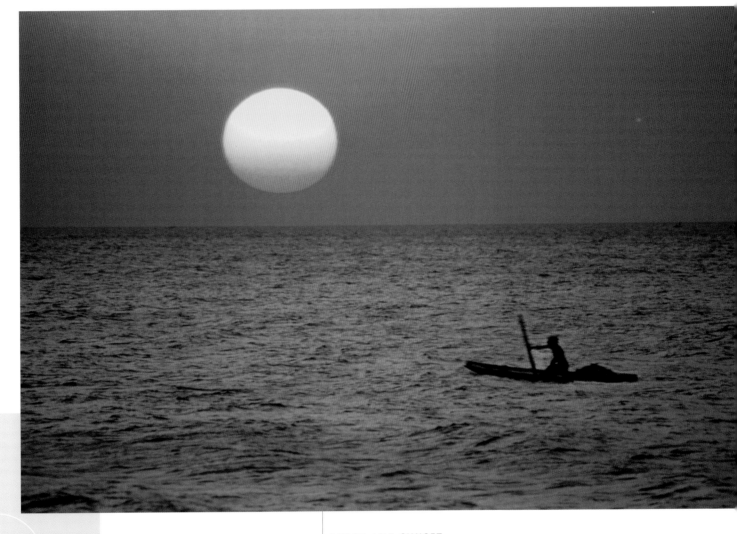

CANOE AND SUNSET

A narrower field of view will limit the amount of foreground that can be included in an image, as well as the breadth of view, and this will inhibit the impression of perspective. This, in turn, will make objects of a similar size that are at different distances from the camera seem much closer to their true relative sizes.

I used a macro lens fitted with an extension tube to produce this larger than life-size image of the interior of an abalone shell, photographed indoors by window light. I used a small aperture to create enough depth of field to record all of the subject in sharp focus. (MB)

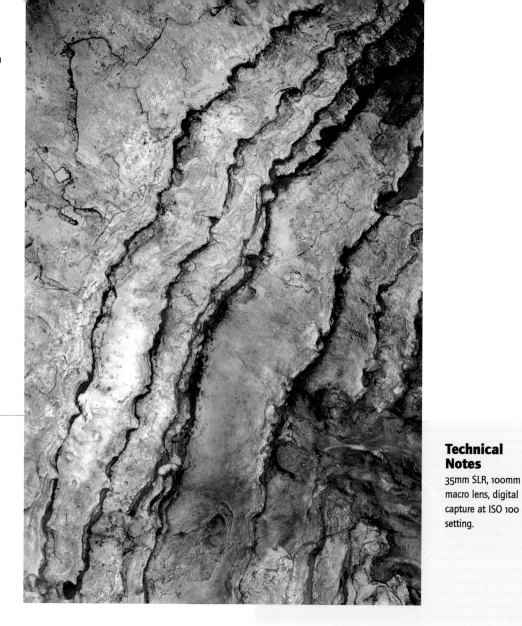

MOTHER OF PEARL

Technical Notes

35mm SLR, 100mm macro lens, digital capture at ISO 100 setting.

Specialist Lenses

There are also specialist lenses, which are designed to deal with particular situations.

Macro lenses One of the most useful specialist lenses is the macro lens, which overcomes the close-focusing limitations of normal lens design. Normal camera lenses are configured to produce maximum resolution at distances beyond 1 metre (3 feet) and most can not be focused closer than this without using extension tubes, bellows units or close-up attachments. Although some lenses have a so-called macro-focusing setting, they do not provide the same image quality as a true macro lens.

Macro lenses are designed to focus at distances that produce a life-size image in the camera with optimum results. They can be bought in a range of focal lengths, but the long-focus versions do not need the camera to be placed so close to the subject. When a 35mm camera with a 50mm macro lens is positioned to produced a life-size image, it is so close that it becomes difficult to light the subject satisfactorily.

Shift lenses A shift lens is designed to raise or lower the optical axis in a similar way to the rising front on a view camera. This enables 35mm and medium-format camera users to have some control over the perspective of their images when shooting subjects such as buildings, as you can raise the image to include more at the top without having to tilt the camera and cause the verticals to converge. Some shift lenses also allow a degree of tilt, which can be used to increase the depth of field just as it can with a view camera.

Situation and Approach

Although a shift lens is used most commonly to photograph architectural subjects, it can be very useful for landscapes, too. I used a 24mm shift lens to shoot this rock formation in Utah's Arches National Park in order to avoid tilting the camera upwards. The lack of distortion has produced a more pleasing and more impressive image. (MB)

Technical Notes

35mm SLR, 24mm shift lens with polarizing and 81B warm-up filters, Fuji Velvia

Situation and Approach

Bryce Canyon in Utah looks particularly spectacular at sunrise when the warm quality of the sunlight intensifies the colour of the rock formations. The effect is heightened by the contrast with the bluish quality of the more distant areas, which are still in shadow. This image shows quite clearly the effect that colour temperature variations can have when recorded on film. I used a polarizing filter to intensify the colours and to enhance the difference in hue between the two areas. (MB)

Technical Notes

35mm SLR, 24–85mm zoom lens with polarizing filter, Fuji Velvia.

Using Filters

Filters are invaluable for controlling the way an image is recorded on film. Colour-balancing filters control differences between the colour temperature of the light and that for which the film is balanced, thus avoiding, or deliberately introducing, colour casts. Colour-correction filters are used to prevent a colour cast when a daylight film is used in tungsten light and vice versa. Polarizing and neutral graduated filters are used to control the tonal range of the image and there are also special effects filters, such as starburst and soft-focus filters, that can be used to deliberately distort the image.

Colour-balancing filters Daylight transparency film is designed to render colours accurately when the subject is illuminated by sunlight with a colour temperature of about 5600°K –

approximating to summer sunlight at midday. But the colour temperature of light can vary from 3000°K (very red) close to sunset to 20,000°K (very blue) in open shade under a blue sky. Transparency film records the colour variation, even though it may not be apparent to the eye.

Although colour accuracy is not necessarily a prime concern for creative images, they should still look pleasing to the eye. A landscape with a blue cast, for instance, can look unattractive, while a portrait can look unflattering if the skin tones are too red. Straw-coloured filters in the Wratten 81 range will correct the blue cast and the pale blue-tinted filters in the Wratten 82 range will balance a red cast. Unless you use a colour temperature meter, deciding which strength of filter to use is a matter of personal judgement and experience.

Colour-correction filters Much stronger filters are needed to remove the colour cast caused by shooting in artificial light, such as tungsten bulbs and fluorescent tubes, on daylight colour transparency film. But if you shoot on colour negative film, it is not so important to use colour-balancing or correction filters, because any unwanted colour casts can be removed at the printing stage. With a digital camera, the white balance control should enable you to remove any colour casts within the camera.

Technical Notes

35mm SLR,
70–200mm zoom
lens, Fuji Provia.

RAJASTHANI TRIBESMAN 1

RAJASTHANI TRIBESMAN 2

Situation and Approach

I took these photographs of a Rajasthani tribesman in the late afternoon, when the sun was low in the sky and its colour temperature significantly less than that for which the film is balanced. This has created the florid skin tones of the image on the left, while the image on the right shows the more natural colour produced by using an 82B colour-balancing filter. (MB)

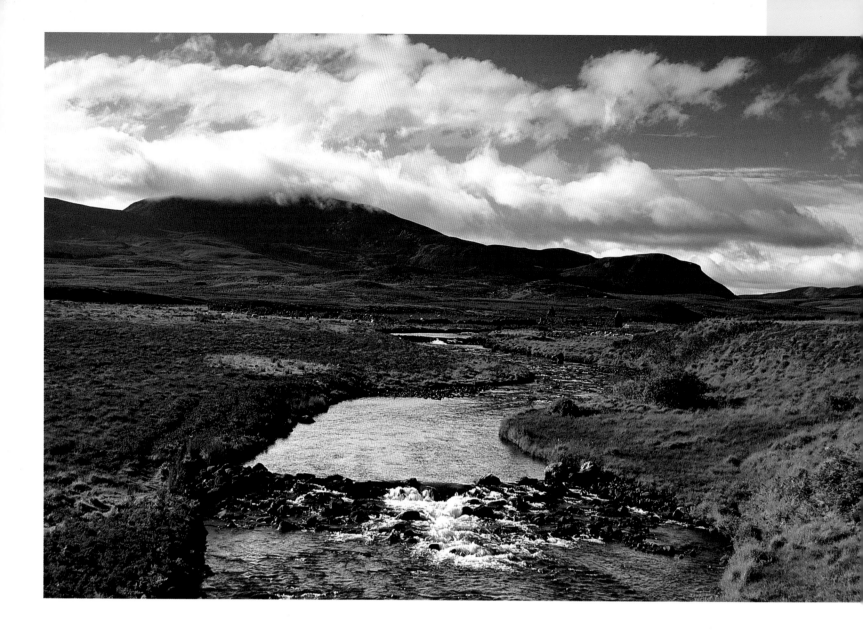

Polarizing filters The main effect of a polarizing filter is to eliminate, or reduce, some of the light that is reflected from non-metallic surfaces. A blue sky is the classic example, as it is created by light being reflected from water droplets in the atmosphere. When photographed with a polarizing filter, the sky will look much more saturated in colour and any white clouds will stand out in bold relief. The effectiveness of the filter depends upon the relative angles between the camera, the sun and the area of sky being photographed and the degree to which the filter is rotated.

A polarizing filter also improves the colour quality of still water and makes it appear more translucent, and it can dramatically increase the colour saturation of foliage such as grass and leaves, especially on a dull day.

The effect of a polarizing filter is controlled by rotating the filter and it's not always desirable to have it at its strongest – especially when photographing a blue sky with a wide-angle lens, as it can make one side of the image noticeably darker than the other.

A shot taken with a polarizing filter will need one-and-a-half to two stops more exposure than an unfiltered shot, but if you are using through-the-lens (TTL) metering remember that if the filter makes a blue sky very dark the meter may suggest more exposure than is actually required. Both linear and circular polarizers are available; while they both have much the same effect, circular polarizers are recommended for use with autofocus cameras and are less likely to interfere with TTL metering systems.

Technical Notes

35mm SLR,
24–85mm zoom
lens with
polarizing, neutral
graduated and 81B
warm-up filters,
Fuji Velvia.

Situation and Approach

The Borgie, one of Scotland's great salmon
rivers, positively sparkled in the autumn
sunlight on this day and I used a polarizing
filter to subdue some of the reflections on
the water as well as to make the sky a
richer colour. I also used a neutral
graduated filter to reduce the brightness
of the white clouds. (MB)

RIVER BORGIE, SCOTLAND

Situation and Approach

The unreal looking colour of this lake in
Andalucía is due to algae, not strange
filters, although I did use a polarizing filter
to maximize the colour saturation of the
image. I did not rotate it to its maximum
effect, as the sky became much darker in
one corner because the light was more
strongly polarized in that area. (MB)

Graduated filters Another invaluable filter, especially for landscape photography, is the neutral graduated filter. Half the filter is tinted grey and the other half is clear, with a gradual transition between them.

The most common use of a graduated filter is to reduce the brightness of the sky and record it as a darker tone — the colour photographer's equivalent of burning in. You can, of course, use a graduated filter on the lower half of an image, to make a foreground darker, for instance, or on one of the sides to balance uneven illumination. Although you can buy round graduates, which screw directly on to the lens mount, they are of limited use as you need to be able to adjust the position of the filter. For this, you need a square filter holder with a slot.

A graduated filter can overcome the potential problem of underexposure when a large area of bright sky is included in the frame. If you are using the filter to emphasize the effect of a dark, stormy sky it's best to use the exposure setting indicated by the meter before you fit the filter, otherwise you are likely to overexpose.

Graduated filters are also available in other colours (for example, to simulate a colourful sunset), but you need to use them very discriminatingly to avoid unnatural-looking results.

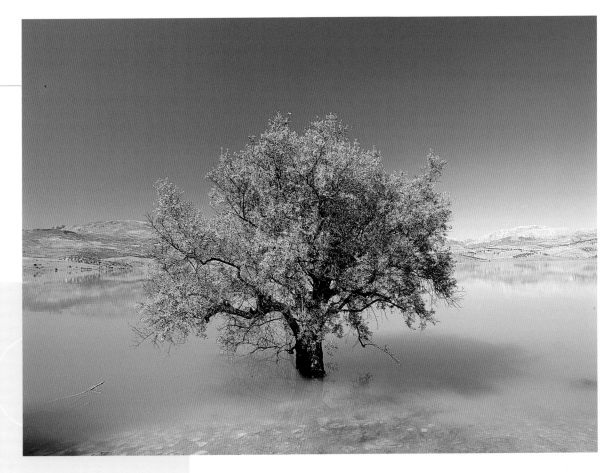

TURQUOISE LAKE

Technical Notes

Medium-format
SLR, 55–110mm
zoom lens with
polarizing and 81B
warm-up filters,
Fuji Velvia.

Camera Accessories

There is a wide range of accessories for most cameras, many of which are designed to overcome specific problems or to create particular effects. Some, however, have such a significant effect on image quality that they should be considered obligatory for the serious photographer.

Tripods A tripod is one of the most important of all camera accessories because it enables you to photograph some subjects that would not be possible without one. It also makes composing your pictures a more considered process.

When subject movement is not a consideration, using a tripod means that you can use slow shutter speeds without the risk of camera shake. This enables you to use small apertures for maximum depth of field and to shoot in poor light, when the lighting quality is often at its most interesting.

When you are using a long-focus lens, a tripod should be considered necessary: even a fast shutter speed will not always prevent camera shake. For subjects such as landscapes, a tripod is essential. Close-up photographs also magnify the effects of camera shake; here, too, a tripod is vital. When shooting moving subjects, such as sports, a monopod can be a good compromise between camera manoeuvrability and stability.

Using a tripod enables you to concentrate more fully on the contents of your viewfinder and to control the way the image is framed much more carefully than when you are

Situation and Approach
The light inside this cathedral was not very bright, although it was fairly even. I also needed to use a small aperture to ensure that the image was sharp from front to back. The resulting shutter speed was about 4 seconds, making the use of a tripod absolutely essential. (MB)

hand-holding a camera. When shooting subjects such as portraits it also allows you to communicate directly with your model and not be obliged to have your eye constantly pressed to the viewfinder.

A tripod is only effective if you have a firm and substantial one and ensure that the camera is not jarred when the exposure is made. Using a flimsy tripod can be more of a liability than using none at all. The use of a cable or remote release is essential. When shooting subjects such as close-ups, and when using a long-focus lens with an SLR camera, it is advisable to lock up the mirror before making the exposure as this can cause vibration.

It pays to take some trouble to find a tripod head that you are comfortable with and which locks easily and positively. A ball-and-socket head is quicker to use, but it's easier to adjust level and tilt separately with a pan-and-tilt head.

Situation and Approach

For this close-up image of a fuschia bloom, I used a 35mm SLR camera with a macro lens mounted on a tripod. As I selected a small aperture to obtain maximum depth of field, the resulting shutter speed was relatively slow – about ¼ second. Because of this, I used the camera's mirror lock and delayed the shutter release to ensure there was no vibration. (MB)

Technical Notes

35mm SLR, 100mm macro lens, Fuji Velvia.

I used a combination of flash bounced from a white ceiling and ambient light for this picture taken at a children's party. I needed a slow shutter speed of about ⅟30 second to record the ambient light, so I used a tripod and waited until the children were relatively still before shooting. (MB)

PARTY GIRL

Technical Notes

35mm SLR, 70–200mm zoom lens, Kodak Ektachrome 100SW.

Flash guns A flash gun is probably the first accessory that most photographers consider buying. Many 35mm cameras have small built-in flash units but these are of limited use, partly because they have only limited power but also because their position is fixed and you cannot alter the quality and direction of the light. Although a built-in flash gun will at least enable you to take a photograph when the light level is too low for a normal exposure, the results are unlikely to be satisfactory from an aesthetic point of view. It's important to appreciate that the intensity of a point source of light, such as a flash gun, diminishes in proportion to the square of its distance from the surface it is illuminating. This is why in many flash-on-camera photographs the main subject appears to be suspended in a black void.

A typical situation in which flash photographs are taken is at a party or reception, where the person being photographed is quite close to the camera (say, 2 metres/6 feet), but the background is some distance away (say, 4 metres/12 feet). This would result in the background receiving only 25% of the light that falls on the subject, making it two stops underexposed and very much darker. If you use a separate flash gun, however, you can aim it at a white wall or ceiling so that the light is reflected and diffused onto the subject, creating a more even and much softer light.

Another solution is to make use of the ambient light. When you use flash in the normal flash mode the shutter automatically sets to the fastest speed at which it will synchronize – typically ⅟125 second or faster, depending on the

Technical Notes

35mm SLR,
24–85mm zoom
lens, Fuji Provia
400F

Situation and Approach

Although built-in flashes are of limited use, in situations like this shop interior they can improve the image quality significantly. The ambient light alone would have produced quite dense areas of shadow but, because I was quite close to the subject, the small integral flash of my SLR camera has provided enough light to illuminate the dense shadows created by the ambient light. (MB)

camera. In low light levels this is not enough for the ambient light to have any significant effect and the scene will be lit only by the flash. Any atmosphere created by the existing light, such as in a home or restaurant interior, will be lost.

By using a much slower shutter speed you can record the ambient light and use the light from the flash to supplement it, lighting only the shadows. This technique can also be used outdoors in harsh lighting conditions, for subjects such as portraits, to illuminate the shadows and create lower contrast. But unless you have a very powerful flash gun it will only be effective when the subject is fairly close to the camera. The solution is to set the flash to fill-in mode, so that the ambient light is recorded and the flash exposure controlled to create the right balance.

Technical Notes

35mm SLR, 70–200mm zoom lens with Fuji Velvia.

Apertures and Depth of Field

A lens gives a truly sharp image only at the point at which it is focused; anything closer or further away than this will become progressively more blurred. To some extent, the degree to which this blur is acceptable depends on the size to which the image is enlarged. The range of acceptable sharpness is known as the depth of field. It is controlled by the aperture and the focal length of the lens.

A wide-angle lens set to a small aperture produces a wide depth of field, while a long-focus lens set to a wide aperture creates a very shallow depth of field. Many lenses have a depth-of-field scale, which indicates the range of sharp focus obtained at a given aperture, but you should remember that

this refers only to "acceptable" sharpness; while a small print of 12.5 x 17.5 cm (5 x 7 inches) might appear sharp throughout, a much bigger enlargement is likely to reveal the lack of definition in details outside the depth of field indicated by the scale on the lens.

In situations where you want maximum depth of field – for example when you want fine detail in objects close to the camera as well as in the far distance – use the smallest aperture possible. But remember also that the depth of field extends further beyond the point of focus than in front (of the point of focus), by about two-thirds to one-third; measure the distance between the closest detail which you want to be sharp and the furthest, and focus at one-third of the distance between them.

Useful Advice

At very close focusing distances the depth of field extends equally in front and behind the point of focus and becomes much shallower. If you want the image to be sharp overall when shooting small objects and close-up details, use the smallest practical aperture.

Situation and Approach

I wanted to fill the frame with the sculptures and ornate decoration of this temple in the Royal Palace in Bangkok. I chose a viewpoint that placed the elephant in the close foreground and focused on a point about one-third of the way between this and the furthest details, using a small aperture to ensure there was enough depth of field to record both in sharp focus. (MB)

Technical Notes

35mm SLR, 24–85mm zoom lens, Fuji Velvia.

BANGKOK TEMPLE

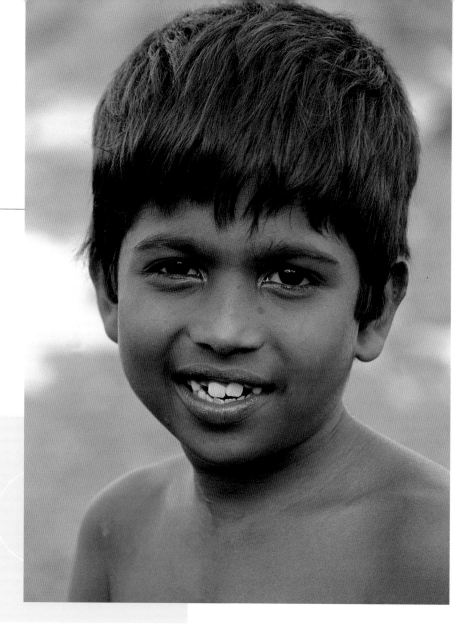

Situation and Approach

For this outdoor portrait, I used a long-focus lens set to a wide aperture to ensure that the background details were thrown well out of focus. This has helped to make the boy's face stand out more clearly. (MB)

SRI LANKAN SCHOOLBOY

Technical Notes

35mm SLR, 70–200mm zoom lens, Fuji Provia.

Selective Focusing

Although our eyes focus in a similar way to a camera lens, we gain the impression that everything is sharp within our field of view because our eyes scan rapidly and continuously over objects at different distances. The ability of a camera lens to isolate details by means of focusing is one of photography's unique properties. In many ways, the areas of an image that are out of focus and blurred can become as important as those that record fine detail, and make an equally positive contribution to the impact of a photograph.

One of the most useful applications of selective focusing is to make a subject stand out more clearly from its background, especially when that background is fussy or distracting. The strongest effect is obtained when there is an appreciable distance between the subject and background and when a long-focus lens is used at a wide aperture. This can be very effective with subjects such as informal portraits outdoors and wildlife when it's not possible to choose a plain, uncluttered background. But it can also be a useful technique when shooting close-ups *in situ*, such as wild flowers, for example. In a similar way, an out-of-focus foreground can sometimes be an effective way of leading the eye towards a sharply defined distant object and giving it greater emphasis.

Useful Advice

When using selective focusing, you need to make sure that you select a depth of field that is shallow enough to blur unwanted details completely; a half-way effect can look very unattractive.

Situation and Approach

This was a potentially fussy and confusing image. To simplify it, I used a 300mm lens set to its maximum aperture and focused on a single bloom to ensure that details both in front of and behind the point of focus were unsharp. (MB)

Technical Notes

35mm SLR, 70–200mm zoom lens with extension tube, Fuji Velvia.

RED DAHLIA

Shutter Speeds and Movement

For photographers who hand hold their cameras, the shutter speed will determine how sharp their images are. Although a photograph taken at a shutter speed of, say, ⅟₆₀ second may appear to be quite sharp, the effects of camera shake may become only too apparent when the image is enlarged or viewed through a magnifying glass.

The degree to which camera shake can create blur depends on a number of factors, including the photographer's ability to hold the camera steady, the type of camera, the focal length of the lens and the distance between camera and subject. There's a rule of thumb that states that a "safe" shutter speed is the reciprocal of the focal length of the lens being used; in other words, it is safe to hand hold a 50mm lens at ⅟₅₀ second. This is very simplistic and misleading and a better guideline is to use the fastest shutter speed that the lighting conditions and depth-of-field requirements will allow.

When photographing a moving subject, the shutter speed that will record it sharply depends on a number of factors, including the speed at which the subject is moving, the direction of the movement and the distance the subject is from the camera. A subject that is close to the camera and moving relatively slowly across the camera's view will need a faster shutter speed to freeze the movement than a faster, more distant subject moving towards the camera.

Technical Notes

35mm SLR, 24–85mm zoom lens, digital capture at ISO 100 setting.

Situation and Approach

I used the fastest shutter speed, 1/500 second, that the lighting conditions and film speed allowed in order to try to freeze the moment when the bull made a pass at this rather lucky matador. (MB)

Useful Advice

When allowing movement blur to occur as a creative effect, make sure that the blur is pronounced enough not to look accidental. At the same time, make sure that the subject is not so blurred that insufficient detail is recorded, as this will blend the tones to such a degree that the image will lack both interest and contrast.

BLURRED LEAVES

Technical Notes

35mm SLR, 200mm lens, Fuji Provia 100F.

MATADOR

Situation and Approach
This picture was taken on an overcast day in the Scottish Highlands, when the rivers were in full flood after heavy rain. With my camera mounted on a tripod, I set a small aperture so that I could use a shutter speed of ½ second in order to capture the blurred, swirling motion. (MB)

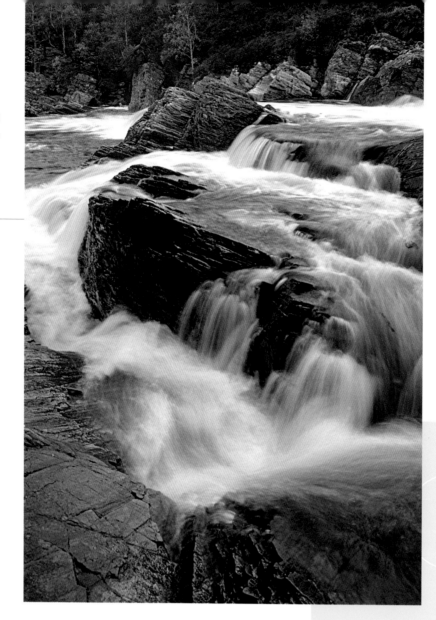

Technical Notes

35mm SLR, 35–70mm zoom lens, Fuji Velvia.

Creative Blur

In the same way that blur caused by lack of sharp focus can be useful and effective in an image, so too can blur caused by movement. While a very fast shutter speed can freeze a moving subject, panning the camera and using a slow shutter speed can sometimes create more impact, as you can keep the main details of the subject in sharp focus while allowing some areas of both subject and background to become blurred. This can heighten the impression of speed and movement as well as creating a striking visual quality.

Another way of using blur is to use a slow shutter speed in combination with a tripod-mounted camera to allow the moving element of a scene to become blurred while the rest of the subject remains sharply focused. A waterfall is a classic example of this technique when the water is given a soft, smoke-like quality.

For images like this it is important that part of the image is static and records sharply. The shutter speed needed to record the desired degree of blur depends on the speed of the movement and the distance the subject is from the camera. A fast-flowing waterfall close to the camera, for instance, could create an effective amount of blur at ¼ second, while a meandering stream might need several seconds to produce the desired effect.

Useful Advice

When a subject is moving across the camera's view, panning is an effective way of obtaining a sharper image with a slower shutter speed. It has the added benefit of giving a blurred background. Frame your subject well in advance. This will give you time to pace the camera's swing so that the subject is held steady in the viewfinder at the moment you make the exposure.

Situation and Approach

I shot this from a boat that was speeding back to harbour after a whale-watching trip off Cape Cod in New England. I used a slow shutter speed of about ½ second, but panned the camera, keeping the sun and distant horizon as steady as possible in the frame. As a result, the sun has been recorded quite sharply while the water close to the boat is very blurred. (MB)

Technical Notes

35mm SLR, 17–35mm zoom lens, Fuji Velvia.

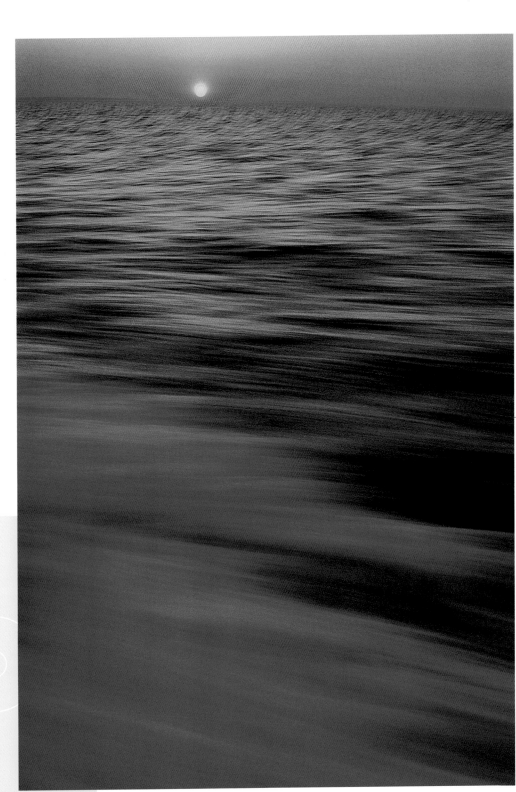

CAPE COD SUNSET

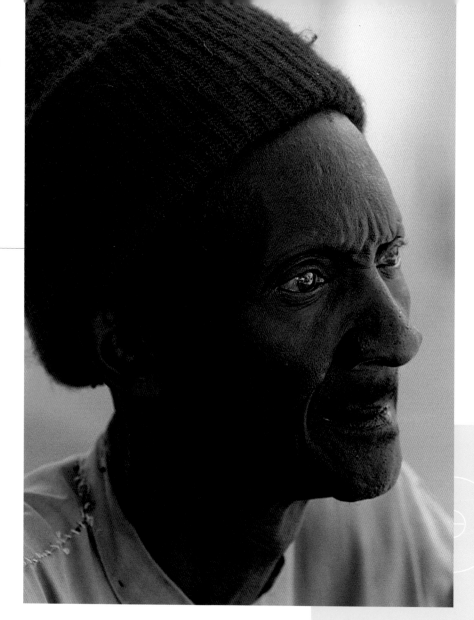
Situation and Approach

I gave this picture half a stop less exposure than the meter indicated to allow for the fact that the subject's dark skin occupied most of the frame. Had I relied on the camera's meter reading, the image would have been too light. (MB)

Technical Notes

35mm SLR, 70–200mm zoom lens, Fuji Provia 100F.

Controlling Exposure

Accurate exposure is important: when film is given too much exposure, detail is lost in the lighter tones of the image; when too little is given, detail is not recorded in the darker areas of the image. Whether you use a camera with through-the-lens (TTL) metering or a separate hand meter, the principle is much the same: the meter measures the light being reflected from a subject and indicates an exposure based on the overall brightness of the area included in the reading.

This exposure is based on the assumption that the range of tones within a scene, if blended together, would create a mid tone, halfway between black and white, and the meter is calibrated to record this tone on the film. In most situations, this provides an exposure that is within the tolerance of the film.

In addition, modern metering systems balance sampled readings from different areas of the image to overcome many of the obvious discrepancies, such as a bright area of sky at the top of an image. But the system is not infallible and the meter can give misleading readings. You have to be able to anticipate when this is likely to happen and adjust the exposure to get the result that you want.

The most widely used method in modern cameras is matrix metering, in which the camera system samples the level of brightness from different areas of a scene and adjusts accordingly. Spot metering gives the most accurate result, as it measures from a very precise area of the subject, but its success depends on your ability to interpret the reading. With experience, you will learn to predict results, but bracketing exposures is the safest solution.

When more exposure is needed than indicated:

1 When a large area of very light tones is included in the area being metered, such as a bride in a white dress or a snow scene.

2 When a large area of bright sky is included.

3 When you are shooting into the sun.

4 When light sources are included in the metered area, such as a street scene at night.

When less exposure is needed than indicated:

1 When a large area of dark tones is included in the area being metered, such as a close-up portrait of a very dark-skinned person.

2 When you are shooting a distant, normal-toned subject with a very dark foreground, such as through a silhouetted archway.

Situation and Approach

For this shot, I gave two-thirds of a stop more exposure than the meter suggested, as the bright highlights and large area of very light tones would have resulted in an image that was too dark. (MB)

Technical Notes

Medium–format SLR, 55–110mm zoom lens with neutral graduated filter, Fuji Velvia.

SNOW IN RIBBLESDALE

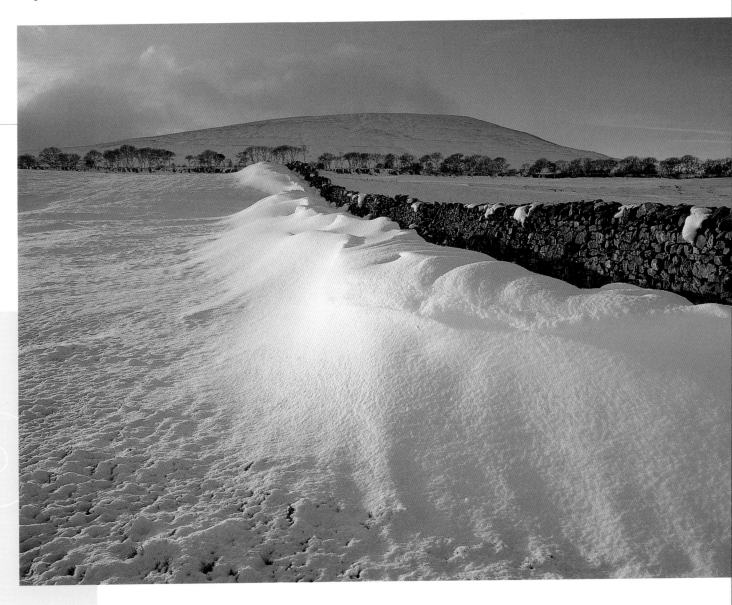

**Technical
Notes**
35mm SLR,
20–35mm zoom
lens with neutral
graduated filter,
Fuji Velvia.

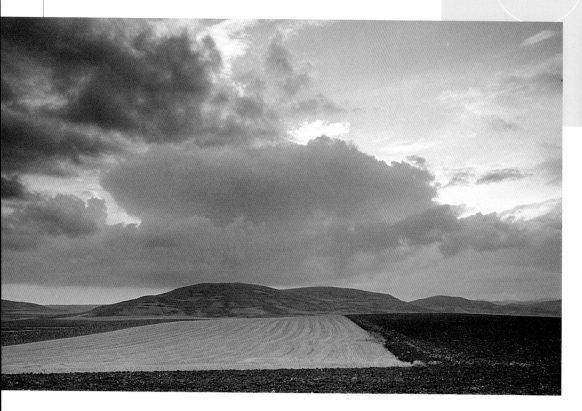

Creative Exposure

An exposure that is technically correct does not always produce the effect you want, however. When your aim is to create atmosphere or to emphasize a specific quality in the image, such as colour or texture, it may well be more effective to over- or underexpose. In most cases, giving slightly less than the technically correct exposure increases colour saturation and also enhances the textural quality of an image.

Image density can have a very striking effect on the impact of an image. With negative film, you can control this aspect of the image at the print-making stage, but with transparencies you have to control image density by the amount of exposure that you give the film. If you are working with digital images, you can control both density and contrast with relative ease after the exposure has been made or scanned.

The brightness range of the subject is also something to consider, because if the difference between the lightest and darkest tones is only just within the tolerance of the film, underexposure will result in dense shadows while overexposure will produce bleached tones with little or no detail.

A softly lit scene, or one with a low brightness range, can create a situation in which you have neither clean, bright highlights nor rich dark tones. When shooting in black and white, the best solution is to give the correct exposure and either increase the development of the negative to increase the contrast or to print on a harder grade of paper.

When you are shooting photographs of a static subject, such as a landscape or building, on colour transparency film the most satisfactory way of ensuring you get exactly the

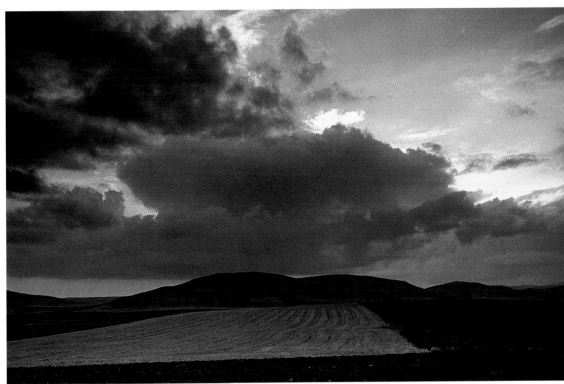

effect you want is to bracket by giving half or one-third of a stop less and more than the indicated exposure. With difficult subjects or lighting conditions, it is wise to extend this to as much as one stop over and under the central exposure, making as many as seven exposures in one-third of a stop increments to ensure that you get exactly the result you want.

Although bracketing is an effective solution when dealing with a subject that remains constant, it is not very practical for shooting action subjects and portraits, because the correct exposure may not the one that captures the best action or expression. When the lighting remains constant you can shoot a whole roll of film at the same exposure and ask the processing lab to cut off one or two frames at the beginning of a 35mm film, or from the end of a roll film, and process this

first. The processing time for the remainder of the roll can then be adjusted to make the image lighter or darker.

The effect of exposure will vary from film to film and from one set of lighting conditions to another. It is best to find a film or two that you like and stick to them. When trying a roll of film for the first time, shoot as wide a variety of subject matter and lighting conditions as possible and bracket your exposures. Assessing the results of a test roll in this way is a very useful shortcut to getting the best from a film.

SEBASTIAN

Technical Notes

35mm SLR, 24–85mm zoom lens, Kodak Supra ISO 400.

Film and the Image

There are several factors to consider when choosing film. The first of these is the speed of the film – and the same principles apply regardless of whether you are shooting in monochrome, on colour negative film or on colour transparency. Film speed is inextricably linked to grain size and its ability to record fine detail. For the highest possible image quality and maximum image sharpness, you need to use a slow, fine-grained film. When you are shooting a static subject and can mount your camera on a tripod, the slower shutter speeds required by a slow, fine-grained film will not matter, but when you are dealing with a moving subject and need a fast shutter speed to avoid blur, you will often need to use a faster film with a higher ISO rating – especially in low-light conditions.

Very fast film of all types can be used to make the large grain structure a feature of the image and it can be very effective with the right subject. Framing the image so that the intended final image occupies only a small area allows it to be enlarged much more for maximum effect.

Grain size and image definition need to be considered in relation to how much you are planning to enlarge a negative or transparency. While a small print from a fast film may look perfectly acceptable, the same negative enlarged to, say, a 50 x 40 cm (20 x 16 inch) print may well appear to be lacking in sharpness and unattractively grainy. In the same way, a large-format transparency shot on a fast film will compare favourably to one shot on a slow 35 mm film when they are both enlarged to the same size.

The choice between black-and-white negative, colour negative and transparency film is not as clear-cut as it might seem at first glance. It might seem obvious to use a black-and-white film to produce monochrome images, but if you intend to scan your images and make ink-jet prints, colour film might be a better option: it offers considerable control over the tonal rendition of the film without recourse to filters (see pages 234–237). Moreover, the dust and blemish filter on most scanners will only work with colour film.

The choice between colour negative and colour transparency film also depends on how you intend to use the photographs. For photographic prints, negative film can be the best choice as it is easy, quick and inexpensive to have small prints made and control the final image quality when making larger exhibition prints. Colour negative materials are also more forgiving of exposure errors and less sensitive to changes in the colour temperature of the light.

If your main aim is to produce photographs for reproduction, for stock photography or for projection, colour transparency film is the best choice. Most publishers prefer to have colour transparencies and the majority of stock photo libraries will not consider prints at all.

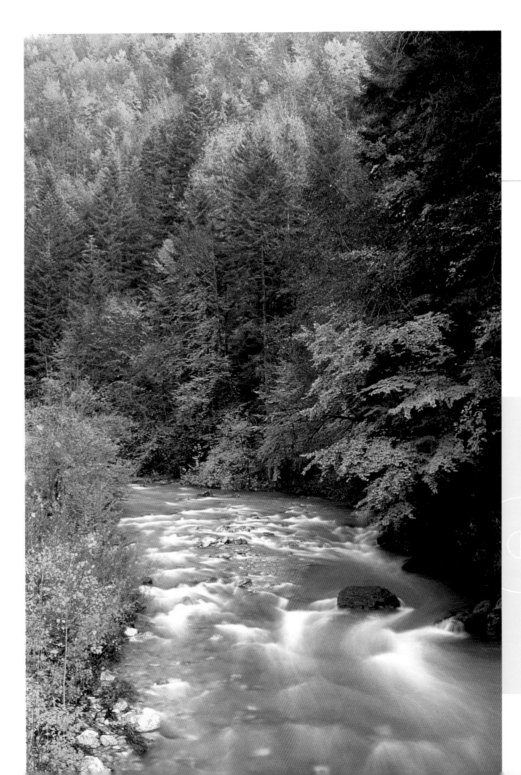

Useful Advice

Film technology has improved significantly in recent years and a fast film such as Fuji's Provia 400F can produce a 20 x 28 cm (8½ x 11 inch) print that is hard to distinguish from one shot on the slow ISO 50 Velvia. But the subject can also be a factor in film choice: a softly-lit image with large areas of plain, subtle mid tones will show grain more readily when shot on a fast film than one with bright colours and lots of detail.

Situation and Approach

I use colour transparency film for the vast majority of my work because it is usually destined for reproduction and for submission to photo libraries and the requirement for both of these uses is almost exclusively for colour transparencies. This picture, taken in the French Alps, was recorded on Fuji Velvia. (MB)

Technical Notes

35mm SLR, 70–200mm zoom lens with polarizing and 81B warm-up filters, Fuji Velvia.

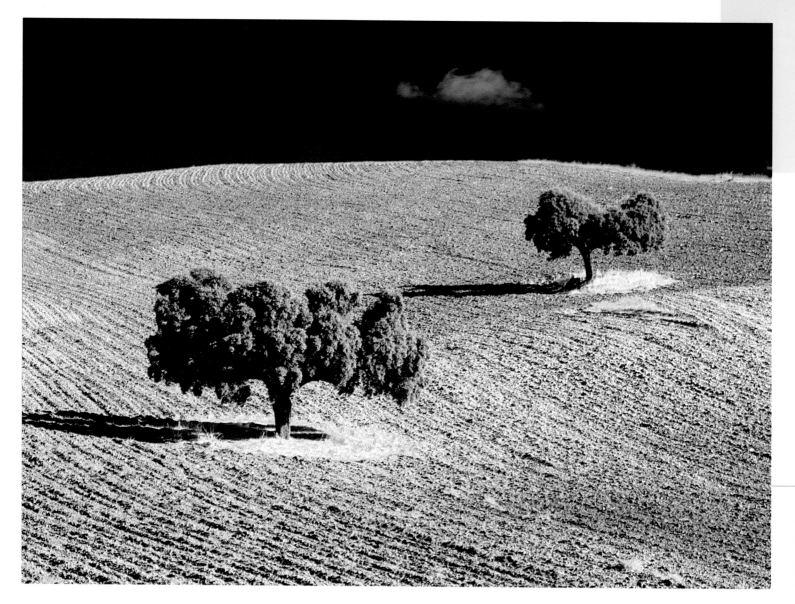

Film Qualities

Apart from speed and grain, the most important decision you need to make when using transparency film is whether to use a type that is balanced for daylight or artificial light (although colour conversion filters can be used to convert one to the other). Subject matter is also a factor, since some saturated films such as Fuji Velvia are not at all flattering for portraits. When a neutral, colour-accurate result is needed, a film such as Fuji Astia might be a better choice.

Similar options exist with colour negative films, as there are very saturated films with high contrast such as Fuji Reala, which is ideal for subjects such as landscapes, and softer, less saturated materials like Agfa Portrait and Kodak Portra, which are a common choice for portrait photography.

When choosing a black-and-white negative film, you have a choice between chromogenic films, such as Ilford XP2, and conventional emulsions, such as Kodak Tri-X. The former can be processed in C41 colour chemistry, making it possible to use one-hour photo labs for initial proofing, but you have no means of controlling contrast during processing. They do, however, offer fine grain at relatively high ISO ratings.

Situation and Approach
I used colour transparency film to record this monochrome photograph shot in the La Mancha region of Spain. This was because I intended to scan the image and convert it to black and white in Photoshop, as described on page 308. (MB)

Technical Notes

Medium-format SLR, 105–210mm zoom lens with polarizing and 81B warm-up filters, Fuji Velvia.

Technical Notes

35mm rangefinder camera, 45mm lens with a Wratten 12 filter, Kodak Infrared Ektachrome.

Useful Advice

When using film grain creatively, make sure that the grain is very pronounced so that you can avoid the possibility of it seeming accidental. In addition to using a fast, coarse-grained film, frame your subject so that it occupies only a small proportion of the frame and can be enlarged. A useful technique is to compose the image using a lens of, say, four times the focal length of that used to make the exposure.

MONT AIMÉE INFRARED

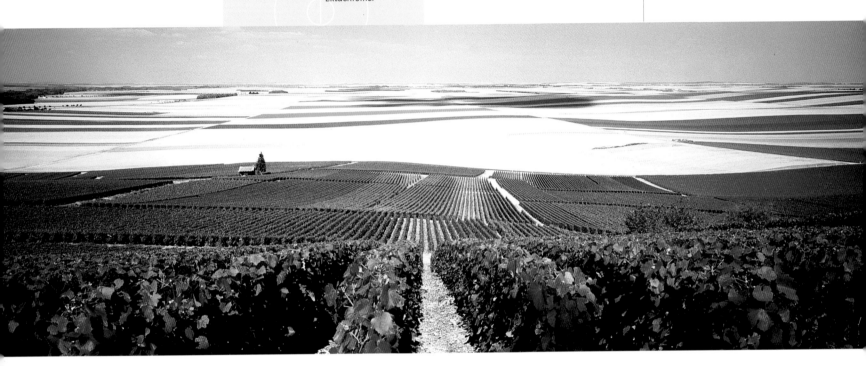

Conventional black-and-white negative films have the advantage of allowing you to fine-tune the image quality by being able to vary combinations of film and developer along with processing times (see page 260). A further option for the black-and-white worker is Agfa Scala, a reversal monochrome film which can be used to produce positive transparencies.

There are a number of infrared sensitive films that can be used to produce unusual tonal effects, depending on the filtration used and the degree to which the emulsion is also sensitive to visible light. With black-and-white infrared film, the effect is similar to that of an image in which a deep red filter is used, making blue skies record as near black and green foliage appear almost white. Used for the right subject in the right light, infrared film can create striking and dramatic images with a quite unique quality.

Kodak's infrared Ektachrome can produce a wide range of colour effects, depending on the subject, lighting conditions and the filtration used. The results are somewhat unpredictable, but that is part of the fun.

Situation and Approach

This strange landscape is, in fact, vineyards in the Champagne region of France. The effect was created by using Kodak Infrared Ektachrome in combination with a Wratten 12 filter. (MB)

The Monochrome Darkroom

The key to successful monochrome work is to record a well-exposed image, to develop the film to a high standard with the characteristics you prefer, and finally to achieve a quality print with atmosphere and personality. The only way to achieve this with any consistency is to understand each stage of the process and to be able to repeat it in varying conditions.

Processing and printing your own black-and-white work will improve your photography, because you will learn what can and can't be achieved and what works best in any given situation. This section sets out proven ways of getting a first-class result. There are no complicated techniques – just methods that have been evolved through practice and experience. The beginner is guided through the initial stages and, for those already competent in the basics, more advanced techniques are illustrated and explained. Darkroom work is really the continuation of the creative process that begins with pressing the shutter.

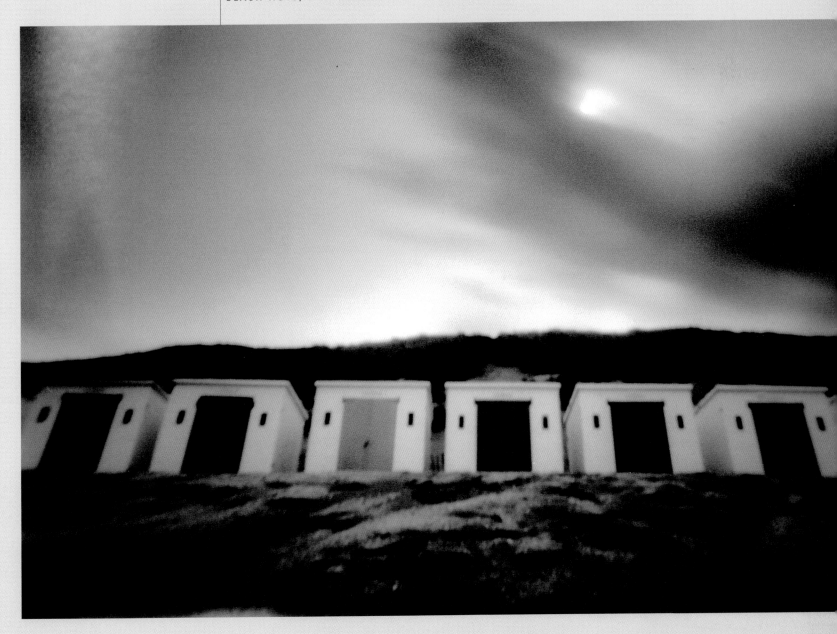

Technical Notes

Medium-format SLR, 100mm lens with extension tube, Ilford Delta 100.

Choosing Film

Film selection is the beginning of the process. A slow film (ISO 125 or less) is likely to be sharper and less grainy in appearance than a fast one, but generally you need a relatively static subject and a tripod to use the film effectively. Films classed as fast (ISO 400 plus) give greater grain and lower sharpness, but allow you to shoot moving subjects and work in lower light levels.

A good way to start is to think about what you want the film to record and what effect you want. If you like the effect of a grainy film, use a fast film and 35mm. If you want a finer grain and a sharper result, use a slower film and a tripod. Here, medium format is likely to be an advantage. If you need the speed but want to minimize grain, choose a fast film with low grain size for its speed and use a fine-grain developer.

Situation and Approach

I came across this sheep's skull during a walk along a river; in monochrome, the shape and form of bones can create a striking image. Lighting needs to be simple but carefully controlled to bring out detail and tone. For this shot I used a single studio flash, lightly diffused and directed from an acute angle to produce a dramatic effect. In order to capture the maximum detail and subtlest tones, I selected a very sharp and fine-grained film with excellent tonal range. It was vital to capture the image in this unforgiving way for my final print to work as I had imagined. (JB)

Situation and Approach

Even when I'm not on assignment or actively looking for pictures, I often carry a 35mm camera in case an opportunity presents itself. In order not to be laden down with equipment, I use a single lens and load the camera with ISO 400 film, which rules out the need for a tripod in most situations.

I took this picture with the quality of the ISO 400 film in mind, as I could see that the subject would be enhanced by the use of a grainier and softer film than I would normally choose for this type of picture. When printed, the result was a much gentler image than I could have achieved with ISO 100 film. (JB)

Technical Notes

35mm SLR, 24mm lens, Ilford HP5.

WHEAT FIELD, FAST, GRAINY FILM

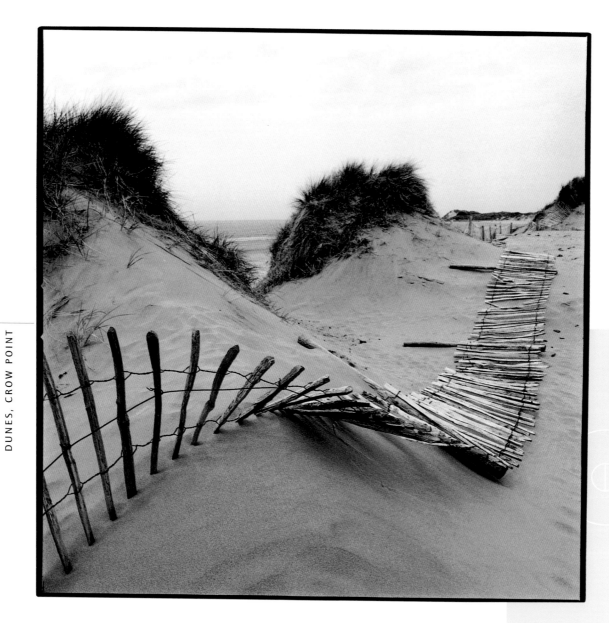

DUNES, CROW POINT

Technical Notes

Medium-format SLR, 50mm lens, Ilford Delta 100 developed in Kodak T-Max.

Choosing Developer

A film developer is far more than a simple chemical designed to turn an exposed film into a negative. It should be used to complement your picture-taking and your film choice. You can enhance whatever quality it is that you like about a particular film through your choice of developer. The standard fine-grain formulation is probably the most widely used developer type. It offers good sharpness with fine grain and is a good all-round choice, but there are alternatives.

An acutance developer will give the appearance of increased sharpness. It can also increase film grain, which may or may not be desirable. Using an ultra fine-grain developer is almost the reverse of an acutance developer. This type of

Situation and Approach

I shot this at Crow Point in North Devon, one of my favourite locations. The first thing that struck was the shapes made by the fence. As I looked through the viewfinder I noticed these two dunes, which looked like a camel's humps and, because of the white sky, were very prominent. Normally I would have cropped out much of the sky, but on this day the impression of bleakness seemed to be an important element of the image and helped to emphasize the shapes of the dunes. I used a fine-grain developer to give a smooth appearance to the scene. (JB)

Technical Notes

Medium-format SLR, 50mm lens with orange filter, Ilford Delta 100 developed in Agfa Rodinal.

RAILWAY TRACK, THE ROCKIES

developer minimizes the appearance of the film grain, giving a slightly softer feel and a less gritty quality to the image. It can reduce film speed, which can be inconvenient when you are shooting non-static subjects with slow film.

Other developers include ones that increase the speed of the film and two-bath developers, which help to contain the tonal range of a contrasty scene. Both of these are specialist developers that have fairly limited uses and are best ignored unless your processing skills are very competent.

There is a trade-off in all this, as enhancing a desirable characteristic may also increase a less desirable one. Start by using a standard fine-grain developer; then, when you are comfortable with the development process, you can experiment with other types to see what effect they have.

Situation and Approach

This was taken in the Colorado Rockies on a day with strong, bright sunlight and a deep blue sky. The clouds were coming and going, but the quality of light remained consistent. I selected a close viewpoint and used a wide-angle lens to give the track a strong sense of perspective, and also used an orange filter to make the blue sky darker and more dramatic.

I opted for an acutance-type developer because, rather than minimize the harsh light, I wanted to make the picture as punchy as possible. This gave the image a severe and unforgiving feel, which was the mood I sensed when I took it. It is more an interpretation of the scene than a straight record of what I saw. (JB)

Technical Notes

Medium-format SLR, 50mm lens with orange filter, Ilford Delta 100 developed in Agfa Rodinal and given 15% less development than usual.

Achieving Negative Quality

Not all cameras give exactly the same meter reading, so it is not unusual to adjust the speed for your particular camera, but it is the development time that is most important. Longer development increases density and contrast, while a shorter development does the opposite. The best way of learning what a particular film can achieve is, quite simply, to shoot pictures; you can make adjustments to either the speed rating or the development time on your next roll. The following test may help:

1 Photograph a scene that includes a full range of tones, from bright highlights to deep shadows.

2 Give the metered exposure and then bracket to give ⅓, ⅔ and a stop each side of the recommended exposure.

3 Develop at the recommended time.

The frame that has some detail in the shadow area is the correctly metered one. Adjust your meter or film speed to match if necessary.

Next, using the same type of film, shoot a roll of the same scene, or similar, at the meter setting without bracketing. Cut the film into five equal strips. Develop one at the recommended time and the others at approximately 10% less, 10% more, 20% less and 20% more development.

The strip in which the highlight detail matches that of the original, correctly metered scene is the development time that you should use. You can then gauge how much (if at all) you need to increase or decrease contrast and set the same film speed and development time every time you use that particular film and developer combination.

THE IMAGES HERE SHOW
HOW NEGATIVES APPEAR
WHEN THEY HAVE BEEN
INCORRECTLY EXPOSED
AND DEVELOPED.

 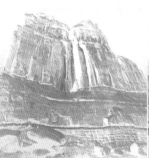 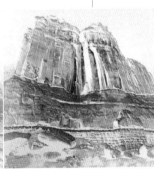 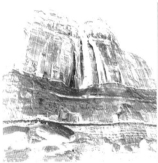 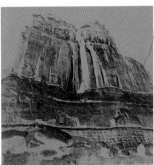

OVERDEVELOPMENT UNDERDEVELOPMENT CORRECT EXPOSURE AND DEVELOPMENT UNDEREXPOSURE OVEREXPOSURE

Situation and Approach

This dramatic structure in Arches National Park, Utah, just had to be photographed. The light was strong as it was approaching mid-afternoon, but my chances of returning were slim and so I had to shoot there and then. The direct light also meant that the rock was well illuminated without too many shadows. I took a meter reading from the area of rock which represented a mid-tone and used an orange filter to darken the sky.

I used a slightly shorter development time than usual to decrease the contrast of the negative and to ensure that all the tones were recorded. (Without doing this some of the more subtle tones would not have been recorded.) Provided you give careful thought to metering and development, creating drama with contrast does not necessarily mean that the mid-tones suffer. (JB)

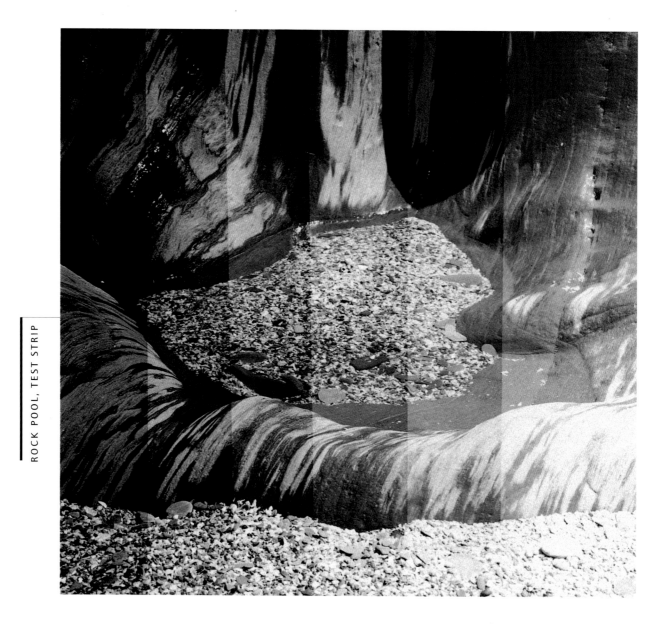

Exposure Test Strip

The humble test strip is the most recognized way of obtaining an accurate starting exposure. The best way to make a test strip is to use a strip of paper approximately one-third of the size, or bigger, than the intended print. Small test strips tell you little. Set an aperture that is small enough to ensure the print is sharp from corner to corner and the exposure times are long enough to control accurately.

Rather than use regular steps of 5 or 10 seconds, which is the most common method, a more informative test strip can be made using the following method:

Exposure Sequence Give the paper a starting exposure of 5 seconds and then progressively cover the paper and give exposures of 2, 3, 4, 6 and 10 seconds. This will give a range of

5, 7, 10, 14, 20 and 30 seconds, effectively increasing the exposure by half a stop each time. This will make the test strip much easier to judge and ensure its accuracy.

If the all the exposures are too dark or too light, repeat the process after changing to a smaller or larger aperture as needed.

Test Strip The test strip sequence shown here demonstrates the method described above. The exposure chosen was the one that gave the most detail in all the tones, along with the desired overall density – in this case 14 seconds. Using this as a base, a straight print will allow you to evaluate any changes to this exposure, or assess any shading that may be needed.

Situation and Approach

This was a difficult subject to capture. I fell for the patterns and tones but also liked the way that this little pool seemed so enclosed and secretive. There was an area of deep shadow on the right that benefited from being kept dark, because it was an unattractive section of the rock. This made the highlights of wet rock more prominent. I metered from the tones on the most attractive section of rock and the pool itself. In printing, I used an exposure based on the test strip shown on the left. At 14 seconds everything was a little too dark; I therefore adjusted the exposure for the final print to 12 seconds. (JB)

Technical Notes

Medium-format SLR, 100mm lens, Ilford Delta 100 developed in Agfa Rodinal.

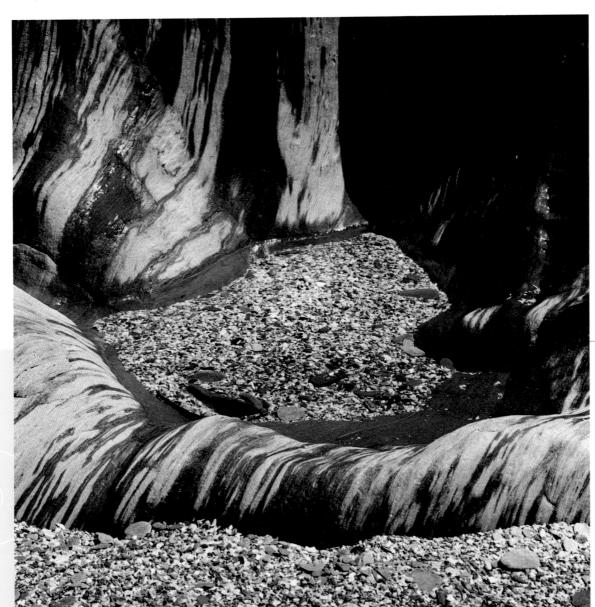

ROCK POOL, STRAIGHT PRINT

Exposure Selection

Although a test strip is the most effective way of establishing a starting exposure, you often need to make adjustments to this. It becomes easier to see whether less or more exposure may be required when you look at the print as a whole. This is why you should make a print of the whole image at the exposure you've selected from the test strip.

Apart from the basic question of whether or not the exposure is correct, you also need to decide whether the print achieves the effect you want. If the result differs from how you visualized the finished image, then you may want to adjust the exposure and make a lighter or darker version.

Situation and Approach

This was a still-life set-up using driftwood as a background for the pebbles – a study in texture and shape. The lighting was kept very simple – just a single flash unit lightly diffused and placed almost directly above the arrangement.

My exposure for this print was 6 seconds – enough to give depth to the shadows with crisp highlight detail. This has resulted in a print in which you can feel the shape and weight of the pebbles and clearly see their texture and form. (JB)

Technical Notes

35mm SLR, 28–70mm zoom lens, Kodak T-Max 400 developed in T-Max developer.

PEBBLES, STILL LIFE

Light Print

At 5 seconds exposure, this print is too light. Although there is detail in the shadows, highlight detail has been lost: the print doesn't have the depth that I want.

Dark Print

At 8 seconds the whole image has sunk into the shadows; highlight detail is there, but it is heavy and dense. The pebbles have lost their shape.

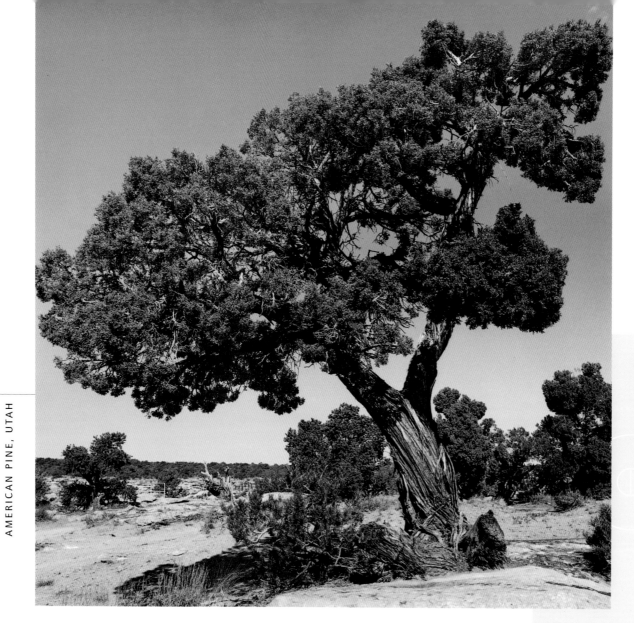

AMERICAN PINE, UTAH

Technical Notes

Medium-format SLR, 50mm lens, Ilford Delta 100 developed in Agfa Rodinal.

Selecting Contrast

The perfect print will include all the available tones reproduced with a full range from white to black. Where prints differ is in the range of tones that have been recorded on the negative and how clean and deep you want the whites and blacks to be.

Printing at a low contrast retains highlight detail but the print can appear lifeless, with too many dull greys. A higher-contrast print will have deep blacks and will appear crisper. The final print should have a contrast level that suits the subject and may, therefore, be lower or higher in contrast than the established ideal. Learning to achieve the ideal and then what happens at different grades is a key factor in achieving a quality print.

Situation and Approach

Like most landscape photographers I have a passion for trees, particularly isolated ones. I spotted this one in Utah and decided I had to add it to my collection – not just because I thought it would make a strong image but also because I loved its shape. At the printing stage, establishing a suitable contrast level was important: I wanted to retain detail within the tree but also produce a print with as much impact as possible. (JB)

Grade 3

This print has the contrast level that I wanted: there are white highlights and black shadows, giving nice depth to the foliage. I printed on variable-contrast paper set at grade 3.

Grade 2

Printed at grade 2, this print lacks the depth of the one shown on page 270. Although it contains both shadow and highlight detail, these areas don't stand out and the image looks flat. The version printed on grade 3 has a more three-dimensional feel to it.

Grade 4

Printed at grade 4, this print is too contrasty. Not only are shadow and highlight detail diminished, but also the mid tones have started to disappear. Compared to the version on grade 3, which shows a range of subtle mid tones, the ground in this print is nearly white.

Ansel Adams

was born in San Francisco in 1902. He took his first photographs in 1916 – of the Yosemite Valley. His first portfolio was published in 1927. Together with other photographers, notably Edward Weston, he formed group f/64 in 1932. The approach was one of perfection and photography as an art form in its own right. Adams developed the famous "zone system" for the then ultimate method of visualization and the utmost quality in monochrome. A Guggenheim Fellowship award in 1948 allowed him to photograph the national parks and monuments that inspired him so much.

Adams was not just one of the most, if not the most, important landscape photographers of the twentieth century, winning awards and recognition, but also a devoted conservationist keen on preserving the areas he loved. He collaborated with Dorothea Lange for *Fortune* and *Time* magazines, producing work of a documentary and humanitarian nature, proving that landscape was not his only subject. He died in 1984.

Jules' Comment

Ansel Adams' pictures of the National Parks represent some of the finest monochrome images ever taken. Dedication to composition and exposure all played a part in his work but, most importantly, it was his love of the areas he photographed and the photographic process itself that produced such inspiring work. This is a classic image that demonstrates his intensity, timing and patience, and his ability to record and print the subtle tones and rich quality that were the hallmark of his work.

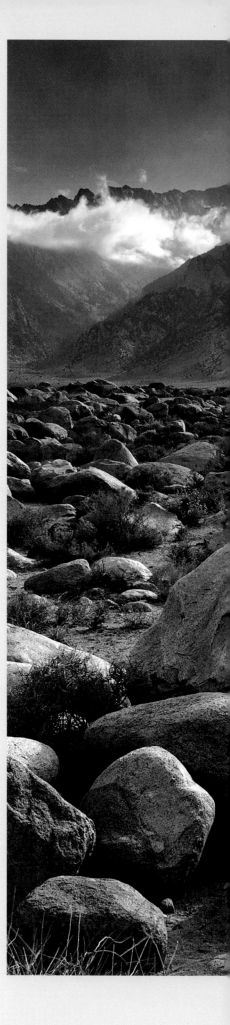

SIERRA NEVADA FROM LONE PINE

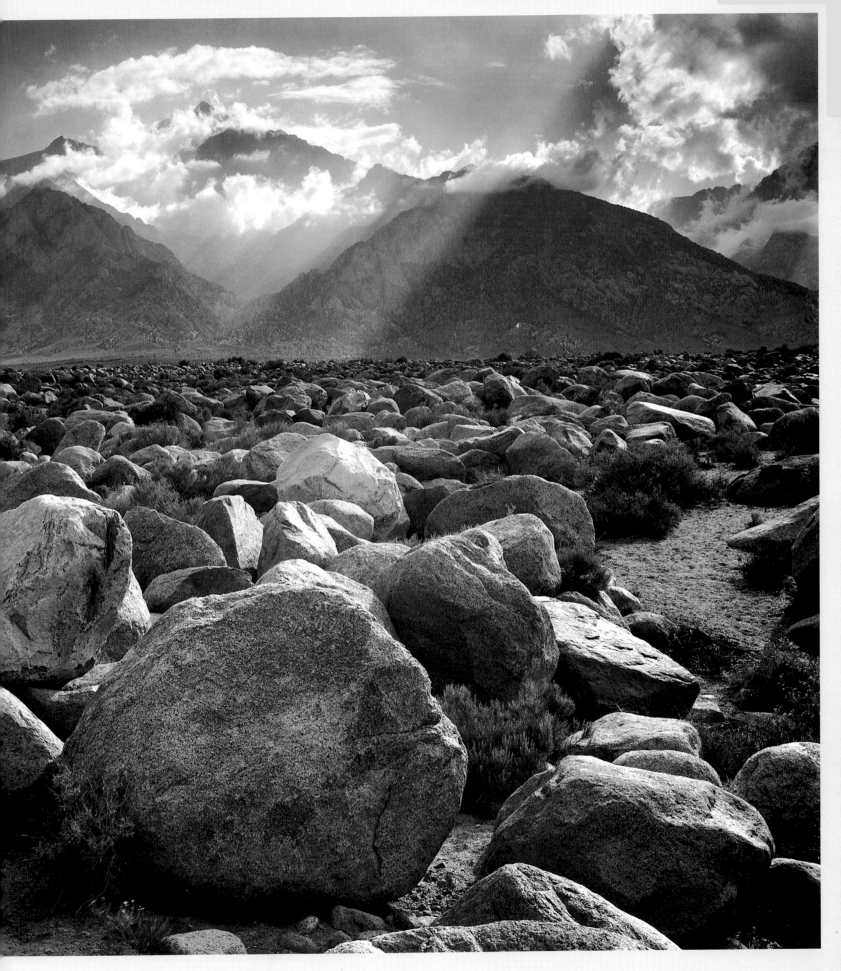

Technical Notes

35mm panoramic rangefinder camera, 45mm lens, Agfa APX 25 developed in Agfa Rodinal.

WINDSWEPT TREE, EXMOOR

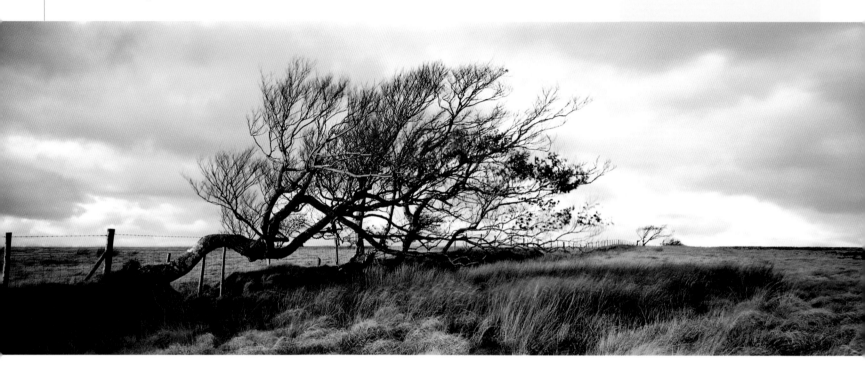

Selective Exposure Control

Often a photograph needs a helping hand to become a better print. Although there are many ways of taking a print further, the first and most important is to increase or decrease exposure in selected areas of the print while leaving the rest unaffected. The aim is to produce a balanced print without any areas that are too dark or too light.

There are two terms that you may hear in connection with this – "holding back" and "burning in". Holding back is when, during the main exposure, you shade part of the print so that it prints lighter than the rest of the image. Burning in is when you add exposure to parts of the print after the main exposure has been made, preventing additional exposure from reaching the areas of the print that you want to remain unaffected by shading them.

Situation and Approach

If you like windswept trees, then Exmoor in the south-west of England is the place to be. I saw this tree as the sun began to sink in the sky and the clouds were building up. The whole scene began to look quite striking. I used the fence to add an element of perspective and then mirrored the first tree with a distant one. (JB)

Test Print

This is a straight print, based on the results of a test strip, on Ilford Multigrade FB warm-tone paper set at grade 3 with an exposure of 12 seconds at f/8. The development time was 2 minutes in Multigrade developer. I wanted to improve this print by darkening down the corners of the sky to give the image a more intense and focused feel.

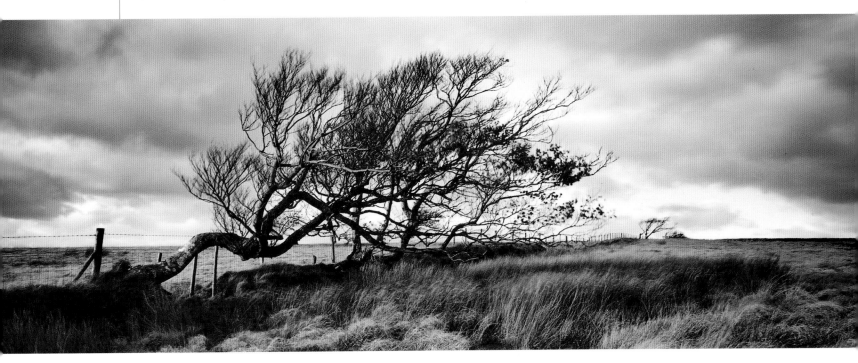

The principle is simple: just shade certain areas so that they receive less exposure. Remember to keep moving whatever tool you shade with, using a consistent, gentle motion, otherwise a line will be visible between the two exposures. You are now gaining creative control of the print.

Final Print

This is how I visualized the shot when I took it. I gave the print the same exposure and contrast level as the one on page 274, but I shaded the shadow area below and to the left of the base of the tree for 2 seconds to lighten it slightly. I then added 3 seconds exposure to the corners of the sky, shading the rest of the print with my hand. I feel that this, particularly darkening the corners of the sky, has created a more dramatic and better balanced print.

Technical Notes

Medium-format SLR, 100mm lens, Ilford Delta 100, developed in Agfa Rodinal.

Using different exposures on the same print can make a real difference and unlock detail that you carefully exposed for on the negative. The prints on these two pages demonstrate how much difference can be made to a print by using a substantial decrease in exposure to a certain area.

Holding back needs to be done very carefully to avoid it becoming apparent; it may take some practice to get right. Above all, the final print should look natural.

Situation and Approach

This picture is of my son, Sebastian. He has limitless energy and getting him to stay still long enough to compose a picture with anything other than a fast autofocus camera is next to impossible. This picture was a milestone in that I managed to capture him on an old medium-format camera. The lighting was particularly harsh and I really didn't expect to get a printable result, but it was a rare enough occurrence to warrant pulling out all the stops in order to get a print worthy of keeping. (JB)

Straight Print

This is a straight print on Ilford Multigrade FB warm-tone matt paper set at grade 3; the exposure was 9 seconds at f/8. I wanted to reduce the exposure in specific areas: Seb's face, hands and knee and the dark area of rock are all too dark for this print to be effective.

Final Print

This print was made on Ilford Multigrade
FB warm-tone matt paper, set at grade 3;
the exposure was 8 seconds at f/8, during
which I shaded Sebastian's face for
2 seconds and then went on to shade his
hands, knee and the rock for 3 seconds.
Reducing the exposure on Seb's face and
hands makes it a stronger portrait.
Reducing the shadows on the rock also
helps to even up the exposure and make
the shading less obvious, because there
are no strong shadows in one area and
light ones in another.

SEBASTIAN AT THE BEACH, FINAL

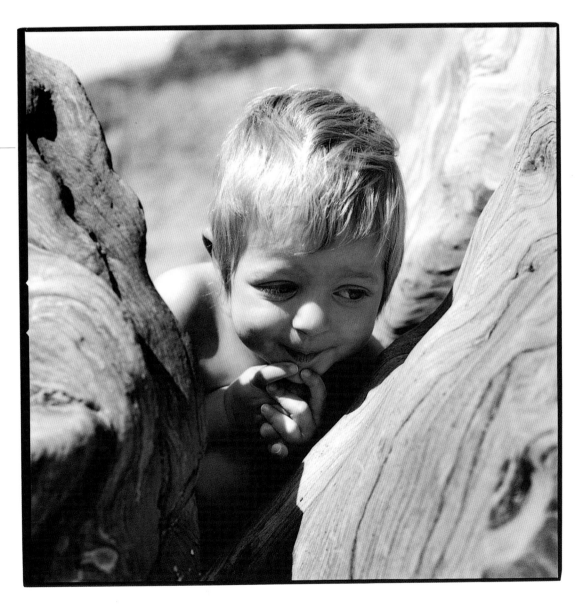

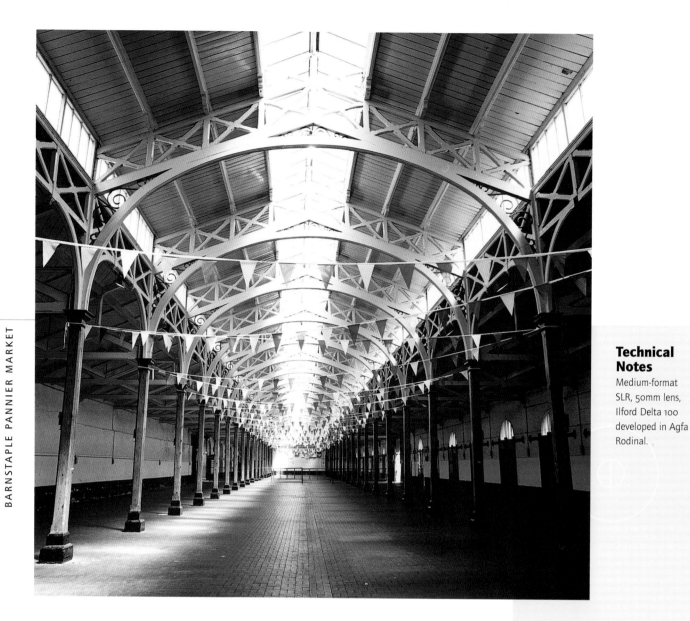

Technical Notes
Medium-format SLR, 50mm lens, Ilford Delta 100 developed in Agfa Rodinal.

Selective Contrast Control

One of the most important developments in printing has been the introduction of variable-contrast paper. The most obvious benefit, of course, is that one box of paper covers all grades; the other is that a print does not have to be all the same grade of contrast. There are different ways of using "split-grade printing" and one of the simplest and most useful is combining the shading techniques with a different grade of contrast filter. This allows you to give a localized section of the print more, or less, contrast than the rest – great for including detail or adding more punch to a print without sacrificing other areas.

Situation and Approach

This empty market had a lot of potential, and I particularly liked the extreme perspective created by the lines on the roof. The biggest problem was the brightness range: there was a major difference between shadow and highlight. Keeping things simple, I metered for the floor, which was where I wanted most detail. I knew that the film and developer combination I intended to use would give adequate shadow and highlight detail on the negative but, with such extremes, retaining this detail on the print might require the use of a split-grade technique. (JB)

Straight Print

This print was made on Ilford Multigrade FB warm-tone matt paper set at grade 3; the exposure was 10 seconds at f/8 and the development 2 minutes in Multigrade developer. The exposure on the floor is correct, but the ceiling is far too light: I wanted the light from above to be at a similar level to the highlights on the floor.

The answer is to burn in the highlights at a much lower grade than the rest of the print. If I used the same grade, the highlights would need a substantial exposure increase and the result would be obvious and crude. The intense level of contrast would still remain, so using a lower grade is the sensible option. I will also hold back the bottom right-hand corner to lighten the floor and the base of the pillars a little.

Final Print

This print was given the same exposure as the previous one but I held back the bottom right-hand corner for 2 seconds to open this area up a little. Then I changed to grade 0 and burned in the entire roof for 4 seconds. Finally I burned in just the skylights and lighter section of the beams at grade 0 for another 3 seconds. I also toned the print in selenium to keep the highlights and shadows clean.

There is now some detail and tone in the highlight areas that I couldn't have achieved on the original grade 3. The print still has strong light and dark areas, but it is now better balanced and this in turn has helped the pools of light and the floor to move forward.

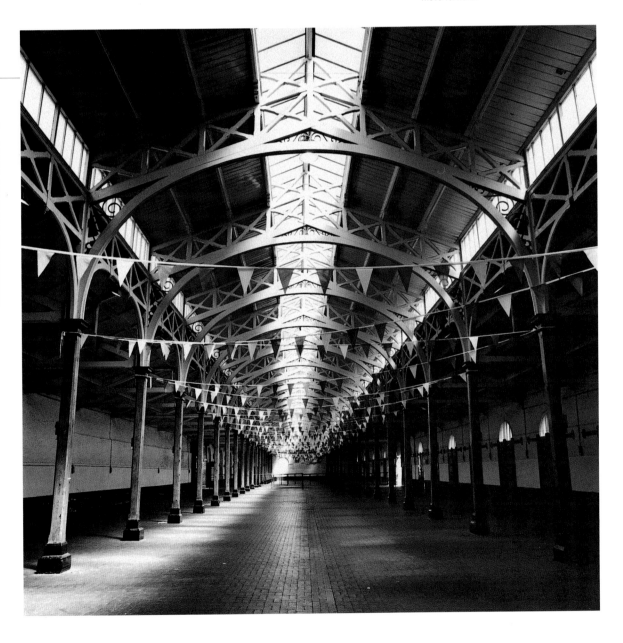

BARNSTAPLE PANNIER MARKET, FINAL

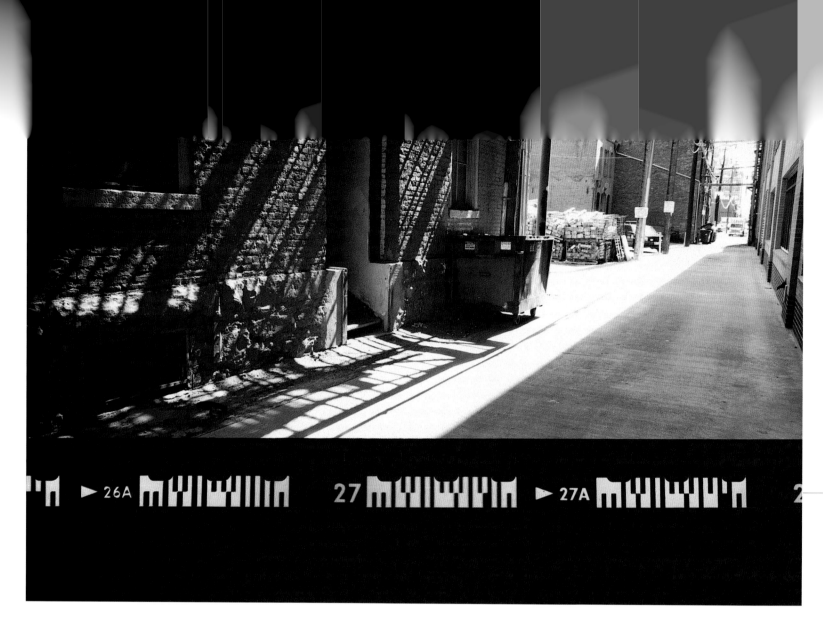

Toning

Toning a black-and-white print can enhance the mood of the picture. It can also protect the print from the environment and make it archival. Even if you do not want a definite colour change, toners such as selenium and gold allow for added definition and the archival effect.

All prints to be toned need to have been processed properly with fresh chemicals, paying special attention to the fixing bath. After this, they need to be very thoroughly washed: skimping on this will invite staining. Ensure that you handle the prints with tongs or wear gloves and that the area you are working in is well ventilated.

When toning, keep an untoned image as reference next to the tray of toner so that any change is obvious. After toning the print must again be thoroughly washed.

Situation and Approach

I had begun to photograph the Denver skyline when I noticed this alleyway. I shot some abstracts of the shadows cast by a fire escape, and then turned my attention to the alley itself. I placed the shadows to the left of the frame and let the long strip of illuminated pavement stretch back for a bit of dramatic perspective. I was just about to take the shot when a truck appeared at the bottom of the alley; although it is difficult to see it on anything other than the original 40 x 30cm (16 x 12 inch) print, it just added that extra touch. (JB)

Straight Print

The print was made on Ilford Multigrade FB matt paper, set at grade 3; the exposure was 12 seconds at f/8 and the development time 2 minutes in Multigrade developer. This print needs extra exposure on the lighter sections of the alley.

**Technical
Notes**

35mm panoramic
rangefinder
camera, 45mm
lens, Ilford Delta
100 developed in
Agfa Rodinal.

DENVER ALLEYWAY

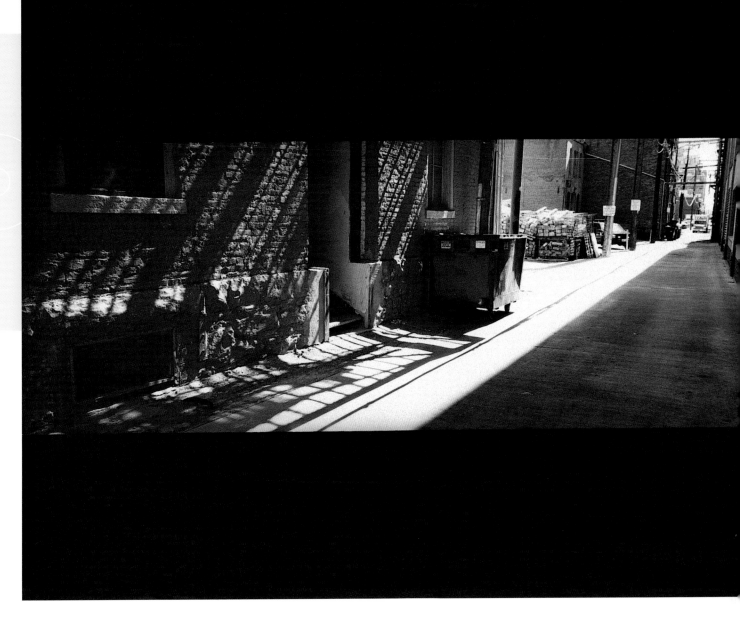

Selenium toning

Many of the black-and-white images in this book have been toned, most using selenium – not to alter the colour, but to enhance the image. Its versatility makes it the most valuable of all toners.

Used at a high dilution, selenium intensifies a print without significantly changing the colour. It adds a little contrast and definition, keeping the print truer to the way it looked when wet. This effect alone justifies its place in the darkroom. A dilution of 1 part selenium to 30–40 parts water is ideal for this purpose. If you wish to progress to a colour change, then a different dilution – say, 1 to 5 through to 20 – is more appropriate.

Toned Print

I gave this print the same basic exposure and contrast as the straight print, with an additional 10 seconds exposure on the lighter sections to burn them in. I also burnt in the black borders to get rid of the film information. Finally, I selenium toned the print at a dilution of 1 to 20 until I got the effect I wanted.

Viradon

Sepia toning, which produces colours ranging from yellow through to brown, is one of the most popular toners. But a rich brown is better achieved by using a toner called Viradon, which is made by Agfa. This is a simple one-bath toner, which sepia is not; like sepia, Viradon is archival. Papers do react differently but the Ilford FB warm-tone Multigrade range gives a particularly pleasing effect, especially in the matt finish.

Situation and Approach

Shooting abstracts and details is a very pleasurable part of photography for me; it helps to refresh my outlook and makes me explore the landscape in more detail. One section of beach near where I live has lots of interesting, but subtle, patterns, which are best captured in a very diffuse light. The limited tonal range sometimes needs a little help to keep images as interesting as the real thing. One of the methods I use is to tone the print in Agfa Viradon. (JB)

Straight Print

The print was made on Ilford FB warm-tone Multigrade paper set at grade 5, the exposure was 12 seconds at f/16, developed for 2 minutes in Multigrade developer. The foreground is distracting, because it is too light in comparison to the background.

Technical Notes

35mm rangefinder camera, 45mm lens. Ilford Delta 100 developed in Ilford DD-X.

Toned Print

The rich brown of Viradon toning complements the image well. I gave the same exposure as in the straight print, but shaded the background for just a second and then added 4 seconds to the foreground to even up the exposure difference. After washing the print for 45 minutes, I placed it in Agfa Viradon toner diluted 1 to 25 at 20°C.

ROCK PATTERNS, TONED

ROCK PATTERNS

Blue Toning

The main use of blue toner is to cool a print down and produce a significant colour shift. It works particularly well with snow-and-ice scenes and architectural subjects.

If the blue effect is too strong, wash the print thoroughly and place it in dilute selenium or in print developer diluted 1 to 9. This will gradually turn the blue into grey; pull the print when you achieve the desired effect.

If your toned print is not blue enough, place it in a standard developer diluted 1 to 9 and leave it for a minute or two until the blue disappears. Rewash the print and then retone it and the tone will have intensified. You can repeat this a number of times if you wish.

Situation and Approach

You could be mistaken for thinking that this is the back of a factory or a housing estate. In fact, it is a theatre (in its defence, it looks better from the front). I particularly like the handrail and, to emphasize its dominance, composed the shot so that it runs from the bottom left corner to the centre of the picture. (JB)

Straight Print

This print was made on Ilford Multigrade FB warm-tone paper set at grade 3; the exposure was 11 seconds at f/8 and the development time 2 minutes. The exposure is about right, but I'd like to give the print a little more character.

Technical Notes

35mm SLR, 28–70mm zoom lens, Kodak Tri-X developed in Kodak T-Max developer.

Toned Print

This was printed at the same basic grade and exposure as the straight print, but I gave an extra 2 seconds to the furthest chimney to give a slightly stronger edge against the white sky. I washed the print for 45 minutes and then placed it in a simple one-bath blue toner until the blue effect reached a pleasing level. The blue has helped to make the image a little stronger and more eye-catching.

LANDMARK STEPS, TONED

Colorvir

Colorvir toner is available in a kit that will produce not only just about any colour under the sun but a range of effects that you couldn't achieve any other way. It doesn't replace the toners already mentioned, but for experimenting and producing some very different images this kit is a lot of fun. Oddly enough, these chemicals are best used on resin-coated paper rather than fibre-based materials. There are many different combinations and dilutions. The kit comes with an extensive instruction book, but the effect I like the most is the solarization bath, shown here.

Situation and Approach

This picture of Saunton Sands in North Devon was taken from a lay-by on the main road, which gives fabulous views, not only of the beach but also of the Taw and Torridge estuary and Westward Ho! Because of this, both the lay-by and beach are often packed – except in winter, when there are fewer tourists and the surf is so wild that only experienced surfers can tackle it. This image was shot in October.

I included a strip of the dry land and excluded the sea itself, concentrating on the wet sand. I kept the surfers very small in the frame because I liked the the sense of scale and emptiness. The result is somewhat abstract: you have to look at it for a while to work out what it is. (JB)

Straight Print

The print was made on Ilford Multigrade IV RC paper set at grade 4; the exposure was 55 seconds at f/5.6 and development 60 seconds in Multigrade developer.

The print lacked the atmosphere that had prompted me to take the shot in the first place. I decided that it needed to be toned to help recapture that atmosphere.

Technical Notes

35mm SLR, 105mm lens, Fuji Neopan 1600 developed in Ilford Ilfosol S.

Toned Print

This version was printed at the same basic grade and exposure as the straight print, but I held back the land for approximately 15 seconds as I felt it was a shade too dark. I also used a Zeiss Softar III filter under the enlarger lens to give a smoother-grained, impressionistic image.

For the toning I used what Colorvir describe as a solarization bath, which I have found to produce one of the most useful effects. The toning process was 2 ml part B, 2.5 ml part C and 2.5 ml part D in 500 ml water. After this bath, the print went into a second bath consisting of 5 ml part A and 2 ml part C in 500 ml of water.

The print then went into the recommended saline bath for 3 minutes before the final wash. I like the way that the blue mostly seems to have settled in the areas of wet sand. The overall gold effect, combined with the Softar filter, has produced the image I was hoping for.

SURF BEACH AND SURFERS

SURF BEACH AND SURFERS, TONED

Print 1

This is a low-contrast print achieved by using an exposure of 30 seconds at f/8. Development time was about 6 minutes in the Novolith developer. All prints were made on Oriental Seagull paper.

Print 2

A higher contrast can be achieved by using a shorter exposure and longer development. This print had a 6-second exposure and 16 minutes development time.

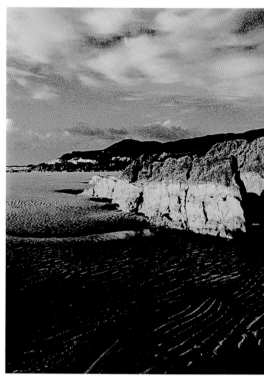

Lith Printing

You either love it or hate it, but you can't deny that there is nothing really like lith. If you need to be totally in control in the darkroom and always print for a full tonal range, then lith is not for you – but if you love experimenting and creating unusual prints, then have a go.

You can achieve a range of effects using standard papers in this developer. Most common is a colour shift – which can be towards browns and golds, or sometimes lilacs and pinks. The contrast also increases quite dramatically and an enhanced grain effect often becomes apparent. The effect depends on the paper you use and the dilution and age of the chemicals. Experimentation is the only way with lith: the developer

changes every time you put a print through, so there is no point in bothering with a test strip: go straight for a print and make adjustments based on this.

Unlike normal printing, the exposure is not crucial. Development times are often long, with everything happening very quickly at the end. The shadows then build very quickly and you have to snatch the print from the developer and plunge it into the stop before things go to far.

I use a lith developer called Novolith and dilute 100 ml each of parts A and B with 1200 ml of water at 20°C. As far as papers go you need to experiment, but I like Oriental Seagull grade 4, Forte Poly warm-tone and Ilford Multigrade FB WA matt.

Print 3

This print has the typical lith feel to it, with an interesting colour, punchy contrast and a grainy image quality. I used a 15-second exposure, holding back the ripples for 5 seconds, and gave it about 10 minutes in the developer.

SAND RIPPLES

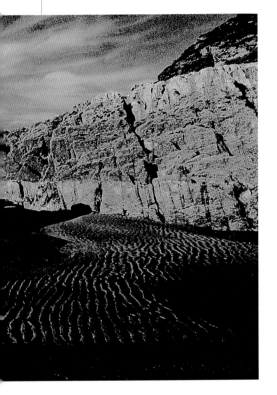

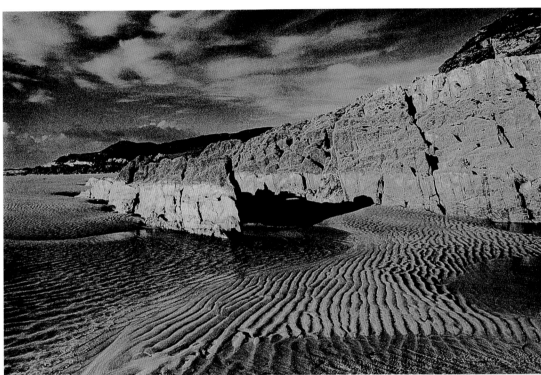

Situation and Approach

This is an Atlantic-facing beach that becomes quite fearsome during a swell. In periods of calm, however, there are wonderful patterns in the sand and the rocks are always interesting. In autumn, the light has a really incredible clarity to it. This shot was taken to capture the ripples in the sand. I also included the section of rock and headland to make this an identifiable scene rather than an abstract. (JB)

Technical Notes

35mm SLR, 28–70 zoom lens, Ilford HP5 developed in Kodak T-Max developer.

Technical Notes

35mm SLR, 28–70 zoom lens, Kodak T400CN, a black-and-white film that is processed in C41 colour negative chemicals.

Situation and Approach

I used window light indoors for this nude shot, making sure the lighting was soft and even, and framed tightly to create an abstract-style image. The lith process works well only if you don't allow the shadows to build, so it's best to begin with a low-contrast image. By beginning with a soft image, I was able to ensure the end result was a little softer and more subtle than the usual lith quality.

The print was made on Oriental Seagull, a grade 4 fibre-based paper. I used Novolith chemicals, with 100 ml each of parts A and B to 1200 ml water at 20°C. I also added 100 ml of "old brown" to increase the effect at the beginning of the printing session. (This is partially used lith developer saved from a previous session; the developer oxidizes if you leave it for a few hours and turns brown, hence the name. It's important to have only partially used developer and not that which is completely exhausted.)

The exposure was 5 seconds at f/8 and the development time 8 minutes. The result is a warm colour with classic lith contrast and a nice, textural quality. (JB)

ABSTRACT FEMALE CURVES

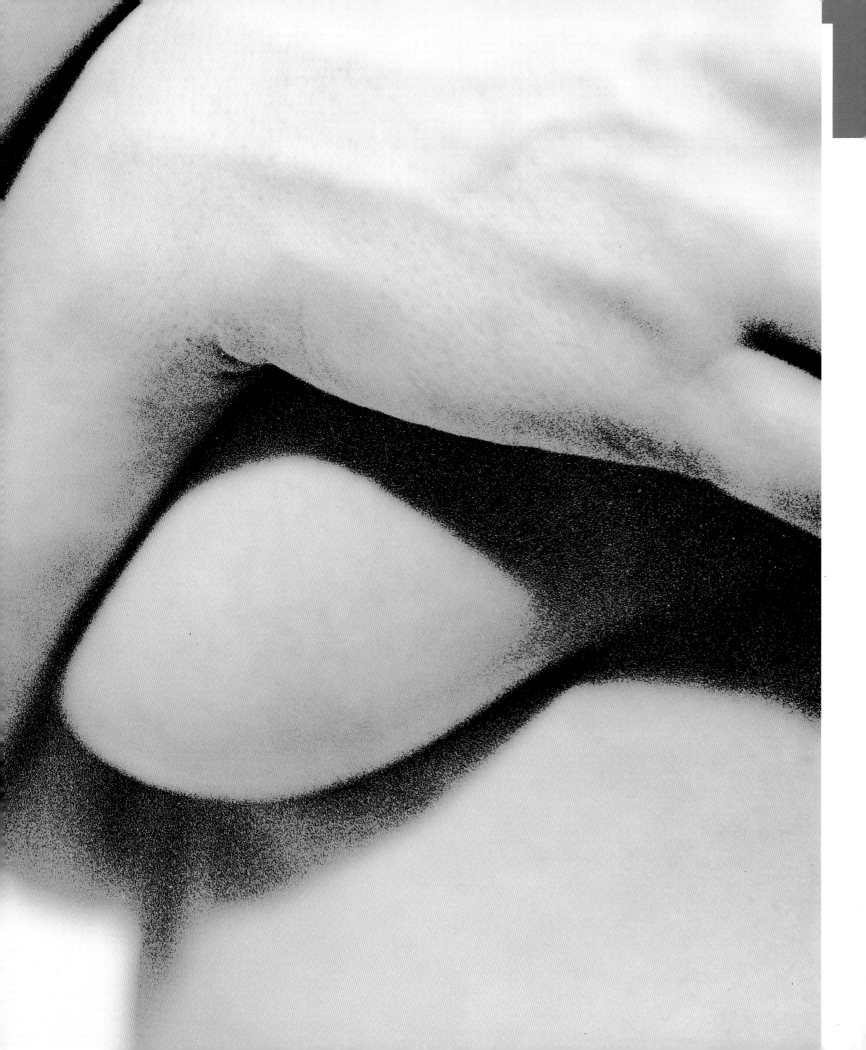

Technical Notes

Medium-format SLR, 50mm lens with orange filter, Ilford Delta 100 developed in Agfa Rodinal.

Situation and Approach

Sometimes I find that the things that seem like an obvious picture opportunity to a photographer leave non-photographers scratching their heads. This shot was a perfect example of that situation. I saw this yard filled with old wrecks in varying states of decay off the beaten track in Colorado. I stopped and asked the owner if I could take pictures – he agreed enthusiastically.

To his horror, I proceeded to photograph the more derelict vehicles, whereupon he threw open his garage doors and showed me his restored 1930s trucks along with Thunderbirds and Mustangs. These were true works of art but to me the old wrecks were a much more interesting subject. We ended up chatting for hours and I hope that by the time I left he thought me less crazy than he had when I arrived. (JB)

Straight Print

This print was made on fibre-based variable-contrast paper set at grade 4; the exposure was 8 seconds at f/8. The print was processed in a standard variable-contrast developer diluted 1 to 9 for 2 minutes at 20°C. While there is nothing particularly wrong with it, I felt that a lith version would produce a more interesting and dramatic image.

Lith Print

This print was made on Ilford Multigrade WA FB matt paper, which works very well in fresh developer. The exposure was 5 seconds at f/8. I gave an extra second to the bottom corners of the print just to darken them a fraction. I used Novolith chemicals with 100 ml each of parts A and B to 1200 ml water at 20°C. Development time was around 4 minutes – very quick for lith. The point at which you grab the print from the developer and plunge it into the stop bath needs accurate timing.

As soon as the print hits the fix, the contrast and density will increase. The time in the developer needs to be a fraction short of your ideal, as the fix will finish the job for you. I just love the colour and effect that this paper produces even though it is quite difficult to work with, but when I get a result like this it's worth the trouble.

DERELICT VAN, COLORADO, LITH PRINT

Finishing and Presentation

Without any doubt, if you hand someone a care-fully presented portfolio of large images on fibre-based paper, they are much more likely to show an interest in your work than if you show them a box of small prints on a standard plastic paper. The way you present your work also represents how you feel about the images. A 16 x 12in/40 x 30cm fibre-based print not only looks good framed on a wall, but feels exquisite in the hand.

A border, carefully chosen to complement the mood of the print, will also enhance your work. Creating borders for your prints is best done at the printing stage: it looks better and, if the print is toned, the border will match it. However, another option is to draw a black border around the image with a permanent marker pen and a clear plastic ruler.

Apart from the standard white border, there are two other methods. The first method is to allow some of the clear negative rebate to print as black by not masking the print down on the base-board. If the negative carrier fits too tightly to allow you to do this, then you need to open up the aperture by carefully filing back the edges, leaving a smooth, even finish.

The second method is to file back the negative carrier as above, but leave the edge looking ragged.

If you crop an image, then you need an alternative method. One of the best and simplest ways of making a black border on a cropped print is to leave the print in the easel and mask off

Technical Notes

35mm rangefinder camera, 45mm lens, Ilford Delta 100 developed in Agfa Rodinal.

Situation and Approach

This image is made particularly striking by the use of subject matter and the way in which it was framed and printed. I used abstract framing to keep the attention where I wanted it and lith to give an unusual effect. The shoulder and dragon tattoo really benefited from using the lith process to add colour and striking contrast, and the process has "sharpened up" that tattoo and made it even more eyecatching.

In order to give the print a finishing touch I felt that a black border would be appropriate. The border was created by not masking the edges of the print and allowing some of the negative rebate through to print as black. This gives a tidier version than the other print but still gives a less formal look. If I had wanted to I could have cropped this tighter and ended up with a neat, thin line. (JB)

all but one side with some card. Place a metal ruler (for a neat, straight edge) or thick torn card (for a ragged edge) between the mask and the edge of the easel, leaving a gap of your chosen border depth. With the negative carrier empty, open up the lens and set the grade to 5 if you are using variable-contrast paper. Give an exposure long enough to produce a black border and then repeat this on the other edges to match. It's a little time consuming, but looks very effective.

Technical Notes

Medium Format SLR with 100mm lens. Ilford Delta 100 developed in Agfa Rodinal.

Digital Imaging

Although many photographers recognize digital photography as being a major advance in their ability to control both the quality and the content of their images, others view it as a very different medium from traditional photography. One reason for this reaction is that digital imaging has made a number of the techniques that helped to define a photographer's skill either redundant or pointlessly difficult and time-consuming and this has tended to foster a feeling of insecurity.

But those who have embraced the new technology regard it as a powerful new tool, which not only allows them to exploit the possibilities of the medium to the full but also frees them from many of the more mundane aspects of image making to concentrate on the true skill of photography – namely the ability to see, capture and realize striking images.

The techniques described in this chapter range from using basic levels and colour controls to extract the maximum possible quality from a recorded image to more obviously manipulated effects that give an image added impact. Adobe Photoshop 7.0 is the program used to manipulate the images, but the essential controls and basic principles are common to all major image-editing software.

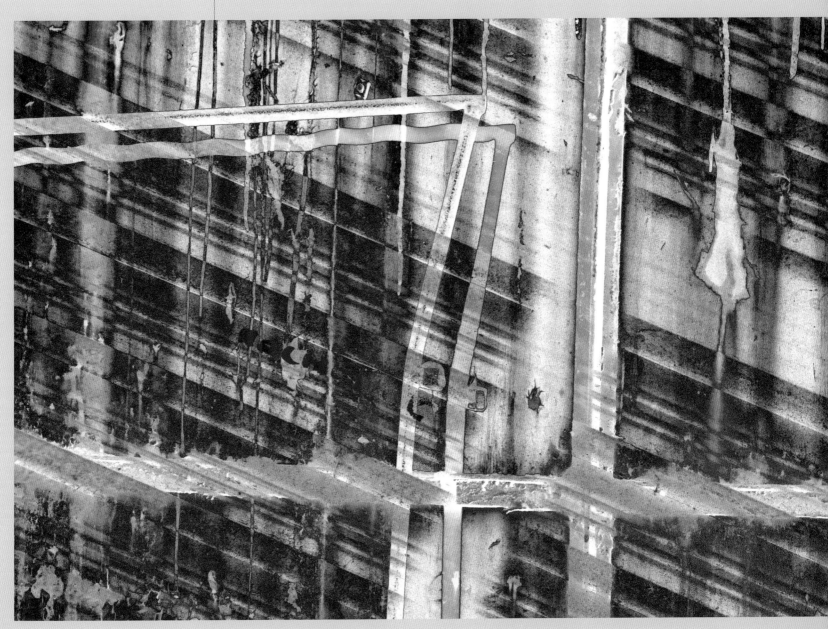

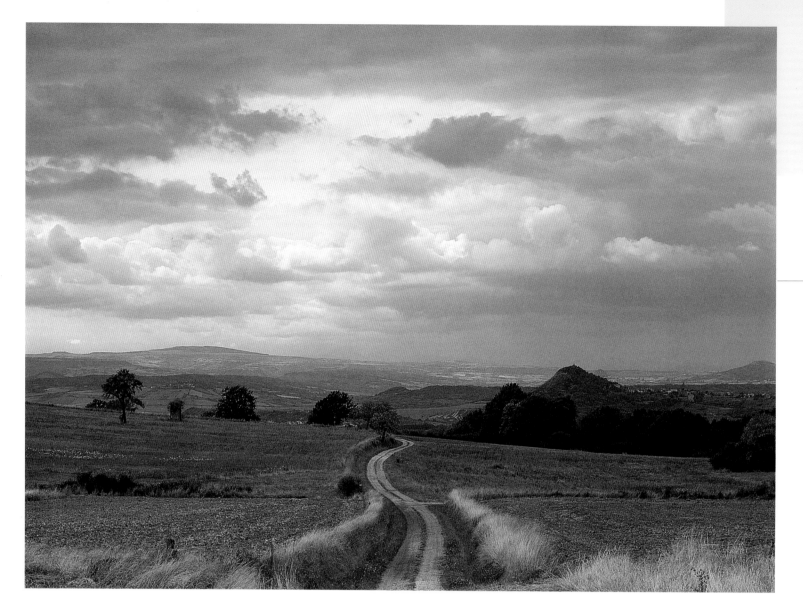

Controlling Density and Contrast

The density and contrast of an image are two of the main factors that determine its quality. Density and contrast depend on several things – the nature of the subject, its brightness range, the quality and direction of the light, and the exposure that is used to record it. When an accurate record of a subject is needed (a copy of a painting, for example), these factors must be controlled in a way that will reproduce each of the original's tones and colours accurately. But when an image is being produced solely for creative reasons, they should be used to produce the result that the photographer has visualized.

It is not difficult to make adjustments of this kind and there are alternative ways of achieving the same result. These range from quite crude changes to ones that are very subtle and almost infinitely controllable. If you are new to image editing, you might be best advised to begin with the more basic controls in order to develop a feeling for what you can achieve, and how to do it, before you move on to more advanced methods, such as manipulating curves.

However, it is important to appreciate that there are limits to the extent to which you can alter an image digitally. If you exceed those limits, the result will be very unattractive. Just as printing a weak, underexposed black–and–white negative on a hard grade of paper in the darkroom usually results in a harsh, grainy quality, so too will an excessively manipulated digital image quickly reveal its inherent shortcomings.

Technical Notes

Medium-format SLR, 55–110mm zoom lens with neutral graduated and 81A warm-up filters, Fuji Velvia.

Situation and Approach

This photograph was taken late on a winter's afternoon, when the sky was cloudy and the light was too soft to create much contrast. Silver-based colour film has a narrow latitude and a subject that has a limited brightness range will appear flat and dull, as it does in the original transparency (left). Even though I had used a graduated filter when exposing the film, this was not enough to correct the poor tonal balance between the sky and the land. In addition, the foreground lacked contrast and the sky was a little too contrasty, which meant that some of the richer tones were lost.

With a digitized image, however, the contrast and density can be readily altered. My first step was to open the Curves control in Image/Adjust and alter the levels until I had the degree of contrast and overall density that I wanted. This alone brought the image much closer to the way I had visualized it at the time of shooting, but I still needed to make a few more adjustments.

I selected the sky area using the Magic Wand and, using Image/Adjust/Curves, reduced its contrast and made it darker until I achieved the fullest possible range of tones. Next I inverted the selection and, again using Curves, increased the contrast and brightness of the foreground. Finally I used the Linear Graduation tool in conjunction with the Quick Mask to create a graduated selection on the sky area and, using the Curves control, made the sky still darker towards the top of the image. (MB)

AUVERGNE LANDSCAPE, DIGITAL TREATMENT

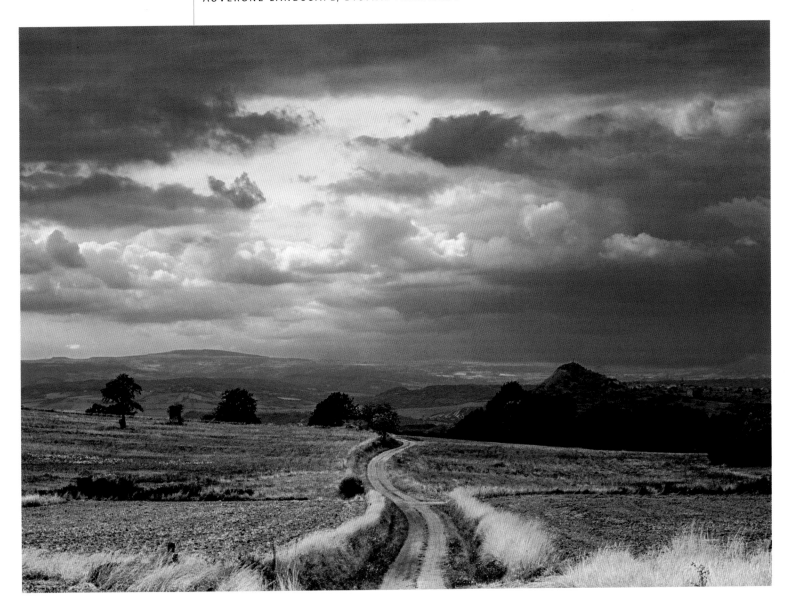

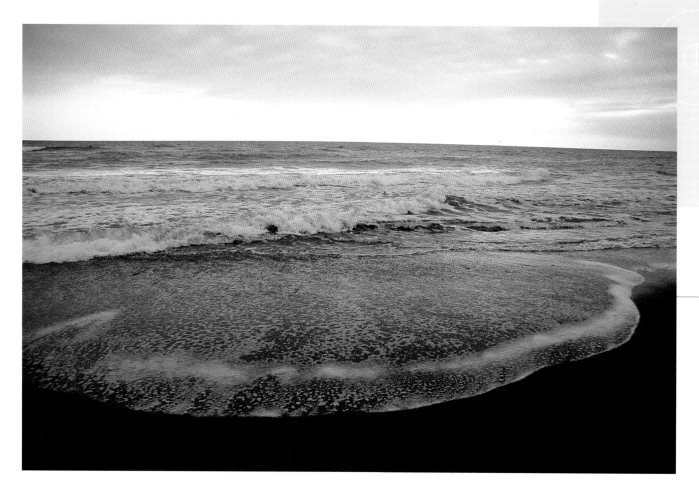

Technical Notes

35mm SLR, 24–85mm zoom lens, Fuji Provia 400F.

SURF, ORIGINAL IMAGE

Balancing the Tones

The tonal range of an image has a marked influence on its mood as well as its quality, and by making an image darker, lighter, softer or more contrasty you can often completely change the way people react to it.

The tonal range of an image is created by the difference in brightness between the darkest shadow and the brightest highlight. A black cat photographed against a white wall would have a high brightness range, or contrast, but a very limited range of tones; it would consist of just black and white. The same photograph taken with a tabby cat would have the same brightness range, or degree of contrast, but a much greater range of tones.

A low-key image consisting primarily of darker tones tends to create a sombre or even threatening mood, whereas a light-toned picture evokes a more peaceful or reflective atmosphere. When an image consists of pixels instead of silver-halide grains, it not only becomes easier to alter the tonal range but also enables you to see the effect it has as you do so. You can also control selective areas of the image in ways that would simply be impossible using traditional techniques.

Using the darkroom analogy again, when you are making a black-and-white print from a negative of a subject with deep shadows, you can hold back this area during the exposure to show more detail in the shadows – although you cannot do this very precisely. With a digital image, not only can you select and lighten a precise area, but you can also alter its colour and contrast. In the same way, you can select and darken a specific area of an image that is too light in tone.

Situation and Approach

This photograph was taken close to sunset on Spain's Costa del Sol. The light was soft enough to create a brightness range that could record detail in both the shadows and the highlights, but the resulting image lacked the atmosphere which I'd been aware of at the time: it seemed rather bland and did not have the tonal quality I wanted. Simply making the image darker overall was not the answer, as the lack of balance between the tones in the sky and those in the surf remained. By making the image darker overall, the highlights on the water became degraded and muddy-looking, giving it a lifeless quality.

First I selected the sky area using the Magic Wand tool and, using Image/Adjust/Curves, made this area darker and less contrasty. Then I created a graduated selection using the Linear Graduation tool and the Quick Mask and made the top of the sky darker still.

I used the same process to make the foreground a little darker and more contrasty. But this did not make the pool of water as prominent as I wanted, so I used the Magic Wand tool to select this area and increased both the brightness and contrast using the Curves control. (MB)

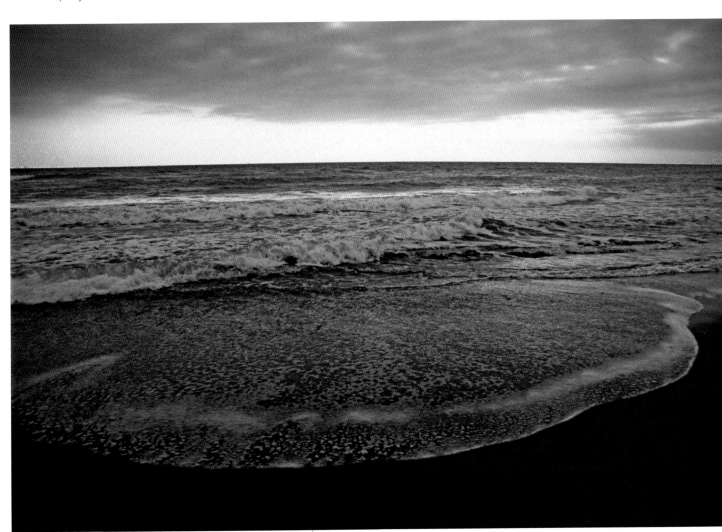

SURF, DIGITAL TREATMENT

DOLLY, ORIGINAL IMAGE

Increasing the contrast of an image also increases its colour saturation. This is not always desirable and you can counter this effect by using the Hue and Saturation sliders found in Image/Adjust. Increasing contrast means making highlights brighter or shadows darker, or both, and the images on this page demonstrate how this can be done with a high degree of control, together with the ability to control the colour saturation at the same time.

There is a distinct difference between colour contrast and tonal contrast. Colour contrast is high when two colours from different areas of the spectrum are seen together – blue against red, for example. Seen as shades of grey, however, they would be very similar in tone and would display low contrast. The technique described here enhances the tonal contrast without affecting the colour saturation by integrating a stronger range of tones within the colour image and creating a quite different quality from simply increasing the image's overall contrast.

Useful Advice

Image contrast is created in two quite distinct ways, that between hues and that between tones. With black-and-white film you can create tonal contrast by using filters, as well as by controlling development and using paper grades in the darkroom. Image-editing software such as Photoshop enables you to use the same techniques with a colour image.

Situation and Approach

This portrait of an elderly lady was lit very softly with a heavily diffused studio flash. Although I did not want the picture to have strong shadows, I felt that the weathered, lived-in texture of her skin had been lost and the image was simply too bland.

A straightforward increase in contrast using Curves did not produce the effect I wanted, and so I made a duplicate layer of the image and, using Image/Adjust/ Channel Mixer, checked the Monochrome box to render it as a grey-scale image. I then used the sliders to get the strongest possible tonal variation and texture on the flesh tones, creating an effect similar to using a dense blue/green filter with black-and-white film.

I set the Blend Mode to Multiply, which brought about a dramatic increase in skin texture and shadow density. I adjusted the effect by using Curves to alter the contrast and density of the top monochrome layer and used the Hue and Saturation sliders to make a final adjustment to the image's colour saturation. (MB)

Technical Notes

Medium-format SLR, 105–210mm zoom lens with extension tube, Fuji Astia.

Controlling Colour Values

To record an image on film in colour with reasonable accuracy, the colour temperature of the light source must closely match that for which the film is balanced. Any deviation from this will result in a colour cast. Automatic white-level adjustments on a digital camera will, by and large, avoid this problem.

But colour accuracy is not always desirable when making photographs with aesthetic or pictorial intent. In these cases, the final choice of colour quality becomes a subjective judgment based on the effect you wish to create. You also need to think about colour saturation: both film and digital cameras often produce results that are different from what you saw at the time of shooting. It is relatively simple to make these adjustments when working with a digitized image and there is a variety of ways in which you can control the colour content of an image.

Technical Notes

Medium-format SLR, 55–110mm zoom lens, Fuji Velvia.

Situation and Approach

I took this photograph of Leeds Castle, in Kent, England, a short time before sunset in order to capture the effect of the warm, orange-tinted sunlight at the end of the day. But the atmosphere was a little hazy and this had the effect of reducing the brightness range of the scene, producing an image that lacked contrast. It also degraded the colours, making the stone walls appear a rather dull, yellowish hue and the sky weak and grey.

First, I increased the image contrast using Image/Adjust/Curves, which immediately increased the colour saturation. It was not enough though and the hues of both the stone and the sky were unattractive.

Next I went to Image/Adjust/Replace Colour and sampled the colour of the stone. Using both the Hue and Saturation sliders, I altered the selected colours until I arrived at a tone that I liked – one that I felt would have existed had the lighting conditions been ideal.

I next went to Hue and Saturation and selected, in turn, Blue and Cyan, altering the hue and saturation slider again until the sky colour was more pleasing. (MB)

Useful Advice

The Hue and Saturation control found in Image/Adjust allows you to reduce or increase the overall colour saturation of an image. Each of the primary colours (red, green and blue) and the secondary colours (cyan, magenta and yellow) can be selected individually and both their saturation and hue altered independently. This can be quite a subtle way of changing the colour values of an image: with a portrait, for example, if the skin tones are a little too florid it can be preferable to reduce the colour saturation of the red element of the image rather than to attempt to alter the overall balance. Similarly, a degraded sky colour caused by atmospheric haze can often be improved by altering the hue and saturation of the image's blue content.

LEEDS CASTLE, ORIGINAL IMAGE

LEEDS CASTLE, DIGITAL TREATMENT

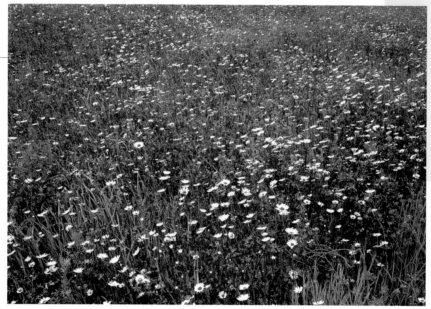

Technical Notes

Medium-format SLR, 105–210mm zoom lens, Fuji Velvia.

The ability to control the colour values of an image can be invaluable when you are attempting to correct the failings of the light or the recording medium – for example, when reducing the orange cast that is created when one area of subject is lit by artificial light and another by daylight. It can also be a very effective way of dealing with colours that are inherently difficult for film to record with any accuracy, such as blue flowers. But much more radical alterations can be made to the colour content of an image, either to produce results that are deliberately unreal or ones that are simply more interesting or dramatic than the natural hues.

Situation and Approach

I saw this splendid swathe of wild flowers while driving through France in the early summer and photographed them using colour transparency film. Although I was quite pleased with the result, it somehow lacked the impact of the original scene.

My first thought was to simply increase the colour saturation, but this looked not only unreal but also unattractive. I decided to take more drastic steps and, since the photograph was not intended as an horticultural record, to ignore the true colours of the blooms and create my own.

Using the Colour Range facility in Image/Select, I sampled the purple flowers and, with this selection in place, used the Hue and Saturation sliders to create a completely different hue. I repeated this process with other blooms of different hues until I achieved what I felt was a pleasing, but not unbelievable, balance. (MB)

Situation and Approach

This house was photographed in New England and seemed almost unrealistically perfect; I wanted to find some way of giving the image greater impact. As the photograph consisted largely of only two colours (red and cream), I though it might be interesting to treat it as a monochrome image that had been hand coloured. An effective way of hand colouring in silver-based photography is to take a black-and-white, or toned, print and add colour to just some of the details within the image. I thought that this might compensate for the rather over-restored appearance of the house and give it the look of an old photograph.

My first step was to make a selection of the reds within the photograph, using Image/Select/Colour Range. I then inverted this selection and desaturated the remainder of the image, rendering it pure grey. I thought that this could be further enhanced by giving the monochrome element of the image a bluish tint, to heighten the contrast with the red details. With this selection still in place, using Image/Select/Replace Colour, I adjusted the hue and saturation sliders until I achieved the degree of blue bias that I wanted. (MB)

Technical Notes

35mm SLR, 70–200mm zoom lens, Fuji Velvia.

CLAPBOARD HOUSE, ORIGINAL IMAGE

CLAPBOARD HOUSE, DIGITAL TREATMENT

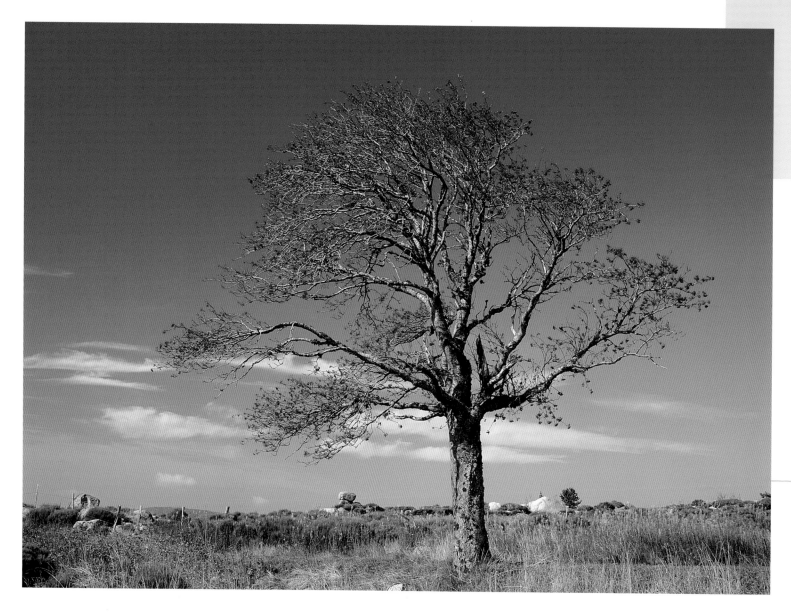

Converting to Monochrome

In film-based photography, converting a colour image to black and white invariably results in a loss of quality. With a digital image, however, you can render the pixels in almost any way you choose without any loss of information or definition.

The obvious way to render a colour image in black and white is to convert it in Image/Mode to Greyscale, but this is rarely the best way. This is because by doing so you lose all of the image's colour information and the ability to control the tones within the image by altering the colour values. Desaturating the colour image will reduce it to tones of grey while still leaving all the colour information in place, and this will allow you to alter the grey tones.

Situation and Approach

I photographed this tree in the autumn on Mont Lozère in France and was attracted by the striking contrast between the red berries and the bright blue sky. As a colour photograph I felt it was a bit too "pretty" and decided to convert it to monochrome.

A straightforward conversion to Greyscale was, predictably, not very satisfactory as the tonal contrast between the red berries and blue sky was very small and did not create the bold effect it had in colour. The smaller monochrome image shows this.

My next step was to reduce the colour saturation to about 60%. This is because when an original has very saturated colours, subsequent manipulations can make the pixels become visible. I went to Channel Mixer in Image/Adjust and checked the monochrome box. By increasing the red input to about 170% and reducing the blue and green to about 40%, I was able to produce the effect I wanted and create a similar degree of contrast in black and white to that of the original colour image. (MB)

Technical Notes

Medium-format SLR, 55–110mm zoom lens with polarizing and 81B warm-up filters, Fuji Velvia.

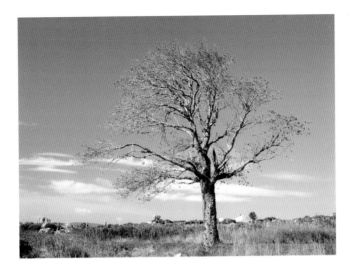

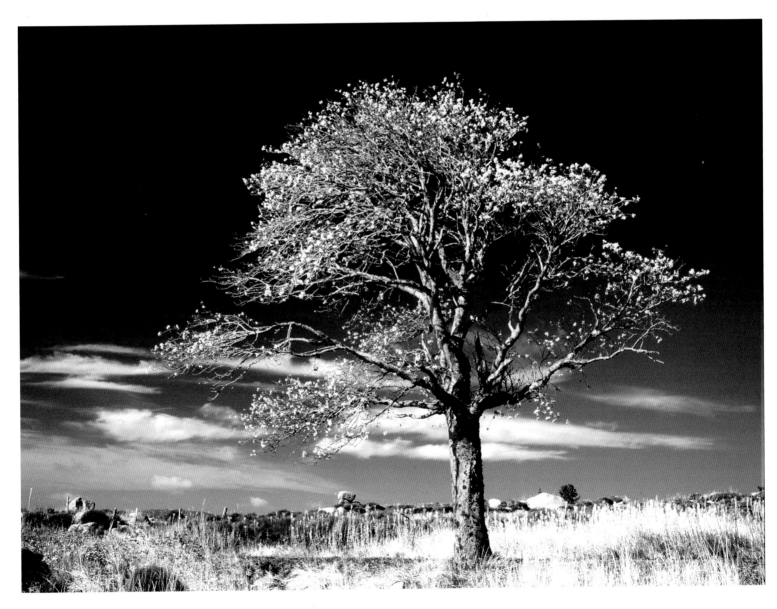

Adding Colour to Monochrome

I t has always been possible to add colour to a black-and-white image by means of chemical toning. This process can provide a range of hues from green/blue to sepia and red and two-colour effects can be be created using methods such as split toning. Digital photographers can draw on a much wider range of possibilities and also have much more control over the colours selected and the way they are distributed in the image.

There are a number of ways of creating colour in a digitized monochrome image, but they all depend on it being in RGB or CMYK mode. When working with a black-and-white original, you need to convert it to one of these two modes before you can add any colour.

Situation and Approach

To obtain the most effective results, you must begin with an image that has a full range of tones with some well-graduated shadows and highlights with good detail. With this image, my aim was to produce an effect similar to that of split toning or lith printing, rather than the single tint that would be obtained by the normal toning of a black-and-white print.

The first step was to make a duplicate layer and switch it off, showing only the base layer. I then went to Image/Adjust/Curves and altered them to create a Cyan/Blue bias in the dark and mid tones of the image. Going to the copy layer, I used the same procedure to create a pinkish sepia hue in the lighter areas of the image. Using Layer/Options, I adjusted the slider until I achieved the desired blue tone in the darker areas of the picture, with a gradual transition into sepia mid tones and highlights.

By returning to each layer in turn and making slight adjustments to the Hue and Saturation control, I was able to fine-tune the colours until I got exactly the colours I wanted. (MB)

**Technical
Notes**
Medium-format
SLR, 55–110mm
zoom lens, Ilford
XP2.

▷**Useful Advice**
The simplest way to add colour to a black-
and-white image, or to render a colour
image as a tinted monochrome, is to go to
Hue and Saturation in Image/Adjust. By
checking the Colorize box and altering the
sliders, you can create almost any colour
you wish.

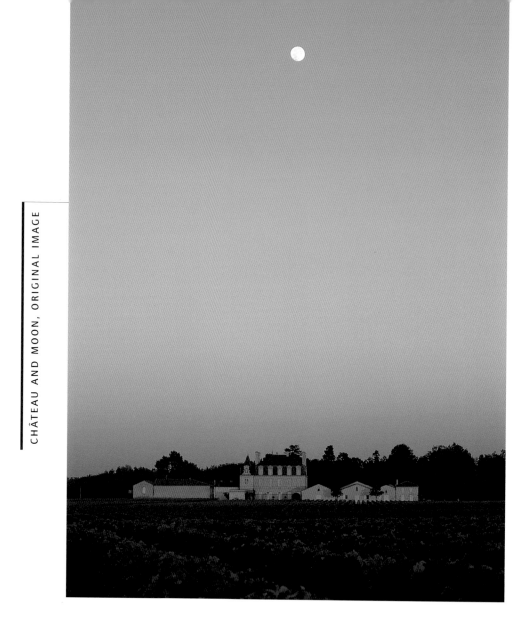

Enhancing the Image

No matter how good the film or digital receptor, and no matter how skilful your use of filters or control of exposure, it's seldom that you end up with an image that is exactly as you would like it. With black-and-white materials in the darkroom, there are a number of ways of enhancing the image; but there is very little you can do to produce a significant alteration to an image taken on colour film.

With an image that has been recorded as pixels, either on a digital camera or as an image scanned from colour film, there are countless ways of enhancing it. Very often a simple alteration to density, contrast or colour quality can be enough to turn a good photograph into a great one, and slight changes to details can achieve a similar result without significantly altering the essence of a picture. The great advantage of digital imaging is that alterations can be made selectively.

Situation and Approach

I photographed this château in the Médoc region of France near the wine village of Pauillac. I'd arrived at a previously chosen viewpoint just before sunrise in order to capture the first light and was delighted to find a bright, full moon nicely placed in the sky above.

I was quite pleased with the resulting transparency, which I shot on Fuji Velvia, but I felt that quite a lot could be done to improve it after scanning. After adjusting the contrast and brightness using the Curves control I decided to improve the colour of the sky, which had a rather degraded quality in the original. This was done using Image/Adjust/Replace Colour.

I also felt that the impact of the moon would be greater if it were a little larger and lower. I drew a circular selection around the moon, applied a degree of feathering using Select/Feather and copied it. I then used the Cloning tool to erase the moon and pasted it back from the copy onto a new layer. This enabled me to reposition it and make it larger, using Edit/Transform/Scale. I set the Blend mode to Lighten to hide the slight difference in sky density.

My one remaining concern was that the château itself was not illuminated strongly enough by the weak sunlight to separate it from its surroundings. Using the Magic Wand tool, I selected just the building and, using a combination of Curves and Hue and Saturation, increased its colour and brightness to the required degree. I also used the Sponge tool set to Saturation and low pressure to improve the sky colour near the horizon. (MB)

Technical Notes

Medium-format SLR, 55–110mm zoom lens, Fuji Velvia

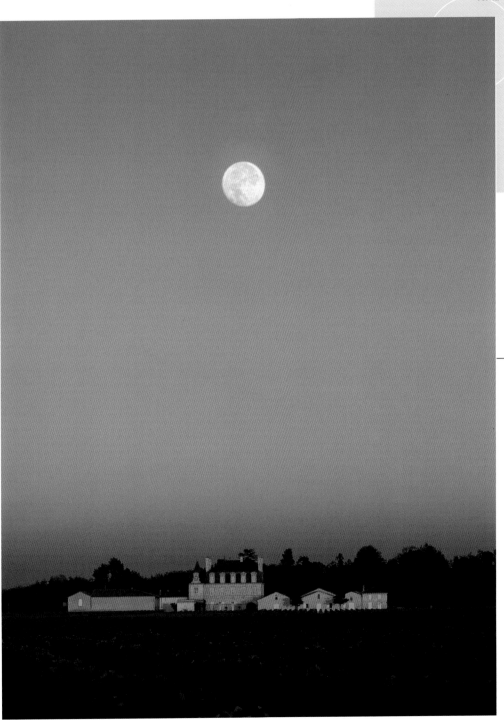

CHÂTEAU AND MOON, DIGITAL TREATMENT

Technical Notes

35mm SLR,
24–85mm zoom
lens, Kodak
Ektachrome
100SW.

Altering Focus

One of the unique qualities of photography is the ability to show elements of a scene either in sharp focus or as a blurred image — something that our eyesight cannot do. It's a very useful tool in controlling image quality and is a valuable element of composition.

As explained on page 248, you can control the amount of blur by selecting the aperture to control the depth of field — but once you have made this decision and recorded the image recorded on film, there is little more you can do to alter it. With an image consisting of pixels, however, you can soften elements of a photograph that have been recorded in sharp focus during the image-editing stage.

Situation and Approach

In a busy market in Gujarat, India, a young woman showed me her handiwork using a henna stencil. The market was very crowded and it was difficult to find the viewpoint I wanted. I used a medium aperture of about f/8 to make sure that her hand was sharp from front to back, but this resulted in the background of her sari being too obtrusive and I felt that it lessened the impact of the photograph.

First I made a duplicate layer and then, using Filter/Blur, applied a degree of Gaussian blur to the whole image which rendered the sari as a much softer, more homogeneous blur. I then made a mask for this top layer and, using the airbrush tool, began to paint out the effect of the blur on the areas that I wanted to be sharp. I began in the centre of the womans palm, using a large brush at 100% pressure. When I reached the more difficult areas, where the edge of the hand met the background, I reduced both the brush size and the pressure in order to erase the blurred image more carefully and make my efforts less noticeable. (MB)

Creating Effects

Digital imaging can create a huge variety of effects. Some people believe that this is an easy way to turn a poor photograph into a good one – but it usually only results in turning it into another poor one with a strange effect. The mark of success is when the right effect is applied to the right image – and the image needs to be good to begin with.

Posterization

One interesting effect is posterization, in which a continuous tone image can be rendered as one in which a series of discernible tonal steps is revealed. It could hardly be easier to apply: simply go to Image/Adjust/Posterize and select the number of steps that you require.

Situation and Approach

I photographed this lovely brass door knocker in a Spanish village on colour transparency film and thought it might lend itself well to a more graphic rendition by using the Posterisation effect.

I first removed the colour from the image by going to Image/Adjust/ Desaturate. Then I set the Posterization level to 7. Using the Colour Picker, I selected a very dark brown.

The next step was to select the darkest step, black, on the posterized image using Select/Colour range. I then filled this with the dark brown. After deselecting this step I made a similar selection of the next lightest level, filling this with a slightly lighter shade of brown. I repeated this process, making each step slightly lighter in colour until the last, white, level which I filled with a pale gold. (MB)

Technical Notes

35mm SLR,
70–200mm zoom
lens, Fuji Velvia.

Technical Notes

35mm SLR,
24–85mm zoom
lens, Fuji Provia
400F.

Situation and Approach

When posterization is applied directly to a colour image, the resulting colours are invariably garish. For this image I set a posterization level of 6 and then used Image/Adjust/Replace Colour to alter each of the resulting colours in turn. (MB)

DOOR KNOCKER, ORIGINAL IMAGE LEFT, DIGITAL TREATMENT RIGHT

MOROCCAN DANCERS, DIGITAL TREATMENT

ROSE COTTAGE, ORIGINAL IMAGE

Find Edges Filter

The Filter menu in image-editing software is where most of the effects can be found and many more can be bought as plug-ins. However, it's fair to say that many of them are simply variations on a similar theme. It's equally fair to say that used in their raw state they can soon become rather predictable and can easily dominate an image to the point where the effect is often more noticeable than the original picture.

Most of the filter effects become less gimmicky when modified and combined using layers – and, of course, when applied to the right image. The Find Edges filter in the Filter/Stylize menu is one of the most useful. It selects the boundaries between tonal changes in the images and renders them as an outline, which has the effect of creating a sketch-like quality and can be used to create quite subtle effects.

Situation and Approach

I came across this old cottage in the Landes forest in France and was attracted by its partially decaying look and the old-fashioned atmosphere it evoked. I photographed it front on to produce a two-dimensional graphic quality which the soft, almost shadowless light has helped to enhance; however, I felt the image lacked texture and needed a little extra edge.

I began by making a duplicate layer, which I desaturated using Image/Adjust. Then I inverted this in the same menu and applied the Find Edges filter. I set the Blend mode to Difference and adjusted the effect using Layer Options. The final touch was to remove the effect from the red roses, which I did by making a mask of the top filtered layer and painting out the effect in areas where I wanted the original image to show through with the Airbrush tool. After flattening the image, I felt the effect could be a little stronger. I made a copy layer, applied the Find Edges filter again, and used Threshold to convert the image to pure black and white. I set the Blend mode to Multiply and adjusted the opacity of this layer until I obtained the effect that I wanted. (MB)

Useful Advice

Making a mask is a very useful device for modifying or removing the effects created on one layer to reveal the original image below. You can easily reverse this by changing from black to white on the colour picker, or vice versa, which is automatically selected when the mask is applied.

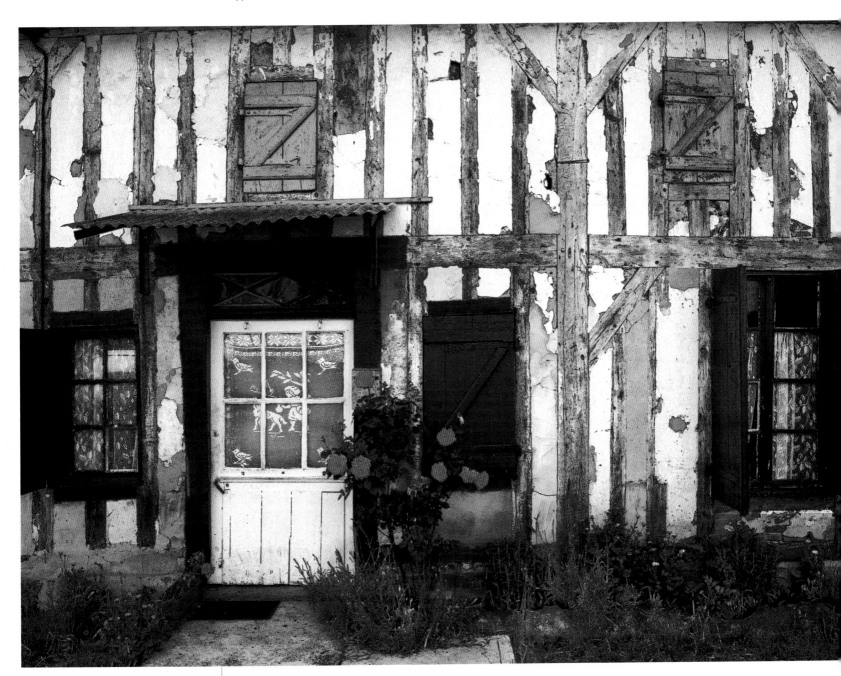

ROSE COTTAGE, DIGITAL TREATMENT

Technical Notes

35mm SLR, 24–85mm zoom lens with polarizing and 81A warm-up filters, Fuji Velvia.

Threshold Effects

Reducing an image to just pure black and white is a technique that can be used to create bold, graphic effects. In film-based photography this is done by using lith materials, a special film and developer combination, and is the basis for a number of reproduction techniques such as silk screen printing. With image-editing software such as Adobe Photoshop, the effect can be produced readily using the Threshold control in Image/Adjust. The method is very simple as you need only to move the slider in order to determine the point at which the image divides into black or white. Although it can produce interesting results on its own with the right type of image, it can also be combined with other techniques to create a much wider range of effects.

Situation and Approach

I wanted to give this image of village houses on the Italian island of Burano a more graphic, poster-like quality, but in a way that retained the original colours and general appearance of the scene. I began by making a duplicate layer and then, using the Threshold control, rendered it in tones of pure black and white, adjusting the slider until most of the image was white and only the densest shadows showed as black. I then set the blend mode to Multiply, which merged the two layers in the way seen. A final touch was to return to the base colour layer and increase the colour saturation in order to make the image a little bolder still. (MB)

Situation and Approach

I used the Threshold control to render this colour image in tones of just pure black and white, adjusting the slider until I arrived at a good balance between the two tones. Then I used Select/Colour Range to isolate the white areas and filled this, using the colour picker, with a yellow hue. Inverting the selection, I then filled the black areas with brown and made final adjustments using Image/Replace Colour until I achieved a comfortable balance between the two colours. (MB)

THREE GIRAFFES

Technical Notes

35mm SLR, 100–400mm zoom lens, Kodak Supra ISO 400 colour negative film.

Combining Images

Combining two or more photographs into a single image is one way in which photographers can produce work that is more than a simple visual record of a subject or scene.

Traditional photographic techniques for combining images include making multiple exposures in the camera, creating montage prints in the darkroom and making collages by cutting out and pasting a number of photographs together. Even with considerable skill and patience, it's almost impossible to combine images in a way that can't be detected, and the effects that can be created are limited. Photographs that consist of pixels, however, can be put together in innumerable combinations, in ways that defy detection.

One of the most useful types of combined images, and one that is often used by monochrome workers in the darkroom, is to replace a bland or weak sky with one that is more interesting or dramatic.

The montage technique is also an ideal way of producing fantasy or abstract images and allows photographers to have a greater degree of control over the content and design of their images than any other means at their disposal. Pictures created in this way can have a very personal stamp.

Useful Advice

When pasting an image on top of another, you may need to go back to the selection to adjust the feathering and recopy it a few times before you achieve a smooth edge. Using the Defringe facility found in Layer/Matting can also help in this respect.

GUJARAT TEMPLE, DIGITAL TREATMENT

Situation and Approach

I took this photograph of a hill-top temple (bottom right) in India in the early morning. Although the sunlight was quite strong and created good contrast and bold relief on the building, the sky lacked tone and colour and did little to contribute to the atmosphere of the scene.

I've collected a file of interesting skies and on looking through it I decided that the one shown top right would add considerable impact to the image of the temple without looking out of place.

First I opened the sky image and roughly adjusted the density and contrast until it looked compatible with the photograph of the building. Using the Magic Wand tool, I selected the sky area of the temple picture and inverted it, adding a small amount of feathering.

I copied this and then pasted the temple element of the image into a new layer on top of the purple sky, using Edit/Transform/Scale to alter its size to fit. I made adjustments to the colour balance, saturation, density and contrast of each layer until I arrived at what I felt was a happy balance between them. (MB)

Technical Notes

Temple image: 35mm SLR, 70–200mm zoom lens, Fuji Velvia. Sky image: 35mm SLR, 24–85mm zoom lens, Fuji Velvia.

GUJARAT TEMPLE, ORIGINAL IMAGES

Situation and Approach

Images of this type must begin with an idea or a brief. There is a theory that we dream in isolated and unrelated images, which are articulated into a scenario only at the time of waking, and this image was inspired by the recounting of a dream.

The technique involved selecting sections from four different images, copying and pasting them onto separate layers above a background image, and merging them together seamlessly using different blend modes and masking and opacity controls. (MB)

NIGHTMARE

Situation and Approach

Image-editing software such as Adobe Photoshop offers a very simple and effective way of presenting photographs in a layout form, such as making a triptych, for instance, or combining an image with lettering. For this image I simply copied eight tree images onto a new file, using Edit/Transform to size and position them. I kept each one on a separate layer until I was happy with the arrangement. You can add lettering to your image by using the Type tool. (MB)

EIGHT TREES

It is relatively simple to create montages using layers, because you can blend the component images together in so many different ways by means of Blend Modes, Opacity Control and Masking techniques. With masking you often do not need to make accurate selections of the individual images you wish to combine, because once you have imported them into a new layer, you can easily remove areas that you do not wish to appear by creating a mask and painting them out using the airbrush tool.

With so many available permutations of the various controls, the possibilities for combining two or more images are almost limitless. The effect will depend to a very great extent on the nature of the images being combined.

Situation and Approach

It was a simple matter to combine the two images shown on the right and the result is reasonably believable because the two images are fairly compatible. With both images open on the desktop, I selected all the flower picture and then copied and pasted it onto a new layer above the tree image. I used Edit/Transform/Scale to alter the size and position of the flower image to fit it. Then I set the Blend Mode to Hard Light and made a mask of this layer.

Using the airbrush tool, I carefully painted out the areas of the flower image that were visible above the horizon, using a low pressure and a small brush when I worked near the join to ensure an accurate merging. I also painted the mask to subdue places where the flower image was too dominant. Finally, I adjusted the density and contrast of each layer and the saturation until the balance between them seemed most natural. (MB)

RAPE TREE, ORIGINAL IMAGES

Catherine McIntyre

was a traditional graphic designer and illustrator until a master of design degree at the Duncan of Jordanstone College of Art in 1994 began a move towards photography. Her interest in digital photography was then triggered in 1995 when she worked at St Andrews University in the graphics department where the use of traditional graphics techniques was discouraged. She very quickly began to appreciate the creative possibilities of digital manipulation and, coming from a traditional illustration background, found the layering techniques available in Photoshop to be a complete revelation. Initial attempts at collage had always been restricted by the given scale and colour of found objects and photographs, and by the

physical problems of attachment; most importantly, translucency was not a variable. In Photoshop, there are no such restrictions. Images can be compiled from widely differing sources and fine-tuned into a coherent whole.

Catherine now works exclusively in this medium, producing images for a variety of uses ranging from CD covers to illustrations for scientific journals. Her imagery has a very organic quality and often features combinations of the nude with textured surfaces, graphic elements and still-life objects found rummaging through junk shops and at car boot sales. She has published a collection of her images in a book called *Deliquescence* and is currently working on a second title.

Mike's Comment

This image combines beauty of form with an element of fantasy, together with rich texture and colour. It's a powerful example of how disparate components can be successfully combined into a single image in a way that seems almost believable, when the image is based on a strong visual idea and executed with a sensitive use of composition, shape and texture.

Further Information

Sources of Inspiration

Books

The Creation, Ernst Haas, Viking Press;
ISBN: 0670245836

Henri Cartier-Bresson in India,
Henri Cartier-Bresson, Bulfinch Press;
ISBN: 0821227351

Europeans, Henri Cartier-Bresson,
Thames & Hudson; ISBN:050028122X

Workers, Sebastião Salgado, Phaidon Press;
ISBN: 0714837180

Migrations, Sebastião Salgado, Aperture;
ISBN: 0893818917

Cyclops, Albert Watson, Pavilion Books;
ISBN: 1862050023
A collection of powerful black-and-white
images by a master of the medium.

California, Ansel Adams, Little, Brown & Co;
ISBN: 0821223690

Yosemite, Ansel Adams, Little, Brown & Co;
ISBN: 0821221965

The Grand Canyon and the South West,
Ansel Adams, Little, Brown & Co;
ISBN: 0821226509

Ansel Adams: Divine Performance,
Anne Hammond, Yale University Press;
ISBN: 0300092415

Women, Annie Leibowitz, Jonathan Cape;
ISBN: 0224061372

Think of England, Martin Parr,
Phaidon Press; ISBN: 0714839914

Common Sense, Martin Parr, Dewi Lewis
Publishing; ISBN: 1899235078
The launch of this book was celebrated by
simultaneous exhibitions in more than 40
different cities worldwide.

Karsh: A Sixty Year Retrospective, Yousuf
Karsh, Bullfinch Press; ISBN 0821223348

Richard Avendon Portraits,
Harry N. Abrams, Inc.; ISBN: 0810935406
A collection of portrait images by a master
of the genre.

In the American West, Richard Avedon,
Harry N. Abrams, Inc.; ISBN: 0810911051

Africa, Art Wolfe, Wildlands Press,
ISBN: 0967591813

Alaska, Art Wolfe, Sasquatch Books;
ISBN: 157061217X

Deliquescence, Catherine McIntyre,
Pohlmann Press ISBN: 1890377066

Stone, Andy Goldsworthy, Viking;
ISBN: 0670854786
An artist who creates his own landscapes
and then photographs them.

Wood, Andy Goldsworthy, Viking;
ISBN: 0670871370

In Praise of Primates, Steve Bloom,
Konemann UK Ltd; ISBN: 3829015569
A sensitive study of our closest genetic
relatives in a stunning collection of images
by a gifted wildlife photographer.

*Still Life: Irving Penn Photographs
1938–2000*, Thames and Hudson;
ISBN: 0500542481
A collection of images by one of the world's
greatest photographers.

Irving Penn: Photographs by Irving Penn,
Little, Brown and Company;
ISBN: 082122459X

France, The Four Seasons, Michael Busselle,
Pavilion Books Ltd; ISBN: 1857938208

England, The Four Seasons,
Michael Busselle, Pavilion Books Ltd;
ISBN: 1862053081

On Photography, Susan Sontag,
Penguin Books; ISBN: 0140053972
A fascinating insight into the philosophical
and social implications of photography.

The Family of Man, Museum of Modern Art,
New York; ISBN: 0870703412
The book of one of the most powerful
exhibitions of photography ever mounted.

Edward Weston: A Legacy, Jennifer A. Watts,
Edward Weston, Merrell Publishers;
ISBN: 1858942063
A master of the black-and-white image.

Web Sites

Henri Cartier Bresson:
www.porto.art.br/bresson

Yousuf Karsh:
www.geh.org/ne/mismi3/karsh_sldoooo1.
html
59 selected portraits

Art Wolfe Gallery: www.artwolfe.com

Ernst Haas Gallery: /www.ernst-haas.com

Martin Parr: www.martinparr.com

Annie Leibovitz:
www.temple.edu/photo/photographers/
leibovitz
A collection of Annie Leibovitzпs striking
portraits.

Michael Fatali Gallery: www.fatali.com

*Tom Till Gallery :*www.tomtill.com
A talented landscape photographer who
uses a large format camera.

Colin Prior Gallery: www.earthgallery.net
A gifted travel and landscape photographer
who works with a large format panoramic
camera.

Catherine McIntyre Gallery:
members.madasafish.com/~cmci

Michael Busselle Gallery: www.michael-
busselle.com

Steve Bloom Gallery: www.stevebloom.com
A collection of images by a master of
wildlife photography.

Joe Cornish Gallery: www.joecornish.com
Large format landscape photography at its
best.

Charlie Waite Gallery:
www.charliewaite.com
A collection of images from an eminent
landscape photographer.

Masters of Photography:
www.masters-of-photography.com
A collection of images form many of the
world's greatest photographers.

George Eastman House: www.geh.org/
An extensive archive of images from
numerous leading photographers including;
Eugene Atget, Harry Callahan, Julia
Margeret Cameron, Alvin Langdon Coburn,
Peter Henry Emerson, Francis Frith, Ralph
Gibson, Man Ray, Aaron Siskind, and Tina
Modotti.

Temple:
www.temple.edu/photo/photographers/in
dex.html
An extensive gallery of images by renowned
photographers together with biographical
notes, essays and dissertations.

Use Film: www.usefilm.com
An on-line Gallery where you can exhibit
your own images and have your own gallery.

Alamy: www.alamy.com
An on-line Photo Library where you can
submit your own images.

Sources of Reference

The Negative, Ansel Adams,
Little Brown & Co; ISBN: 0821221868

*The Master Photographers Lith Printing
Course*, Tim Rudman; ISBN 1-902538-02-1

The Master Photographers Printing Course,
Tim Rudman; ISBN 1-85732-407-2

Creative Digital Photography,
Michael Busselle, David & Charles;
ISBN: 0715311549

Processing and Printing, Julien Busselle,
RotoVision; ISBN: 2880464277

Printing Special Effects, Julien Busselle,
RotoVision; ISBN: 2880464285

The Art of Nature Photography, Art Wolfe,
Crown Publications; ISBN: 0517880342

Adobe Photoshop 7 for Photographer,
Martin Evening, Focal Press;
ISBN: 0240516907

Useful Contacts

Silver Print www.silverprint.co.uk
Digital and conventional darkroom supplies
with large and thoughtful stock.

Calumet http://www.calumetphoto.com
An international photographic dealer with a
vast range of cameras, lenses, accessories
and materials.

The Royal Photographic Society
www.rps.org
An influential international photographic
society.

The Austrian Super Circuit
www.supercircuit.at
A major international photographic
exhibition to which all can submit images
with medals and prizes awarded for winners
and a large well-reproduced catalogue
given to all entrants.

The British Journal of Photography
www.bjphoto.co.uk
The web site of the English professional
magazine with advice, gallery lists,
portfolios, resources and useful links.

*Profoto*s www.profotos.com
An vast source of information with galleries
of master photographers, member galleries,
lists of resources and extensive links.

Pixiport www.pixiport.com/photo-ezine.htm
An on-line magazine with galleries and
information source.

Index

Abode Photoshop 296, 320, 326
abstract approach 72–3
 to architectural photography 198–9
Adams, Ansel 206, 210, 272
Agfa Scala 257
Alhambra Palace, Granada, Lion's
 Court 10
Alnwick Castle, Northumbria 197
Andalucian landscapes 42, 86, 104,
 237
animal photographs see wildlife
 photography
apertures 229, 242–5, 314
 and close-up photographs 183
 and implied lines 28
 juxtaposing shapes 19
 and perspective 104
 and portrait photography 172, 244
 and studio lighting 162
 and texture in black-and-white
 photography 61
application and purpose 74–5
Aragon landscapes 28, 130
architectural photography 196–201
 abstract approach to 198–9
 Alnwick Castle, Northumbria 197
 black-and-white 62, 294
 details 200–1
 and digital imaging 304–5
 distorted perspective 106
 illuminated buildings 147
 Leeds Castle, Kent 304–5
 and light 196, 197, 198
 lighting for form 38
 Sydney Harbour Bridge and Opera
 House 76–7
 and time of day 138, 140, 147
artificial light 160–1
Australian tree trunk 132

backgrounds for portraits 174–5
backlighting 136–7, 199

Bangkok
 compressed Thai temple 109
 market stall 219
 royal palace 243
barns 114
beaches see seaside photographs
Beachy Head lighthouse 91
bears, fighting 190–1
beauty in the mundane 70–1
black-and-white negative films 257
black-and-white photography 56–63
 C41 (colour negative) compatible
 film 58
 and colour film 255
 contrast in 58–60
 and digital imaging 308–11
 and form 34
 and format 98
 and light 56–7
 morning light through blinds 27
 and mood 54
 nudes 59, 176, 179, 290–1
 and texture 40, 60–1
 using the medium 62–3
 see also monochrome darkroom
blinds, morning light through 27
blue toning 283–5
boats
 Crow Point 116–17
 in dense cloud 152
 lighting for form 39
 wrecks 93, 116–17
 see also fishing boats
bones in monochrome 260
borders, for monochrome prints 294–5
bracketing 253
Brazil, Sierra Pelada gold mine 94–5
breaker's yards 13, 73
Bruce Canyon, Utah, USA 68–9
builders' yards 13, 224
buildings see architectural
 photography

cameras
 accessories 238–41
 filters 234–7
 formats 224–6
 types 216, 218–21
 see also lenses
Capa, Robert 48, 210
cars
 licence plates 23
 wrecked 13, 73, 292–3
Cartier-Bresson, Henri 20–1, 100
close-up photography 180–5, 221,
 238, 239
 architectural details 200–1
clouds
 and black-and-white
 photography 56
 dense cloud 152–7
 form in 36
 and light quality 148
 overcast days 150–1
colorvir toner 286–7
colour 46–55
 and artificial light 160, 161
 contrast 46–7
 and design 110–15
 and digital imaging
 adding colour to monochrome
 310–11
 colour values 304–7
 converting to monochrome 308–9
 and form 34, 37
 in fungi 33
 harmony 50–1
 in landscape photography 202
 and design 110, 112, 113, 114
 in lichen 43
 and mood 54–5
 restricted 52–3
colour correction filters 235
colour film 255, 256
colour-balancing filters 234–5

commissioned photographs 122
composition 64–123
 choice of format 96–9
 choosing the moment 100–3
 colour and design 110–15
 exploiting perspective 104–9
 focus of interest 84–9
 placing the frame 90–5
 selection process 66–75
 style and approach 116–23
 and viewpoint 76–83
compressed perspective 108–9
contrast
 in black-and-white 58–60, 270–1
 in colour 46–7
 and digital imaging 298–303
 selective contrast control 278–9
The Creation (Haas) 48
creative exposure 252–3
Cromer 54

dark tones, and exposure 250, 251
dawn photographs 52, 138–41
daylight 126–31
 and colour-balancing filters 234
 and colour-correction filters 235
Dead Horse Point, Utah 100
The Decisive Moment (Cartier-Bresson)
 20
density, and digital imaging 298–303
Denver, red house in 111
depth of field 242–5, 314
 and close-up photographs 183
 and implied lines 28
 juxtaposing shapes 19
 and plants 194
 and the selection process 73
 and studio lighting 162
 and texture 45
 and tripods 238
digital cameras 220
digital imaging 296–329
 adding colour to monochrome 310–11
 combining images 322–7
 masking techniques 326
 montages 322, 326
 controlling colour values 304–7
 controlling density and contrast
 298–303
 converting to monochrome 308–9
 creating effects 316–19
 enhancing the image 312–15
 altering focus 314–15
 Find Edges filter 318–19
 and format 225
 and image density 252
 and nude photography 176
 threshold effects 320–1
distorted perspective 106–7, 132
documentary photography 210–11, 214
 East-End hop pickers 211
 Jerusalem 210
 photographing local people 214–15
 viewpoint 76
doors
 brass door knocker 316

illuminated door handle 85
 implied lines in 30–1
double exposure 48
dreams, and enhanced digital images
 324–5
ducks, abstract approach to
 photographing 72
Dungeness, hut at 12
dusk photographs 52, 129, 161

England
 Alnwick Castle, Northumbria 197
 Canterbury Cathedral 200
 cottage garden 193
 Cromer 54
 Cumbria 137, 149
 Dartmoor 18, 136
 Devon seascape 129
 giant beach boulder 209
 East-End hop pickers 211
 Exmoor 89, 274–5
 Leeds Castle, Kent 304–5
 lighthouse at Beachy Head 91
 North Devon 186
 Crow Point 116–17, 262
 Saunton Sands 286–7
 North Yorkshire moors 84, 96–7
 St Ives at dusk 161
 West Country beach 156
eucalyptus trees 187
 in black and white 61
exposure 250–3
 and backlighting 136
 and close-up photography 185
 creative 252–3
 and dark tones 250, 251
 double 48
 and form 37
 and graduated filters 237
 selective exposure control 274–7
 and sunsets 158
 test strips 266–7

Fatali, Michael 222–3
feathers 15
film grain 262–3
film qualities 256–7
film speed 254
filters 234–7
 colour correction 235
 colour-balancing 234–5
 graduated 237
 see also polarizing filters
fish on rock 105
fishing boats
 in bright sunlight 39
 in early-morning sunlight 141
 on Skye 205
flare, and backlighting 136, 137, 199
flash, and studio lighting 164, 165, 166
flash guns 240–1
flowers see plants and gardens
focus of interest 84–9
foreground 80–3
form
 identifying 32–9

lighting for 38–9
 limited colour and detail 34–7
 Pyrenees foothills 32
 Pyrenees fungi 33
format
 camera formats 224–7
 choice of 96–9
 see also panoramic format
framing
 car licence plates 23
 and film speed 254
 and nude photography 176, 177, 179
 placing the frame 90–5
 plants and gardens 192
France
 Alpine valley 46
 Arbois, Jura 88
 Ardèche region 14
 Auverge 102, 119, 288–9
 Bugey region 78
 Burgundy landscapes 50, 66
 castle of Bretenoux 122
 Champagne landscapes 36, 257
 château of Pichon 106
 Dordogne sunrise 139
 Drôme region 52
 foothills of the Pyrenees 32
 forest of Compiègne 310–11
 game of pétanque 215
 grocer's shop 241
 Honfleur 140
 Lac du Bourget 146
 Lafite caves 228
 Landes forest cottage 318–19
 market stall 40
 Médoc region 312, 313
 Mont Lozère 308
 Périgord 118
 Provençal vineyards 26
 Provence in spring 203
 river Marne 20–1
fungi, identifying form in 33

Gambian man 250
garden photographs see plants and
 gardens
garlic cloves 181
Gibson, Ralph 168
"Golden Hour" 140–1
graduated filters 237
Greyscale 308

Haas, Ernst 48
halogen lights 161
harmonious colour 50–1
hay bales
 in black and white 60
 plastic 206
heather on a cloudy day 150
herbs, display in French market 40
honeycombs 166
horse, photographed in the Ardèche 14

image cropping 98–9
 and borders 294–5
image density 252

implied lines 28–9
India
 bazaar in Delhi 214
 cattle in Jaisalmer 196
 dawn photograph 138
 elephant in sunlight 134
 guardian of Jaipur temple 44
 Gujerat temple 322–3
 henna palm 314–15
 Jain Temple, Mount Shatrunjaya 128
 Jaipur royal palace 201
 palace of Samode, Rakasthan 218
 Pushkar Camel Fair, Rajasthan 212
 Qutab Minar in Delhi 81
 Rajasthani tribesman 235
 Royal Observatory in Jaipur 51
 shrine at Jaisalmer 183
 woman in Jaipur 103
infrared film 257
intangible, transitory shapes 16–17
Israel, Jerusalem 210
Italy, village houses on Burano 320
ivy leaves in moss 182

Jaipur
 guardian of temple 44
 Royal Observatory 51
 royal palace 201
 woman sitting outside temple 103
Jerusalem 210
junk, abstract 73
juxtaposing shapes 18–21

Karsh, Yousuf 169

landscape-format images 96
landscapes 202–9
 in black-and-white 261, 270–5
 choice of format 97–9
 choosing the moment 102
 colour in 202
 and design 110, 112, 113, 114
 and digital imaging 288–91, 310–13
 and exposure 252–3
 farm tracks 16, 28, 29
 and film quality 256, 257
 focus of interest in 84,
 86–7, 89
 form in 36
 light in
 and daylight 126–7, 130
 and dense cloud 152–7
 and time of day 202
 and weather 204–5
 man-made objects in 114, 206
 natural elements in 208–9
 nudes in 178–9
 and perspective 104, 108
 and polarizing filters 42, 203, 236
 and the selection process 66, 68–9
 and shift lenses 233
 Spanish landscape with cloud 252
 texture in 42
 and tripods 238
 viewpoint 76
 see also mountains; trees

Las Vegas, glass-fronted hotel building 24
leaves
 close-up photographs 182, 185, 221
 early spring foliage 52
 pond covered with fallen leaves 22
 red and green 194–5
Leeds Castle, Kent 304–5
Leibovitz, Annie 168
lenses
 macro lenses 221, 232
 shift lenses 196, 232, 233
 and shutter speeds 246
 telephoto 19, 36
 using creatively 228–33
 zoom lenses 70, 229
 see also long-focused lenses; wide-angled lenses
lichen, texture in 43
light 124–69
 and architectural photography 38, 196, 197, 198
 artificial 160–1
 and black-and-white photography 56–7
 contrast 58
 texture 60
 choosing the moment 103
 daylight 126–31
 and exposure 250–3
 for form 38–9
 harnessing pattern 24
 and implied lines 29
 morning light through blinds 27
 Pyrenees foothills 32
 shafts 87
 and shape 15
 and the sky 148–59
 studio lighting 162–7
 and time of day 138–47
 dawn photographs 52, 138–41
 landscape photography 202
 midday sunlight 142–3
 sunsets 144–7
 travel photography 213
 see also sunlight
lilies 58
 crocosmia 166
lines
 seeing 26–31
 implied 28–9
 morning light through blinds 27
lith printing 288–93
long-focused lenses
 and architectural photography 147, 198, 200, 201
 and composition 110
 and landscape photography 202
 and perspective 108
 photographing local people 214
 and portrait photography 172
 and the selection process 68, 69, 72
 and tripods 238, 239
low-angled sunlight 135–6

McCullin, Don 210

McIntyre, Catherine 328–9
macro lenses 221, 232
mailbox, texture in 45
man-made objects in landscapes 114, 206
markets 40, 182, 219, 278–9
matrix metering 250
metering systems
 achieving negative quality 264
 TTL (through-the-lens) metering 185, 236, 250
meters, matrix metering 250
midday sunlight 142–3
mime artist 162
monochrome darkroom 60, 258–95
 achieving negative quality 264–5
 choosing developer 262–3
 choosing film 260–61
 combining images 322
 exposure selection 268–9
 exposure test strip 266–7
 finishing and presentation 294–5
 lith printing 288–93
 selecting contrast 270–1
 selective contrast control 278–9
 selective exposure control 274–7
 toning 280–7
montage technique 322, 326
Morocco
 Atlas mountains 110
 dancers 317
 Marrakesh 82–3, 144
 midday sunlight 142
moss, ivy leaves in 182
mountains
 Atlas mountains 110
 foothills of the Pyrenees 32
 French Alpine valley 46
 La Sal mountains, Utah 157
 Sierra Nevada 273
moving objects 78–9, 86, 90, 238
 and film speed 254
 and shutter speed 246, 247
 creative blur 248, 249

negative film 254, 255, 256
Novolith 288
nude photography 176–9
 black-and-white 59, 176, 179, 290–1
 in landscapes 178–9
 lighting for form 38
 and studio lighting 164–5, 176
 Victorian 34

Other Americas (Salgado) 94

Page, Tim 210
palm trees, in black and white 63
panoramic format 27, 98, 99, 117, 120, 153, 225
 sunsets 158
 travel photography 213
parallax error 219
Parr, George 49
Parr, Martin 49
passport photographs 74

pattern, harnessing 22–5
perspective 104–9, 120
 and architectural photography 196
 compressed 108–9
 distorted 106–7, 132
 and lenses 230
pinhole cameras 62
plants and gardens 192–5
 colourful border 192
 English cottage garden 193
 flower-bed 79
 fuchsia bloom 239
 lilies 58, 166
 red dahlia 245
 see also leaves; trees
polarizing filters 236
 and composition 110
 and form 37, 39
 harnessing pattern 22
 and implied lines 28
 and landscape photography 42, 203, 236
 and portrait photography 175
portrait photography 172–9
 application and purpose in 74
 backgrounds 174–5
 choosing the moment 103
 and digital imaging 302–3
 dragon tattoo 295
 and exposure 250
 and flash guns 240
 focus of interest in 88
 form in 34, 35
 jovial vigneron 174
 and light direction 130
 outdoor portraits 172
 photographing local people 214–15
 Sebastian 254, 276, 277
 and studio lighting 162
 surfer at home 175
 texture in 44
 and tripods 239
 viewpoint 76
 see also nude photography
Portugal, Algarve 178
posterization 316–17
pragmatic approach 122–3
printing, variable-contrast paper 278
Pyrenees, foothills 32

reflectors
 and nude photography 177
 and studio lighting 166
restricted colour 52–3
rocks
 cloud and rock 153
 harnessing pattern in rock shapes 25
 Joanie's rock 178
 limpets on 131
 rock form in black and white 57
roll-film cameras 224
Roussillon, vineyards 26
rubbish tips 13

safaris 151, 188
Salgado, Sebastião 94

"Workers" 94–5
Scotland
 Borgie river 236
 cascading river 248
 croft against thunderous sky 154–5
 Skye 205
 west coast 108
sculptures, lighting for form 38
seagulls 49
seaside photographs
 beach in storm 156
 in black-and-white 262, 286–7
 breaking waves 101
 Cromer 54
 Devon seascape 129
 dune grass 133
 fish on rock 105
 fisherman's hut 70–1
 jogger 100
 low-angled sunlight 135
 muted wave 171
 nightime amusements 160
 and personal style 120, 121
 sand and twig on beach 41
 sunsets 145, 158–9
 Westbay 49
 see also boats
seaweed 184
seeing lines 26–31
selection process 66–75
 and the abstract approach 72–3
 application and purpose 74–5
 and beauty in the mundane 70–1
selective focusing 244
selenium toning 281
sepia toning 282
shadowy tree roots 17
shapes
 discovering 14–17
 intangible, transitory 16–17
 juxtaposing 18–21
Shaw, George Bernard 169
sheet film 224
shift lenses 232, 233
 and architectural photography 196
shops, derelict 74–5
shutter speeds 246–9
 and architectural details 200
 and close-up photographs 183
 and creative blur 248–9
 and film speed 254
 and flash guns 241
 and form 37
 and landscape photography 208
 and tripods 238, 239
skies 148–59
 cloudy 148–57
 and landscape photography 204
 lighting for form 39
 sunsets 158–9
 and texture 42
SLR (single-lens reflex cameras) 218, 220, 221
snoots 166
snow scenes 89, 149, 251
Spain

Alhambra Palace, Granada, Lion's Court 10
Andalucian landscapes 42, 86, 104, 237
Aragon landscape 28, 130
Castilian plain 90
Cordoba cathedral 238, 242
Costa del Sol
 beach basketball nets 207
 boats 141, 152
 surf 300, 301
foothills of the Pyrenees 32
jogger on beach 100
La Mancha 256
landscape with cloud 252
matador 247
monastery of Piedra, Aragon 208
poplar plantation 115
specialized subjects 170-215
 architectural photography 196-201
 documentary and travel photography 210-15
 landscape photography 202-9
 plants and gardens 192-5
 portrait photography 172-9
 still-life and close-up 180-5
 wildlife 170, 186-90
spot metering 250
spotlights 166
Sri Lanka, canoe and sunset 231
still life 180-5
 aubergines 34
 black-and-white photography 58
 canna leaves 185
 fungi 33
 garlic cloves 181
 ivy leaves in moss 182
 lighting for form 38
 seaweed 184
 sticks and stones 180
 and studio lighting 162
 tortured strawberry 47
 using texture 40, 41
 viewpoint 76
strawberry, tortured 47
studio lighting 162-7
 and nude photography 164-5, 176
style and approach 116-23
sunlight 132-7
 backlighting 136-7, 199
 and colour harmony 51
 and dense cloud 152, 156
 fishing boat in 39
 and the foreground 80
 and landscape photography 202
 low-angled 134-5
 midday 142-3
 mountains in 46
 and portrait photography 44, 173
sunsets 144-7, 158-9, 231
Sydney, Harbour Bridge and Opera House 76-7

telephoto lenses
 juxtaposing shapes 19
 and landscapes 36

textures 40-5
 and black-and-white photography 40, 60-1
 and colour harmony 51
 in landscapes 42
 in lichen 43
 mailbox shot 45
 in portraits 44
 in still lifes 40, 41
Thai temple, compressed 109
tones
 and digital imaging
 balancing 300-1
 tonal contrast 302-3
toning black-and-white prints 280-7
tortured strawberry 47
transparency film 254, 255, 267
travel photography 212-15
 photographing local people 214-15
trees
 Australian tree trunk 132
 backlit 137
 in black and white 61, 63, 270-1
 and camera format 226-7
 colour harmony 50
 and digital imaging 308-9, 326-7
 distorted perspective 107
 early spring foliage 52
 eucalyptus 61, 187
 framing 92
 implied lines in 28
 juxtaposing shapes 19
 lone trees 118, 119
 in midday sunlight 143
 misty morning in Kent 204
 poplar plantation 115
 shadowy tree roots 17
 silhouetted 46
 skeletal 53
 Utah rock tree 65
 and winter sunset 146
 see also leaves
tripods 238-9
 and architectural details 200
 and close-up photographs 183, 238, 239
 and creative blur 248
 and wildlife photography 188
TTL (through-the-lens) metering 185, 236, 250
tungsten lighting 161, 162, 164
 and nude photography 176
Tuscany, farm track 16
twin lens reflex camera 219

United States
 American shop front and signs 213
 Cape Cod 249
 Colorado
 gift shop 148
 rail crossing 230, 263
 wrecked cars 292-3
 Denver
 high-rise buildings 62, 198
 red house 111
 Mono Lake, California 126-7

Monument Valley, Arizona 202
New England clapboard house 307
see also Utah, USA
upright format 96, 97, 122
 and architectural photography 199
urban environments, harnessing pattern 24-5
Utah, USA
 Arches National Park 233
 Bruce Canyon 68-9, 234
 Canyonlands National Park 98-9, 113
 La Sal mountains 157
 pine tree 270-1

vehicles, photographing from 188
Victorian photographs 34
view cameras 218
viewfinder/rangefinder cameras 218-19
viewpoints 76-83
 architectural photography 76, 196, 197, 199
 foreground 80-3
 harnessing pattern 24
 landscape photography 209
 moving objects 78-9
 photographing local people 214
 and portrait photography 174, 179
vineyards
 at Roussillon, Provençe 26
 Champagne 36, 257
Viradon toning 282, 283
visual skills 8-62
 black-and-white photography 27, 34, 40, 54, 56-63
 colour awareness 46-55
 discovering shape 14-17
 harnessing pattern 22-5
 identifying the elements 10-13
 identifying form 32-9
 juxtaposing shapes 18-21
 seeing lines 26-31
 simple bucket and broom 9
 using texture 40-5

warm-up filters, and implied lines 28
waterfalls
 at the Monastery of Piedra, Aragon 208
 cascading 248
 colour and mood 55
 form in 37
weather, and landscape photography 204-5
Westbay 49
wide-angled lenses 228, 230
 and aperture 242
 and architectural photography 196, 198
 and colour 53, 54
 and dense cloud 156
 and documentary photography 210
 and implied lines 28, 29
 and landscape photography 204, 205, 209
 and lighting for form 39

and moving objects 78
and perspective 104, 106
photographing local people 214
and portrait photography 175
 nudes 179
and the selection process 66, 67
and sunlight 132
wildlife photography 170, 186-91
 baboon 151
 and digital imaging 321
 fighting brown bears 190-1
 giraffes 220, 321
 koala bear 187
 kudu (antelope) 188
 lions 189
 swans 186
 zebra 229
Wolfe, Art 190

zoom lenses 70, 229

Dedicated to Colin Webb

First published in Great Britain in 2003 by
PAVILION BOOKS LIMITED
The Chrysalis Building
Bramley Road
London W10 6SP
www.chrysalisbooks.co.uk

An imprint of **Chrysalis** Books Group plc

Designer: Andrew Barron at thextension
Senior Commissoning Editor: Stuart Cooper
Editor: Lizzy Gray

ISBN 1 86205 483 5

A CIP catalogue record for this book is
available from the British Library.

Set in Bembo and Quay Sans EF

Printed by Leefung, Hong Kong

The publisher wishes to thank the
photographers listed below for their kind
permission to reproduce the photographs in
this book. Every effort has been made to
acknowledge the pictures, however we
apologise if there are any unintentional
omissions.

20/21 ©Henri Cartier-Bresson/Magnum
Photos. 48 Ernst Haas/Getty Images. 49
©Martin Parr/Magnum Photos. 94/95
Sebastiao Salgado/Amazonas/NB Pictures.
168 Annie Leibovitz/Contact/NB Pictures.
169 Yousuf Karsh/Camera Press, London.
190/191 ©Art Wolfe/www.ArtWolfe.com.
222/223 ©Michael Fatali
1993/www.fatali.com. 272/273 Ansel
Adams/Corbis. 328/329 Catherine
McIntyre.

This book can be ordered directly from the
publisher. But try your bookshop first.